C

D1616353

W

THE
MODERNIST
TEXTILE

EUROPE AND AMERICA
1890 – 1940

VIRGINIA GARDNER TROY

THE
MODERNIST
TEXTILE

EUROPE AND AMERICA

1890 – 1940

Lund Humphries

First published in 2006 by

Lund Humphries
Gower House
Croft Road
Aldershot
Hampshire GU11 3HR
United Kingdom

and

Lund Humphries
Suite 420
101 Cherry Street
Burlington
VT 05401-4405
USA

www.lundhumphries.com

Lund Humphries is part of Ashgate Publishing

British Library Cataloguing-in-Publication Data
A catalogue record for this book is available from the British Library

Troy, Virginia Gardner, 1956-
 The modernist textile : Europe and America, 1890-1940
 1. Textile design – History – 20th century 2. Textile
 design – History – 19th century 3. Modernism (Art)
 I. Title
 746'.09041

ISBN-10: 0 85331 900 6
ISBN-13: 978-0-85331-900-9

Library of Congress number 2006927557

The Modernist Textile: Europe and America 1890–1940
© 2006 Lund Humphries
Text © 2006 Virginia Gardner Troy

Designed by Chrissie Charlton
Printed in Singapore under the supervision of MRM Graphics

(title page)
detail of fig.92, p.131

CONTENTS

ACKNOWLEDGEMENTS

I would like to thank my editors at Ashgate/Lund Humphries, especially Lucy Clark, for supporting this project in the beginning stages and working with me to shape it into its final form.

I am extremely grateful to Berry College for providing me with sabbatical leave, release time, administrative assistance and travel and subvention grants over the last few years in support of this project. I also thank The Wolfsonian Museum-Florida International University for financial and scholarly support through a Wolfsonian Fellow award, and through generous permission and photography subventions.

Many museum professionals in the United States and Europe have offered their expertise and help over the years. I would like to thank these individuals in alphabetical order of their institutions: Jacqueline Atkins, Allentown Art Museum; Karen Herbaugh, American Textile History Museum; Jessica Batty and Christa Thurman, Art Institute of Chicago; Susan Neill, Atlanta History Center; Brigitte Herrbach-Schmidt, Badisches Landesmuseum Karlsruhe; Anita Jones, Baltimore Museum of Art; Sabine Hartmann, Bauhaus-Archiv, Berlin; Marian Wardle, Brigham Young University Museum; Cathy Stoike, Brücke-Museum, Berlin; Laura Muir and Peter Nesbit, Busch-Reisinger Museum of Harvard University; Aliki Economides, Centre Canadien d'Architecture; Ken Clark, Chihuly Studio, Seattle; Barbara Duggan and Matilda McQuaid, Cooper-Hewitt Museum; Roberta Gilboe, and Gregory Wittkopp, Cranbrook Art Museum; Kevin Tucker, Dallas Art Museum; Libby Sellers, Design Museum, London; Lynn Felsher, Fashion Institute of Technology Museum; Rainer Hüben, Fondazione Arp, Locarno; Jonna Gaertner, Galerie im Lenbachhaus und Kunstbau, Munich; Eberhard W. Kornfeld, Galerie Kornfeld & Cie., Bern; Ashley Callahan, Georgia Museum of Art, Athens; Peter Trowles, The Glasgow School of Art; Ann Lane Hedlund, The Gloria F. Ross Center for Tapestry Studies, Arizona; Cecilia Öri-Nagy, Gödöllö Museum, Hungary; Charles Mathes, Jane Kahan Gallery, New York; Brenda Danilowitz and Nicholas Fox Weber, Josef and Anni Albers Foundation; Roland Scotti, Kirchner Museum, Davos; Franziska Heuss, Kunstmuseum Basel; Dale Gluckman, Los Angeles County Museum; Lotus Stack, Minneapolis Institute of Art; Danielle Blanchett and Rosalind Pepall, Musée des Beaux-Arts de Montréal; Jacqueline Jacqué, Musée de l'Impression sur Etoffes, Mulhouse; Michèle Giffault, Musée Tapisserie, Aubusson; Ana Paula Machado, Museu Nacional de Soares dos Reis, Portugal; Tunde Farkas, Museum of Applied Arts, Budapest;

Angela Völker, Museum of Applied Arts, Vienna; Linda Clous, Museum of Arts & Design, New York; Kristin Haefele, Museum Bellerive, Zurich; Mienke Simon Thomas, Museum Boijmans Van Beuningen, Rotterdam; Lauren Whitely, Museum of Fine Arts, Boston; Ursula Strate, Museum für Kunst und Gewerbe, Hamburg; Christian Larsen, Museum of Modern Art, New York; Margot Th. Brandlhuber, Museum Villa Stuck, Munich; Dorothee Bieske, Museumsberg Flensburg; Dilys Blum and Deborah Lippincott, Philadelphia Museum of Art; Susan Hay and Madelyn Shaw, Rhode Island School of Design Museum; Thomas Gaedeke, Stiftung Schleswig-Holsteinische Landesmuseen; Ahuva Israel, Tel Aviv Museum; Guus Boekhorst, Textile Museum Tilburg, Netherlands; Anna Jackson, Linda Parry, Charlotte Samuels and Claire Wilcox, Victoria & Albert Museum, London; and Caryl Burtner, Virginia Museum of Fine Art, Richmond. Finally, I express my thanks to members of the Wolfsonian in Miami Beach for introducing me to their collection, coordinated by Jonathan Mogul; for financial support by director and associate director Cathy Leff and Melissa Smith Levine; and for professional expertise by curator Marianne Lamonica, registrars Kim Bergen and Amy Silverman, librarians Nicholas Blaga and Frank Luca, and photographer Silvia Ros.

I would like to thank the many scholars whose pioneering work on the subject of nineteenth- and twentieth-century textiles inspired this project. I am grateful to these scholars for their assistance: Whitney Blausen, Elizabeth Ann Coleman, Charlotte Douglas, Marjan Groot, Giles Kotcher, Matteo de Leeuw-de Monti, Maria Makela, Francis Naumann, Bibi Obler, Amy Ogata, Brooke Pickering, Clark V. Poling, Tommye Scanlin, Mary Schoeser, T'ai Smith, Petra Timmer, Julia Tulovsky and Gabriel Weisberg.

I thank the photographers, private collectors and museum and foundation representatives who granted permission to reproduce art for this book, and am especially thankful to those who graciously reduced or waived photography and permission fees. Every effort has been made to give credit to third party copyright holders; I apologise for any omissions or errors.

In Rome, Georgia, I am deeply grateful to Mindy Wilson for her editorial expertise. At Berry College I thank Aziza Ali, Casey Roberson and professors Vincent Gregoire and Michael Smith for helping with translations; Xaiojing Zu for securing interlibrary loans; Patrick Allison for help with multi-media production; and Robin Hubier, Megan Cippolini and Amy Summerlin for assistance with the index and other details.

Finally I express my heartfelt gratitude to my family.

ILLUSTRATIONS

Chapter One

1 Henry Van de Velde, *Engelswach; La Veillée des Anges* (Angels' Watch), 1893. Wool appliqué and silk embroidery, 140 x 233 cm (55⅛ x 91¾ in.). Kunstgewerbemuseum Zürich, Museum Bellerive, No.1959-71. Photo: Marlen Perez.

2 Japan, kimono, 1860–90. Monochrome figured satin silk, with paste-resist decoration and embroidery in silk and metallic thread, 160 x 125.5 cm (63 x 49⅓ in.). Purchased from Liberty & Co, Victoria & Albert Museum, London, 874-1891.

3 Edouard Vuillard, *La tapisserie* (The Tapestry, or Embroidering by the Window), 1895–96. Oil on canvas, 177.37 x 65.61 cm (69⅞ x 25⅞ in.). The Museum of Modern Art, New York, Estate of John Hay Whitney, 294.1983. Photo credit: © The Museum of Modern Art/Licensed by SCALA/Art Resource, New York; © 2006 Artists Rights Society (ARS), New York/ADAGP, Paris.

4 József Rippl-Rónai (designer), Lazarine Boudrion (embroiderer), *Woman in Red Dress*, 1898. Wool, embroidered with satin stitch, 230 x 125 cm (90½ x 49¼ in.). Museum of Fine Arts (Szepmuveszeti Muzeum), Budapest, Hungary, 52.3491. Photo credit: Erich Lessing/Art Resource, New York.

5 Liberty of London Ltd, *Field Flowers*, c.1900–10. Duplex-printed cotton, 19 x 29 cm (7½ x 11⅓ in.). Victoria & Albert Museum, T.317–1976.

6 Indonesia, Java, Lasem, woman's hip wrapper (Sarung Kelengan), c.1910. Hand-drawn wax-resist (batik) on machine-woven cotton, natural dyes, 107.2 x 197.3 cm (42¼ x 77⅝ in.). Los Angeles County Museum of Art, Inger McCabe Elliott Collection. Photograph © 2005 Museum Associates/LACMA.

7 Hermann Obrist (designer), Berthe Ruchet (embroiderer), embroidered cloth with floral motifs, c.1895. German linen with silk embroidery, 316 x 218 cm (124⅓ x 85⅞ in.). Münchner Stadtmuseum, Die-Neue-Sammlung, Munich, 737083.

8 Maurice Pillard Verneuil, pages 234–35, *Avione* (Oats), from *Étude de la plante*, 1903. Published by Librairie Centrale des Beaux-Arts, Paris. 36.2 x 28.5 cm (14¼ x 11¼ in.). The Wolfsonian-Florida International University, Miami Beach, Florida, The Mitchell Wolfson Jr Collection, 84.2.154. Photo: Silvia Ros.

9 Margarethe von Brauchitsch, Kissenplatte (pillow cover), c.1904. Silk embroidery on silk ground, 34.5 x 34.5 cm (13⅝ x 13⅝ in.). Münchner Stadtmuseum, Die-Neue-Sammlung, Munich.

10 Wassily Kandinsky, *Stickereientwurf mit stilisierten Bäumen* (embroidery design with stylised trees), c.1904. Gouache and white crayon on black paper, 8.2 x 15.3 cm (3¼ x 6 in.). Städtische Galerie im Lenbachhaus München. Photo: Städtische Galerie im Lenbachhaus München; © 2006 Artists Rights Society (ARS), New York/ADAGP, Paris.

11 Attributed to Gerrit Willem Dijsselhof, panel from a screen, 1900–10. Cotton, wax-resist dyed (batik), 157.8 x 50.5 cm (62⅛ x 19⅞ in.). Museum of Fine Arts, Boston, Edward J. and Mary S. Holmes Fund, 1994.291. Photograph © Museum of Fine Arts, Boston.

12 Chris Lebeau, fireplace screen panel with fish motifs. Silk, wax-resist dyed (batik), 73 x 69 cm (28¾ x 27¼ in.). Kunstgewerbemuseum Zürich, Museum Bellerive, No.7047. Photo: Marlen Perez.

13 Charles Francis Annesley Voysey, *Vine and Bird*, design for textile, 1899. Watercolour and pencil, 46.5 x 37.7 cm (18⅓ x 14⅘ in.). Victoria & Albert Museum, given by Courtaulds Ltd, E.180-1974.

14 Alexander Fisher, *Rose Tree*, c.1904, executed by Royal School of Art Needlework, London. Silk damask with wool and silk embroidery, 309.88 x 280.04 cm (122 x 110¼ in.). Los Angeles County Museum of Art, gift of Max Palevsky, M.2001.191.7.1-3.

15 May Morris, *portière* (one of four), 1892–93, for Morris & Co. Silk damask with silk embroidery, silk fringe and cotton lining, 259.1 x 137.2 cm (102 x 54 in.). Museum of Fine Arts Boston, in memory of J. S. and Sayde Z. Gordon from Myron K. and Natalie G. Stone, 1983.160d. Photograph © Museum of Fine Arts, Boston.

16 Margaret Macdonald Mackintosh, two panels, c.1900. Silk appliqué, embroidery with silk and metal threads, silk braids, ribbon and glass beads on linen, watercolour on paper, each: 177.2 x 41 cm (69¾ x 16¼ in.). Glasgow School of Art Museum, Mackintosh Collection.

17 Candace Wheeler, water-lily textile, manufactured by Cheney Brothers, 1883–1900. Warp printed silk, 90.8 x 21.6 cm (35¾ x 8⅛ in.). The Metropolitan Museum of Art, New York, gift of Mrs Boudinot Keith, 1928, 28.70.23.

18 Anna Frances Simpson, embroidered table runner, c.1902–15. Embroidered linen, 50.8 x 182.88 cm (20 x 72 in.). Los Angeles County Museum of Art, gift of Max Palevsky, AC1995.250.45. Photography © 2003 Museum Associates/LACMA.

19 Page 507 from *The Craftsman*, vol.5, no.5, February 1904, table scarves with Indian designs. Published by The United Crafts, Syracuse. 26.1 x 20.4 cm (10¼ x 8 in.). The Wolfsonian-Florida International University, Miami Beach, Florida, The Mitchell Wolfson Jr Collection, XB2005.03.28. Photo: Silvia Ros.

20 Harriet Powers, pictorial quilt (the 'Bible Quilt'), 1895–98. Pieced, appliquéd and embroidered printed cotton, 175 x 266.7 cm (68⅞ x 105 in.). Museum of Fine Arts, Boston, bequest of Maxim Karolik, 64.619. Photograph © Museum of Fine Arts, Boston.

21 Otto Eckmann, *Fünf Schwäne* (Five Swans), 1897. Tapestry weave, wool and cotton, 240 x 76 cm (94½ x 30 in.). Otis Norcuss Fund, Curator's Discretionary Fund, Charles Potter Kling Fund and Textile Purchase Fund, courtesy Museum of Fine Arts, Boston.

22 Heinrich Sperling, *Möpseteppich* (Pug Tapestry), 1899. Tapestry weave, wool and cotton, 238 x 71 cm (93¾ x 28 in.). Museum Flensburg, Inv.Nr.24896.

23 Gerhard Munthe (designer), Nini Stoltenberg (weaver), *Die Nordlichttöchter* (The Daughters of the Northern Lights (Aurora Borealis) or The Suitors), 1895, executed 1896. Tapestry; cotton, wool, 129.5 x 163.8 cm (51 x 64½ in.). The Wolfsonian-Florida International University, Miami Beach, Florida, The Mitchell Wolfson Jr Collection, TD1993.132.1. Photo: Bruce White.

24 Frida Hansen, wall hanging, *c*.1900. Wool tapestry and open weave, 269.24 x 76.84 cm (106 x 30¼ in.). Los Angeles County Museum of Art, gift of Miss Helen and Miss Edna Schuster, M.75.56.

25 Eliel Saarinen, *Ruusu* (Rose), Ryijy rug, 1904. Woven by Suomen Käsityön Ystävät (Friends of Finnish Handicraft), 1904. Cotton, wool, 304.8 x 186.7 cm (120 x 73½ in.). The Wolfsonian-Florida International University, Miami Beach, Florida, The Mitchell Wolfson Jr Collection, TD1989.49.1. Photo: Bruce White.

26 Aladár Körösföi-Kriesch, *Kalotaszeg Women*, *c*.1907. Kelim tapestry, 164 x 165 cm (64½ x 65 in.). Gödöllöi Városi Múzeum, Gödöllö, Hungary.

Chapter Two

27 Designer unknown, scarf, *c*.1901. Made by Pfaff Company. Cotton, 43.8 x 49.5 cm (17¼ x 19½ in.). The Wolfsonian-Florida International University, Miami Beach, Florida, The Mitchell Wolfson Jr Collection, XX1990.3373. Photo: Silvia Ros.

28 Koloman Moser, *Die Reifezeit* (The Ripe Time), plate 7 from *Flächenschmuck* (Surface Decoration) by Koloman Moser. Published by M. Gerlach & Co, Vienna, 1902. Ink on paper, 26.1 x 30.5 cm (10¼ x 12 in.). The Wolfsonian-Florida International University, Miami Beach, Florida, The Mitchell Wolfson Jr Collection, XB1990.15. Photo: Silvia Ros.

29 Koloman Moser, *Goldfische* (Goldfish), plate 17 from *Flächenschmuck* (Surface Decoration) by Koloman Moser. Published by M. Gerlach & Co, Vienna, 1902. Ink on paper, 26.1 x 30.5 cm (10¼ x 12 in.). The Wolfsonian-Florida International University, Miami Beach, Florida, The Mitchell Wolfson Jr Collection, XB1990.15. Photo: Silvia Ros.

30 Japan, stencil (katagami), 19th century. Mulberry paper, 24.8 x 40.2 cm (9¾ x 15⅞ in.). Victoria & Albert Museum, D957–1891.

31 Dagobert Peche, textile sample, *Krone* (Crown), 1919, made by Wiener Werkstätte, Vienna. Printed silk, 39.1 x 93.7 cm (15⅜ x 36⅞ in.). The Wolfsonian-Florida International University, Miami Beach, Florida, The Mitchell Wolfson Jr Collection, 1994.38.1. Photo: Silvia Ros.

32 Josef Hoffmann, *Theben* (Thebes), 1910, made by Wiener Werkstätte, Vienna. Block-printed silk. 20.3 x 26.0 cm (8 x 10¼ in.). The Wolfsonian-Florida International University, Miami Beach, Florida, The Mitchell Wolfson Jr Collection, 1994.43.36. Photo: Silvia Ros.

33 Ludwig Jungnickel, *Papageienwald* (Parrot's Forest), 1910, made by Wiener Werkstätte, Vienna. Block-printed linen, 65.4 x 53.3 cm (25¾ x 21 in.). The Wolfsonian-Florida International University, Miami Beach, Florida, The Mitchell Wolfson Jr Collection, 1994.9.28. Photo: Silvia Ros.

34 Gustav Klimt, *Friedericke Maria Beer*, 1916. Oil on canvas, 168 x 130 cm (66⅛ x 51⅓ in.). Mizne Blumental Collection, Tel Aviv Museum of Art.

35 Atelier Martine, textile sample in three colourways, workshops of Paul Poiret, Paris, 1919. Block-printed satin, 84 x 43 cm (33 x 17⅞ in.). Victoria & Albert Museum, T.539–1919.

36 Raoul Dufy, design for textile, *c*.1912, for Bianchini-Férier, Lyon. Gouache and pencil on paper, 23.5 x 49.53 cm (9¼ x 19½ in.). Private Collection. Photo: Paul O'Mara; © 2006 Artists Rights Society (ARS), New York/ADAGP, Paris.

37 Photogaph of Ernst Ludwig Kirchner and Erna Schilling in Kirchner's Berlin studio, Berlin-Wilmersdorf, Durlacherstrasse 14, 1911–12. Courtesy Kirchner Museum Davos.

38 Ernst Ludwig Kirchner (designer), Lise Gujer (weaver), *Zwei Tänzerinnen*, (Two Dancers), 1924. Woven tapestry; linen warp, wool weft, 192 x 82 cm (75⅔ x 3¼ in.). Courtesy of Galerie Kornfeld, Bern.

39 Omega Workshop, fabric samples, 1913, a. *Amenophis* by Roger Fry, b. *Margery* by Duncan Grant, c. *Maud* by Vanessa Bell, d. *Mechtilde* by Roger Fry, e. *Pamela* by Duncan Grant, f. *White* by Vanessa Bell. Colour-printed linen, each: 25.4 x 38.1 cm (10 x 15 in.). The Wolfsonian-Florida

International University, Miami Beach, Florida, The Mitchell Wolfson Jr Collection. 85.14.1.1-25.

40 Sonia Delaunay, Broderie de Feuillages (embroidery of foliage), 1909. Wool embroidery on canvas, 83.5 x 60.5 cm (32$\frac{7}{8}$ x 23$\frac{7}{8}$ in.). Musée National d'Art Moderne, Centre Georges Pompidou, Paris, France. Courtesy © L&M Services B.V., Amsterdam 20050208.

41 Sonia Delaunay, Untitled, called 'Couverture' (Blanket), 1911. Appliquéd fabric, 111 x 82 cm (43$\frac{3}{4}$ x 32$\frac{1}{4}$ in.). Musée National d'Art Moderne, Centre Georges Pompidou, Paris, France. Courtesy © L&M Services B.V., Amsterdam 20050208.

42 Sonia Delaunay, Robe Simultanée, 1913. Appliquéd and sewn fabric, life size. Private Collection. Courtesy © L&M Services B.V., Amsterdam 20050208.

43 Liubov Popova, pieced and embroidered panel, 1916–17. Location unknown. Photograph © and courtesy Charlotte Douglas.

44 Nadezhda Udaltsova, pieced and embroidered panel, 1916–17. Location unknown. Photograph © and courtesy Charlotte Douglas.

45 Sophie Taeuber Arp, Composition verticale-horizontale, 1916. Needlepoint, 50 x 38.5 cm (19$\frac{3}{4}$ x 15$\frac{1}{8}$ in.). Fondazione Marguerite Arp, Locarno. Photograph courtesy Fondazione Marguerite Arp; © 2006 Artists Rights Society (ARS), New York/VG Bild-Kunst, Bonn.

46 Man Ray, Tapestry, 1911. Wool fabric stitched on canvas, 204.5 x 147.5 cm (80$\frac{1}{2}$ x 58 in.). Inv.: AM 1994-296. Musée National d'Art Moderne, Centre Georges Pompidou, Paris, France. Photo: Adam Rzepka. Photo Credit: CNAC/MNAM/Dist. Réunion des Musées Nationaux/Art Resource, New York; © 2006 Man Ray Trust/Artists Rights Society (ARS), New York/ADAGP, Paris.

47 Hannah Höch, silk embroidery, page 262 from Stickerei- und Spitzen-Rundschau (Farbige Seiden-Stickerei from Stickerei- und Spitzen-Rundschau), 1916. Published by Alexander Koch, Darmstadt. 29.3 x 22.3 cm (11$\frac{1}{2}$ x 8$\frac{3}{4}$ in.). The Wolfsonian-Florida International University, Miami Beach, Florida, The Mitchell Wolfson Jr Collection, XC1991.876. Photo: Silvia Ros. © 2006 Artists Rights Society (ARS), New York/VG Bild-Kunst, Bonn.

48 Giacomo Balla, study for a fabric motif, 1913. Watercolour on paper, 13 x 19 cm (5$\frac{1}{8}$ x 7$\frac{1}{2}$ in.). Casa Balla, Rome No.409, La Collezione Biagiotti Cigna.

49 Fortuno Depero, Procession di Grande Bambola (Procession of the Large Doll), 1920. Wool appliqué on canvas, 330 x 230 cm (130 x 90$\frac{1}{2}$ in.). Museo di Arte Moderna e Contemporanea di Trento e Rovereto.

50 Page from Peruvian Art: A Help for Students of Design by Charles W. Mead, American Museum of Natural History, 1917, plate III, and reproduced again in December 1929, no.46, plate III, 17.15 x 24.77 cm (6$\frac{3}{4}$ x 9$\frac{3}{4}$ in.). Private Collection.

51 Ilonka Karasz, textile design, n.d. Gouache or casein over graphite on wove paper, 15.24 x 14.81 cm (6 x 5$\frac{7}{8}$ in.). Collection of the Portas family. Photograph courtesy Georgia Museum of Art. Photo: Michael McKelvy.

Chapter Three

52 Maria Likarz-Strauss, Uruguay, 1925. Block-printed silk crêpe, 93.98 x 106.68 cm (37 x 42 in.). Los Angeles County Museum of Art, purchased with funds provided by the Georges and Germaine Fusenot Charity Foundation, M.2000.14.2.

53 Anonymous, roller-printed cotton, manufactured by F. Steiner & Co England, 1920s. Roller-printed cotton, 77 x 76 cm (30$\frac{1}{3}$ x 30 in.). Victoria & Albert Museum, CIRC.668-1966.

54 Leon Bakst, Design #12, c.1923-4. Gouache on paper, 66 x 51.5 cm (26 x 20$\frac{1}{3}$ in.). Collection of the Maryland Institute College of Art, on extended loan to the Baltimore Museum of Art, R.15061.10.

55 France, shawl, 1920s. Silk, satin lamé damassé, 161.3 x 161.3 cm (63$\frac{1}{2}$ x 63$\frac{1}{2}$ in.). Museum of Fine Arts, Boston, John Wheelock Elliot and John Morse Elliot Fund, 1986.758. Photograph © Museum of Fine Arts, Boston.

56 Mary Crovatt Hambidge, detail from a hand-woven dress with Dynamic Symmetry motif at yoke and hem, 1920s. Commercially-spun silk, plain weave with laid-in pattern, 9.22 x 9.22 cm (3$\frac{5}{8}$ x 3$\frac{5}{8}$ in.). Atlanta History Center, purchase from The Hambidge Center, 1998.233.M798. Photograph courtesy The Atlanta History Center, 2005.

57 André Durenceau, page from book Inspirations, 1928, plate 8. Published by H. C. Perleberg, Woodstock, New York, printed by Birmbaum-Jackson Co, Philadelphia. 44.4 x 36.8 cm (17$\frac{1}{2}$ x 14$\frac{1}{2}$ in.). The Wolfsonian-Florida International University, Miami Beach, Florida, The Mitchell Wolfson Jr Collection, 83.2.2103. Photo: Silvia Ros.

58 Swatch from fabric sample book, Broughton Co, 1928. Roller-printed cotton, approximately 2.5 x 5 cm (1 x 2 in.). Courtesy Musée de l'Impression sur Etoffes, Mulhouse.

59 Gregory Brown, fabric, 1922, for William Foxton manufacturers. Linen, 112 x 94 cm (44 x 37 in.). Victoria & Albert Museum, T 325-19334.

60 Photograph of model draped in fabrics by Sonia Delaunay, c.1925. Bibliothèque Nationale, Paris. Courtesy © L&M Services B.V., Amsterdam 20050208.

61 Liubov Popova and Varvara Stepanova, textile designs reproduced in L'art International d'aujourd'hui 15: Tapis et tissus, 1929, by Sonia Delaunay, plate 48; 1 and 3 Stepanova; 2 Popova. Published by Charles Moreau, Paris. Pochoir print, 33.6 x 25.5 cm (13$\frac{1}{4}$ x 10 in.). The

Wolfsonian-Florida International University, Miami Beach, Florida, The Mitchell Wolfson Jr Collection, XC1991.46. Photo: Silvia Ros. Courtesy © L&M Services B.V., Amsterdam 20050208.

62 Vilmos Huszár, printed linen for Metz & Co, 1922. Printed linen, actual size. Private Collection, Berlin.

63 Bart van der Leck, rug, 'Estate' design c.1918, reissued in 1989 by Tapis et Tissus, France. Wool, 211 x 106 cm (83 x 41¾ in.). Textile Museum Tilburg, The Netherlands, No.6597. Photo: Textile Museum Tilburg, The Netherlands; © 2006 Artists Rights Society (ARS), New York/Beeldrecht, Amsterdam.

64 Maurice Pillard Verneuil, plate 19 from *Kaleidoscope: ornements abstraits: quatre-vingt-sept motifs en vingt planches*, composés par Ad. et M.P.-Verneuil; *pochoirs* de Jean Saudé, published by Albert Lévy, c.1925. *Pochoir* print, 46 x 36 cm (18⅛ x 14¼ in.). The Wolfsonian-Florida International University, Miami Beach, Florida, The Mitchell Wolfson Jr Collection, XB1994.2. Photo: Silvia Ros.

65 Maurice Pillard Verneuil and Alphonse Mucha, page 19 from *Combinations ornamentals se multipliant à l'infini à l'aide du miroir,* 1901, published by Librairie Centrale des Beaux Arts, Paris. *Pochoir* print, 22.9 x 26.1 cm (9 x 10¼ in.). The Wolfsonian-Florida International University, Miami Beach, Florida, The Mitchell Wolfson Jr Collection, TD1989.22.1. Photo: Silvia Ros.

66 Herta Wedekind Ottolenghi, design for textile, 1920–29. Ink on graph paper, 8.3 x 8.3 cm (3¼ x 3¼ in.). The Wolfsonian-Florida International University, Miami Beach, Florida, The Mitchell Wolfson Jr Collection, TD1992.167.16. Photo: Silvia Ros.

67 Herta Wedekind Ottolenghi (designer), Brunilde Sapori (stitcher), wall hanging, c.1924. Wool stitching on woven wool, 231.1 x 126.4 cm (91 x 49¾ in.). The Wolfsonian-Florida International University, Miami Beach, Florida, The Mitchell Wolfson Jr Collection, TD1992.131.1. Photo: Silvia Ros.

68 Jaap Gidding (designer), Tuschinski Theatre foyer, completed 1921. Photograph © Jan van der Woning 2005.

69 Raoul Dufy, *Le Cortège d'Orphée* (The Procession of Orpheus), 1927, plate 60013, *Tissus modernes: nuances solides,* c.1927, published by Bianchini Férier, Lyons. Fabric samples, 33.0 x 27.9 cm (13 x 11 in.). The Wolfsonian-Florida International University, Miami Beach, Florida, The Mitchell Wolfson Jr Collection, XB1990.334. Photo: Silvia Ros. © 2006 Artists Rights Society (ARS), New York/ADAGP, Paris.

70 Eugène Alain Séguy, plate 14 from *Floréal: dessins & coloris nouveaux* (Floral: New Designs and Colours), published by A. Calavas, Paris, 1920s. *Pochoir* print, 54.6 x 38.7 cm (21½ x 15¼ in.). The Wolfsonian-Florida International University, Miami Beach, Florida, The Mitchell Wolfson Jr Collection, 87.1583.2.1. Photo: Silvia Ros.

71 E.H. Raskin, plate 11 from *Fantaisies Oceanographiques*, Paris:

F. Dumas, c.1926. *Pochoir* print, 39.1 x 29 cm (15⅜ x 11⅖ in.). The Wolfsonian-Florida International University, Miami Beach, Florida, The Mitchell Wolfson Jr Collection, XB1989.241. Photo: Silvia Ros.

72 Artur Lakatos, folk-inspired bird design for textile, 1920–29. Gouache on paper, 34.2 x 49.5 cm (13½ x 19½ in.). The Wolfsonian-Florida International University, Miami Beach, Florida, The Mitchell Wolfson Jr Collection, TD 1994.198.7. Photo: Silvia Ros.

73 Attributed to Marguerite Pangon, panel, France, Paris, 1920s. Silk velvet, wax-resist dyed (batik), 88.26 x 190.5 cm (34⁹⁄₄ₛ x 75 in.). Museum of Fine Arts, Boston, Arthur Mason Knapp Fund, 1998.411. Photograph © Museum of Fine Arts, Boston.

74 Marian Buck Stoll, embroidered picture, 1926. Linen plain weave embroidered with wool, 59.7 x 49.5 cm (23½ x 19½ in.). Museum of Fine Arts Boston, gift of Gillian C. Creelman, 2003.331. Photograph © Museum of Fine Arts, Boston.

75 Marguerite Zorach, panel from bedcover, 1925–28. Linen and wool, embroidered 232 x 182 cm (91⅓ x 71⅔ in.). Museum of Fine Arts, Boston, Fran B. Bemis Fund, 1992.352. Photograph © Museum of Fine Arts, Boston.

76 Edward Steichen, *Moth Balls and Sugar Cubes*, 1927, manufactured by Stehli Silks Corporation, New York. Printed silk crêpe de Chine, 20.5 x 19 cm (100 x 37 in.). Victoria & Albert Museum, T.87P-1930.

77 Ruth Reeves, *Manhattan*, 1930, produced for W. & J. Sloane for the Americana series. Printed cotton voile, 254 x 94 cm (100 x 37 in.). Victoria & Albert Museum, T.57-1932.

Chapter Four

78 Margarete Bittkow-Köhler, wall hanging, c.1920. Linen, 258 x 104.2 cm (101½ x 41 in.). Busch-Reisinger Museum, Harvard University Art Museums, BR66.33, gift of Margarete Koehler Estate.

79 Page 498 from Max Schmidt, *Kunst und Kultur von Peru*, Berlin: Propyläen Verlag, 1929. Woven textile with cornstalks, birds and crabs; from Pachacamac, Berlin Museum für Völkerkunde, Gretzer Collection, 1907.

80 Marcel Breuer (chair), Gunta Stölzl (textile), *Afrikanischer Stuhl* (African Chair), 1921. Oak and cherry wood, gold paint with water-soluble colours in blue and red tones; textile parts from hemp, wool, cotton and silk, on hemp warp, 179.4 x 65 x 67.1 cm (70⅔ x 25⅔ x 26⅘ in.). Bauhaus-Archiv Berlin, Inv.Nr.2004/33. Photo: Hartwig Klappert.

81 Gunta Stölzl, covering/wall hanging, 1922–23. Tapestry; cotton, wool and linen fibres, 256 x 188 cm (100¾ x 74 in.).

Courtesy of the Busch-Reisinger Museum, Harvard University Art Museums, Association Fund, BR49.669. Photo: Michael Nedzweski. © 2004 President and Fellows of Harvard College; © 2006 Artists Rights Society (ARS), New York/Beeldrecht, Amsterdam.

82 Paul Klee, *Monument im Fruchtland* (Monument in the Fertile Country), 1929. Watercolour and pencil on paper on cardboard, 45.7 x 30.8 cm (18 x 12⅛ in.). Zentrum Paul Klee, Bern; © 2006 Artists Rights Society (ARS), New York/VG Bild-Kunst, Bonn.

83 Marguerite Willers, page 13 from Bauhaus notebook, *c*.1927. Graphite on paper, 16.51 x 21.59 cm (6½ x 8½ in.). Centre Canadien d'Architecture, DR1985.0400.001-018.

84 Anni Albers, wall hanging, 1926. Woven silk, three-ply (triple) weave, 178.8 x 117.8 cm (70¼ x 46¼ in.). Courtesy of the Busch-Reisinger Museum, Harvard University Art Museums, Association Fund, BR48.132. Photo: Katya Kallsen; © 2006 The Josef and Anni Albers Foundation/Artists Rights Society (ARS), New York.

85 Anni Albers, textile sample, *c*.1928. Woven jute and cellophane, broken twill weave, 15.5 x 11 cm (6⅛ x 4⅓ in.). Courtesy of the Busch-Reisinger Museum, Harvard University Art Museums, Gift of Anni Albers, BR48.33. Photo: Katya Kallsen. © 2004 President and Fellows of Harvard College; © 2006 The Josef and Anni Albers Foundation/Artists Rights Society (ARS), New York.

86 Bauhaus Weaving Workshop, textile samples for tubular furniture upholstery, after 1927. Woven twill weave; cotton and wax-covered cotton, various sizes. Courtesy of the Busch-Reisinger Museum, Harvard University Art Museums, Association Fund. Photo: Allan Macintyre. © 2004 President and Fellows of Harvard College.

87 Page 394 from *Berliner Illustrirte Zeitung*, No.11, 1933. 15.24 x 11.43 cm (6 x 4½ in.). Private Collection.

88 Otti Berger, Christmas card, 1937. Typewriting on silk weave, 17.3 x 13 cm (6⅞ x 5⅛ in.). Courtesy of the Busch-Reisinger Museum, Harvard University Art Museums, gift of Lydia Dorner in memory of Dr Alexander Dorner, BR58.166. Photo: Michael Nedzweski. © 2004 President and Fellows of Harvard College.

89 Ludwig Mies van der Rohe and Lilly Reich, photograph of the 'Café Sampt und Seide' ('Velvet and Silk Café'), for *Die Mode der Dame* (Women's Fashion) *Exhibition*, Berlin, 1927. Gift of the architect. © The Museum of Modern Art/Licensed by SCALA/Art Resource, New York; © 2006 Artists Rights Society (ARS), New York/VG Bild-Kunst, Bonn.

90 Alen Müller-Hellwig, *Baum* (Tree), *c*.1930. Woven wool, jute fringe, 158 x 130 cm (6⅕ x 51⅕ in.). Courtesy of the Busch-Reisinger Museum, Harvard University Art Museums, anonymous gift, BR31.95. Photo: Katya Kallsen. © 2004 President and Fellows of Harvard College.

91 Marion Dorn, rug, Wilton Royal Carpet Factory Ltd (manufacturer),

c.1934. Hand-knotted wool, 200 cm x 122 cm (78¾ x 48 in.). Victoria & Albert Museum, 480–1974.

92 Eileen Gray, felt mat, designed *c*.1928. Wool felt, 223.52 x 135 cm (88 x 53⅛ in.). Gift of Prunella Clough, The Museum of Modern Art, New York, New York, USA. Photo Credit: Digital Image © The Museum of Modern Art/Licensed by SCALA/Art Resource, New York, ART302063.

93 Otto Lange, lace, illustrated in Herbert Read, *Art and Industry* (1934), 1947, page 130. 12.7 x 8.89 cm (5 x 3½ in.).

94 Ethel Mairet, photograph showing a selection of woven work by Ethel Mairet, 1930s. Crafts Study Centre at The Surrey Institute of Art & Design, University College, 2002.21.2. Photo: David Westwood.

95 Eliel Saarinen and Loja Saarinen, photograph of Saarinen living-room, Saarinen House, Cranbrook, 1928–30. Photograph courtesy of Cranbrook Archives, CEC3902.

96 Eliel Saarinen (designer), Studio Loja Saarinen (weaver), *Cranbrook Map Tapestry*, 1935. Linen warp; linen silk and wool weft; plain weave with discontinuous wefts, 262.9 x 313.7 cm (103½ x 123½ in.). Collection of Cranbrook Art Museum, Bloomfield Hills, Michigan. Gift of George Gough Booth and Ellen Scripps Booth through the Cranbrook Foundation (CAM 1935.7). Photograph courtesy of Cranbrook Art Museum. Photo: R.H. Hensleigh and Tim Thayer.

97 Anni Albers, *Monte Albán*, 1936–37. Woven silk, linen, wool, 146 x 112 cm (370⅞ x 284½ in.). Courtesy of the Busch-Reisinger Museum, Harvard University Art Museums, gift of Mr and Mrs Richard G. Leahy, BR81.5. Photo: Michael Nedzweski. © 2004 President and Fellows of Harvard College; © 2006 The Josef and Anni Albers Foundation/Artists Rights Society (ARS), New York.

98 Dorothy Liebes, wall hanging, 1936. Cotton, silk, rayon; hand-woven tapestry, with floating weft, 264.2 x 81.3 cm (104 x 32 in.). Museum of Arts and Design, New York, 1973.2.2. Gift of Dorothy Liebes Design, 1973; donated to the American Craft Museum by the American Craft Council, 1990.

99 Maria Kipp, textile length for drapery, *c*.1940. Linen, chenille, Lurex, rayon, 289.56 x 132.08 cm (114½ x 52 in.). Los Angeles County Museum of Art, Costume Council Fund, AC1999.19.1.

Chapter Five

100 Bandana, n.d. Transfer lithography on cotton, 56.5 x 55.9 cm (22¼ x 22 in.). The Wolfsonian-Florida International University, Miami Beach, Florida, The Mitchell Wolfson Jr Collection, TD1995.30.1. Photo: Silvia Ros.

101 Barbara Warren, wall hanging, 1935–42, produced for the WPA Milwaukee Handcrafts Project. Linoleum print on cotton, 128 x 81.9 cm (50⅜ x 32½ in.). The Wolfsonian-Florida International University, Miami Beach, Florida, The Mitchell Wolfson Jr Collection, XX1990.2964. Photo: Silvia Ros.

102 Walter Dorwin Teague, *Buttresses of the Transportation Building, Century of Progress Exposition, Chicago*, 1933, manufactured by Beau Monde Silk for Marshall Field. Printed silk, 36.8 x 46.7 cm (14½ x 18⅜ in.). The Wolfsonian-Florida International University, Miami Beach, Florida, The Mitchell Wolfson Jr Collection, 86.14.1. Photo: Silvia Ros.

103 Ruth Reeves, tablecloth, c.1935. Screen-printed linen, 89 x 90 cm (35 x 35 in.). Cooper-Hewitt Museum. Museum purchase from General Acquisitions Endowment and Friends of Textiles through gifts of Eleanor and Sarah Hewitt and Robert C. Greenwald, and through the estate of Florence Choate, 1995-103-1. Photo: Matt Flynn.

104 Fannie B. Shaw, *The Fannie B. Shaw Prosperity Quilt, Prosperity is Just Around the Corner*, 1930–32. Cotton; appliqué, embroidery, quilting, 218.44 x 182.88 cm (86 x 72 in.). Dallas Museum of Art, anonymous gift, 1998.209.

105 Ruth Clement Bond (designer), Rose Phillips Thomas (maker), *Tennessee Valley Authority Appliqué Quilt Design of a Black Fist*, 1934. Cotton and yarn; pieced, sewn, and stitched, 32.7 x 27.3 cm (12⅞ x 10¾ in.). Museum of Arts and Design, New York, 1994.17.1. Gift of Mrs Rose Marie Thomas, 1994.

106 Unknown maker, Kirtland, New Mexico, rug, 'Proud to be an American', c.1920–40. Wool tapestry weave, 178.4 x 137.8 cm (70 x 54 in.). The Wolfsonian-Florida International University, Miami Beach, Florida, The Mitchell Wolfson Jr Collection, XX1989.384. Photo: Silvia Ros.

107 Russell Lee, *Spanish-American woman weaving rag rug at WPA project (Works Progress Administration), Costilla, New Mexico*, 1939. Photograph. Farm Security Administration – Office of War Information Photograph Collection, Library of Congress Prints & Photographs Division, Washington, DC, fsa 8b22912.

108 Pendleton Woollen Mills, blanket, Green Center Point pattern, c.1920s–30s. Wool, approximately 203 x 162.6 cm (80 x 64 in.). Collection Dale Chihuly. Photo: Teresa N. Rishel.

109 Berry College Weavers, 'Whig Rose' pattern sample (detail). Wool, double-weave, 15.24 x 20.32 cm (6 x 8 in.). Collection Berry College.

110 V. Maslov, *New Life in the Countryside,* cotton textile, manufactured by the Zinoviev factory, 1926. Printed cotton, 62.5 x 59.5 cm (24⅗ x 23⅗ in.). Russian State Museum, St Petersburg, Russia. Photo credit: Scala/Art Resource, New York.

111 Artist unknown, Italy, silk scarf, late 1930s. 73 x 73 cm (28¾ x 28¾ in.). The Wolfsonian-Florida International University, Miami Beach, Florida, The Mitchell Wolfson Jr Collection, XX1990.3372. Photo: Silvia Ros.

112 'Rebel Arts' division of Union Arts Service, New York, *Stop Lynching Shame of America*, 1939. Ink on cotton, 90.8 x 57.8 cm (35¾ x 22¾ in.). The Wolfsonian-Florida International University, Miami Beach, Florida, The Mitchell Wolfson Jr Collection, 87.1028.14.1. Photo: Silvia Ros.

113 Eve Peri, wall hanging, c.1938–41. Linen, corduroy, wool and yarn; sewn, stitched and pieced, 68.6 x 54 cm (27 x 21¼ in.). Museum of Arts and Design, New York, 1992.71.7. Gift of Dr Georgiana M. Peacher, 1992.

114 Harrell Studios, design for textile, c.1930–39. Gouache and graphite on paper, 54.6 x 67 cm (21½ x 26⅜ in.). The Wolfsonian-Florida International University, Miami Beach, Florida, The Mitchell Wolfson Jr Collection, 84.5.49.10. Photo: Silvia Ros.

115 Elsa Schiaparelli (designer) (produced by Drucker-Wolf Co), *Une Main à Baiser* (A Hand to Kiss) dress fabric, 1936. Printed silk crêpe, 46.36 x 47.63 cm (18¼ x 18¾ in.). Allentown Art Museum, 1978.026.354, gift of Kate Fowler Merle-Smith, 1978.

116 Jean Lurçat, needlepoint screen, 1928. Wool, linen, cotton, three panels, each: 195.5 x 73.6 cm (77 x 29 in.). Virginia Museum of Fine Arts, Richmond. Gift of the Estate of Mrs T. Catesby Jones, 68.10.3. Photo: Katherine Wetzel; © 2006 Artists Rights Society (ARS), New York/ADAGP, Paris.

117 Le Corbusier, *Marie Cuttoli*, 1936. Tapestry, wool and silk, 147 x 175 cm (58 x 69 in.). Fondation Le Corbusier. © 2006 Artists Rights Society (ARS), New York/ADAGP, Paris/FLC.

12

INTRODUCTION

The story of modern textiles is inextricably linked to the story of modern art and modern life. The social, political and economic transformations that prompted modernist experimentation also fuelled a sea change in the way textiles were made, used and perceived. Indeed, by looking more closely at these often-neglected objects of art and utility, we can trace not only the larger cultural influences but also the important artistic movements that took shape during the modernist period. Modernist textiles are in fact fascinating social and aesthetic documents that reflect the conditions of their creation and embody the spirit of their age.

During the extraordinary decades from 1890 to 1940, textiles moved to the centre of modernist theoretical dialogues and debates, as they began to embody the ways in which art, craft and architecture could be fused in decorative and architectural programmes. The revolutionary new notion of the 'total work of art' (*Gesamtkunstwerk*), which placed textiles on an equal footing with other arts, began to permeate modernist practices and impact all facets of textile design, theory, production, marketing and consumption. Textiles were suddenly visible in every aspect of modern life – the home, the factory, the art showroom – and each had its own economic and artistic implications.

The nineteenth century represents an era when traditional notions of artistic expression collided with the realities of mass-production during the height of the industrial revolution, leading to a rapidly widening chasm between those arts removed from the chains of industry, such as easel painting and sculpture, and those aligned with or impacted by it, such as printmaking and metalwork, with textiles occupying a middle ground. This tension actually began in the Renaissance, when the demand for intricate, one-of-a-kind textiles, such as pictorial tapestries, engendered highly specialised, labour-intensive and time-consuming means of production. Production was so specialised that the product was not typically designed and produced by the same person. This division of labour intensified during the nineteenth century, as the technological innovations of the industrial revolution and the increasing emphasis on machine-made products meant textiles began not only to be mass produced but also mass consumed, which exacerbated the conflicts between art, craft and mass-production. During the second half of the nineteenth century, applied arts reformer William Morris and his followers in England actively sought to reconcile design and production and to revive the medieval handicraft tradition by promoting handcrafted objects for daily use. He believed that the act of handcrafting was an integral part of the artistic process and experience, and the value of the object increased through practical use and joy in labour.[1] Morris understood that textiles represented the materials and processes most directly tied to the industrial revolution, now that all of the processes once exclusively controlled by hand – spinning, dyeing, weaving – had become mechanised; thus textiles became central to his vision of bridging the gap between art and craft, or 'intellectual art' and 'decorative art'.[2] Under Morris' reform movement, textiles began to be perceived and produced

aesthetically, meaning that they were designed and produced in conjunction with a unified decorative and production programme, a development that led to the Arts and Crafts movement.

As artists, designers and theorists such as Morris engaged in these kinds of theoretical and artistic dialogues regarding the unification of applied art and fine art, textiles were rediscovered and re-evaluated as objects that could fit into both categories. Artists began to create textiles not as imitations of paintings, but as independent objects that related to other objects through the decidedly non-painterly, flat and decorative style of Art Nouveau. Indeed, in an interesting reversal, some painters, particularly those of the Nabis group, simulated the look and texture of textiles in their painted work in order to participate in creating a *Gesamtkunstwerk* for which the distinctions between fine art and decorative art were becoming increasingly blurred. By the turn of the twentieth century, the notion of the 'decorative' became synonymous with the notion of modernity, with textiles serving as prime exemplars of decorative art for modern life. Many artists who began their careers working in painting or other fine arts media, including Henry Van de Velde, for instance, ventured into actual textile work, discovering along the way that textiles fulfilled modern demands for an art that embraced abstract visual form, that was made by hand, and that functioned in daily life.

Textiles also facilitated the growing Western fascination with the art of non-Western societies; Japanese embroidered cloth, Javanese batiks, African tie-dyed fabric and Andean woven tunics were but a few of the many examples of non-Western textiles that inspired modern artists and fuelled consumer desires in Europe and America throughout the period. Activated by international expansion, exploration, expositions and even conflicts, textiles from all parts of the world became known to Europeans and Americans on an unprecedented scale, due in part to the easy accessibility and transportability of the textile medium.

Modernist textiles embodied significant turning points in art history and served as catalysts for change, specifically involving developments in abstraction and Constructivism. By the first decades of the twentieth century, designers and theorists in Europe and America worked to establish deeper connections between art and industry by exploring textile designs and processes that emphasised the structural properties of cloth itself while embracing the visual forms conducive to mass-production. This shift resulted in a new interest in textiles that reflected efficiency, modernity and truth to materials. At the same time, handmade textiles, especially embroidered and hand-woven textiles, continued to be valued for their unique qualities that distinguished them from painting, paving the way for artists to explore elements of design – colour, scale, texture – in extraordinary ways. Indeed, textiles, precisely because they were not like paintings – they could be tactile, three-dimensional, cut-up and pieced together, folded, twisted, hung on walls or put down on the floor – enabled those working in them to explore new visual and expressive possibilities. As textiles and the method of their production and consumption changed over time, the notion of the *Gesamtkunstwerk* and aesthetic unity among the arts continued to be addressed, but with different results for different contexts.

The tensions inherent in the conditions distinguishing mass-production from artistic creation, and fine art from applied art, make the study of modern textiles and design theory not only fascinating but also necessary for a fuller understanding of modernism. Textiles provided artists and theorists with the ideal medium, format and process to engage with contemporary ideas regarding the role of the machine, the use of non-painterly expressions, and

the blending of art and utility in the modern era. Perhaps more than any other medium, textiles explained an era in great transition, in that they could be simultaneously artistic, utilitarian and accessible to a large portion of a population that had previously not been considered connoisseurs or makers of art. As textiles engaged new consumers, they also engaged new artists, both men and women, while also serving as gateways to abstraction, as prototypes for industry and as carriers of nationalist agendas and personal visions. As the weaver Dorothy Liebes wrote in 1939, 'By their fabrics ye shall know them', meaning that through textiles one can understand aspects of the era in which they were created and the motivations of those who created them.[3]

This book will provide a much-needed opportunity to continue and to expand our understanding of modern art by delving into the theoretical underpinnings of textile design and practice, while integrating this with stylistic and national trends. Textiles were at the centre of all of the significant developments in art at the time, developments that took place to varying degrees in every country, including evolving gender roles; experimentation with primitivism, abstraction and Constructivism; use of new technology; and the growing influence of consumerism. Indeed, textiles helped initiate many of these developments. Modernist textiles, both handmade and machine-made, existed in many realms by continually crossing and re-crossing the boundaries between art, craft, industry and commodity.

Objects of Neglect

Despite their significant role in art historical developments, textiles have generally been neglected and marginalised in most critical studies of art and design. This is due to a number of reasons, but

gender bias and the nature of the medium are largely responsible for locking textiles into a state of perpetual ambiguity that denies them a clear-cut place in critical and historical discourses.

From ancient times to the present, textiles have been inextricably associated with women's work, the 'minor' arts, the domestic environment and a kind of anonymous, amateur production.[4] Later, they became associated with industrialisation and mass-production. All of these factors helped disqualify textiles from the realm of high art (painting, sculpture, architecture), which traditionally was considered men's work, produced by professionals for the museum environment. Indeed, even among the various disciplines comprising the applied or utilitarian arts, which include stained glass, wood-work, jewellery, ceramics and glass, textiles fall behind in terms of critical and pedagogical attention. Again, gender bias is partly to blame, as, historically, women working in textiles did not have ready access to academic and training programmes, nor did they have ample opportunities to run large workshops or studios, which would have contributed to greater production and recognition.[5] Even the rich European tapestry tradition, which elevated textiles into public, aristocratic and royal spheres, is associated with a disconnection between designer and producer, a division of labour in which women were typically assigned the role of labourer to carry out in thread the ideas of men.

Interestingly, many of the women discussed in this book seem to have embraced textiles in part by necessity, particularly those who sought to carve out their own artistic space within the shadows of their inevitably more famous artist husbands, fathers or brothers. Sonia Delaunay, Sophie Taeuber, Anni Albers, Mary Hambidge, May Morris and Marguerite Zorach are among those who grappled, and generally came to terms, with imbalanced artistic recognition,

despite the fact that, in many cases, their work in textiles paralleled or instigated artistic innovations taking place in other media.[6] Even in today's art historical surveys of modern art, when only a cursory glance, if any, is devoted to textiles, these women artists' relationships to more prominent men tend to dominate critical discussions; and if the textiles themselves are addressed, they are frequently compared to the dominant high art styles that they appear to imitate and reflect rather than those they contributed to or initiated.

The textile medium also makes analysis problematic in that the sheer presence of so many different techniques – from weaving to embroidery, needlepoint to appliqué, block print to machine print – frequently confounds efforts to properly categorise it. Contributing to this dilemma is the fact that textiles sometimes serve auxiliary or supporting roles for other artistic expressions, such as furniture or fashion, which has the effect of rendering the textiles invisible to critical eyes. How textiles are qualified and categorised – as art or craft, for museum or home, unique or mass-produced – differs as much as one technique differs from the next. The continually shifting role of textiles during the modernist period and even today is further complicated by frequent misunderstandings of their structural properties, their artistic purpose and value, and of their appropriate preservation and display, ultimately leading to critical neglect. Fortunately, a growing body of pioneering scholarship has countered this trend by addressing textiles within artistic, social and historical contexts.

Objects of Value

Textiles deserve re-evaluation within modern art history for many reasons, and primary among these is the fact that modernist textiles provided solutions to artistic concerns in ways that other media could not. Artists worked in textiles in order to address and explore timely issues and ideas involving the use of new materials and visual forms for the modern era. Modernist textiles, because they functioned on so many levels – as decoration, for clothing, in architecture – were inherently engaged in modern life; they were actively used, and they were activated by life, they occupied actual space in the gallery, home and showroom, they transformed the human body, and they changed the face of industry. As such, they constituted a vital element in developing conceptions of the total work of art.

Textiles were the ideal crossover medium in modernist attempts to erase the social and visual boundaries separating art from craft, art from industrial design, and élite from popular culture. Work in textiles facilitated new approaches to artistic form and content, especially as they were used to investigate alternatives to conventions and to explore worlds outside of the Western sphere. When seen together, documented within a continuum where theoretical underpinnings are put into context, modernist textiles become an extraordinarily interesting and important subject.

Indeed, it turns out that the subject of the modernist textile, from Art Nouveau through the revivalist and nationalist 1930s, is so vast that this book serves as but an introduction. The sheer scope of examples make it necessary to exclude from major consideration certain kinds of textiles, such as carpets and furnishing fabric, for which recent scholarly attention has already been devoted, as well as certain topics related to textiles, such as fashion and interior design, although aspects of these textiles and topics are by necessity addressed throughout the book. In a broadly embracing book such as this, it becomes clear that each subheading could effectively be expanded into a chapter, with some themes

providing enough interest to be developed into richly illustrated books or monographs. Fortunately, some of those books have already been written, such as those dealing with Arts and Crafts, Art Deco and Bauhaus textiles, which serve as models for this project. In other cases, manuscripts are presently being developed. However, as a whole, the history of the modernist textile has not to my mind been presented as a cohesive survey since the publication of Giovanni and Rosalia Fanelli's 1976 Italian language tome, *Il tessuto moderno: disegno, moda, architettura 1890–1940*.

One of the goals of this project was to explore a wide range of textile collections and to discover modernist textiles that had not been previously studied. While much has been accomplished, it was impossible to see and include everything. Thus, many great textile collections remain unexplored, and many individual names, especially those who worked in near obscurity over a century ago and who have been forgotten through time, have been left out. Furthermore, while this study draws on the work of many fine scholars, whose pioneering work is credited in the notes, there will undoubtedly be important studies and opinions that have been overlooked. For these unintended omissions, I offer my apologies, with the hope that this study will generate increased scholarly attention to the growing field of textile history. Therefore, this book claims to be neither all-inclusive nor definitive in scope but rather seeks to pinpoint significant theoretical and visual moments using textiles as the primary exemplars, and to focus primarily on textiles that were considered avant-garde in their day, those that challenged prevailing conventional ideas about what a textile should be, in short, to explore the fascinating history of textiles created within the context of modernism.

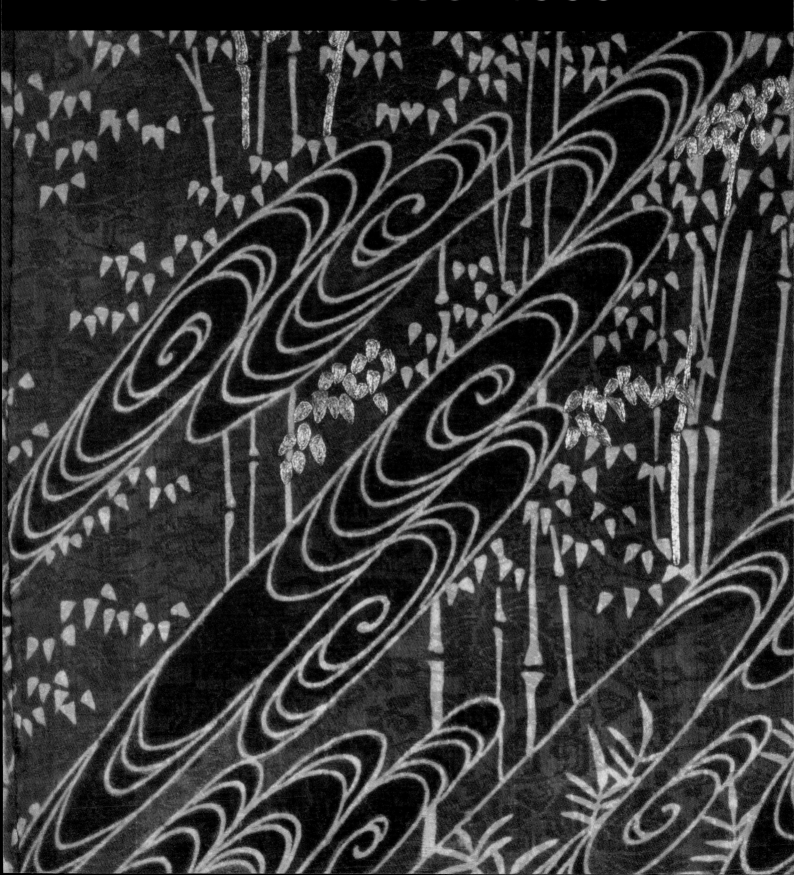

The notion that a textile could represent modernity – that a utilitarian object was the ideal medium with which to express modern aesthetic theories and forms – began to crystallise during the 1890s, a period of political revolution, social reform and radically changing attitudes toward art. The new artists of *fin de siècle* Europe and America challenged traditional artistic conventions by questioning the relevance of artistic classifications and hierarchies, and by aligning themselves with social reform movements. These artists and theorists believed that traditional academic classifications that distinguished the 'high' arts (painting, sculpture, architecture) from the 'minor' arts (ceramics, glass, metalwork, textiles) had to be abandoned in favour of unifying all of the arts into a dynamic and socially relevant ensemble. This was a complicated task because it meant re-thinking the definition and purpose of art itself as well as the role of the artist. Could art also be utilitarian? Was a curtain as significant as a painting? Was the craftsman also an artist? Reformers answered these questions with a resounding yes, but the central dilemma inherent in them – the impossibility of defining a work of art – would engage artists and theorists, dealers and con-sumers for years to come. Indeed, this very dilemma is at the heart of modernism. Just where textiles fit into this discourse, during the years in which it helped inspire the Art Nouveau, Jugendstil, Nieuwe Kunst and Arts and Crafts movements, is the subject of this chapter.

2 (left)
Japanese kimono (detail) 1860–90
monochrome figured satin silk, with paste-resist decoration and embroidery in silk and metallic thread
160 x 125.5 cm (63 x 49⅓ in.)

The Total Work of Art

Practitioners of the new art were indebted in various ways to the achievements of William Morris (1834–1896), the influential late-Victorian artist, writer and social reformer. Morris was one of the first and most vocal reformers of applied arts. He rejected the categories that separated classes of art, thereby expanding his definition of art to include crafts and utilitarian items. If modern art was to reflect modern life, then art and life needed to intersect somewhere beyond the static activity of viewing, producing or even reproducing easel paintings. A dynamic, living art could only be developed by merging art and craft within the context of modern life. Textiles in all forms – printed, woven, embroidered – were crucial to this ideology because they functioned simultaneously as pictorial expressions and as utilitarian objects. They exemplified living art, art that had both practical and artistic applications in daily life. For these reasons, many artists, even those without training in textile arts, began to work in this medium in order to engage more fully in modernist discourses.

The idea of the 'total work of art', or *Gesamtkunstwerk*, became the central leitmotif of this period. The original notion of the *Gesamtkunstwerk* – the synthesis of art and life as a condition of modernity – was put forth as early as 1849 by Richard Wagner (1813–1883) in his essay 'The Art-Work of the Future' (*Das Kunstwerk der Zukunft*), but the term was not widely used until the end of the nineteenth century, when it came to represent a new attitude about class, environment, consumerism and art.[1] Wagner's vision was for unification of the arts toward a common purpose, in his case dramatic opera. He envisioned drama as a product of collaboration of the arts – music, set, movement – and through this 'fellowship' of the arts, the whole artwork, the *Gesamtkunstwerk*, could thus be

grasped and understood by the general public, not just the private élite.[2] He wrote,

> The highest conjoint work of art is the Drama; it can only be at hand in all its possible fullness, when in it each separate branch of art is at hand in its own utmost fullness. The true Drama is only conceivable as proceeding from a common urgence of every art towards the most direct appeal to a common public.[3]

William Morris later applied this theory of fellowship to protect handicrafts against the 'tyranny of commerce' and the stain of commercialism. In his 1888 lecture, 'The Revival of Handicraft', Morris theorised that only a society of equals, one that united all classes, from the middle class, to the industrialists, to the aristocracy, could support and sustain a 'revival of handicraft', and thereby restore the ability to appreciate true beauty through well-crafted ordinary things.[4] He believed that the aesthetic tastes of the general public would continue to cheapen and decline if they allowed badly designed machine-made goods to take the place of finely crafted and designed objects, or 'intelligent handicrafts', as he called them.[5] Again, textiles were perceived as playing a central role in this dialogue, since they held the unique position as the most industrialised of the arts. Historically, handmade textiles, such as tapestries and embroidered silks, were considered among the noblest arts, coveted for their natural sumptuousness and because they were the products of copious hours of skilled labour. As these textile processes became mechanised, and labour pools shifted from those of skilled experts to unskilled labourers, textiles' status as art declined. Morris' solution to this problem, though it may have seemed anachronistic in the face of the industrial revolution, was to restore to textiles their aesthetic

and handmade qualities by promoting the unity of artistic design and craftsmanship.

The New Art in Europe

As successive generations filtered and translated Wagner's and Morris' theories, the environment for which artistic fellowship and the total work of art was manifested shifted from the opera house to the home, and circuitously, from the museum to the art showroom. The domestic interior was the ideal location for unification of the arts to take place, and the decorative arts were the elements whose arrangements and forms produced a new aesthetic paradigm.[6] Tapestries and embroidered wall hangings, for example, came to be understood as appropriate artistic endeavours for artists to pursue and as significant decorative elements within the new, modern environment. This shift in focus from easel paintings to textiles required new models and materials of modernity. The decorative and applied arts, those arts that are intimately connected to life, became the catalysts for change, with textiles emerging as ideal intermediaries between art and craft.

At the same time, artists no longer felt the need to confine themselves to work in one medium. In the ever shifting and expanding era of consumerism, brought about in part by the focus on the domestic interior and the rise in the production and accessibility of decorative arts, the boundaries separating fine art from applied art were disappearing. From these developments, a new type of art practitioner emerged: the multi-faceted designer, who not only worked with materials but also created designs for others to apply to materials. New art called for a new artistic discourse, and often the new designers were also theorists, teachers and manufacturers who could navigate between the studio, the workshop and the

retail venue. If there was true unity among the arts, then it follows that an artist could work interchangeably in similar artistic modes, such as flat pattern design for books, wallpaper and other surface treatments, and this was especially true for textiles, which bring together elements of painting and pattern design.

The Art Nouveau style dominated artistic experimentation in Europe at this time, and because this style grew out of advances in decorative arts and design and the rejection of Victorian pictorial conventions that relied on imitating rather than interpreting nature, most visual and ideological innovations of the period can be understood by studying utilitarian objects such as furniture, ceramics and textiles. Art Nouveau, like most broad artistic terms, varied according to nationality and ideology, among other factors. In general the visual style of Art Nouveau is characterised by the development toward abstraction, often through stylisations of natural growth patterns; a rejection of traditional perspective formulae in favour of flat, unmodulated forms, inspired in part from Asian examples; and a new fascination with the possibilities of line and surface ornamentation. Application of these characteristics to all of the arts, including fashion, produced unified ensembles that were accessible to a wide population of consumers and artists. Textiles, especially embroidery, appliqué, tapestry and batik, both initiated and exemplified this modern style.

The New Art: Embroidery

Artists and designers of the period discovered in textiles new sources of information for their investigations into modernism. They studied and utilised textiles as examples both of artistic design and of handcrafted utilitarian objects. Because many textile techniques, such as embroidery and batik, share affinities with painting, they were more easily appropriated by those who wanted to work with crafts but maintain a link to the 'high' arts. At the same time, textiles from different cultures and traditions, especially Asian textiles, introduced to Westerners exciting examples of linear design, dynamic formal arrangements and sumptuous surface treatments that were subsequently appropriated and absorbed into the new art. Altogether the expanding interest in textiles created new opportunities in the commercial realm, as the quantity and quality of consumers, practitioners and dealers increased.

Embroidery was a particularly important medium during this period. Up to this point in time, embroidery had been used primarily as embellishment, for liturgical and furnishing cloth, for example, and as a pictorial alternative to painting, primarily for women.[7] But as the role of textiles in the modern interior began to be considered within the larger context of the total work of art, embroidery and other needlework techniques such as appliqué (pieces of fabric stitched together and to a fabric ground) were studied and practised with increased attention to and appreciation for their unique aesthetic properties and applications.

One of the earliest and most important examples of embroidery and appliqué that reflects modernist concerns is the large wall hanging *Angels' Watch* (*Engelswach; La Veillée des Anges*) (fig.1), designed in 1892 by Henry Van de Velde (1863–1957) and produced and completed in 1893 in collaboration with his aunt, Maria Elisabeth de Paepe-van Hall, who was an experienced embroiderer.[8] The work is a physical manifestation of the contemporary discourse involving the unification of fine and applied art, and it marks a turning point in Van de Velde's career as he shifted from painter to craftsman.[9] Indeed, it was only through embroidery and appliqué that Van de Velde could achieve a new level of artistic confidence

Henry Van de Velde
Engelswach; *La Veillée des Anges* (Angels' Watch) 1893
wool appliqué and silk embroidery
140 x 233 cm (55⅛ x 91¾ in.)

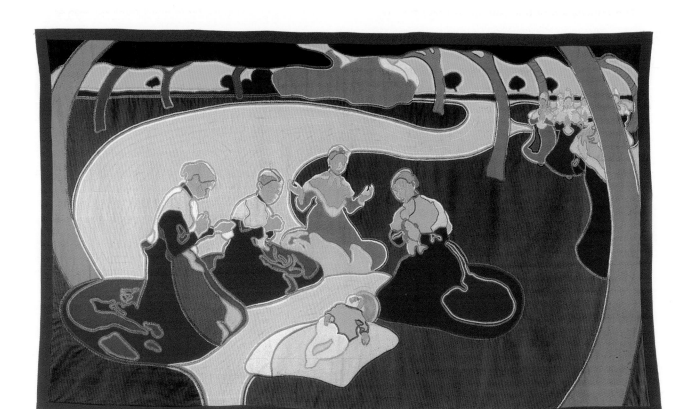

by synthesising art and craft into one complete idea.
'It was in front of the draft of *Angels' Watch*, at the
moment when I felt that I would never complete it,
that I conceived the idea to carry out in embroidery
that which I could no longer bring myself to do by
painting', he wrote in his autobiography.[10] As Van de
Velde explained it, the work, which was produced by
piecing patches of wool felt together with embroidery
stitches, allowed him to at last realise his theories of
colour and form and to orchestrate those elements

through fabric and thread.[11] Inspired by examples of
stained glass, Van de Velde used a couching stitch
technique, for which threads are laid down on the
fabric, in some places up to eleven rows deep, and
then meticulously stitched down with another thread,
to literally and harmoniously hold the felt pieces
together as well as to create linear patterns.[12]
Through this technique, Van de Velde explained, he
was able to apply his theory of colour:

It is with them [the rows] that I applied the principle of the theory of the colors. Any plane of color, if it is lit by the sun, takes part in the orange that sunlight diffuses, and any plane located in the shade reveals blue, by contrast. The application of this law determined the choice of the primary silk contour lines whose width was in connection with the extent of the surface that they enclosed. It was the same for the secondary outlines that were placed beside the primary ones, running faithfully alongside each other. By their presence, they underlined the reciprocal optical reactions of juxtaposed tones. These supplementary outlines, infinitely layered according to the multiplicity of opposing nuances, gave the tapestry its magnificence.[13]

For Van de Velde, appliqué and embroidery were not simply alternatives to painting but were processes and finishes that enabled him to explore new artistic possibilities, as well as to see himself in a new light. Van de Velde believed that he had learned a new trade, a new skill that was achieved through long hours of work and thought. When *Angels' Watch* was exhibited in the Salon of 1893, accompanied by a catalogue passage that implied Van de Velde had earned the title of 'Master Embroiderer', his transformation from artist to craftsman was complete: 'I considered myself, from that moment, a craftsman, and that I wanted, henceforth, to be considered as such'.[14]

In his 1895 essay, 'Observations Toward a Synthesis of Art' (*Allgemeine Bemerkugen zu einer Synthese der Kunst; Aperçus en vue d'une synthèse d'art*), Van de Velde argued that 'ornament is the essence of all arts', and is therefore the basis of pure artistic purpose, as opposed to academic realism.[15] 'The old artistic ideal is a thing of the past', he stated, 'It lies embalmed in our museums'.[16] For Van de Velde, these ideas, bolstered by what he had learned

from Morris, were confirmed by his work in textiles.

It is noteworthy that Van de Velde depicted the women in *Angels' Watch* wearing versions of what was then termed 'reform clothing' and 'artistic dress', loosely structured, flowing gowns with ornamented collars that were worn by forward-thinking women, especially those in William Morris' circle, who desired less restrictive, more breathable clothing. Not surprisingly, Van de Velde's interest in textiles extended to women's clothing, which he designed and wrote about. He wanted to include the human element in his synthesis of the arts in an artistically unified environment, and, inspired by British reform clothing that he and his wife Maria saw in catalogues published by London's Liberty & Co, he wanted to liberate women from the restrictive fashions of the day.[17] A well-known photograph of Maria, published in a 1901 edition of the German decorative arts journal *Dekorative Kunst*, shows her wearing a loose-fitting velvet gown of his design standing next to a piano that holds Wagner sheet music.[18] The drape of the luxurious cloth and the embroidered ornamentation around the neckline, sleeves and hem correspond to Van de Velde's artistic style focusing on volumetric proportion and linear patterning.[19] Interestingly, reform dress was developed at the same time that the textile and garment industry, notorious for its poor, sweatshop conditions, was undergoing its own reforms, and although there was an obvious aesthetic and economic disconnection between what was happening in artists' studios and what was taking place in garment factories, developments in each area overlapped somewhat within the context of social and cultural change.[20] Morris' social programme was indeed being applied, albeit in different degrees.

Angels' Watch also embodies modernist concerns in its obvious reference to Asian artistic sources. Van de Velde synthesised his Western aesthetic with what he understood of an Asian aesthetic by borrowing

certain elements from Japanese art. The flatness of the picture plane and the outlined, curvilinear, unmodulated forms recall Japanese woodblock prints of which he was well aware. In particular, Van de Velde's work recalls Japanese *textiles*, especially embroidered kimonos, panels, wrapping cloths (*fukasa* and *furoshiki*) and screens that could be seen in shops, exhibitions and journals throughout Europe and America as early as the 1870s, especially in Siegfried Bing's Parisian boutiques and his journal *La Japon Artistique*, and at Arthur Liberty's London shop, Liberty & Co, where many examples of embroidered and resist-dyed kimonos were sold (fig.2, p.18).[21]

Decorative Painting and Textiles

Interestingly, artists' work in textiles influenced those working in a more traditional artistic medium: painting. The subject matter of *Angels' Watch* – that of women keeping vigil over a sleeping infant – is aligned to Post-Impressionism themes of maternal protection and regeneration, as examined in paintings produced by Van de Velde's French contemporaries, members of the Nabis (Hebrew 'prophets') group, which included Edouard Vuillard (1868–1940), Pierre Bonnard (1867–1947) and Maurice Denis (1870–1943) and attracted others such as the Hungarian József Rippl-Rónai (1861–1927). Not surprisingly, the Nabis developed their notions of 'decorative painting' in part through their desire to imitate textiles – tapestries, embroideries and painted fabric folding screens – in order to more completely integrate image and interior.[22] In fact, textiles, as examples of art utilising decorative patterning, conformed better to these painters' conception of visual modernity than did academically realistic paintings. Maurice Denis wrote on this subject as early as 1890 in his oft-quoted essay, 'Definition of Neo-Traditionism',

We should remember that a picture – before being a warhorse, a nude woman, or telling some other story – is essentially a flat surface covered with colours arranged in a particular pattern.[23]

For Denis and others, the notion of the decorative was inextricably linked to the idea of modernity; therefore these painters created effects that were inherently unique to textiles in order to emphasise the interconnected relationship between decorative art and modern art. Their decorative paintings from the period frequently doubled as textiles, through references to the subject of textiles, by visually simulating the look of textiles, and through titles with textile terms, such as *portière* (doorway curtain panel) and *tapisserie* (tapestry). For example, many Nabis artists utilised textile-like features such as patterned borders to suggest selvages or fringes, thickly applied and scumbled paint to suggest embroidered surfaces, or thinly applied distemper to reveal the canvas weave.[24] In addition, these artists frequently chose to work in formats that did not conform to academic easel sizes, preferring instead vertical, horizontal and square formats that resemble tapestries, wall hangings and panels. Vuillard, whose mother, with whom he lived, was an important dressmaker for high-end couturiers, frequently represented textiles and used painting techniques that suggested a textile surface; the overall appearance and theme is nearly indistinguishable from a textile, as exemplified in his 1895 work, *La tapisserie* (fig.3).[25] While Vuillard referred to and represented textiles, other Nabis artists found it essential to work directly with them.

Like Van de Velde, Rippl-Rónai believed that his design for *Woman in Red Dress*, 1898 (fig.4), in which the woman literally becomes part of the texture of nature through embroidery, could succeed only in the medium of embroidery. Conceived as part of an entire decorative programme for the dining-

room of Count Tivadar Andrássy in Budapest, this embroidered tapestry, as Rippl-Rónai referred to it, was embroidered by Rippl-Rónai's wife Lazarine Boudrion. Embroidery allowed Rippl-Rónai to experiment with artistic elements – a bright, complementary colour palette and a flattening of the picture plane – that he was not willing to attempt in his painting.[26] Ironically, by removing himself from the actual production process, Rippl-Rónai was indeed liberated to experiment with these visual challenges.

That Van de Velde, Rippl-Rónai and others functioned more as designers than executioners of the final products is not surprising. At that time the bias toward idea (male) over labour (female) within the discipline of textiles persisted despite concerted efforts to bridge other related gaps, such as those between art and craft, and museum and home. But since textiles have belonged almost exclusively to the latter categories – female, craft and home – once those categories suddenly became part of larger theoretical and artistic discourses, the conditions under which textiles, especially embroidery, were conceived, produced and displayed began to transform. These transformations resulted in progressively more complex opportunities for women in art and design. However, the fact remained that women had the skills to produce handcrafted textiles – passed down from generations and taught in schools – and men were encouraged to explore aesthetic ideas, often in unacknowledged collaboration with their skilled female counterparts. For this reason, the contributions of men working in textiles during this period have outweighed those of women, even though many women, as we shall see, were innovators of both design and execution. It is nevertheless noteworthy that men chose to work in textile production, design and theory at this time, despite their lack of technical training, and points to the role that textiles played in the dismantling of

artistic hierarchies and their perceived gender equivalents. As we look more carefully throughout the book at the contributions of both men and women artists in textile developments, we find a great degree of collaboration and interaction between genders, even though gender roles and hierarchies did not disappear entirely.[27]

The Art Showroom

New commercial ventures in art marketing, which included artistically designed showrooms, journals, galleries, temporary exhibitions, the *atelier* or studio-boutique and the *maison* or artisan-firm, allowed the modern consumer to envision, even purchase, the elements comprising a total work of art, inspired in part by the model of the department store.[28] Van de Velde, who welcomed these fresh alternatives to the dusty museum, spent much of this period not only creating objects for display in these new venues, but also in designing many of the actual spaces. Showrooms served as alternatives to official, juried salons and allowed newly formed applied arts societies autonomous venues in which to exhibit and to sell their work.

Van de Velde, through his travels, writing and architecture and design practice, served as a significant link between French and Belgian Art Nouveau and its German counterpart, Jugendstil. He, along with members of the Nabis, participated in the 1895 inaugural exhibition at the gallery/boutique 'L'Art Nouveau' (1895–1905), established by Siegfried Bing (1838–1905), which gave the movement its name. Bing conceived of his gallery not as a place to showcase single works but rather as an artful environment of unified rooms and objects – a *Gesamtkunstwerk* – that also included Asian textiles and embroidered panels, and textile work by

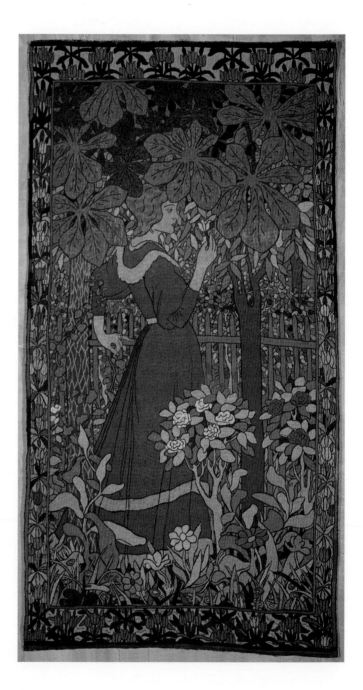

3

Edouard Vuillard
La tapisserie (The Tapestry, or Embroidering by
the Window) 1895–96
oil on canvas
177.37 x 65.61 cm (69⅞ x 25⅞ in.)

4

József Rippl-Rónai (designer), **Lazarine Boudrion** (embroiderer)
Woman in Red Dress 1898
wool, embroidered with satin stitch
230 x 125 cm (90½ x 49¼ in.)

European and American designers, such as Hector
Guimard, Louis Comfort Tiffany, Edward Colonna,
Georges de Feure and Liberty & Co, all innovators in
the field.[29] Bing's endeavours, in part inspired by his
counterpart in London, Arthur Liberty (1843–1917),
inspired fellow German Julius Meier-Graefe
(1867–1935), the art historian, to embark on a
similar quest in Paris, the Maison Moderne
(1899–1904), and to enlist Van de Velde to design
the salesroom. Most of these influential designers
were also associated with popular pictorial journals
founded at the time, such as *The Studio* (1893), *Pan*
(1895), *Jugend* (1896), *Dekorative Kunst* (1897),
Deutsche Kunst und Dekoration (1897), *Ver Sacrum*
(1898) and *L'Art decorative* (1898), all of which served
to spread the style of Art Nouveau internationally.

Bing, Liberty and Meier-Graefe typified the new
role of retailer/art dealer through their expertise as both
salesmen and connoisseurs, and they collaborated on
various projects, despite the fact that they were in
some ways competitors.[30] These entrepreneurs'
broad artistic interests and savvy business sense
allowed them to cater successfully to both the art
establishment and the general public while inventing
a new kind of retail venture.[31] Bing, for example,
was by this time well respected as a dealer of Asian
art, having previously travelled to Asia, opened his
Oriental Art Boutique in 1875 (the same year that
Liberty opened his retail venue in London), published
the journal *Le Japon Artistique* (1888–1891), and
curated numerous exhibitions of Asian art such as
the impressive 1890 exhibition of Japanese wood-
block prints, *Exposition de la Gravure Japonais*, at
the Ecole des Beaux-Arts (School of Fine Arts) in
Paris. When Bing died in 1905, so, for all
practical purposes, did Art Nouveau, and his name
remains inextricably linked to the movement. Liberty
on the other hand, continued to expand his
operations well into the twentieth century. Not only

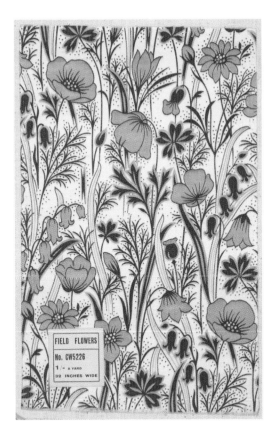

5
Liberty of London Ltd
Field Flowers c.1900–10
duplex-printed cotton
19 x 29 cm (7½ x 11⅓ in.)

6
Indonesian woman's hip wrapper (Sarung Kelengan) c.1910
hand-drawn wax-resist (batik) on machine-woven cotton,
natural dyes
107.2 x 197.3 cm (42¼ x 77⅝ in.)

did he import textiles from many parts of Asia – Java, India and Japan – but also due to British advances in textile printing, he engaged British manufacturers to produce Asian-style textiles that he sold at his store and to European and American department stores. For example, a cotton fabric from around 1900, manufactured for Liberty of London Ltd (fig.5), was roller-printed on both sides – making it both reversible and bright with saturated colour – using the latest printing technology and newly synthesised indigo (blue) dye. Interestingly, the indigo blue and white pattern recalls both embroidery, especially Elizabethan blue and white needlework that was becoming fashionable again, as well as wax-resist batik cloth, especially the blue and white batiks (fig.6) that were being produced in Indonesia and imported to the West at exactly the same time.[32] This clever cross-cultural exchange, and Liberty's use of high technology to simulate low-tech handicrafts, proved to be a very popular innovation that helped elevate Liberty to a new level of commercial success, still in evidence today.

Jugendstil artist Hermann Obrist (1863–1927) was well aware of Bing's and Liberty's activities, and through the example of their commercial enterprises that united art, craft and non-Western art, Obrist conceived of even more artistic, commercial and pedagogical possibilities for the applied arts. In 1890, when Obrist was in Paris studying at the Academie Julien, he encountered Japanese woodblock prints first-hand at Bing's Japanese woodblock exhibition at the Ecole des Beaux-Arts. This spectacular show contained 725 prints and 428 books by important Japanese masters, such as Katsushika Hokusai (1760–1849) and Ando Hiroshige (1797–1858); Obrist was able to see some of the most famous examples, including Hokusai's *Great Wave* of 1828, which would prove to have a significant impact on his subsequent artistic work and ideology.[33]

Like Van de Velde, Obrist sealed his artistic fame through work in textiles, embroidery to be exact, and through them he was able to contribute to the international dialogue involving the role of textiles in modern artistic developments. Knowing the importance of fine technique and production, Obrist and Berthe Ruchet (1855–1932), a family friend trained in embroidery, went to Italy in 1892 to visit embroidery studios, and soon after set up their own studio in Florence; by 1894, Obrist had moved the studio to Munich, with Ruchet serving as studio manager and master embroiderer until 1900.[34] The embroideries that resulted from this collaboration are some of the most astounding and beautiful ever created. It might seem surprising today to learn that Obrist and Ruchet's 35 groundbreaking embroideries of 1895, including a large linen and silk panel depicting rhythmically patterned plants with undulating roots (fig.7) and the frequently reproduced panel titled *Peitschenhieb* (whiplash) that coined the ubiquitous Art Nouveau term, were so revolutionary. With Ruchet's expertise, Obrist was able to utilise the technique of embroidery to express an entirely new kind of artistic language that he referred to as a 'free-fantasy' of 'stylized modern plant ornamentation'.[35] The series of embroideries, exhibited in Munich, Berlin and London, created a resounding vibration in artistic circles because, like *Angels' Watch*, they blurred the boundaries between fine and applied art while establishing new formal solutions to the problem of what new art should look like.[36] Georg Fuchs, art critic for *Pan*, wrote in 1895 that the embroideries 'fulfilled our yearnings for a more spiritual, purer, more creative art'.[37] Mary Logan, the reviewer for *The Studio*, keenly observed upon seeing Obrist's exhibition in London that the work succeeded precisely because it 'could only be done in embroidery [f]or in no other form of art is there the same opportunity for getting relief [three-dimensional

7 (above)
Hermann Obrist (designer),
Berthe Ruchet (embroiderer)
*c.*1895
embroidered cloth with floral
motifs, German linen with silk
embroidery
316 x 218 cm (124⅓ x 85⅞ in.)

8
Maurice Pillard Verneuil (right)
Avione (Oats), pages 234-35
from *Étude de la plante* 1903
published by Librairie Centrale des
Beaux-Arts, Paris
36.2 x 28.5 cm
(14¼ x 11¼ in.)

volume] combined with the most subtle variations of texture and colour'.[38]

Experimental Approaches to Design

Obrist's activities helped make Munich a centre of avant-garde activity involving applied arts reform during the 1890s and the first decade of the twentieth century. Obrist established an artists' cooperative and exhibition venue in 1898, the United Workshops for Art and Craft (Vereinigte Werkstätten für Kunst im Handwerk), which later became the Society of Applied Arts (Vereinigung für Angewandte Kunst). In 1902 he founded with partner Wilhelm von Debschitz (1871–1948) the Obrist-Debschitz school (1902–1914), a co-educational institution that offered instruction in both two-dimensional design and three-dimensional work in crafts, including textiles. This progressive and innovative school that united the arts and crafts would serve as a model for the education programme at the Bauhaus.[39] Obrist's and Debschitz's school enrolled at various times students Ernst Ludwig Kirchner (1880–1938) and Sophie Taeuber (1889–1943); Paul Klee (1879–1940) taught there for a short time in 1908.[40] A large component of the curriculum involved analysing the rhythmic and linear patterns found in nature as preliminary exercises for practical work in applied art.[41] Just as he achieved with his own embroidery designs, Obrist encouraged students to investigate these qualities of plant formations as a way to facilitate new approaches to design through the process of abstraction.[42]

Obrist was not alone in this fascination with the visual forms of nature, and it is interesting to compare his embroideries with some of the illustrated design books that were being produced at the time, in particular those by Maurice Pillard Verneuil (1869–1942), such as his 1897–99 *La Plante et Ses Applications Ornamentales* (The Plant and Its Ornamental Applications) and the immense 1903 *Étude de la plante*, which featured artistically rendered plant illustrations on nearly every page (fig.8). Verneuil's books were intended to serve as source books for applied arts designers who could gain inspiration from his interpretations of plants presented in various stages of abstraction. Verneuil also experimented with mathematical and scientific formulae to arrive at innovative design solutions. For example, collaborating with Art Nouveau designer Alphonse Mucha (1860–1939) in 1901, Verneuil produced a cleverly conceived set of designs created with the aid of a mirror, which was published as a portfolio of *pochoir* (hand-coloured prints using stencils) plates titled *Combinations ornamentales se multipliant à l'infini à l'aide du miroir* (Ornamental Combinations Multiplied Ad Infinitum Using the Mirror). Artists working in the applied arts quickly appropriated these interdisciplinary approaches to design, which combined experimental and empirical methods of investigation, and the abstract language of design that grew from them.

Obrist and Debschitz championed experimentation and abstraction as methods of enquiry that could liberate students from conventional pictorial representation and outdated notions of artistic hierarchies. Indeed, they originally called their school the 'Munich teaching and experimental studios for applied and free art' (Lehr-und Versuch-Ateliers für angewandte und Freie Kunst).[43] Their venture into art education reform through co-education and the applied arts marks a significant turning point in art history, and reflected the endeavours of other artists who were exploring similar pedagogical programmes in newly established schools of applied arts, such as Wassily Kandinsky's (1866–1944) Phalanx school in Munich (1901–1903) located directly across the

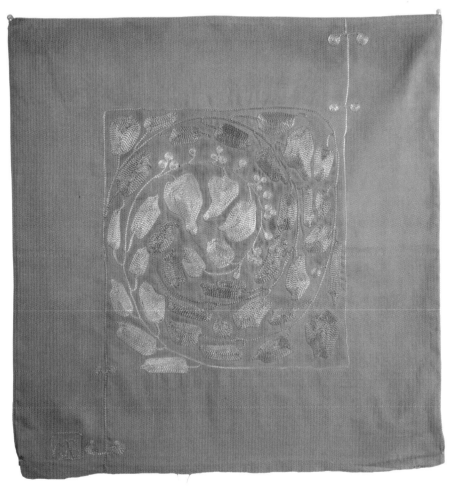

Margarethe von Brauchitsch
Kissenplatte (pillow cover) *c.*1904
silk embroidery on silk ground
34.5 x 34.5 cm (13⅜ x 13⅜ in.)

street from Obrist's school, or through small colonies and workshops, such as the Kunstler-Kolonie in Darmstadt (1899–1914), initially led by Josef Olbrich (1867–1908).[44] These undertakings also provided artists with a level of financial independence through work in the applied arts, which offered an element of freedom and flexibility that large-scale patron-funded projects did not.

Not surprisingly, Kandinsky and Obrist were friends, and at this moment in time their ideological goals regarding the central role of decorative arts were very similar. Indeed, by 1903 Kandinsky was recognised primarily for his decorative work.[45] He belonged to the Society of Applied Arts and had been invited by designer and architect Peter Behrens (1868–1940) to teach decorative painting at the Kunstgewerbeschule (School of Arts and Crafts) in Düsseldorf, a job he turned down in order to continue at Phalanx.[46] As with other artists discussed here, Kandinsky believed he could succeed financially and artistically by working in the applied arts and embracing the *Gesamtkunstwerk*. He was inspired to work in embroidery by his friend Obrist and also by his Society colleague Margarethe von Brauchitsch (1867–1957), who had her own design studio and who produced elegantly abstract embroideries (fig.9) and reform clothing, which Kandinsky would also try his hand at designing.[47] Von Brauchitsch's embroidered

panel, which she created from white and gold chain-stitched lines on a gold ground, is a sophisticated study in abstract spiral forms and tone-on-tone colour.[48]

Like von Brauchitsch, Kandinsky used embroidery to explore colour and shape relationships. He was clearly revitalised by his work with decorative arts during this period. In 1904 he wrote to his colleague and partner Gabriele Münter (1877–1962), '…pictures, decorative painting, embroideries, whole rooms are suddenly in my head again and once more I am thinking in color'.[49] His embroidery designs from 1904, including a design of stylised trees on black paper (fig.10) that was among those Münter worked into handbags and wall hangings, helped him perfect techniques for his later abstract work because they required a level of abstraction in order to succeed.[50] Kandinsky's experiments with decorative arts and ornament demonstrated the potentialities of pure abstraction and non-representation, though he later feared that too great a reliance on repetitive geometric forms might undermine the inner necessity and organic life of the work, as this famous passage in his 1912 book, *Concerning the Spiritual in Art* (Über das Geistige in der Kunst) explains:

> If, even today, we were to begin to dissolve completely the tie that binds us to nature, to direct our energies toward forcible emancipation and content ourselves exclusively with the combination of pure color and independent form, we would create works having the appearance of geometrical ornament, which would – to put it crudely – be like a tie or a carpet.[51]

This essential dilemma of creating meaningful form through abstract design, of uniting the decorative with the modern, dominated the artistic and intellectual deliberations of artists and theorists then and well into the next decades.

One way to derive meaning from abstraction was to base designs on natural growth patterns, as Obrist and von Brauchitsch did; another was to develop the connections between abstraction and non-Western art through handmade textile processes. While many artists found inspiration from folk and Asian sources, artists in The Netherlands were exploring the batik tradition of Indonesia. Batik is a wax-resist technique, used with great virtuosity by experts in Indonesia, whereby melted wax is applied with a pen-like copper container called a *tjanting* tool to fabric that is subsequently dyed; when the wax is removed, the negative, or resisted pattern, is revealed. This process can be repeated with different dye colours and intricate wax patterns. Javanese batik was introduced to The Netherlands through Dutch colonial expansion in the seventeenth century and became widely popular there by the 1890s from exposure in world expositions and ethnographic collections.[52] Dutch artist Jan Toorop (1858–1928), who was born in Java and lived there for the first 13 years of his life, contributed to a cross-cultural artistic awareness through his knowledge of both Indonesian batik and Art Nouveau, by way of his contact with Henry Van de Velde.[53] Artists such as Lion Cachet (1864– 1945) and Gerrit Dijsselhof (1866–1924), working in the modern Dutch variant of Art Nouveau called Nieuwe Kunst, adapted the forms and techniques of Javanese batik to their modern aesthetic, resulting in work that is governed both by strict geometry and organic forms derived from nature. For the screen panel shown in figure 11, created early in the century, Dijsselhof drew realistically rendered herons – seen in Javanese batiks from the same period – but situated them in a flat, decorative field of abstracted reeds. The interaction of tight patterning and loose curvilinearity, and of representation and abstraction, is enriched by the small cracks and drips inherent to batik.

One of the finest of the Nieuwe Kunst batik artists was Chris Lebeau (1875–1948) who developed an elaborate wax drawing technique using the *tjanting* tool to achieve nearly incomprehensible, tightly packed and interwoven plant and animal designs. Lebeau's 1903 panel for a fireplace screen (fig.12) reveals his virtuoso technique; eight fish circle the central area surrounded by a border of what appears at first to be leaf and tendril forms but are in fact camouflaged fish and abstracted frogs that morph into one another due to their shared contour lines, or rather, contour dots, as the linear elements are composed not of lines but of various sized droplets.

The New Art in Britain and America

The Arts and Crafts style, as practised by artists in England, Scotland and America, was modest in contrast to the overly undulating and sometimes erotic or illegible style of its continental counterparts. The name itself was derived from the Arts and Crafts Exhibition Society, a group of artists and designers who shared the common goal of uniting art and craft for the purposes of achieving good design. The Society, chaired by artist and theorist Walter Crane (1845–1915), had its first exhibition in 1888.[54] The diverse group of associated artists, many of whom were followers of Morris (who died in 1896), practised a more restrained, less florid style than Art Nouveau. Due in part to Morris' ideas about textiles, as well as to Liberty's commercial accomplishments and connections to industry, Arts and Crafts textiles succeeded in both artistic and commercial spheres.[55] Charles Francis Annesley Voysey (1878–1941) – architect, designer of patterns for textiles, wallpapers and rugs – was one of the many multi-faceted designers of the period who worked with textiles. Voysey's bird and vine design (fig.13), which could

10
Wassily Kandinsky
Stickereientwurf mit stilisierten Bäumen
(embroidery design with stylised trees) *c.*1904
gouache and white crayon on black paper
8.2 x 15.3 cm (3¼ x 6 in.)

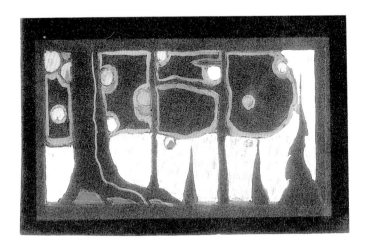

function equally well as a textile or wallpaper, typifies his graphic style for which he frequently incorporated silhouetted birds, stylised trees and other obvious references to Asian patterns that he saw at Liberty's shop. Indeed many of Voysey's patterns were manufactured by Liberty & Co. Here one can see how Voysey arrived at an overall pattern by flipping and rotating the basic bird and vine motif within a symmetrical format, producing a restrained, orderly and repetitive design that characterises the Arts and Crafts style.[56]

Walter Crane, who helped to advance the Arts and Crafts programme both on the continent and in America, carried on Morris' legacy most faithfully. Crane advanced the notion, particularly in his 1892 book, *Claims of Decorative Arts*, that the new art was to be both beautiful and utilitarian, and that the domestic interior was the environment in which modern design should flourish. Like others of his

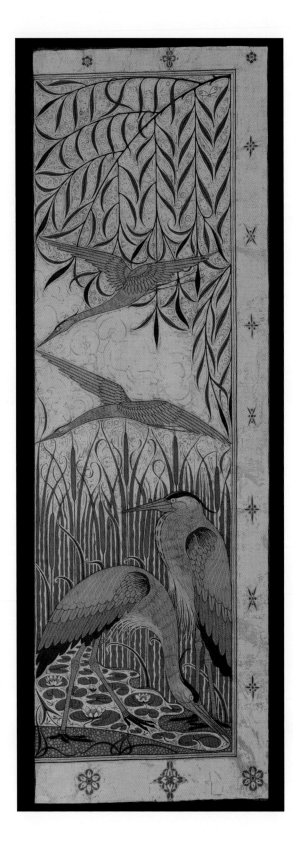

11
Attributed to **Gerrit Willem Dijsselhof**
panel from a screen 1900–10
cotton, wax-resist dyed (batik)
157.8 cm (62⅛ x 19⅞ in.)

12 (opposite)
Chris Lebeau
fireplace screen panel with fish motifs
silk, wax-resist dyed (batik)
73 x 69 cm (28¾ x 27¼ in.)

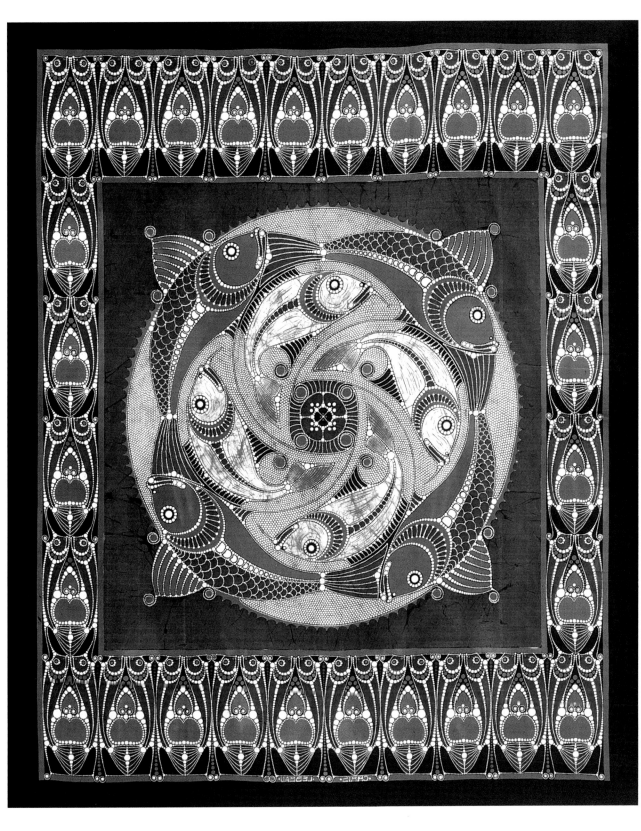

13
Charles Francis Annesley Voysey
Vine and Bird, design for textile 1899
watercolour and pencil
46.5 x 37.7 cm (18⅓ x 14⅘ in.)

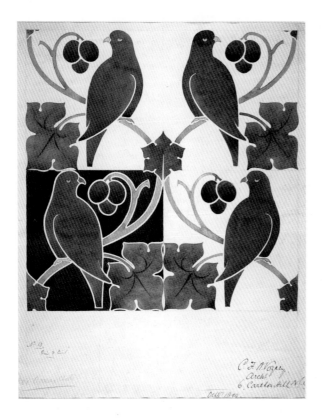

generation, Crane perceived women as naturally proficient needleworkers and generally maintained the gender separation between idea/design (male) and labour (women). This was certainly not unusual, especially in England, which was renowned for needlework schools such as the Royal School of Art Needlework (established 1872), in which primarily female students learned the fine points of embroidery by skilled female needleworkers. The principal designers, however, were frequently men, such as Crane, who provided many of the actual embroidery designs that students carried out in thread.[57]

Similarly, Alexander Fisher (1864–1936), who was known for his silverwork, created designs for embroideries, such as his *Rose Tree* panels in 1904 for Farnams Hall (fig.14), which were executed by embroiderers at the Royal School. The swirling root forms recall Obrist's whiplashes, while the tight and symmetrical flowers follow the orderly structure of British Arts and Crafts designs.

The embroiderers who carried out these designs used their needlework skills primarily for artistic and couture purposes, since the school's in-house studio workshop received outside commissions for embroidery projects, but some embroiderers were forced into low wage jobs as 'sweated' needleworkers, women who took in piece work but earned barely enough to get by.[58] An economic and artistic hierarchy governed the realm of needlework, and while theorists such as Crane were aware of sweatshop conditions and of the reality of outsourcing needlework to poor, overworked women, his aesthetic concerns for good design overshadowed tendencies he may have had to practise social activism at the expense of art.[59] Like Morris, Crane believed that the vulgarisation of design was due to mechanisation, which separated the artist from the production process, a problem that could be partly solved by providing good designs to industry. But Crane did not seem to have a solution to how the machine could be successfully integrated into his concept of art.

One way that designers differentiated unique, studio-created embroidered work from factory-made imitations was to use the terms Art Embroidery and Art Needlework to describe the former. May Morris (1862–1938), daughter of William Morris and head of the Embroidery Department of Morris & Co from 1885, was instrumental in establishing these concepts. She was not only an accomplished embroiderer but also a noted writer, businesswoman and artist. In her 1893 book, *Decorative Needlework*,

14
Alexander Fisher
Rose Tree c.1904
silk damask with wool and silk embroidery
309.88 x 280.04 cm
(122 x 110¼ in.)

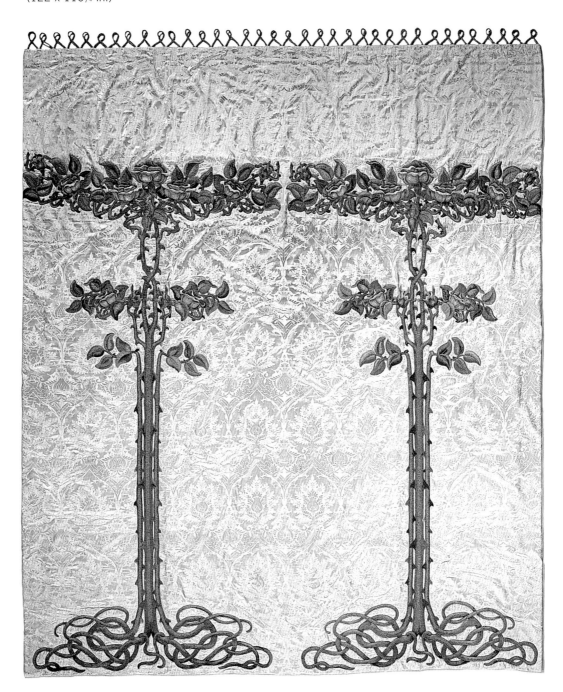

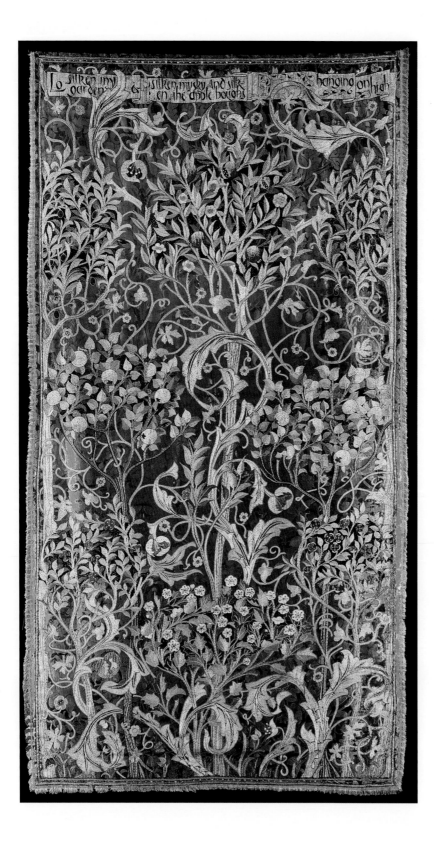

38

15
May Morris
portière (one of four), for Morris & Co,
1892–93
silk damask with silk embroidery,
silk fringe and cotton lining
259.1 x 137.2 cm (102 x 54 in.)

16
Margaret Macdonald Mackintosh
two panels c.1900
silk appliqué, embroidery with silk
and metal threads, silk braids, ribbon
and glass beads on linen, watercolour
on paper
each: 177.2 x 41 cm (69¾ x 16¼ in.)

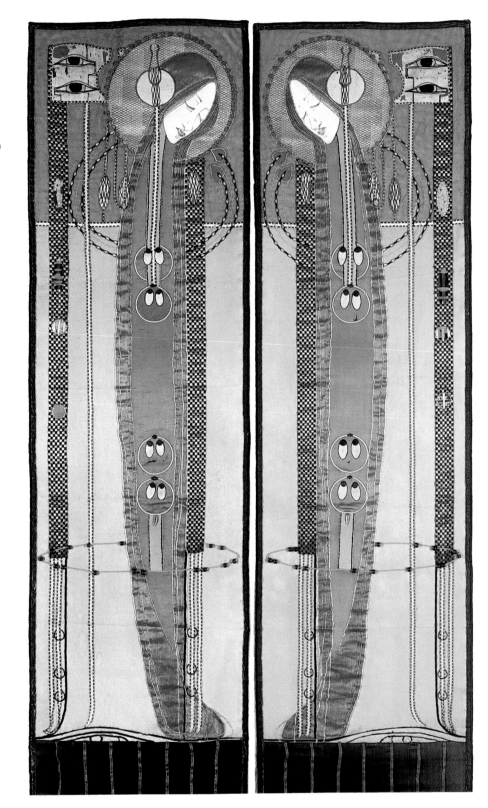

she advanced the idea that well-constructed and well-designed embroideries could potentially function as art, and she encouraged her readers to explore the unique properties inherent to embroidery, such as its linearity, its connection to both drawing and writing, and its texturally complicated surfaces.[60] In 1893, she completed a large-scale *portière* project for the Longyear home in Brookline, Massachusetts (fig.15), for which she combined text, silk and plant forms to create a virtual indoor garden made of fibre and references to fibre: 'Lo silken my garden and silken my sky, And silken my apple-boughs hanging on high', she wrote in silk from her father's 1891 poem, 'The Flowering Orchard'.[61] Because May Morris represented her father's aesthetic and was a skilled embroiderer in her own right, her artistic theories and techniques were admired and practised by many of her contemporaries and later generations of artists working in embroidery. Lewis F. Day (1845–1910), for example, an influential teacher and promoter of embroidery, echoed May Morris in his 1900 book *Art in Needlework: A Book About Embroidery*, which he co-authored with Mary Buckle and which continues to serve as a primer even today! More than just a book about technique, *Art in Needlework* advanced the notion that embroidery 'at the best is an art' when good design and good workmanship unite, and the dictates of needle and thread are followed.[62] This notion of truth to materials would become another leitmotif of modernist design and was understood by all of the significant designers and theorists of the modernist period. Indeed, the lessons of the Arts and Crafts movement, specifically the importance of understanding the dictates of materials, were admired and practised by followers on the continent and in America, where parallel investigations were taking place.

The British style was especially admired in Italy; Walter Crane was invited to serve as Honorary President for the 1902 Turin First Exposition of Modern Decorative Art, an Italian successor to the much more monumental 1900 Exposition Universelle in Paris. The furnishing fabrics for much of the Italian designs seem to have been imported from Liberty of London, but the undulating forms of the furniture itself echoed the Art Nouveau style.[63] One of the standouts of the Turin exposition, earning praise and honours, was the 'Rose Room' by Scottish designers and married couple Charles Rennie Mackintosh (1868–1928) and Margaret Macdonald (1864–1933), whose work had already been well received in Vienna at the Eighth Viennese Secession exhibition of 1900.[64] Their work, a *Gesamtkunstwerk* that included furniture, murals and wall hangings, unified by white painted walls, stood in stark contrast to the curving, nature-inspired forms of Art Nouveau because it was organised around a different visual structure, that of pure geometry. This work signalled that geometric abstraction and streamlined design, which had the potential to work more favourably with industry, would soon dominate textile design.[65]

Glasgow artists also explored new ways of depicting women that were far removed from the academic realism and moral underpinnings of Victorian and Pre-Raphaelite traditions, but also distinct from their more sexualised continental Art Nouveau counterparts. Macdonald, for example, produced images that combined geometric shapes, abstracted plant forms and elongated female bodies, usually punctuated by a clearly defined face with closed eyes or a fixed stare, earning her the dual distinction of belonging to both the 'Spook School' and the 'Glasgow School'.[66] For the *c*.1900 textile diptych, or double panel piece, shown in figure 16, Macdonald worked in a pioneering multi-media technique for which she combined braid, ribbon, beads, watercolour and embroidery to form an elaborate and sculptural visual statement. Here, various motifs –

Egyptian-style eyes, checkerboard patterns and circular forms – intermesh and appear to engulf the sleeping, cocooned women. The figures merge into the decorative patterning as with the other elements of design, creating an example of visual camouflage that contemporary artists, particularly Austrians Gustav Klimt (1862–1918) and Koloman Moser (1868–1918), would also explore. Interestingly, a nearly identical single panel (it is unclear whether it had a mate) was exhibited at the 1900 Vienna Secession exhibition and later at the 1902 Turin exposition; the panels illustrated here are either duplicates made by Macdonald, or are the originals that have been revised.[67] These examples of new art for the modern interior brought Macdonald immediate and inter-national recognition. Her work, as well as that of her colleague Jessie Newbery (1864–1919), who utilised the famous Glasgow Rose pattern along with Mackintosh, was published in all of the leading international journals, such as *The Studio*, *Ver Sacrum* and *Dekorative Kunst*, and exhibited internationally as examples of the new Scotto-Continental Art Nouveau.[68] The checkerboard pattern in particular points to Macdonald's awareness of developments in Vienna – a reciprocal awareness – where extraordinary artistic innovations in textiles, particularly involving the use of geometric abstraction, were underway.

Like their counterparts in Britain and Europe, American artists and designers were aware of contemporary trends in textiles and non-Western artistic traditions. Americans, for example, by the time of the 1893 Worlds' Columbian Exposition in Chicago, were keenly aware of Asian art, motivated in part by Bing's numerous auctions, publications, donations and exhibitions of Chinese and Japanese works in New York, Philadelphia and Boston starting in the 1880s, and also of American Indian and Pre-Columbian art from Mesoamerica.[69] For example, at

17
Candace Wheeler
water-lily textile,
manufactured by Cheney
Brothers 1883–1900
warp printed silk
90.8 x 21.6 cm
(35¾ x 8½ in.)

41

the 1893 exposition, entries from 50 nations were on display, including recreations of Maya and Japanese temples, in an effort to illuminate the arts of non-Western societies. Unfortunately, organisers failed to recognise the achievements of African-Americans, and, in keeping with time-honoured traditions, textiles were housed in the Women's Building.[70] Nevertheless, Candace Wheeler (1827–1923), Director of Applied Arts and Color for the Women's Building, used this opportunity to display and promote artistic textiles as a viable art and profession, especially for women.[71] Wheeler already had extensive training in both textile production and textile marketing, as manager of the textile design and embroidery division of Tiffany and Co until 1883, and after that as founder of her own company, Associated Artists, for which she produced innovative textile patterns and invented new textile

processes.[72] Her work for the 1893 exposition was important because she succeeded in displaying embroidery that demonstrated artistic merit and professionalism: 'it was on the highest possible plane…it was not amateur work, not a thing to be taken up and laid down according to moods', she recalled in her 1921 book *The Development of Embroidery in America*.[73] Indeed, Wheeler wrote, echoing others before her, 'embroidery promises to be a permanent and growing art…quite competent to answer any of the higher calls of art'.[74]

Wheeler was also knowledgeable about other textile techniques, such as printed and machine woven textiles. Her awareness of Asian textile motifs and techniques enabled her to produce some of the most complex and beautiful textiles of the period, including the textured 'shadow silks' that changed with the light. Created through a process she derived from Japanese textiles, Wheeler used preprinted warp (vertical) threads to create a pattern that would become slightly out-of-focus when intersected by contrasting weft (horizontal) threads (fig.17).[75] The resulting shimmering effect, enhanced through the use of silk, worked particularly well with water themes, so well that the painter William Merritt Chase remarked that she 'could do more with silk than we can with pigments, because it reflects color as well as holds it'.[76]

Japanese art provided a rich source of design ideas to American artists, writers and collectors, including the important art educator Arthur Wesley Dow (1858–1922), who was instrumental in formulating a theory of composition based upon the unique principles of line, colour, rhythm and balance found in Japanese design.[77] His 1899 book, *Composition: A Series of Exercises in Art Structure for the Use of Students and Teachers*, provided examples and formulae with which to create patterns derived and abstracted from natural forms. As Obrist

and Verneuil had in their studies, Dow explored alternatives to pictorial form that could be adapted to applied arts objects, especially textiles. Followers of Dow used his Asian-inspired principles of composition to create embroidered wall hangings of asymmetrical simplicity, such as those produced by Anna Frances Simpson, a student at Newcomb College in New Orleans whose arts and crafts programme was strongly influenced by Dow's aesthetic (fig.18).[78] By cropping the tops of the trees, outlining them in black stitches and forgoing shading in favour of single-coloured areas, Simpson emphasised pure pattern over representation.

Another important source for design in America was the journal *The Craftsman*, established by Gustav Stickley (1858–1942) and published from 1901 to 1916.[79] Stickley advocated using textiles in ways that exploited the beauty and texture of fibre, primarily silk and linen, and he decorated these textiles with simple geometric forms that harmonised with other objects and surfaces in order to create a unified assemblage of parts for the decoration of the American home.[80] So that purchasers would have an element of control in creating the Craftsman Gesamtkunstwerk, Stickley provided instructions and pre-designed kits for his stencil, embroidery, appliqué and stamp patterns, many of which were adapted from American Indian designs, which he believed were examples of solid, well-balanced, geometric design, superior to the excessive curvilinear ornamentation of Art Nouveau.[81] A page from a 1904 issue of *The Craftsman* (fig.19) illustrates table scarf kits with Indian designs, such as the Cross of Life, a tree motif and the Thunder Bird; it also offers instruction on technique, in this case appliqué held in place with a couching stitch, as well as summarising Stickley's principles of design, such as those dealing with colour and proportion, to help the home embroiderer achieve the Craftsman style. While

quality handwork was a priority for Stickley, he was, like his colleague Candace Wheeler, not opposed to the process of mechanical production, as long as the principles of 'artistic craftsmanship' and design were followed, as he explained in his 1906 essay, 'The Use and Abuse of Machinery, and its Relation to the Arts and Crafts'.[82] These sentiments, as well as Stickley's prevailing interest in geometric design, were shared and amplified by Frank Lloyd Wright (1867–1959), whose carpets and furnishing fabrics for his prairie style homes reveal a similar attention to the process of building patterns through the arrangement of basic geometric forms such as circles and squares.[83]

These American artists were probably aware of some of the vernacular handmade textile traditions in the United States, including quilting, appliqué, sampler making and weaving, though these traditions would not be thoroughly understood and revived until the 1930s. One rare quilt from the 1890s that stands out as an important example of the expressive potential of textiles is the so-called 'Bible Quilt' by Harriet Powers (1837–1911) from 1895 (fig.20). Powers, born a slave in Georgia, adapted the pictorial appliqué style of West African traditions and the American pictorial quilt vernacular to reflect her own memories and visions.[84] The faculty wives of Atlanta University purchased this work after they became aware of her previous quilted work at a regional exposition. Powers carefully cut and stitched, from hundreds of fabric remnants, 15 panels that form abstract references to biblical themes – Noah, Jonah, Adam and Eve, the Crucifixion – and events from recent history, such as the Leonid meteor shower of 1833.[85] Interestingly, the size of Powers' two extant quilts do not conform to standard bed sizes, indicating that her quilts functioned more as expressions of oral history and artistic ideas than as utilitarian objects.[86]

18
Anna Frances Simpson
embroidered table runner c.1902–15
embroidered linen
50.8 x 182.88 cm (20 x 72 in.)

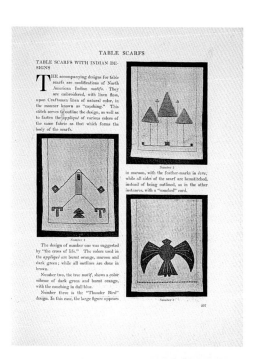

19
page 507 from *The Craftsman*, vol.5, no.5, February 1904
table scarves with Indian designs
26.1 x 20.4 cm (10¼ x 8 in.)

44

20
Harriet Powers
pictorial quilt (the 'Bible Quilt') 1895–98
pieced, appliquéd and embroidered printed cotton
175 x 266.7 cm (68⅞ x 105 in.)

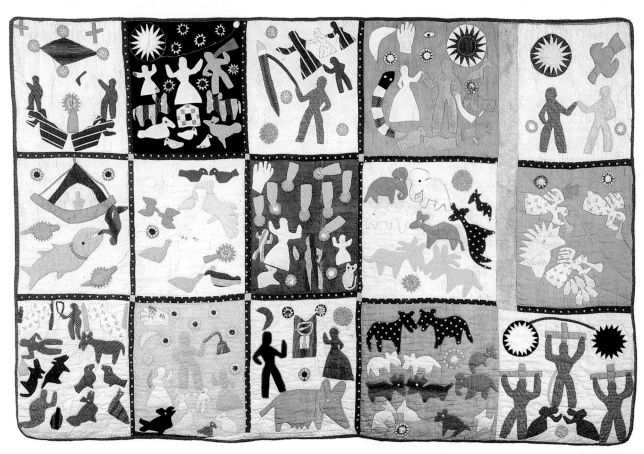

The New Art: Tapestry

For many artists in Europe and America, weaving and tapestry provided the ideal entrée into the applied arts reform movement and, in some cases, provided the opportunity to revive folk myths and techniques. Artists and designers could work in an ancient technique while experimenting with new pictorial contexts and forms. Tapestry, because of its traditional role as both a noble art and an ancient craft, and its natural adaptability as a decoration for walls, floors or other surfaces, played a key role in contemporary efforts to unify art and craft. Those seeking to explore both new approaches to tapestry and new financial opportunities established weaving workshops and colonies, which flourished during this period.

One of the most prolific European workshops created with these goals in mind was the Scherrebek Art Weaving School and Workshop, then located in northern Germany, now Denmark. The school was founded by Marie Luebke (1860–1932), a skilled weaver, and Justus Brinckmann (1843–1915), director of the Museum für Kunst und Gewerbe (Museum of Art and Craft in Hamburg) and an old friend of Hamburg native Siegfried Bing. The workshop was by design a collaborative endeavour, with the goal of unifying art and craft through tapestry. Between 1896 and 1903, weavers trained and supervised by Luebke created over 200 tapestries designed by over 50 of the top Jugendstil and Art Nouveau designers at the time including Otto Eckmann (1865–1902), Henry Van de Velde and Hans Christiansen (1866–1945).[87] These 'picture carpets', such as Eckmann's renowned 1896–97 Fünf Schwäne (Five Swans) (fig.21), were primarily intended to function as textile wall panels that would enliven the modern interior and contribute to the notion of the Gesamtkunstwerk. The tapestries functioned as unique works of wall art, much like decorative painting did, in the modern style characterised by flat, unmodulated areas of colour and subject matter derived from nature. The tapestries, however, unlike their painted counterparts, were textiles, and so had the additional qualities intrinsic to the medium: they were flexible, lightweight, not burdened by heavy frames, malleable, warm, textured and, importantly, they could be easily replicated.

The practice of making replicas of popular works of art is not uncommon in art history, especially when one considers the great Renaissance and Baroque painting workshops that replicated portraits and popular subjects. Tapestry is no exception. Indeed, Eckmann's Five Swans was reproduced over 100 times by various weavers even after the school went bankrupt in 1903.[88] Of course, this practice contradicts the notion of originality and uniqueness that one traditionally expected from a work of art, signalling instead mass-production and loss of preciousness. But when understood within the context of applied arts reform, textiles such as these, despite, indeed because of, the ambiguity of originality and authorship, were every bit as modern as other avant-garde creations being produced at the time, including furniture, graphic arts and photography, because they crossed over to the realm of popular culture without losing the integrity of the medium or the freshness of modern design.

Besides contributing to the modern Gesamtkunstwerk, Scherrebek tapestries, in a few cases, functioned as tongue-in-cheek artistic commentary. For example, Heinrich Sperling (1844–1924) created two alternatives to Eckmann's swans, a 1901 tapestry titled Five Storks and the more complicated Möpseteppich or Fünf Möpse (Pug Tapestry or Five Pugs), 1899 (fig.22), for which he appropriated Eckmann's vertical format, curving central path and decorative upper and lower borders, but substituted dogs for swans. Sperling's version is

45

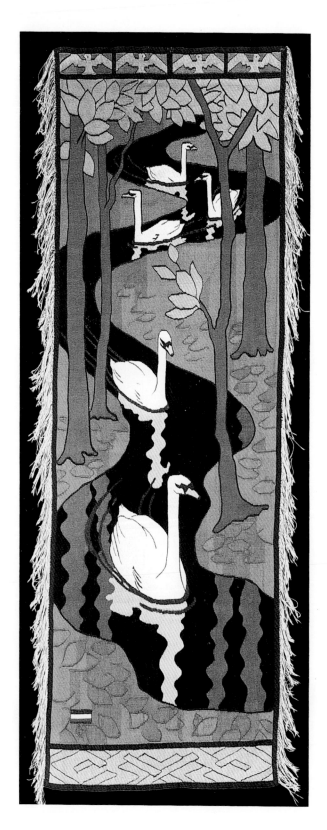
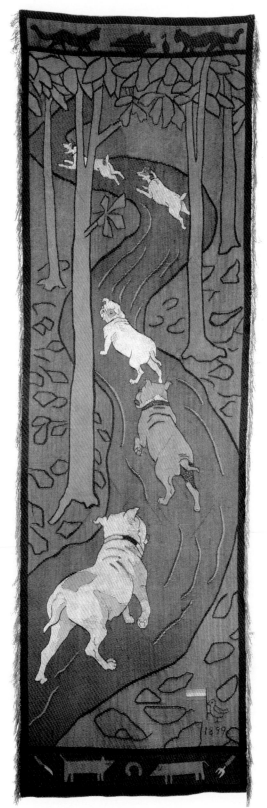

21 (far left)
Otto Eckmann
Fünf Schwäne (Five Swans) 1897
tapestry weave, wool and cotton
240 x 76 cm (94½ x 30 in.)

22 (left)
Heinrich Sperling
Möpseteppich (Pug Tapestry) 1899
tapestry weave, wool and cotton
238 x 71 cm (93¾ x 28 in.)

23
Gerhard Munthe (designer), **Nini Stoltenberg** (weaver)
*Die Nordlichttöchter (*The Daughters of the Northern Lights
(Aurora Borealis) or The Suitors) 1895, executed 1896
tapestry; cotton, wool
129.5 x 163.8 cm (51 x 64½ in.)

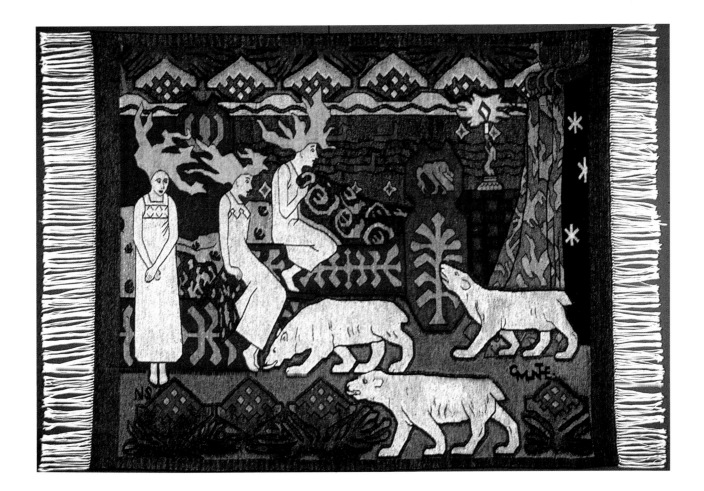

certainly less tranquil: three pugs lag behind two Pomeranians up a trail, while the lower register depicts two pigs between a knife and a fork, and the upper register shows two cats walking toward a platter with a pig's head. Ironically, Sperling's tapestry was commissioned by steel manufacturer Friedrich Krupp, who was obviously familiar with the left-wing journal *Simplicissimus* (1896–1914) that devoted much of its pages to attacking capitalists like Krupp himself.[89] Here we see a textile that functions much like a satirical cartoon that could have been found in the pages of *Simplicissimus*, a caricature of both Eckmann's peaceful and popular image, and of *Simplicissimus* itself: the tough bulldog that served as the watchdog and mascot for the journal has been demoted to a charming pug.

Since tapestry allowed artists to explore both pictorial and abstract forms simultaneously through a handmade process, there was a resurgence of interest in this art throughout Europe, which created an international dialogue that resonated among weavers, designers and collectors. In addition, since tapestry is an applied arts medium that lends itself particularly well to collaboration, a variety of relationships developed around the shared interest of participating in collaborative textile endeavours. Married couples, such as Carl and Karin Larsson in Sweden and Eliel and Loja Saarinen in Finland, and brother and sister Aládar and Laura Kriesch in Hungary, collaborated with textiles in various ways, as did larger groups consisting of curators, artists and teams of weavers, such as Scherrebek. Justus Brinckmann, for example, was keenly aware of developments in tapestry taking place in Norway. He commissioned Norwegian artist Gerhard Munthe (1849–1929) to adapt one of his watercolour paintings to tapestry for the Hamburg Museum, which was to be woven by weavers at the Trondheim Museum of Applied Art.[90] Munthe's design, *Die*

Nordlichttöchter (The Daughters of the Northern Lights) (fig.23), in which narrative pictorialism and references to Nordic symbols are united with flat, abstracted patterns, proved to be such a popular image that it was reproduced by various weaving studios for the next 30 years.

Scandinavian weavers were renowned not only for their innovative weaving techniques, but also for creating tapestry images that, like Munthe's design, united pictorial traditions with the geometric style of folk tapestries. Frida Hansen (1855–1931), weaver, teacher and founder of the Norwegian Weaving Society (1897), was instrumental in reviving these traditions while exploring modern approaches to design and technique. A detail from one of Hansen's c.1900 tapestries (fig.24) reveals her virtuosity as a weaver: she created visual depth by alternating tapestry-woven passages – the floral motifs in this case – with a ground pattern formed from open-worked passages, for which the vertical warp threads were left unwoven.[92] This technique was both practical – the tapestry could be hung as a light-filtering curtain, for example – and artistically modern, in that the overall design was created to reflect the inherent structure of weaving itself. Interestingly, her work was discussed and reproduced in the same issue of *Dekorative Kunst* that highlighted Van de Velde's reform fashion; Hansen was praised for her 'masterful use of technology and joy in ornamentation'.[93]

Similarly, in Finland, Eliel (1873–1950) and Loja (1879–1968) Saarinen worked in textiles to revive traditional Finnish crafts and to explore modern design. A 1904 carpet titled *Ruusu* (Rose) (fig.25) was designed by Eliel for the rose-themed room of the Suomen Käsityön Ystävät exhibition (Friends of Finnish Handicraft).[94] Although woven by the Friends of Finnish Handicraft, Loja may have had a hand in the design and execution since she was a trained

weaver and sculptor whom Eliel married that year (his expertise was architecture).[95] It is woven in a traditional, hand-knotted pile technique and was intended to function as a traditional ryijy rug, which is a rug for couch and floor simultaneously.[96] The work unites rose, checkerboard and cocoon forms in an abstracted version of traditional Finnish pictorial weavings and also reveals an obvious indebtedness to international trends, especially designs from the Glasgow School by Margaret Macdonald (fig.16, p.39).[97] Certainly Eliel Saarinen was familiar with Macdonald's work through publications that featured her award-winning innovations at the Vienna and Turin expositions, and he most likely admired Macdonald and Mackintosh's collaborations on their modern interiors. Like the Glasgow examples, Saarinen's design initiates and anticipates modernism's eventual move toward complete abstraction, which would occur within the next decade.

The same year, 1904, in the small Hungarian town of Gödölló, near Budapest, Aládar Körösföi-Kriesch (1863–1920), his sister Laura Kriesch Nagy (1879–1962) and her husband Sandor Nagy (1869–1950) formed an artists' colony, Gödölló, which was to highlight weaving as the central workshop. Interested in reviving the Hungarian folk textile tradition and in depicting scenes from Hungarian folklore – interests motivated in part by a desire to locate a Hungarian national art – the artists worked to adapt traditional techniques and forms to create modern wall hangings.[98] For example, Körösföi-Kriesch's tapestry, *Kalotaszeg Women* (fig.26), depicts three Kalotaszeg women from the village of Körösfó, famous for its handicrafts and preservation of peasant traditions, including the wearing of folk costumes. The work probably dates to 1907, the year Körösföi-Kriesch officially added the Körösföi to his name as a way of declaring himself connected to the Hungarian past.[99] Strongly

geometric, the forms of the figures recall both folk carpets and embroideries while reflecting the international interest in abstraction.

As the expenses of producing and purchasing Art Nouveau products began to exceed the income of most artists and consumers, the notion of a new *Gesamtkunstwerk* evolved into one that was more aligned to industry and more connected to the consumer economy. While many artists and workshops began to envision a new art that could be produced in collaboration with industry, some denounced the increasing mechanisation and commercialisation of art. Art Nouveau, as well as its international counterparts Jugendstil, Nieuwe Kunst and the Arts and Crafts movement, became a casualty of this conflict, especially as its once avant-garde formal innovations were subsequently over-commercialised and mass-produced. It was within the context of this conflict that the applied arts reform began; not surprisingly, these issues would continue to be of concern to artists and theorists during the following decades as the next stage of modernist textiles unfolds.

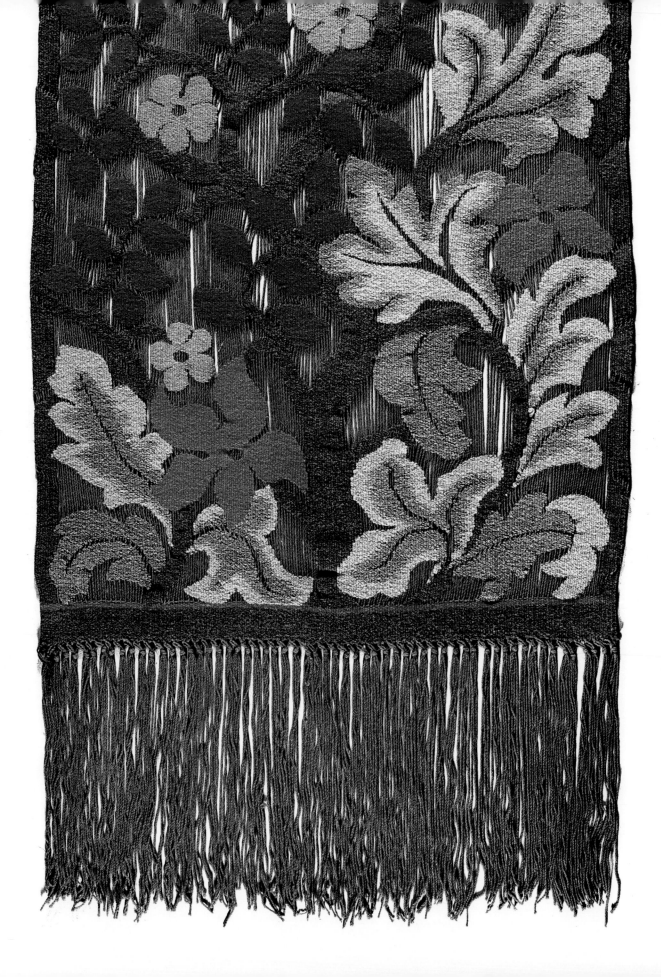

50

24 (left)
Frida Hansen
wall hanging (detail) c.1900,
wool tapestry and open weave
269.24 x 76.84 cm (106 x 30¼ in.)

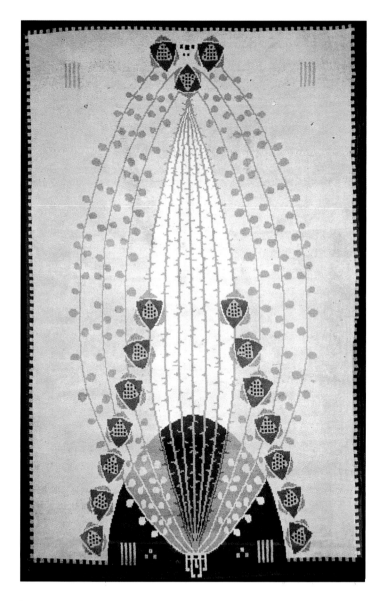

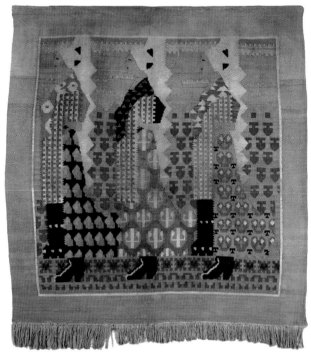

26
Aladár Körösföi-Kriesch
Kalotaszeg Women c.1907
kelim tapestry
164 x 165 cm (64½ x 65 in.)
25

25
Eliel Saarinen
Ruusu (Rose), ryijy rug 1904
cotton, wool
304.8 x 186.7 cm (120 x 73½ in.)

Chapter Two:
Primitivism, Abstraction and Experimentation 1905–1920

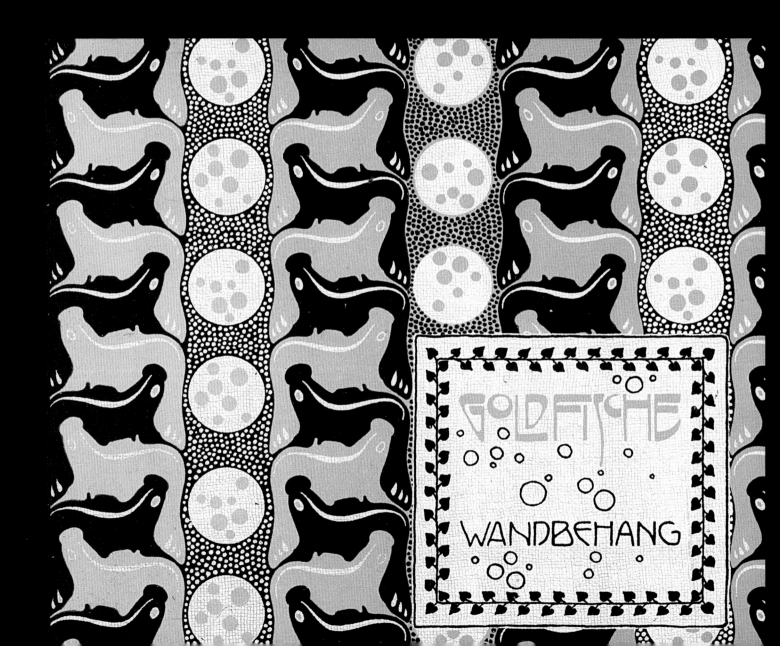

By the turn of the twentieth century, artists in Europe, especially in Vienna, were becoming increasingly aware of the limitations of Art Nouveau design. The florid and undulating lines now served as only superficial decorative treatments for ordinary mass-produced items or as frames for advertisements, exemplified by a printed textile advertising Pfaff sewing machines (fig.27). Interestingly, the central image of the mother and daughter, depicted in stark black-and-white precision, reinforces the traditional relationship between women and textiles, while the border design and text is drawn in the modern style of Art Nouveau, creating a confusing conflation of styles and messages. A new generation of applied arts reformers, recognising this contradiction, believed that Art Nouveau's ubiquitous whiplash literally needed straightening in order to conform more appropriately to developing trends involving machine production and geometric abstraction, elements that would contribute to the formation of a new vision of the *Gesamtkunstwerk*.

During the years from approximately 1905, when Art Nouveau was winding down, to approximately 1920, after the chaos of World War I had somewhat subsided, the modernist movement became more complex, and elements of abstraction, primitivism and experimentation became interconnected. Artists sought to defy societal expectations governing education and gender roles and to complicate conventional modes of artistic expression that, despite significant advances during the previous decades, continued to distinguish the 'fine' or 'high'

arts from the 'applied' or 'minor' arts, as well as the handmade work of art from the machine-assisted one.

As artists and theorists increasingly confronted questions about the role of art in life and about artistic authenticity, they again looked outside the Western canon for answers. Many pursued their fascination with Asian art while expanding their understanding of non-Western art to include those societies for whom art was perceived as being integrally linked to life. This meant art that was perceived as both functional and culturally symbolic, such as in African, ancient American and Oceanic societies, the so-called 'primitive' societies, as their European colonisers frequently referred to them. This art, which included textiles, was perceived as being intimately tied to the practices of daily life, a relationship that many modern artists sought to revive in their own work. In addition, the visual forms of this art were perceived as being fundamentally abstract rather than illusionistic. Art historians such as Alois Riegl (1858–1905) and his student Wilhelm Worringer (1884–1965) advanced the linked theories that the origins of creative expression were governed by an innate human urge toward abstraction as well as by an innate human drive to decorate and adorn one's environment and the objects within those environments. These ideas led many artists to conclude that the origins of art, which they sought to rediscover, were therefore both abstract in form and utilitarian in function.

At the same time, due to earlier advances by innovators such as Van de Velde, Obrist and others, artists continued to experiment with modes of art that were entirely handmade, such as embroidery, but that had practical applications, such as for fashion. These artists naturally began to consider how this art could be marketed and produced for not only élite connoisseurs, but also for the growing middle class, leading to new considerations about

53

29
Koloman Moser (left)
Goldfische (Goldfish), plate 17 from *Flächenschmuck* (Surface Decoration) 1902
ink on paper
26.1 x 30.5 cm (10¼ x 12 in.)

27
scarf *c.*1901
cotton
43.8 x 49.5 cm (17¼ x 19½ in.)

54

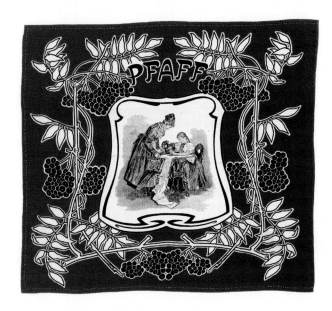

the role of mass-production within the context of art and design. As artists began to seek alternatives to Art Nouveau forms and ideologies, they also began to consider new financial opportunities in the arts, which resulted in a period of enormous experimentation and exploration. All of these innovations were taking place at the Wiener Werkstätte (Vienna Workshops) by 1910, when in-house production and marketing of textiles really accelerated, and the notion of the *Gesamtkunstwerk* expanded to include the accoutrements of consumer culture: showrooms, sales assistants, contract artists, catalogues, inventory and income.

The Wiener Werkstätte

For nearly three decades, from 1903 until its unfortunate collapse in 1932, some of the most remarkable objects of modern design were produced at the Wiener Werkstätte. The idea of the Wiener Werkstätte developed from reforms made by members of the Viennese Secession, an association of artists and designers who were determined to re-evaluate and transform the current state of applied arts.[1] Established in 1897 and led by the painter Gustav Klimt, architect Josef Hoffmann (1870–1956) and designer Koloman Moser, the Secession sponsored international exhibitions emphasising the integration of the arts and featuring much of the new art from the period, such as work by Van de Velde and members of the Glasgow School, which was admired for its elegant and restrained linear form. Like their colleagues in Glasgow, Hoffmann and Moser, then professors at the Vienna Kunstgewerbeschule (School of Arts and Crafts) with successful outside practices, were also exploring the design possibilities of geometric forms – circles, squares, diamonds, checkerboards – and the application of these forms to the decorative arts. Motivated by their entrepreneurial spirit and a pioneering sense of style, Hoffmann and Moser, with financial backing from textile manufacturer Fritz Waerndorfer, founded the Wiener Werkstätte in order to establish, according to Hoffmann, 'close contact between the public, designer, and craftsman and to create a good and simple household object' without compulsive dependence on decorative excess.[2] Although the Wiener Werkstätte was clearly grounded in Morris' Arts and Crafts philosophy calling for artists to practise fine craftsmanship, maintain truth to materials and unify the arts, it was the site of extraordinary innovation and collaboration. For example, women began to gain prominence as

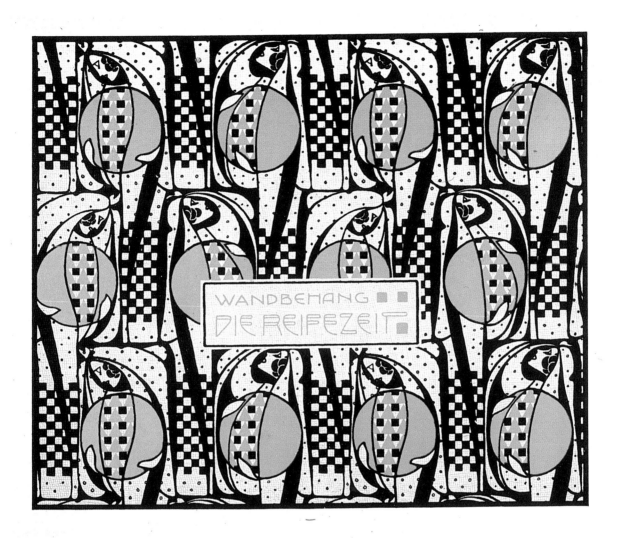

28
Koloman Moser
Die Reifezeit (The Ripe Time), plate 7 from *Flächenschmuck*
(Surface Decoration) 1902
ink on paper
26.1 x 30.5 cm (10¼ x 12 in.)

designers, including Mathilde Flögl (1863–1950), Fritzi Löw-Lazar (1891–1975) and Maria Likarz-Strauss (1893–1971), and a corporate marketing and production plan was developed that blurred the boundaries between fine art, decorative art and consumer culture.

Moser personified the progressive *fin de siècle* artist who could apply his artistic sensibilities to a wide range of media, from graphic art to textiles. He absorbed ideas from his contemporaries, especially those working in Glasgow, as well as from a variety of non-Western sources. His early textile designs – created from 1898 to 1903, manufactured by the luxury textile firm Johann Backhausen & Söhne, and often reproduced in the Secessionist journal *Ver Sacrum* – are noteworthy for their strict reliance on geometry. Moser's design for a wall hanging titled *Die Reifezeit* (The Ripe Time) (fig.28), published in a lavishly produced portfolio of his designs titled *Flächenschmuck* (Surface Decoration) in 1902, is strikingly similar in form and content to work that Margaret Macdonald produced at the same time and that was exhibited in Vienna in 1900 and at the 1902 exposition of modern design in Turin (fig.16, p.39). But Moser's design is not as dependent on the meticulous hand painting and encrusted surface treatment of Macdonald's textiles. Instead, Moser has streamlined the geometric elements of the pattern with a mathematical precision. This design appears at first glance to depict ripe fruit hanging from trees, but upon closer inspection the trees metamorphose into women who alternate between looking up and looking down. The figures have become abstracted to the point of being unrecognisable, signalling an important development in modernist design toward geometric abstraction. Moser's goldfish pattern (fig.29, p.52), produced for the same portfolio, was composed using a complex tessellated pattern derived in part from mathematical formulae.

The pattern was also influenced by Japanese sources, specifically stencil papers for fabric called *katagami* (fig.30), as well as by Islamic textile patterns that Moser would have seen in Owen Jones' monumental illustrated book *The Grammar of Ornament* (1856) and in the textile department at the Österreichischen Museum für Kunst und Industrie (Austrian Museum of Art and Industry), directed by Alois Riegl from 1858 to 1905.[3] Indeed, the Austrian Museum was affiliated with the Vienna Kunstgewerbeschule, where Moser was a professor, and students and professors alike could study the exceptional Asian and Near Eastern rug collection that Riegl had assembled.[4]

By 1905, the Werkstätte, eventually staffed by students of Hoffman and Moser in addition to top designers such as Dagobert Peche (1887–1923), was equipped to produce its own block and roller printed textiles. By 1910, the textile department was officially formed, although without Moser, who left in 1907; the fashion department was established in 1911.[5] The combined success of the fashion and textile departments held the Werkstätte together economically over the years, especially during the 1920s when Werkstätte textiles were sold internationally through branches and partnerships with retail shops.[6] Altogether, the textile department employed more than 100 artists, many of whom were women, and produced approximately 1800 patterns – some of which were produced in up to 20 colourways (colour schemes) – totalling tens of thousands of samples.[7]

The sheer diversity and quantity of designs and designers complicates efforts to define a Wiener Werkstätte style. Indeed, it is this very versatility that largely characterises the style. Yet the textiles share a general tendency toward abstraction – Hoffman's starkly geometric repeats and checkerboard designs are a prime example – and experimentation, as seen

30
Japanese stencil (katagami) 19th century
mulberry paper
24.8 x 40.2 cm (9¾ x 15⅞ in.)

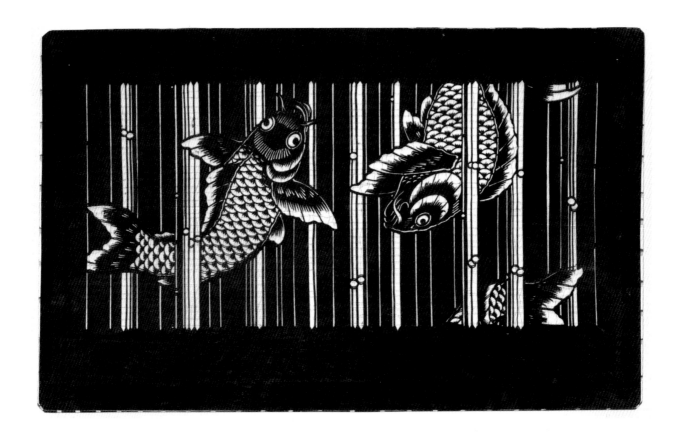

in the many examples of blended stripe patterns (*ombré*) and spray painted and stencilled patterns (*spritz-drucke*) initiated by Peche (fig.31).[8] Hoffmann's 1910 block-printed silk *Theben* (Thebes) (fig.32) is an example of his early geometric style, for which he adapted ancient Egyptian architectural references. *Papageienwald* (Parrot's Forest) by Ludwig Jungnickel (1881–1965) (fig.33) is remarkable for its optically dynamic pattern in which parrots are seemingly camouflaged within the overall design. Jungnickel's popular pattern was used for the library upholstery in the Villa Primavesi, designed by Hoffmann in 1913.[9] Noteworthy is the fact that one could find variations of these patterns, and many more, in a single room or ensemble. The textiles were intended to serve multiple purposes – as wall décor, upholstery, screens, curtains and, importantly, decoration for the body – and it was a characteristic of the Werkstätte style to employ different textile patterns for each. The overall effect of this preference for pattern multiplicity was dazzling and highly ornamental.

31
Dagobert Peche
textile sample, *Krone* (Crown) 1919
printed silk
39.1 x 93.7 cm (15⅞ x 36⅞ in.)

32
Josef Hoffmann
Theben (Thebes) 1910
block-printed silk
20.3 x 26.0 cm (8 x 10¼ in.)

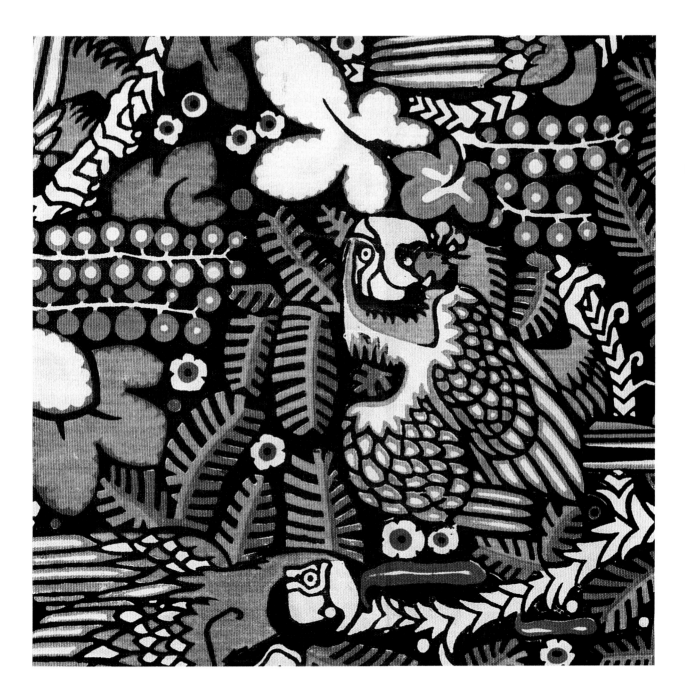

33
Ludwig Jungnickel
Papageienwald (Parrot's Forest) 1910
block-printed linen
65.4 x 53.3 cm (25¾ x 21 in.)

The Werkstätte design strategy of using textiles to alter the environment by repeating patterns, by covering entire surfaces with patterns, and by combining different patterns in a single ensemble demonstrates how textiles were embraced to create the total work of art. One of the most famous Werkstätte commissions was the decoration of Adolphe Stoclet's Brussels mansion, the Palais Stoclet (1905–1911), for which Hoffmann, as architect and project manager, collaborated with members of the Werkstätte as well as Klimt on all aspects of the interior decoration, from silverware to wall murals, to create a unified whole. Not surprisingly, Hoffmann even designed a dress for Madame Stoclet so she would become a living element of the total work of art.[10] The strategy of pattern multiplicity was also a shrewd marketing device, for the technique worked to sell an exclusive lifestyle as much as a coordinated ensemble of goods. The captivating displays were presented in showrooms where customers could buy readymade pieces or place orders for larger commissions.

Gustav Klimt's portraits of fashionable Viennese women demonstrate the Werkstätte preference for pattern multiplicity within the context of modernity. Klimt clearly understood the relationship between modern society and modern art and how this relationship was activated by women, textiles, fashion and the domestic interior. Women patrons could now choose from a boundless variety of textile patterns – geometrics, florals and adaptations of folk, Asian, Egyptian, Cretan and South American motifs – to satisfy their desire to be cosmopolitan and modern.[11] In Klimt's portrait of Friedericke Maria Beer (fig.34), for example, the subject is engulfed by Werkstätte patterns – one of which is Peche's 1911 *Mariana* – which are in turn overwhelmed by Asian-inspired patterns on the wall; Beer appears simultaneously unified and trapped by pattern itself.[12]

This multi-media and cross-cultural overload was one way that Klimt broke from tradition and created cacophonous yet gorgeous pictures of modernity.

But this vogue for excessive ornamentation – driven by consumer tastes and spending habits – was criticised as frankly anti-modern by Austrian architect and theorist Adolf Loos (1870–1933). In his famous essay from 1908, *Ornament and Crime* (Ornament und Verbrechen), Loos argued that the modern era should be free from 'the ornament disease' that wastes labour and materials, a disease that Loos believed had infected Art Nouveau and Jugendstil artists such as Eckmann and Van de Velde and their progeny at the Wiener Werkstätte. 'The evolution of culture is synonymous with the removal of ornament from utilitarian objects', he wrote, implying that the decorative arts were neither art nor should be decorative or decorated, thus dismantling the term completely.[13] By removing ornament from utilitarian objects, Loos advised, one would have time to concentrate without distraction on more important matters, such as art.

As early as 1908, then, Loos proposed a new approach to design that allowed for the possibility of standardisation and introduced a design aesthetic that focused attention on industrial production. This ideology, and the heated debates it ignited, would resonate throughout Europe and America for the next decade before reaching a viable resolution at the Bauhaus in the 1920s, through investigations focused on the constructive properties of woven cloth. Certainly part of the fundamental debate – hand v. machine-made, expressive v. objective design and art v. utilitarian object – impacted woven textiles most directly, since cloth and thread, unless hand-spun and woven, are integrally tied to industry through the mechanical production process. Yet, textile designs are the product of an artistic hand, as are surface textile processes such as embroidery,

needlepoint, appliqué and batik, among others. This ambiguous, yet fluid, relationship between hand and machine put textiles at the forefront of discourses involving notions of originality and mass-production, generating an exchange of ideas that would continue well into the century. During this period many workshops, organisations and associations were formed or strengthened around the issue, each achieving various degrees of success. For some groups, maintaining control over the handmade textile within a studio environment was a paramount concern, for others, designing for mass-production, often in affiliation with department stores, was most important; still others found a middle ground.

Artistic Collaborations in the *Atelier* and *Maison*

Despite Loos' objections, the Wiener Werkstätte was an international success precisely because Hoffmann was able to introduce the element of fine art, through artist designed and crafted objects, into the realm of consumer culture, through retail marketing under the Werkstätte label.[14] The designer and the artist were one and the same; the functional object was also a work of art, and the showroom was also a gallery. This blurring of boundaries served to elevate Werkstätte textiles and fabric into a new category, the art-fabric, which both straddled and unified the fine line separating art from utility. One admirer of the Werkstätte's production and marketing strategy was the French couturier Paul Poiret (1879–1944), who was already a popular and internationally known designer when he visited the Werkstätte in 1910 and 1911. Indeed, he bought bolts of Werkstätte fabric to take back with him to Paris.[15] Although Poiret found Werkstätte designs too repetitive and geometric, he was nevertheless inspired by three main innovations: its workshop format that resembled artists' studios,

or *ateliers*; the finished *Gesamtkunstwerk* of its unified projects, as demonstrated by the Palais Stoclet, which he visited; and the gallery showroom, or *maison*, where in-house products were on display.[16] Immediately upon returning to Paris from Vienna in 1911, Poiret formed his own workshop, the Atelier Martine. Here he employed teenage girls, called 'Martines', untrained in the fine arts, to create animated patterns for curtains, furnishing fabrics and most importantly fabrics for his avant-garde fashions, especially the loose-fitting empire gowns and *jupes-culottes* (divided skirts) that he championed and marketed. He subsequently established a retail outlet, Maison Martine, where Martine products and fabrics were sold, including fabrics printed in a variety of colourways (fig.35). Poiret also cultivated artistic relationships with established artists such as Raoul Dufy (1877–1953) and photographers such as Edward Steichen (1879–1973) in part to ensure that his products and his name would be associated with avant-garde artistic endeavours, and also because he thought of himself as an artist, envisioning his creative work in textiles and fashion as parallel to artistic endeavours such as painting, a notion that contributed to the expanding conception of the modernist artist.[17]

The extensive collaborations among fine artists, textile manufacturers, fashion designers and theatre producers that took place during this period exemplify the crossover between fine and applied art that contributed to new conceptions of the total work of art, with fine artists exploiting the market potential of applied arts while exploring new creative outlets. Textiles, again, in part because they so resemble painting, provided artists with a welcome opportunity to realise their ideas under new conditions and contexts. Henri Matisse (1869–1964), for example, was fascinated with textiles; he painted images of them, he collected them, and he designed them.[18]

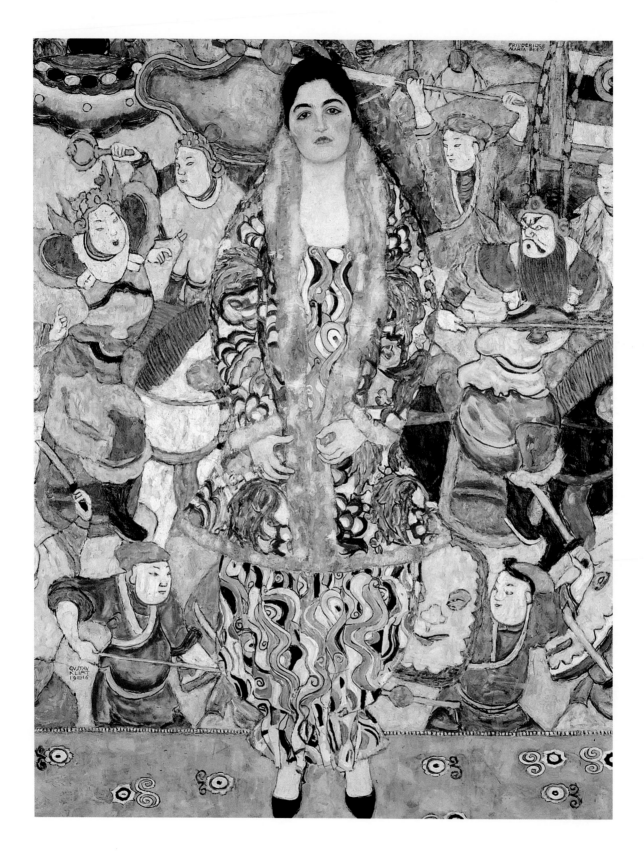

34 (left)
Gustav Klimt
Friedericke Maria Beer 1916
oil on canvas
168 x 130 cm (66⅛ x 51⅓ in.)

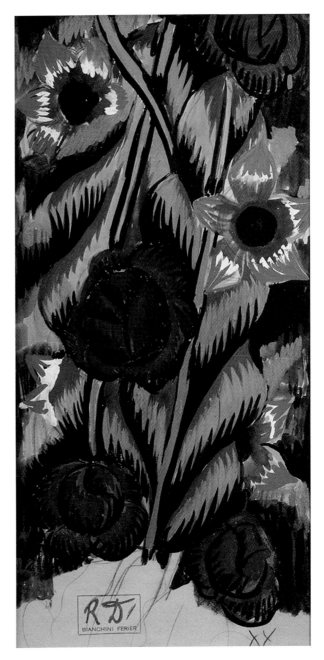

35
Atelier Martine
textile sample in three colourways,
workshops of Paul Poiret, Paris 1919
block-printed satin
84 x 43 cm (33 x 17⅞ in.)

36
Raoul Dufy
design for textile *c*.1912
gouache and pencil on paper
23.5 x 49.53 cm (9¼ x 19½ in.)

Matisse visited Atelier Martine in the early years before the war and probably admired the decorative textiles that the Martines created; indeed, some of the textiles he depicted in his paintings from the time resemble Martine fabrics.[19] For example, his 1911 *Interior with Aubergines* (Grenoble) depicts textiles for both background pattern and actual subject – the textile pinned to the folding screen. Matisse and Poiret collaborated on at least one occasion, but it remains unknown if Matisse designed textiles for Poiret. Poiret collected Matisse's artwork, including *La Ferme Bretonne* (The Breton Farm), 1896 and *Vue de Collioure* (View of Collioure), c.1906; Matisse signed a letter on Poiret's behalf when in 1917 Poiret was embroiled in a lawsuit against the journal *La Renaissance Politique*, which claimed that he plagiarised ideas from the Austrians as well as sympathised with war enemies; and Matisse worked in Poiret's *atelier* in 1920 to finish costumes for the Ballet Russes ballet *La Chant du Rossignol*.[20] In addition, both artists travelled to Morocco, separately but during the same time period, and shared a deep love of folk, Mediterranean and Middle Eastern textiles, which they both collected.[21]

Poiret's collaboration with Fauve painter and printmaker Raoul Dufy was more renowned and prolific. In 1911, Poiret and Dufy formed the *Petite Usine* (Little Factory), a small workshop where Dufy designed and hand block-printed fabrics that Poiret subsequently used for his fashions.[22] Here, art and fashion fused with success, as Dufy's dazzling textiles enhanced the intensity of Poiret's elegant, avant-garde fashions. But, by the next year, Dufy found a more lucrative partnership with the luxury textile manufacturing firm Bianchini-Férier, where from 1912 to 1928 he produced, under an exclusive contract with the firm, more than 2000 spectacular patterns ranging from stylised florals (fig.36), to pictorial narratives and cubist inspired still lifes.[23]

Poiret continued to use Dufy fabrics well into the next decade, culminating in another grand collaboration at the 1925 Paris Exposition Internationale des Arts Décoratifs et Industriels Modernes (International Exposition of Modern Decorative and Industrial Arts), where Dufy created large textile wall hangings for the interior of one of three floating barges that served as Poiret's showrooms.

Primitivism and the Art Market

Entrepreneurial artistic ventures such as the Wiener Werkstätte and Maison Martine successfully merged showroom, workshop and gallery to reach a broad consumer base while still promoting the preciousness of handmade objects. This combination proved attractive to many artist-entrepreneurs in Europe and America who believed that, by creating and marketing handmade decorative art objects, they could rediscover the relationship between expression and creation while simultaneously earning an honest living, as in pre-industrial times. This integral relationship between the artist and the handmade object was perceived at the time to be threatened by the coldness of machines and the 'false principles', as Poiret put it, of formal art academies.[24] Therefore, artists sought to emulate what they perceived as a purer, more original art, such as that of children and non-Western, ancient and folk societies, ushering in a modernist phenomenon referred to as 'primitivism'.

A prime exemplar of the post-Jugendstil quest to merge art and life through applied arts occurred in Germany through the activities of the group Die Brücke (The Bridge), which sought to bridge the gap between creative processes and meaningful products. Ernst Ludwig Kirchner, Karl Schmidt-Rottluff (1884–1976) and Max Pechstein (1881–1973) are of particular interest because their experiments to

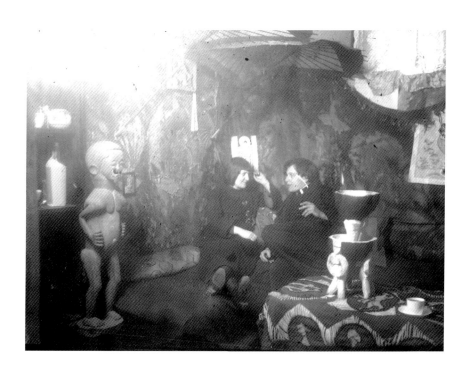

37
photograph of Ernst Ludwig
Kirchner and Erna Schilling in
Kirchner's Berlin studio
1911–12

create a new version of the *Gesamtkunstwerk* through textiles included appropriation of both non-Western art and applied art. Kirchner's understanding of 'primitive' art – perceived to be the art produced by small-scale and/or ancient societies outside of Western European contact – was inspired, significantly, by his teacher Hermann Obrist, with whom Kirchner studied at the Obrist-Debschitz School in Munich from 1903–04.[25] Just as Obrist had encouraged his students to interpret rather than replicate forms found in nature, he also cautioned his students against imitating the forms of 'primitive' art; instead, he encouraged them to emulate what he perceived as the natural creative urge of the 'primitive' or pre-modern artist. 'We should create, as they created, unselfconsciously, truthfully, simply, as it came to them naturally', Obrist wrote in 1903. 'We must become what human beings were earlier: Creative'.[26]

Obrist's understanding of 'primitive' and non-Western art was not unique at this time; indeed, many theorists, historians and artists, were engaged in studying non-Western and ancient art in order to uncover the origins of abstraction and creative impulses. Riegl, for example, put forth the notion of artistic urge (*Kunstwollen*) in his 1893 book *Stilfragen: Grundlegungen zu einer Geschichte der Ornamentik* (Problems of Style: Foundations for a History of Ornament); Riegl believed that human beings have a natural tendency to ornament their environments through the design and creation of beautiful forms, which vary according to cultural and chronological differences.[27] Riegl's student Wilhelm Worringer took Riegl's theory a step further by advancing, in his important 1908 book *Abstraktion und Einfühlung* (Abstraction and Empathy), the idea that the earliest artistic expression was fundamentally abstract.[28] Later, in his 1911 essay *Entwicklungs-geschichtliches zur modernsten Kunst* (The Historical Development of Modern Art), published in the avant-garde journal *Der Sturm*, Worringer explained that 'primitive' art has a mystical, natural power that conventional art lacks precisely because

38
Ernst Ludwig Kirchner (designer), **Lise Gujer** (weaver)
Zwei Tänzerinnen (Two Dancers) 1924
woven tapestry; linen warp, wool weft
192 x 82 cm (75⅔ x 32¼ in.)

'primitive' artists did not rely on painterly illusionistic techniques to achieve creative expression.[29] These early theoretical underpinnings of abstraction point to artists' and theorists' growing interest in developing new art forms for a new era, leading them to seek examples of abstract art in unconventional places, such as through textiles.

Kirchner's, Schmitt-Rottluff's and Pechstein's interest in both 'primitive' art and applied art – which they saw as integrally linked – was therefore part of a larger modernist context. Textiles played a significant role in this primitivist discourse because they served as exemplars of handmade, useful, abstract and ancient art. For Kirchner and Pechstein, this interest extended to their pedagogical and professional work as well as their private lives. Both produced textiles for their studios and for public commissions; in 1911 in Berlin they opened their short-lived (1911–1912) Moderner Unterricht in Malerei, or MUIM (Institute for Modern Instruction in Painting), which was to include instruction in textiles, probably with additional instruction from Kirchner's new girlfriend, Erna Schilling (1884–1943), who, with her sister Gerda (1893–1923), embroidered a number of pieces based on Kirchner's designs.[30] The Schilling sisters probably assisted in creating the painted and embellished cloths for Kirchner's *atelier*, which can be seen in a 1911–12 photograph of Kirchner and Erna in his Berlin studio (fig.37); Erna, who became Kirchner's lifelong companion, continued to create embroidered and needlepoint textiles based on his designs.[31] Interestingly, the cloth on the Berlin studio table resembles painted bark cloth, or Tapa cloth, from Oceania – which the artists would have been aware of through examples in German collections and books – now enlivened by cavorting nude figures. Unfortunately, very few Brücke textiles exist today, but some textiles designed by Schmidt-Rottluff for Dr Wilhelm Niemeyer still exist.[32] After serving in

39
Omega Workshop
fabric samples 1913
a. *Amenophis* by Roger Fry, b. *Margery* by Duncan Grant,
c. *Maud* by Vanessa Bell, d. *Mechtilde* by Roger Fry,
e. *Pamela* by Duncan Grant, f. *White* by Vanessa Bell
colour-printed linen
each: 25.4 x 38.1 cm (10 x 15 in.)

World War I and suffering a nervous breakdown, Kirchner moved to the Swiss mountain town of Davos in 1917, where he spent much of the rest of his life painting landscapes and creating designs for tapestries that weaver Lise Gujer (1893–1967) executed. Perhaps by venturing into tapestry, Kirchner was seeking a wider audience for his work and believed that collaborative work in the applied arts would expand his financial and artistic opportunities. These tapestries refer to a different 'primitive' model – that is, the European folk model – than his earlier works. Their bright colours and themes of humans and animals in harmony in nature

recall some of the early Brücke paintings, though now they were infused with an expressive force that Kirchner achieved through the technique of dovetail or interlocking tapestry using wool and linen yarn, which, unlike finely-packed woven pictorial tapestries, accentuates immediate colour changes and blocky figure constructions. Kirchner's 1924 *Zwei Tänzerinnen* (Two Dancers) (fig.38), for example, reveals his ability to translate expressionism into the medium of weaving. This was the first wall hanging that Kirchner was fully pleased with after collaborating with Gujer for some time; he exhibited it on numerous occasions in the 1920s until it was confiscated by the Nazis for the 1937 Degenerate Art display in Essen.[33]

The Brücke artists were familiar with Matisse's famous 1908 essay, *Notes d'un peintre* (Notes of a Painter), translated into German in 1909, in which he equated decoration with expression while arguing that artists should work according to the laws of the given materials.[34] Decorative art, in other words, was the result of an intuitive, expressive response to content, composition and medium. It was not a pejorative or obsolete term, as Loos would have it, but a modern one that corresponded to current ideas about the integral relationship between art and life. This notion of direct expression, put forth at the same time that practitioners of Cubism were exploring the possibilities of geometric abstraction, provided a new source of inspiration to those working in textiles.

The British art historian and curator Roger Fry (1866–1934), for example, an early champion of both Matisse and the Cubists, believed that he could achieve financial and creative fulfilment by working in the applied arts and making objects for daily life, created with a sense of 'free play' and spontaneity.[35] In 1913 he and artists Vanessa Bell (1879–1961) and Duncan Grant (1885–1978) founded the Omega Workshop (1913–1919) in London's Bloomsbury district. The Omega Workshop was a cooperative *atelier/maison*, or studio/boutique where artists could design, manufacture and sell utilitarian items created, as Fry wrote, with the 'freshness of primitive or peasant work' for 'modern cultivated man'.[36] Textiles constituted a large part of their efforts: curtains, rugs, scarves and wall hangings were among the objects produced by hand textile techniques that included needlepoint, embroidery, collage, batik and block-printing.[37] Despite the energetic collaborative effort, the Omega Workshop never generated the same degree of avant-garde recognition or gathered the number of wealthy patrons as its counterparts in Vienna and Paris; the improvisatory and joyful patterns of Omega textiles (fig.39), especially those designed by Fry – printed by the French firm Besselievre – were perhaps too wild and spontaneous for the tastes of London's upper-class patrons, who were accustomed to more formally structured Arts and Crafts patterns.[38] Not surprisingly, the formidable Arts and Crafts designer and founder of the Guild of Handicrafts, Charles Robert Ashbee (1863–1942), referred to Omega's products as 'crimes against truth and beauty'.[39] Yet through the applied arts, Fry, Grant and Bell were able to generate an extraordinary range of abstract and expressive forms in a variety of media.[40]

Abstraction

Work in textiles allowed artists to explore, indeed invent, new approaches to modern art and design, especially through the visual language of abstraction. Just as Van de Velde had discovered in 1893, textiles offered artistic possibilities that painting simply could not provide. Many textile techniques, such as collage and appliqué – additive techniques

whereby the image is built up through the assembly of different parts – are by nature conducive to abstract forms. Even embroidery and batik, two techniques closely linked to but fundamentally different from painting, have unique properties that allow artists a degree of freedom to explore purely formal relationships of colour, line and shape, rather than being compelled to create the illusion of space through strategies such as modelling and perspective. Sonia Delaunay (née Sarah Stein Terk) (1885–1979) was one of the first to experiment with textiles as a way to turn completely away from pictorial references toward a pure abstract language based on the interplay of form, colour and texture.[41] For example, the embroidered stitches of her 1909 work *Broderie de Feuillage* (embroidery of foliage) (fig.40) create not only a very dense surface texture, but also lines of receding and advancing hues that work to fracture and flatten the illusion of space. This was a pivotal work for Delaunay, made shortly after she met her future husband, Robert (1885–1941) (they married in 1910), and signalling, as Robert pointed out, a 'break' from traditional perspective toward a more abstract one.[42] Soon after, in 1911, she created her now well-known patchwork coverlet (fig.41), which in essence is an abstract fabric collage that defies spatial or pictorial readings. Delaunay stated later that the work 'fit in with the cubist concept and we decided to use this theme [of appliqué and collage] on other objects and paintings'.[43] Delaunay chose to understand and expand upon the language of abstraction through embroidery, appliqué and collage, as well as through painting; she did not categorise her work at this time as either 'fine' art or 'applied' art, but rather viewed all of her endeavours as steps to achieving a pure, abstract art through dynamic colour relationships, or 'simultaneous contrasts', as she and Robert coined them. 'There was no gap between my painting and my so-called

decorative work', she stated, rather, 'it was the application of the same research; the conception was very exciting'.[44] Interestingly, the Delaunays derived their understanding of simultaneous contrasts from the chromatic theories of chemist Eugène Chevreul (1786–1889), who wrote his pioneering book *De la Loi du Contrast Simultané des Couleurs* (The Law of Simultaneous Contrast of Colours) in 1839 when he was director of the Gobelin tapestry works, the Royal French tapestry workshop established in Paris by Louis XIV in 1664. By observing the vertical and horizontal crossing of various coloured warp and weft threads, Chevreul discovered that colour is as much determined by hue as by perception and that colours change according to the quality of light and proximity to other colours that are simultaneously reflected and absorbed by one another. The Delaunays' experiments, grounded in colour theory derived from textiles, would take Chevreul's ideas to new artistic levels.

Sonia Delaunay's early explorations in abstract textiles and collage were exhibited along with her paintings in Berlin in 1913, first at the famous *Erster Deutscher Herbstsalon* (First German Autumn Salon) organised by Herwarth Walden (1878–1941) for his Sturm Galerie and later at a duo exhibition with Robert at Sturm. Walden was an important supporter of modern art during this period. He promoted and exhibited the work of some of the most pre-eminent European avant-garde artists of the time, including Klee, Kandinsky, members of Die Brücke and the Italian Futurists and Jean Arp (1886–1966). Walden's wife, Nell (1887–1975), collected non-Western art, including Andean textiles, which were occasionally exhibited alongside modern works to reveal their abstract formal affinities.[45] In this community of modernists, textiles were considered valid artistic expressions, and artists such as Sonia Delaunay participated in blurring the boundaries

40
Sonia Delaunay
Broderie de Feuillages (embroidery of foliage) 1909
wool embroidery on canvas
83.5 x 60.5 cm (32⅞ x 23⅞ in.)

41
Sonia Delaunay
Untitled, called 'Couverture' (Blanket) 1911
appliquéd fabric
111 x 82 cm (43¾ x 32¼ in.)

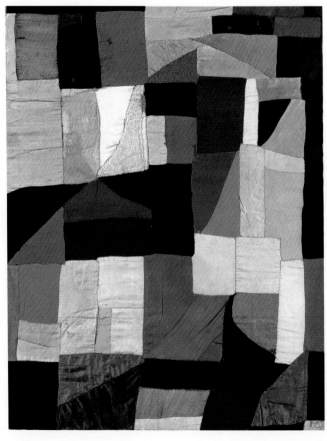

42
Sonia Delaunay
Robe Simultanée 1913
appliquéd and sewn fabric
life size

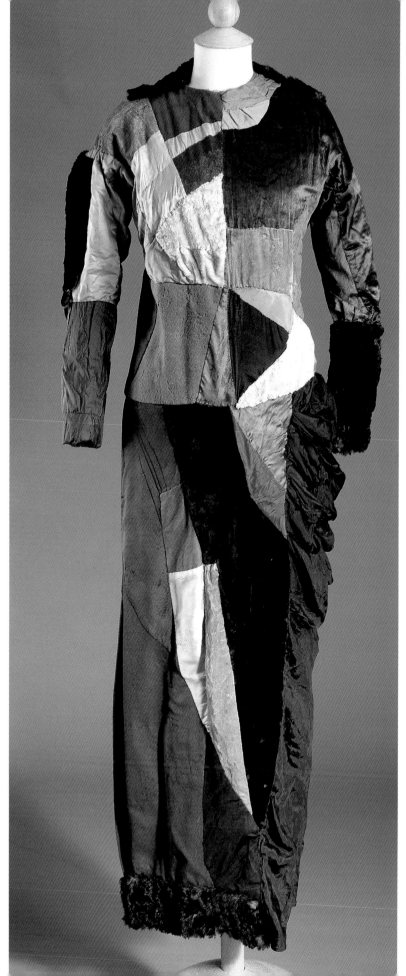

43
Liubov Popova
pieced and embroidered panel
1916–17

44 (right)
Nadezhda Udaltsova
pieced and embroidered panel
1916–17

between fine and applied art by exploring the language of abstraction through them.

The Delaunays were at the centre of a vibrant artistic community in dynamic pre-war Paris. In 1913 Sonia created her celebrated *Robe Simultaneé* (fig.42), a fabric collage jumpsuit of contrasting colour and shape patterning that she wore to the Parisian nightclub the *Bal Bullier*. Delaunay was not interested in tailoring *per se*, but in devising a three-dimensional kinetic collage for which colour, shape and movement were perceived simultaneously. She also created 'simultaneous' clothing for Robert, which were ensembles, or 'vestementary innovations', as their friend Guillaume Apollinaire (1880–1918) described them in 1914, composed of brightly coloured 'zones'.[46] These investigations into the kinetic possibilities of textiles naturally led Delaunay into the realm of theatre; in 1917, Ballets Russes

director Serge Diaghilev commissioned Sonia and Robert Delaunay to design the costumes and sets for the ballet *Cleopatra*, thus enabling her to participate in the creation of an avant-garde *Gesamtkunswerk* that merged body, textile, stage and sound.[47]

Delaunay's work paralleled the work of other modernists in her circle, who sought alternatives to painting and who worked in multiple media to define their new aesthetic ideas. Her fellow Russians, for example, the avant-garde artists Alexandra Exter (1882–1949) and Natalia Goncharova (1881–1961), designed and worked in embroidery as early as 1908 as a way to revive folk traditions and to simultaneously experiment with abstraction.[48] Later, at the 1915 and 1917 Modern Decorative Art exhibitions in Moscow, many practitioners of the Russian avant-garde, including the Suprematist Kasimir Malevich (1873–1935) and his colleagues

Liubov Popova (1889–1924) (fig.43) and Nadezhda Udaltsova (1886–1961) (fig.44) exhibited modernist textiles and designs for textiles with decidedly geometric and non-representational shapes and arrangements, suggesting that textile work may have been a catalyst for later Russian art exploring the use of non-objective form.[49] Although most of these textile objects are no longer extant, the significance of textile work during this period is important because it underscores the relationship between textiles and abstraction. For example, Popova's embroidery/appliqué piece functioned as an example of the Suprematist goal to both dissolve and expand space through fractured and overlapping forms. The lack of extant textile examples also underscores the ephemeral nature of the medium and its traditional status as a minor art, which often results in imperfect preservation practices.

Subversive Textiles

The ephemeral nature and 'minor art' status of the textile medium is part of what attracted Jean Arp and Sophie Taeuber to work with it. Shortly after the couple met in 1915 in Zurich (they were married in 1922), they 'executed embroideries and collages together', Arp stated, to subvert traditional art hierarchies and find a way toward abstraction.[50] Their early independent work in textiles, including Taeuber's costumes and Arp's 1915 collage *Abstract Composition* (Basel), which included fabric among other materials, and their subsequent collaborative needlepoint work *Pathetische Symmetrie* (Pathetic Symmetry), 1916–17, which Taeuber executed, developed out of their mutual quest to find alternatives to easel painting, which, during the war period in neutral Zurich, was considered élitist and obsolete. As central members of the Zurich Dada movement, Arp and Taeuber were clearly among the international avant-garde in their attempt to redefine the processes and purposes of art. Interestingly, Taeuber studied at the Obrist-Debshitz school in Munich from 1910 to 1914, which she interrupted in 1912 to study at the Hamburg School of Arts and Crafts, and this early training helped to shape her approach to art that was fundamentally experimental and process-based; she then worked from 1916 to 1929 as Professor of Textile Design and Techniques at the Zurich School of Applied Arts.[51] One of Taeuber's most important textile pieces was her 1916 *Composition verticale-horizontale* (fig.45), a grid-based geometric composition worked in needlepoint (small stitches that are worked by hand in regular, countable diagonals or Xs within the small squares of a canvas grid). Taeuber was well aware that the constructive nature of needlepoint is inherently geometric; her deliberate choice to explore abstraction through this technique makes her one of

45
Sophie Taeuber Arp
Composition verticale-horizontale
1916
needlepoint
50 x 38.5 cm (19¾ x 15⅛ in.)

the pioneers of Constructivist design, while the visual form of the work corresponds to the inherent structure of the materials.[52]

Like Sonia Delaunay's, Arp's and Taeuber's textile projects were not mere copies or translations in thread of works in other media, but were created precisely because the inherent properties of textile techniques – additive, constructive, multi-media, malleable – corresponded to their artistic goals. Their

work in needlepoint and fabric collage was created with a similar spirit to the work of their American colleague and fellow Dadaist Man Ray (Emmanuel Radnitsky) (1890–1976), who worked in textiles as early as 1911, when he produced a large fabric collage (fig.46) before he moved to Paris. Man Ray, whose father was a tailor, stitched together the composition from wool samples at his family home in Brooklyn; it was to serve as a bed cover at his new

46
Man Ray
Tapestry 1911
wool fabric stitched on canvas
204.5 x 147.5 cm (80½ x 58 in.)

lodgings in Ridgefield, New Jersey.[53] Later, in 1919, he hung it on the wall of his basement studio in Greenwich Village and gave it a title, *Tapestry*, thereby changing the context of the piece from utilitarian object to work of art.[54] Seen together, the Taeuber, Popova, Udaltsova, Delaunay and Man Ray works are surprisingly alike in form and motivation, and point to these artists' success in undermining the status quo through textiles by using various manifestations of the medium – needlepoint, embroidery, collage and appliqué – to explore similar ideas.

The German Dadaist Hannah Höch (1889–1978) also worked in embroidery and collage both to subvert conventional approaches to art and to explore the artistic qualities of those media.[55] Höch worked for Ullstein Publications, publisher of popular journals such as *Die Dame* and *BIZ* (*Berlin Illustrirte Zeitung*, or Berlin Illustrated Newspaper), as a handicraft

47
Hannah Höch
silk embroidery 1916
29.3 x 22.3 cm (11½ x 8¾ in.)

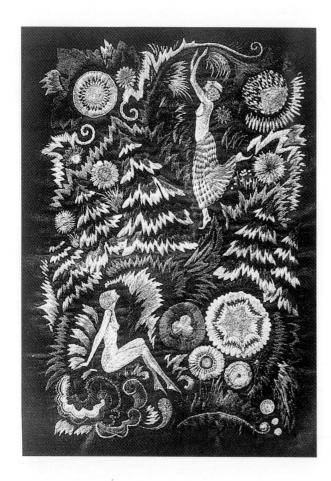

designer from 1916 to 1926. During that time she straddled two worlds: she was a designer of traditional and folk inspired patterns for embroidery and, in her own time, an avant-garde artist whose photomontages called attention to conventional notions of gender, beauty and consumer culture. Yet the careful designing and snipping process that Höch devoted to each endeavour – embroidery and photomontage – reveals a deeper connection between

them.[56] An early embroidery by Höch (fig.47), highlighted in the 1915–16 volume of *Stickerei- und Spitzen-Rundschau* (Embroidery and Lace Review), not an Ullstein publication, reveals an intersection between the two worlds: an invented scene of nude women, perhaps representing the soon-to-be liberated New Women of what would become the Weimar Republic, frolicking among abstracted flowers and trees. The image is at once charmingly folk-like and clearly modernist, as one becomes aware that by conflating embroidery – 'women's work' – with nude women in nature – women's 'natural place' – Höch was most likely commenting on the gendered aspect of textiles by referencing them though the medium itself. Far from a rigid medium and technique, embroidery allowed Höch to investigate the boundaries between traditional 'women's work', images of the New Woman and the hierarchical distinctions between fine and applied art.[57]

The Italian Futurists, Giacomo Balla (1871–1958) and Fortuno Depero (1892–1960), also used textiles to subvert the status quo. Their experiments represent a complex interweaving of utopian ideals, raw machismo and a move toward abstraction that culminated in textiles, tapestry and fashion designs produced from the early teens well into the 1930s. Having spent time in Düsseldorf in 1912, Balla came into contact with Jugendstil applied arts reform at the same time that he was working to produce kinetic colour and shape relationships through art.[58] These experiments naturally led him to work with multiple media, including poetry, and to explore the possibility of clothing design in an effort to invent his own living *Gesamtkunstwerk* of spatial dynamism through fabric and clothing.[59] Balla may have been inspired by Sonia Delaunay's work at the 1913 Erste Deutsche Herbstsalon exhibition in which he, too, participated and by her 'simultaneous' outfits for the *Bal Bullier*.[60] He envisioned fashion as a catalyst for

change, an idea he articulated in his 1914 manifesto 'The Anti-Neutral Dress' and his 1916 manifesto 'The Futurist Reconstruction of the Universe', written with Fortuno Depero, and which he demonstrated through his prolific production of textile and fashion designs.[61] Textiles, in fact, were instrumental in Balla's conversion to Futurist abstraction, a turning point in his career at which he denounced the 'old', pictorialist Balla in favour of the new abstractionist Balla, or FuturBalla, as he referred to himself.[62] His fabric designs, especially those from 1913 (fig.48), conceived to express his desire for movement and transformation, were composed according to his notion of 'force lines' that continually pull the viewer's eyes in opposing directions.[63] For Balla, Futurist textiles had to conform to certain heady requirements: they should be 'dynamic' and of 'muscular colors', and should 'inspire the love of danger, speed, and assault' – a tall order for a textile.[64] Ironically, Balla's designs were made manifest by his devoted daughters, Luce and Elica Balla, for whom danger, speed and assault were probably not high priorities.[65] Nevertheless, Balla's decades-long dialogue with textiles and fashion points to the conviction at the time that textiles could reflect and even change society.

Futurist Fortuno Depero, like Balla, explored alternatives to painting such as graphic and stage design, sculpture and the applied arts. By 1918 he had designed his first 'paintings in cloth', which were masterfully produced by his wife, Rosetta Amadorí.[66] These works, made in the appliqué technique, although sometimes referred to as 'tapestries', were more like felt mosaics; Amadorí, who later trained a team of skilled workers in the process, would cut brightly coloured wool felt patches based on Depero's preliminary cartoons and then precisely fit and stitch these pieces onto a stretched canvas ground. Since the patches are flat and unshaded, the works, such

as *Procession di Grande Bambola* (Procession of the Large Doll), 1920 (fig.49), have a wildly animated appearance in which representational forms merge with abstract patterns and borders. This stimulating, theatrical appearance was intentional, for Depero sought to enliven daily life with art that represented playful themes enhanced with lively patterns and colour schemes, despite his own serious and often frustrating quest for recognition in light of the looming spectre of Fascism.[67]

Modernist Textiles in America

The development of modernist textiles in America during the years between 1905 and 1920 took place on a smaller scale than in Europe. Most serious American artists and collectors, especially those who sought to participate in a culture of artistic experimentation, were compelled to study, travel and even live in Europe. However, New York City was well on its way to becoming a centre of avant-garde activities: Alfred Stieglitz opened Gallery 291 in 1905; the International Exhibition of Modern Art (Armory Show) opened in 1913; Kandinsky's *Concerning the Spiritual in Art* was translated into English in 1914; the Society of Modern Art was founded in 1914; and some art schools began to offer instruction in modern textile design, facilitated by recent émigrés from Europe including the Hungarian designer Ilonka Karasz (1896–1981) and the German illustrator and educator Winold Reiss (1886–1953). By 1915, at The Modern Art School in New York City, textiles and embroidery classes were taught by Karasz and Reiss along with the American artist Marguerite Zorach (1887–1968), all of whom experimented with various textile techniques, especially batik and embroidery.[68] Batik was very much in vogue at the time in the United

48
Giacomo Balla
study for a fabric motif 1913
watercolour on paper
13 x 19 cm (5⅛ x 7½ in.)

49 (right)
Fortuno Depero
Procession di Grande Bambola (Procession of the Large Doll)
1920
wool appliqué on canvas
330 x 230 cm (130 x 90½ in.)

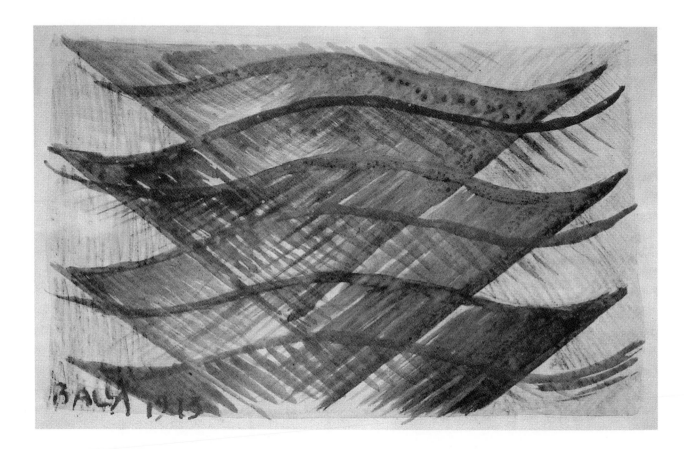

States, due to a profusion of 'how-to' books and articles, including those in *The Craftsman*; batik instruction was offered in some schools and, inspired by the success of Liberty & Co, the American textile industry began to appropriate batik-like patterns for machine printed textiles.[69]

Marguerite Zorach had been trained as a painter, but after travelling to Europe and Asia in 1911, marrying William Zorach (1887–1966), and moving to Greenwich Village in 1912, she began to produce batiks and embroidered wall hangings, which she called 'tapestry painting'. Zorach knew firsthand about the technique and tradition of batik from her travels to Java, China and Japan, and she owned a set of *tjanting* tools.[70] While Zorach enjoyed working in batik, she found embroidery more suitable to her artistic ideals and her busy lifestyle. She approached her first experiments in embroidery with passionate spontaneity rather than skilled deliberation, beginning in 1913 in collaboration with William, she recalled,

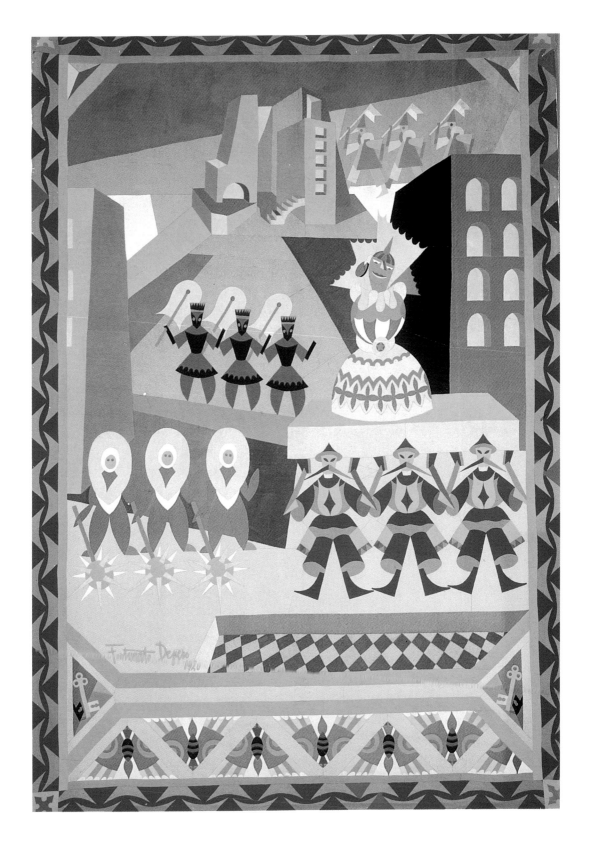

page from *Peruvian Art: A Help for Students of Design*
by Charles W. Mead 1917
17.15 x 24.77 cm (6¾ x 9¾ in.)

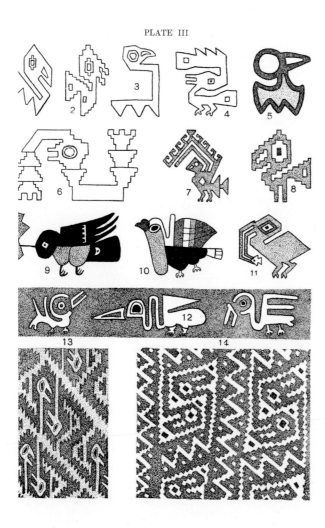

PLATE III

My husband became so fascinated that he too got a needle and we both stitched, hardly stopping to eat. It was so exciting. We didn't know anything about stitches.[71]

The experience of working with thread was exhilarating, allowing her to explore colour 'beyond anything in

paint', and it also provided her with a degree of financial and artistic success well into the 1920s.[72]

Zorach was among a group of American avant-garde artists and writers who were inspired by a wide range of artistic sources, from Cubism to ancient American art. Charles W. Mead (1845–1928), Curator of Anthropology at the American Museum of Natural History in New York from 1912 to 1927, helped to advance interest in the latter source. Mead was a scholar of Pre-Columbian textiles and a prolific writer who as early as 1906 had published illustrated books dealing with Andean featherwork and textile motifs and had written the popular *Peruvian Art: A Help for Students of Design* series, which served as illustrated guides to textile motifs in the museum's collection. A page from the 1917 edition (fig.50), for example, which was reproduced again in a 1929 edition, illustrates bird motifs, which Ilonka Karasz probably consulted when she made an undated design for a textile (fig.51). Interestingly, the page from *Peruvian Art* shows the range of stylised motifs and complex patterning – in this case just involving the bird motif – that could be found in Andean textiles; included are examples of contour rivalry (where an outline of one motif shares the outline of another), block-patterning (formed from the natural horizontal-vertical structure of weaving) and figure/ground ambiguity (where foreground alternates as background). Indeed, Andean textiles would have provided Karasz and her colleagues with a seemingly endless supply of motifs and patterns from which to draw for their modern adaptations. The similarities between the Pre-Columbian motifs and the birds in Karasz's textile design are not a coincidence, for the museum's collection was the focus of an innovative textile design contest in which Karasz and many other artists participated. The contest, called 'Designed in America', was established in 1916 by Morris de Camp Crawford (1882–1949), an editor

51
Ilonka Karasz
textile design
gouache or casein over graphite on
wove paper
15.24 x 14.81 cm (6 x 5⅞ in.)

8 l

for the daily journal *Women's Wear*, as a way to initiate new designs for industry using museum textile collections.[73] Within this industrial context, America was on its way to becoming a textile manufacturing capital.

The relationship between modernist textile design and the textile industry would expand to unprecedented levels during the next decade due to advancements in dye and fibre technology, to increased collaboration between artists and textile manufacturers, and to greater awareness and exploration of the artistic and constructive properties of textiles. At the same time, artists continued to embrace the handmade textile as a valid fine art expression on the same level as painting, although in some cases these handmade products would also serve as ideal prototypes for mass-production. These issues dominated textile work in the 1920s and 1930s, a period in which modernist experimentation in the medium flourished.

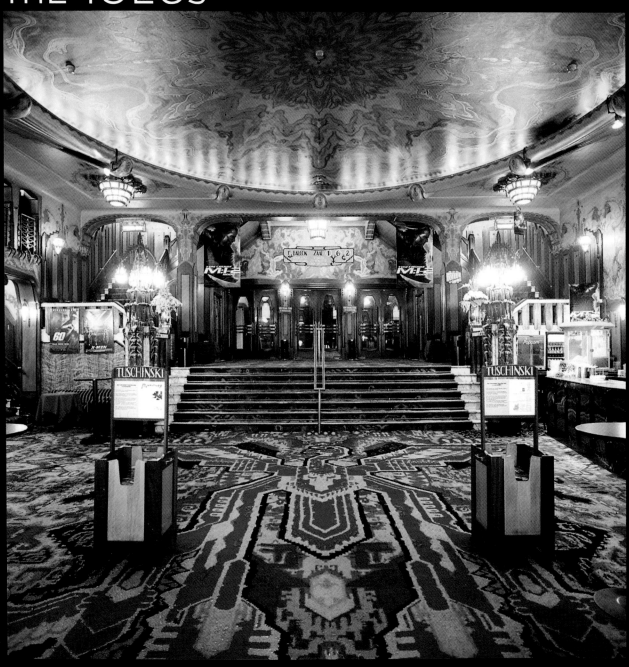

Werkstätte objects, were subsequently exhibited at the 1925 Paris exposition. The huge Werkstätte showcases there, packed full with every possible item that the firm produced, from teapots to lampshades, resembled more a boutique than an exhibition, which meant that individual contributions ran the risk of being overwhelmed by the spectacle of consumer goods.[11] Included in the Paris exposition were textiles by Maria Likarz-Strauss, one of the most prolific and innovative Werkstätte designers of the 1920s.[12] Her 1925 block-printed silk, *Uruguay* (fig.52), which she created in 19 colourways (colour schemes), reveals her subtle understanding of the masonry and weaving traditions of a country on the other side and other end of her world by simulating the under and over structure of weaving in stacked blocks resembling masonry.

Printed textiles, such as those produced at the Wiener Werkstätte and elsewhere by hand or by machine, provided the perfect format for twentieth-century designers to translate and transfer other worlds and other media – architecture, fresco and vase painting, for example – into the flat, multi-purpose medium of printed cloth. Some non-Western sources were copied nearly verbatim onto the textile surface, such as Egyptian hieroglyphic fresco patterns (fig.53) that were produced during the height of the Egyptomania craze, right after Howard Carter's discovery of King Tutankhamun's tomb in 1922. A home or body decorated in this textile would have indicated that the patron was both adventurous and up-to-date, even though the symbols, such as the cartouche glyphs and flowers, as well as the colour palette, were clearly the designer's invention. Imitations such as this, as well as conglomerated designs for which the symbols of one culture were morphed and combined with another, appeared frequently in textile designs from the 1920s, and they provide a fascinating glimpse into Western

reception and understanding of cross-cultural sources. Exemplifying this era of cross-cultural encounters, Russian designer Leon Bakst (1866–1924) was inspired by Southwest American Indian art and culture for a group of textile designs he produced in the 1920s (fig.54) while visiting the United States and coming into contact with indigenous American art. For this textile design, Bakst united adaptations of the ubiquitous 'stepped fret' and 'key' motifs – as prevalent in Greek art as in Peruvian or Navaho art – with a winged, moccasin- and mask-clad dancer repeated in a decorative and animated all-over pattern.[13]

Certainly non-Western, ancient and folk art provided a rich source of abstract geometric forms to Western artists more accustomed to their own pictorial and painterly visual traditions. While the original sources of these modernist designs might be difficult to pin down, the Greek-inspired key or meander motif was used with regularity during the 1920s when a Greek revival was underway. The art and culture of ancient Greece exemplified order and classicism to a modern culture stunned by World War I and, as a result, artists explored ancient Greek design on many levels, imitating its forms, investigating its proportional principles, and using pictorial narration to render its mythology. Some motifs were used without apparent reference to any particular source but rather for the sheer dynamism of the shape. For example, a dazzling textile of violet silk and gold lamé (flat metal threads, usually of silver or gold) (fig.55) utilises the ubiquitous key motif now flipped and rotated in an interlocking, optically charged design.

Americans Mary (1885–1973) and Jay (1867–1924) Hambidge were among those captivated by the harmonious proportions of ancient Greek art and architecture. By 1919, Jay Hambidge had distinguished himself as the originator of the

54
Leon Bakst
Design #12 c.1923–4
gouache on paper
66 x 51.5 cm (26 x 20⅓ in.)

completely different from her own.[9] At the same time, the Americans were learning about the Wiener Werkstätte through its New York showroom, established by Josef Urban (1872–1933) and operated from 1922 to 1924, which brought the American consumer into direct contact with the workshop's avant-garde practices in textile design and in its notion of the *Gesamtkunstwerk* through multi-patterned orchestrations and ensembles.[10] Many of these textiles, as well as hundreds of

Surface-printed and embellished textiles from the 1920s were designed with an invigorated sense of chronology, geography and cultural iconography; art from many cultures was appropriated, and the vices and virtues of life in the modern age were illustrated, as artists explored new artistic sources and visual forms, exploited new technology, and engaged with industry and the consumer culture.[1] An enormous variety of sources, from recent archaeological discoveries, such as Tutankhamun's tomb in Egypt and the pyramids of Tikal in Guatemala, to technological advancements in transportation, communication and entertainment, influenced and inspired a flurry of new textile designs. At the same time, artists gained a greater understanding of mechanisation and began to appreciate and exploit its possibilities. Not only was machinery literally represented and the streamlined look of mechanical materials, such as steel and chrome, simulated, but also machine-fabricated objects themselves were being designed and admired with new aesthetic attention.

The textile industry took part in these developments by inventing new synthetic dyes and fibres and streamlining weaving and printing processes. As the pace of textile design, production and trade increased, a seemingly endless supply of textiles entered both the high and low ends of the market, from *haute couture* to furnishing fabric. Not surprisingly, therefore, no single artistic style dominated textile design during the decade, as the role of textiles within modernist discourse continually shifted between the gallery and the department store, and between the studio and the factory, blurring the line between fine art and popular design.

68 (left)
Jaap Gidding (designer)
Tuschinski Theatre foyer 1921

Although Art Deco is the term commonly used today to describe the art of the 1920s, it was not widely used until the 1960s, and it refers specifically to the decorative style that emerged from the groundbreaking 1925 Paris Exposition Internationale des Arts Décoratifs et Industriels Modernes (International Exposition of Modern Decorative and Industrial Arts), from which the term is derived.[2] Art Deco was a modernist style for which new materials, sources and references were deliberately explored in all of the arts – architecture, sculpture, painting, furniture, ceramics, glass and textiles – and even in areas of industrial design for products such as appliances and automobiles. The Art Deco style was closely tuned to the machine aesthetic, though not always machine production. However, not all textiles from the 1920s can or should be considered Art Deco, a term too specific for this study. For example, textile work taking place at the Bauhaus, specifically, that which involved the constructive approach to weaving, was not created under the umbrella of Art Deco but under an entirely different set of conditions. Furthermore, some textile work from the period evolved out of concerns that were not directly connected to the streamlined aesthetic of Art Deco but rather to more idiosyncratic processes and pictorial motivations.

The 1920s was a decade of great textile manufacturers, including Schumacher, Stehli and Bianchini-Férier. As these manufacturers took greater control of the production and marketing of cloth, they demanded greater quantity and variety of patterns to satisfy the growing consumer market. This inevitably led to an increase in anonymously created designs for which individual contributions were eliminated in favour of the manufacturer's label.[3] In some cases, the artist's name, nationality and gender remain unknown and/or cannot be associated with a particular design. Indeed, many designers chose not

52
Maria Likarz-Strauss
Uruguay 1925
block-printed silk crêpe
93.98 x 106.68 cm (37 x 42 in.)

to cultivate a distinct design style but rather to produce designs in many styles, from neo-Islamic, to geometric, to pictorial, in order to remain active in the field. This variety is evident in the numerous fabric swatch books and illustrated *pochoir* portfolios of textile designs produced during the decade. The 1920s was also a decade of great textile designers, such as Raoul Dufy and Sonia Delaunay, whose contributions to modernist textile design were internationally recognised and who readily collaborated with manufacturers. The role of textiles was changing

– they were frequently designed to coordinate with, or even take a backseat to, fashion or furniture – but artists continued to create textiles that functioned as complete, independent works of art that both initiated and reflected artistic developments of the modernist era.

As the multi-purpose role of textiles inspired new collaborations among artists, workshops, industry and consumer culture, technological innovations in fabrics and dyes were also expanding the possibilities. Among the new fibres, rayon, a fibre

synthesised from wood cellulose, emerged as the miracle fabric of the 1920s. Although a nineteenth-century invention, rayon was not widely manufactured and available until the 1920s, when it soon rivalled silk as the popular fabric of choice.[4] Indeed, rayon could not only simulate silk – earning it the name 'art silk' or *kunstseide* – but it could simulate other luxury fabrics as well, such as lustrous, suede-like, sheer or textured fabrics, while remaining less expensive than the real thing.[5] Rayon also absorbed dyes effectively, especially the new synthetic dyes, which introduced to the market a plethora of intense and colourfast hues, and inspired artists to use colour in new ways, often in wild and clashing combinations. Rayon, a product of the machine age, perfectly embodied the era. Because rayon was so versatile, demand for it increased as it entered the market with increasing speed and variety, requiring greater quantities of innovative textile designs.

Despite the broad range of styles, motivations, names and dates, textiles from the 1920s can generally be categorised by overlapping themes: the cross-cultural, the geometric and the pictorial. First, European and American artists appropriated 'other worlds' into their designs as the world outside, and in some cases even within, Europe and America became accessible and fascinating to these artists on an unprecedented scale. Secondly, investigations in geometric abstraction drew on developments in science and mathematics to create a universal language of design that was not dependent on representational imagery. Finally, textiles with pictorial and narrative designs continued to be important but within the context of the modern age that they represented. Throughout this period, developments in technology and the increasing influence of consumerism had an important effect.

Other Worlds: Cross-Cultural Sources

Although some artists did travel the world to view and collect exotic examples of non-Western art, taking advantage of new forms of transportation and tourism, they did not need to travel to the source to see it. Plenty of examples, exhibitions, catalogues and archaeological reports were accessible in Europe and America at the time. In fact, by the turn of the twentieth century, collections of North American, South American, Asian, African and Oceanic art appeared in nearly every major art, ethnographic or natural history museum from New York to Vienna.[6] Reception to non-Western art was mixed, depending in large part on how this art was displayed. When viewed within the context of colonial expositions, the art, sometimes accompanied with human 'specimens', was frequently perceived as a product of 'primitive' and 'savage' cultures in contradistinction to 'civilised' Western culture.[7] But, by the 1920s, new generations of art historians, anthropologists and archaeologists were studying art from many cultures and eras with scholarly attention and analysis. In addition, art gallery dealers, such as Albert Flechtheim (1878–1937) and Herwarth Walden in Berlin and Alfred Stieglitz (1864–1946) in New York, pioneered a new approach to exhibition design for which non-Western art was presented in juxtaposition to modern art in order to emphasise affinities between them. As a result of these developments, an abundance of both popular and scholarly illustrated books and catalogues was published, which disseminated the art of other worlds into the cultural mainstream.

From the beginning, Wiener Werkstätte textile designers excelled at referencing other worlds through designs that represented the symbols and monuments of various societies and that combined and metamorphosised cultures and eras. This

53
roller-printed cotton 1920s
77 x 76 cm (30⅓ x 30 in.)

practice continued into the 1920s with designers, many of them women, whose awareness of distant places and societies was enhanced by the eclectic Werkstätte library that included books on Chinese bronze sculpture, Austro-Hungarian folk art and African and Greek art, among others.[8] This global influence was reflected in the titles of their textiles, such as *Sudan, Ozone, Borneo, Inka, Brazil* and even *Kentucky*, a location that designer Mathilde Flögl might have thought represented a world

55
French shawl 1920s
silk, satin lamé damassé
161.3 x 161.3 cm (63½ x 63½ in.)

56
Mary Crovatt Hambidge
detail from a hand-woven dress with Dynamic
Symmetry motif at yoke and hem 1920s
commercially-spun silk, plain weave with laid-in pattern
9.22 x 9.22 cm (3⅝ x 3⅝ in.)

term 'Dynamic Symmetry', a theory of proportion
that linked natural growth patterns (the law of
phyllotaxis) to the proportions of Classic Greek design
through their parallel proportional ratios of 1:618
(the golden mean), which he published in his books,
Dynamic Symmetry, 1919, *Dynamic Symmetry: The
Greek Vase*, 1920, and in the pages of his journal,
The Diagonal.[14] Jay and Mary went to Greece from
1919 to 1921 to prove his theory by measuring
Greek temples and vases and diagramming their
similarly proportioned shapes. Jay Hambidge

believed that by applying the principle of Dynamic Symmetry to contemporary art and design, artists could create more harmonious compositions. Mary Hambidge applied the ratios and patterns not only to the embellished surface patterns on her woven Grecian-style tunics, as seen in a detail from one of her fringed tunics from the 1920s (fig.56), but also to the rectangular proportions of the tunic itself, styled after ancient Greek examples (called a peplos or chiton) that she saw depicted on vases. In addition, she applied the principle of Dynamic Symmetry to colour itself by inventing dye formulas and colour relationships that corresponded to the ratio of 1:618 as well as to the colours of nature.[15] The Hambidges knew Raymond Duncan (1874–1966), brother of dancer Isadora, who was equally captivated by Greek textile traditions and mythology as early as 1912, in part because he was married to Penelope Sikelianos, sister of Greek writer Angelo Sikelianos. Like Mary Hambidge, Duncan, too, wore hand-woven Grecian-style tunics to engage more fully in his adopted identity. By the 1920s, he had established a weaving, painting and drama school in Paris, during which time he produced a series of hand block-printed silk scarves and tunics with motifs derived from Greek art and themes.[16] Duncan and Mary Hambidge's primitivism involved living out their fantasies and perceptions of ancient Greek life through textiles, just as patrons of fashion and textile designer Mariano Fortuny (1871–1949) were able to do by wearing his pleated silk 'Delphos' tunics that resembled the gowns depicted on ancient Greek statues.

Greek, Egyptian and American Indian art spurred the imaginations of Western designers, but examples of Pre-Columbian art and architecture, particularly textiles, were especially attractive because of the formal complexity of the designs and the evidence of exceptional technical skill by a pre-industrial society. Indeed, Andean textiles found buried in the dry

57
André Durenceau
page from book *Inspirations,* plate 8 1928
44.4 x 36.8 cm (17½ x 14½ in.)

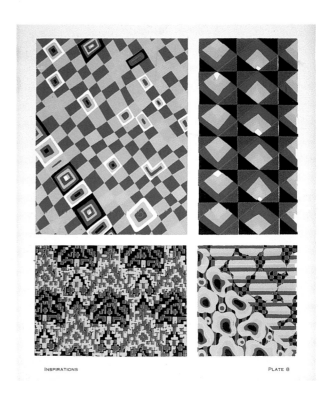

INSPIRATIONS PLATE 8

coastal deserts of Peru remain some of the most masterfully mind-boggling designs ever created. Interestingly, the largest collection of Pre-Columbian textiles outside of Peru was in Berlin; by 1907 the Museum für Völkerkunde (Ethnographic Museum) had nearly 40,000 Andean textiles in its collection.[17] These textiles, and Andean textiles from other European collections, were illustrated in numerous publications during the 1920s, the most important being Walter Lehmann's *Kunstgeschichte des Alten Peru* (The Art of Old Peru), 1924, Raoul d'Harcourt's *Les Tissus Indiens du Vieux Perou* (The Fabrics of the Indians of Old Peru), 1924 and Max Schmidt's *Kunst und Kultur von Peru* (Art and

Culture of Peru), 1929, all of which discussed Andean weavers' technical mastery and design innovations. American collections were also highlighted in catalogues, including Charles Mead's long-running series *Peruvian Art: A Help for Students of Design*, which illustrated Andean motifs from textiles in the American Museum of Natural History collection, including the plate illustrating single bird motifs and camouflaged images of birds locked into a pattern of stepped contours that reflect the horizontal-vertical nature of weaving itself (fig.50). This latter pattern device was borrowed in the 1920s by André Durenceau (1904–1985), a French textile designer who had moved to America in 1923, for the lower left design in his 1928 *pochoir* pattern book, *Inspirations* (fig.57), now enlivened with psychedelic colours. While Durenceau may not have appropriated this particular example, he would have had plenty of opportunities to see similar examples of Andean textiles produced by Nasca, Chancay and Paracas societies in various collections and publications. But Durenceau, like others working in surface design, was more interested in the visual patterns of ancient models than their construction or iconography.

During the Art Nouveau period, American and European artists admired and collected Asian textiles, especially Japanese textiles, for their fine workmanship, delicate asymmetrical compositions, and flat, linear naturalism. By the 1920s, artists had begun to investigate textile models from other cultures, such as African raffia cloth, Pacific Northwest Coast Chilcat blankets, Fijian bark fibre cloth and Turkish and Moroccan rugs, for their bold and graphic patterns. Western manufacturers and designers appropriated these original textiles, many of which were woven, resist-dyed, or embellished with super-structural ornamentation, to the medium of printed cloth. For example, a fabric sample from 1928

58
swatch from fabric sample book, Broughton Co 1928
roller-printed cotton
approximately 2.5 x 5 cm (1 x 2 in.),
Musée de l'Impression sur Etoffes, Mulhouse.

(fig.58), printed in Britain using the mechanised roller-printing technique, simulates the natural indigo dye colour as well as the tie-dye technique (hand tied and resist-dyed) of African adire cloth.[18] While the original context may have been lost through this transformation, the fabric draws attention to the innovative cross-cultural borrowing, and sometimes exchange, that was taking place in the realm of textile design and production.

59
Gregory Brown
fabric for William Foxton manufacturers 1922
linen
112 x 94 cm (44 x 37 in.)

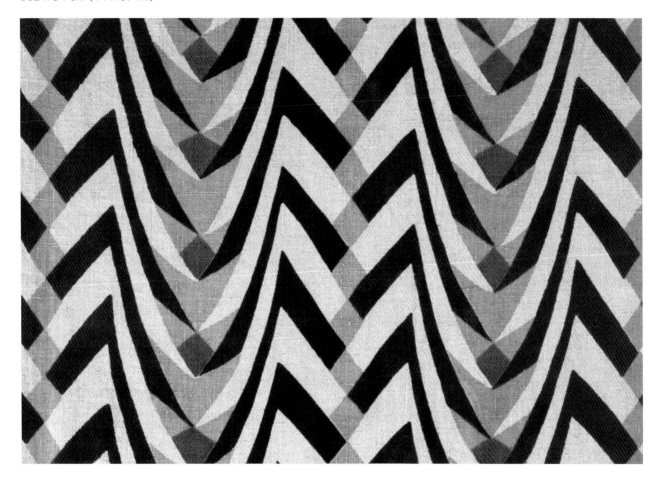

Geometric Design

The new emphasis on geometric design for textiles grew out of avant-garde artistic developments, through movements such as Cubism, Futurism, De Stijl, Suprematism and Dada, which were driven by the growing need to move away from narrative pictorial representations toward a metaphysical and universal language of form. Sonia Delaunay, Sophie Taeuber, Giacomo Balla and other artists working during the previous decade continued to utilise textiles in the 1920s to explore purely non-objective form and the interrelationship between form and idea. Visual forms that were non-specific and free of references to objects were also free of references to class, gender and nationality. While some artists utilised textiles to reference nature and the outside world, they did so by filtering and abstracting these references through the geometrising lens of science and mathematics. Artists working with these forms

60

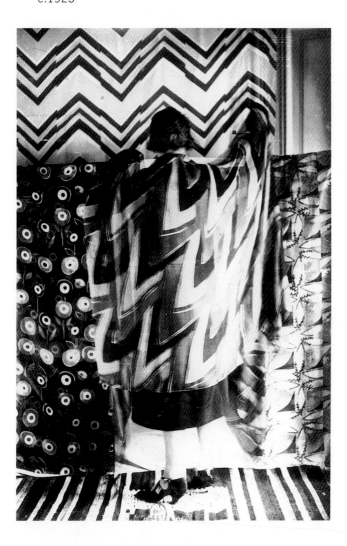

Photograph of model draped in fabrics by **Sonia Delaunay** c.1925

dynamism of modern life. Designer Gregory Brown (1887–1941) demonstrated a clever utilisation of non-specific form for a geometrically abstract textile he designed for the William Foxton Company in 1922 (fig.59), which won a gold medal at the 1925 Paris decorative arts exposition. The under- and over-lapping arches repeat *ad infinitum* to produce a purely optical dynamism that references neither place nor time, but seems to capture the experience of speed and syncopated rhythms without any reliance on pictorial narrative.

Sonia Delaunay, who by the early 1920s had established a successful fashion and textile business, Simultané, championed geometric design so that she could liberate cloth from conventional uses. Delaunay had always conceived of her textiles as multi-purpose and adaptable, as much cladding for building as for body; by focusing entirely on formal and colour relationships for her textile designs – typically composed of large, geometric shapes, such as 'Ls', zigzags, diamonds, squares and rectangles, in bold, unmodulated colours – she created textiles that could function within a number of contexts, from an architectural environment to fashion, since the textile did not conform to any preconceived identifying elements.[19] This multi-functionality allowed her to use textiles as an element in the total work of art, one that was not static but rather functioned spatially, to be activated by the movement of the cloth itself and the illusion of movement created by the colours and patterns in relationship to other objects, a phenomenon she referred to as 'simultaneity'. 'The characteristics of the new style', she wrote, are formed by the 'simultaneity of the surface, form and color of objects together'.[20] A 1925 photograph advertising Delaunay's *Simultané textiles* (fig.60) illustrates the unity of form and function she sought to achieve, as both the model and studio are wrapped in geometry, so to speak, concealing

could engage in an abstract and independent artistic language by focusing on the elements of design – such as shape, colour and value – and thereby arrive at a restricted yet universal visual language that could be applied to all of the arts. Geometric forms, such as prisms, zigzags, registers and grids, created through neutral and objective processes such as repetition, reflection, inversion, rotation and distortion, not only were universally accessible, but also the resulting patterns perfectly expressed the

individual identity and specificity of place in order to create a universally accessible ensemble.[21] Indeed, the photographer captured the model in motion, allowing the viewer to experience the visual sensation, the simultaneity, of Delaunay's textiles in motion. This attention to movement distinguishes Delaunay's textiles from De Stijl and Cubist paintings, to which her work is often compared: she was able to amplify the quality of movement through the malleable and drapable properties of printed textiles; the colours and shapes, when worn on a body, continually shifted, creating visual movement that a painting could not accomplish. 'Armored by this geometry a woman discovers a figure unforeseen', a reviewer for the journal *Art et Décoration* wrote with poetic effusion, resulting in a 'kaleidoscopic pleasure controlled like the diagram of a rainbow'.[22]

This notion that a textile could function within the realm of actual, physical space was one Delaunay understood as early as 1913, when she began to make 'simultaneous' clothing, such as her *Robe Simultanée* for the *Bal Bullier*. In the 1920s she expanded her production from one-of-a-kind wearable art to ready-to-wear ensembles and ready-to-sew prepared patterns that emphasised the textile – pattern and colour – rather than the body. 'The construction and cut of the dress is henceforth to be conceived at the same time as its decoration', she stated, referring to her new concept, the 'tissue-patron' (fabric-pattern).[23] Delaunay did not invent the tissue paper sewing pattern, whereby the pattern and fabric were conceived and purchased separately depending on the taste of the patron, but she did originate the idea of conflating textile and cut as one complete concept in order to maintain the integrity of the textile.

The idea of disguising the natural curvilinearity of the body with non-objective, bold, geometric patterns while at the same time allowing the body to activate

61
Liubov Popova and **Varvara Stepanova**
textile designs reproduced in *L'art International d'aujourd'hui 15: Tapis et tissus*, 1929, by Sonia Delaunay
pochoir print
33.6 x 25.5 cm (13¼ x 10 in.)

95

the pattern through movement was also gaining ground among Delaunay's colleagues in post-revolution Russia, particularly Liubov Popova and Varvara Stepanova (1894–1958), who were working for the First State Textile Print Factory in Moscow in 1923 and 1924. Delaunay paid tribute to these Russian women and other modernist textile designers in her 1929 publication *Tapis et tissus* (fig.61), in which she distinguished true innovators linked by the common denominator of geometric abstraction, such as Popova and Stepanova, from copiers or 'fakes', as she called those who merely imitated outmoded patterns.[24] Delaunay must have been aware of and was almost certainly in contact with her Russian compatriots by at least 1912, when Popova, and her colleague Nadezhda Udaltsova, were taking art courses in Paris at the Academie de la Palette (where Delaunay had studied from 1906–08) and Sonia and

Robert were hosting weekly soirées for the international avant-garde. The parallels between Delaunay and Popova are noteworthy: four years apart in age, Delaunay and Popova were both raised by enlightened families; both studied painting at La Palette and admired modern developments in art such as Fauvism and Cubism; both worked in textiles – appliqué and embroidery at first, printed textiles later – as an alternative to painting and as a way to free colour and shape from representation; both designed costumes for the theatre; and both abandoned painting in the 1920s in order to reinvent art and fashion through bold, geometrically abstract textiles.[25] Unlike Delaunay, however, Popova and Stepanova, as well as fellow textile and clothing designers Aleksandr Rodchenko and Vladmir Tatlin, were limited in their experiments by the paucity of available technology in post-revolution Russia and the fact that their severe designs were not unanimously adopted by the working masses, as they had envisioned.[26]

Art, Politics and Commerce

Soviet textile designers were motivated by ideological as well as aesthetic concerns after the revolution. Their artistic work shifted from pre-revolutionary explorations in easel painting and individual artistic expression to post-revolutionary work in the applied arts and working with materials for production. This shift from the conception of 'artist' to 'technical worker' was motivated by the post-revolution political climate that demanded attention to mass culture and issues related to production: production for the masses, production of textiles that neutralised élitism, and production of textiles that corresponded to the function of the clothing they would be fabricated into.[27] 'The new industrial production',

Popova wrote in 1921, 'will be directed chiefly not at adorning the object with artistic devices (applied art) but at... creating the utilitarian object itself'.[28] Handwork, therefore, was but a preliminary step to industrial production, not a means in itself. Popova's productivist textiles were meant to be neither 'fine art' nor 'applied art' but rather a component of life itself, 'the material elements of life', as Popova wrote, offering a new approach to the notion of the total work of art.[29] Fellow Soviet Osip Brik (1888–1945) shared these ideas, claiming in his 1924 essay 'From Picture to Calico-Print', published in the journal *LEF*, that the design and production of printed cotton textiles – known as calico, an inexpensive cloth for daily use – had replaced easel painting as *the* cultural art for the modern era. 'The belief is growing that the picture is dying... and that the calico-print is now moving into the centre of creative attention – that calico, and work on it, are now the peaks of art work', Brik wrote.[30] Sadly, Popova died of scarlet fever in 1924, but her textiles were exhibited in the Soviet pavilion at the 1925 Paris decorative arts exposition along with the work of other young Soviet textile designers who, as A. Lebedeff remarked in the exhibition catalogue, were invigorating the Russian textile industry by linking art work and factory work.[31]

While the geometric abstraction of Delaunay's work resembled the work of her colleagues in Russia, as well as work by the De Stijl group in The Netherlands, Delaunay did not create her textiles with a similar political agenda or within the same political context but as a way to succeed financially and artistically. She designed modernist textiles within a capitalist context. At Delaunay's boutique, Simultané, one could, in a sense, buy the accoutrements for a modernist life; here, one could find 'living art for daily life', Delaunay advertised, and 'all the elements of a modern setting that you would like to live with'.[32] At Simultané, art, fabric, fashion,

accessories and interior design were displayed as objects for patrons – not only women but men and those working in stage and film design – to both admire and purchase in order to engage more fully in modern life.[33] There were other such venues in Paris, including Marie Cuttoli's Maison Myrbor and Eileen Gray's Galerie Jean Désert, as well as Paul Poiret's Maison Martine. Poiret, who, like Delaunay, was able to merge artistic and commercial realms, was still very much in business as a textile designer, courtier and proprietor of Maison Martine, despite increasing financial difficulties that ultimately forced him into liquidation.[34] Poiret's extravagant showroom for the 1925 Paris exposition, which consisted of three barges decorated with Martine and Dufy textiles, furnished with Martine accessories, and occupied by his elegantly fashioned models wearing Poiret's creations, contributed to his financial difficulties.

Interestingly, both Poiret and Delaunay supplied the progressive Dutch department store, Metz & Co, with textiles and textile designs during this period, showing that they were receptive to ancillary commercial opportunities.[35] Although some accounts claim that Delaunay abandoned textiles in the early 1930s to focus on painting, she continued to supply textile designs to Metz & Co, more than 200 in all, as well as to design garments and receive royalties, well into the 1950s, first through company founder Joseph de Leeuw until 1940, and then, after de Leeuw was murdered by the Nazis in 1944, through his son, Henk, who took over operations and re-established business with Delaunay until 1954.[36]

Metz & Co also commissioned textile work by De Stijl artists Vilmos Huszár (1884–1960) and Bart van der Leck (1876–1958). The formal language of geometry, without decorative excess or sentimentality, was integral to the ideology of De Stijl, an artistic style, journal *and* group formed by Piet Mondrian (1872–1944), Theo van Doesburg (1883–1931),

Huszár and van der Leck that was based in The Netherlands from 1917 to 1931. Surprisingly, given De Stijl's fundamental decree that geometric forms and primary colours were universal and could therefore serve as the foundational elements for all media, from windows to chairs to interior design, only Huszár and van der Leck spent considerable energy conceiving of De Stijl within the context of textiles, a medium that is fundamentally geometric in construction.[37] Both Huszár and van der Leck eventually ended their affiliation with De Stijl, preferring to explore more pictorial approaches to geometric abstraction and, perhaps because of their experience designing textiles for Metz & Co, to venture more fully into commercial opportunities.

Huszár created three designs for Metz & Co in 1922 for surface printed textiles, which were produced in various colourways and featured small-scale patterns that repeated in an all-over configuration (fig.62).[38] These patterns are surprisingly unlike the asymmetrically arranged compositions of Huszár's colleagues, partly because of the nature of machine printing: the pattern exists as an endless stream rather than a discrete single unit. Furthermore, due to the overlapping of ink during the printing process, the edges of each design unit are not crisp. Huszár may have found these factors problematic, fearing that the pattern, while derived from the De Stijl vocabulary, might overwhelm other parts of a coordinated De Stijl interior scheme and dilute the effect of the total work of art for which textiles were but one element.[39] The consumer, however, may not have shared the same concern but might have appreciated the dynamic pattern and colour combinations of Huszár's exclusive fabrics.[40]

Van der Leck, meanwhile, focused his textile endeavours primarily on designs for tapestries and carpets, something he had explored years earlier and continued to investigate into the 1930s.[41] He

97

62 (left)
Vilmos Huszár
printed linen for Metz & Co 1922
actual size

63 (right)
Bart van der Leck
rug, 'Estate' design *c.*1918
wool
211 x 106 cm (83 x 41¾ in.)

envisioned his carpet designs functioning within an environment organised around the unifying principles of geometry and pure colour; for this reason, his carpet designs cleverly echo his aerial plans for interior room designs.[42] Van der Leck's textiles from this period, such as a 1929 rug for Metz & Co based on one of his designs (fig.63), reveal that he applied De Stijl's strict horizontal and vertical vocabulary to the flat surface of a fabric but deviated from De Stijl style by using diagonals and free-floating shapes.[43] Nevertheless, he took into account the rectangular format of each rug by carefully balancing the internal colour and shape elements according to the overall outside dimensions, and he understood that the design had to function in reverse, because Metz rugs were reversible.[44] Huszár and van der Leck therefore conceived of their textile work under different conditions using different kinds of textiles – length of

cloth v. single rectangle – and the respective outcomes of those properties – repeated pattern v. pre-determined dimensions – thus accounting for their divergent interpretations of De Stijl within the textile medium.

During the 1920s, artists frequently collaborated with department stores and other retail venues, either by working on specific collections, by selling designs or by selling finished textiles. Artists were able to negotiate between studio and retail venture with relative ease without the stigma that was later to accompany artistic crossover into commercial realms. The boutique Myrbor, for example, founded and operated in Paris from 1922 to 1936 by Delaunay's friend Marie Cuttoli (1879–1973), was similar to Simultané, Martine and Metz in that patrons could purchase from an exclusive inventory of textiles, objects and fashions in the newest styles

designed by an international group of modern artists.[45] Cuttoli's husband, whom she married in 1912, was an Algerian-born, French government official; while living in Algiers, Cuttoli came into contact with the fine embroidery and rug workshops there, and she soon embarked on a plan to market their products in Europe.[46] She organised a clever collaborative programme whereby she hired Algerian artisans to execute works from modern designs that she commissioned from France-based artists such as Natalia Goncharova, Raoul Dufy and Jean Lurçat (1892–1966), which she then sold at Myrbor under the Myrbor label.[47] Goncharova, a Russian émigré, was one of the top designers at Myrbor during the 1920s, creating highly abstract, collage-like designs that were meticulously embroidered, beaded and appliquéd by Algerian workers into fashionable, flapper-style dresses.[48] By the late 1920s and into the next decades, Cuttoli widened her collaborative endeavours to include artists such as Matisse, Joan Miró, Fernand Léger, Le Corbusier and Pablo Picasso, from whom she commissioned designs for tapestries to be executed by skilled weavers at the French tapestry workshops in Beauvais and Aubusson. This innovative project led to the blossoming and re-emergence of the pictorial tapestry tradition during the 1930s.[49]

Formulae for Design

During the 1920s, artists explored the language of geometric abstraction and its application to design and modern life in unprecedented ways. In some cases, they relied on mathematical formulae and other objective, externally generated processes to discover new ways of creating patterns. This development, coupled with the availability of new, intensely saturated synthetic colours, led to a

64
Maurice Pillard Verneuil
plate 19 from *Kaleidoscope: ornements abstraits: quatre-vingt-sept motifs en vingt planches* c.1925
pochoir print
46 x 36 cm (18⅛ x 14¼ in.)

profusion of dynamic textile designs. Maurice Verneuil, whose illustrated books on plants and patterns had influenced Art Nouveau, adapted to the new era's textile technology and aesthetic by producing in 1927 a *pochoir* portfolio of designs derived from the kaleidoscope, titled *Kaleidoscope: ornements abstraits* (Kaleidoscope: Abstract Ornaments). Figure 64 shows how Verneuil combined machine-like shapes and intense colour schemes in repeated sequences to achieve dynamic arrangements that recall the constantly shifting patterns one sees when looking through a kaleidoscope. In an era when Cubism was no longer considered an obscure pre-war experiment but had now entered the artistic main-stream, geometric patterns such as these were applied with great enthusiasm to a wide range of media in order to invigorate and unify the modern *Gesamtkunstwerk*.

Verneuil was an important contributor to modernist design; even his early books served to inform successive generations of artists who, during the 1920s, were searching for novel ways to break up the picture plane and to fragment and repeat motifs for visual interest and kinetic sensation. One compositional formula that was utilised in a number of astounding ways during the 1920s, due in part to Verneuil's earlier investigations, was mirror imagery. Verneuil and Alphonse Mucha had explored the mirror as a tool for textile design as early as 1901 in their *Combinations ornamentales se multipliant à l'infini à l'aide du miroir* (Ornamental Combinations Multiplied Ad Infinitum Using the Mirror). As Verneuil explained, designers could achieve unexpected ornamental patterns through a simplified version of the kaleidoscope by placing a hinged mirror at angles next to a design and copying the reflection from several directions. The resulting images, as illustrated in figure 65, are both abstract and pictorial, as the linear contours of motifs – derived primarily from plants but also including lizards and fish in this case – are transformed into geometric sequences of abstract design. Verneuil warned against using this method for all representational motifs – animals, for example, or sea-horses in this case – because they would not successfully translate using his technique. Those motifs were better left alone. Instead he favoured using linear and non-representational forms to achieve the richest designs, since 'one sees little advantage in being able to draw a bird with three heads or a dog with eight legs'.[50] Verneuil's experiments with the mirror allowed him to discover design solutions using a variation of one of the most basic principles of design, that of bilateral symmetry.

Bilateral symmetry as a fundamental design formula became popular in the 1920s because it referenced both mechanical processes and developments in psychology. Symmetry was frequently employed for

textiles because it conformed to mechanical processes that utilised repetition and inversion, and produced designs that were not relegated to a single vantage point but were balanced equally on either side of the central axis. Symmetry was also perceived as being connected to the fundamental design of the human body and was therefore utilised in psychology to investigate aspects of human perception and its relation to the psyche.[51] In addition, symmetry provided a stable and ordered structure that many artists of the time craved during the post-war period, a period that is often referred to as a 'return to order' after the chaos of the previous decade. Giacomo Balla, for example, reigned in the 'force lines' of his earlier textile designs to conform to a more bilaterally symmetrical organisation for his wall hangings and designs for textiles that he produced during the 1920s. Indeed, his display of four wall hangings at the 1925 Paris exposition, for which he was awarded a gold medal, was installed precisely to emphasise symmetry of the individual units as well as their symmetrical relationship to each other within the overall display.[52] Similarly, Fortunato Depero, whose adjacent showroom at the 1925 exposition won two gold medals, continued production of his 'fabric mosaics', many of which were symmetrically organised with decorative borders and central focal points. Balla and Depero's success at the 1925 exposition signalled a high point in the reception and production of their textile work. Through their Futurist vests, scarves, wall hangings and interior design, they hoped to revolutionise the modern world through textiles. Symmetry brought order to these Futurist textiles, which Balla and Depero looked to increasingly to fulfil their financial and artistic aspirations. Depero, his wife Rosetta and his workers at his Casa d'Arte Futurista (House of Futurist Art) in Trentino produced hundreds of textile objects during the 1920s and, due to the success of their large-

65
Maurice Pillard Verneuil and
Alphonse Mucha
page 19 from *Combinations ornamentals se multipliant à l'infini à l'aide du miroir* 1901, published by Librairie Centrale des Beaux Arts, Paris
pochoir print
22.9 x 26.1 cm (9 x 10¼ in.)

66
Herta Wedekind Ottolenghi
design for textile 1920–29
ink on graph paper
8.3 x 8.3 cm (3¼ x 3¼ in.)

scale felt appliqués, he and Rosetta decided to open a New York branch of the Casa in 1928; unable to establish a stable production programme, they abandoned the project and returned to Italy in 1930.[53]

Another exhibitor in the Italian Pavilion of the 1925 exposition was exploring the idea of symmetry in the form of 'inkblot' images. Herta Wedekind Ottolenghi (née Herta von Wedekind zu Horst) (1885–1953), a German countess who married into the wealthy Italian Ottolenghi family in 1914, was trained as a sculptor but had begun to work in textiles by the early 1920s. She was inspired by the design potential of inkblot images, perhaps through contact with the Swiss psychiatrist Hermann Rorschach (1884–1922). Rorschach, the son of an art teacher, had experimented with the medical uses of inkblots and art therapy as early as 1911 while working at Swiss clinics and asylums. His clinical observations and diagnostic interpretations of patients' responses to inkblot images were published in his book *Psychodiagnostics* in 1921, accompanied by 15 (later decreased to ten) inkblot cards. Ottolenghi did enter a sanatorium, although it is not known where or when, and she eventually settled in Switzerland, where she continued to make inkblot creations.[54] In the 1920s, Ottolenghi created hundreds of works on graph paper composed by the inkblot method (fig.66), whereby ink is applied to a sheet of paper that is subsequently folded in half, revealing a mirror image when unfolded. These drawings served as preliminary designs for her rugs and wall hangings, which received quite a bit of attention at both the French and Italian decorative art expositions in the 1920s. By this time she would have been familiar with, and might have even been a patient of, Rorschach. Ottolenghi's drawings on grid paper appear to be derived from both the visual structure of Rorschach's cards as well as the process of free-association that the cards were intended to

initiate, for some of her drawings contain little faces and other recognisable images. Her hand-stitched textile work from the 1920s (fig.67) – essentially enlargements in thread of her inkblot drawings – were admired for their inventive design, strong use of colour, 'vigour', and 'architectonic character'.[55] The surface embellishment technique that she devised, painstakingly executed by Brunilde Sapori, was so innovative that she patented it. The process, not unlike expanding a drawing to a mural, involved translating in thread the shape and colour of each gridded unit of the original cartoon to a stitched version on canvas, using both horizontal and vertical stitches. For example, an intense orange would result from crossing an orange vertical with an orange horizontal, or a light blue from crossing a blue thread with a grey one. Ultimately, the methodical and tedious embellishment process is disguised by the overall exuberance of the finished piece, and the pyschodiagnostic underpinnings that Ottolenghi may have been exploring though her drawings were subverted by the decorative pattern and texture of the textile.

Other textile designers began to work with inkblot symmetry during the 1920s. The Dutch artist Japp Gidding (1887–1955) created a spectacular body of textile designs using this system. In what is now known as the 'Tuschinski Style', named for the lavish interiors of the Tuschinski Theatre in Amsterdam that he designed in 1921 (fig.68, p.82), Gidding combined symmetry and eye-popping colour combinations to achieve a signature decorative style.

67 (right)
Herta Wedekind Ottolenghi (designer), **Brunilde Sapori** (stitcher)
wall hanging (detail) *c.*1924
wool stitching on woven wool
231.1 x 126.4 cm (91 x 49¾ in.)

Many of his textile designs were derived from the quadrilateral parallelogram formula, for which opposite sides – right and left, top and bottom – reflect one another. The resulting coloured shapes in Gidding's textiles appear as if they were produced by pouring colours and blotting them both horizontally and vertically, then outlining the shapes in contrasting colours, recalling the liquid lines produced by a batik *tjanting* tool. Gidding's appropriation of one textile technique for another, his emphatically precise reliance on symmetry, and his daring colour choices point to an extraordinarily modernist exploration of function, form and colour through the medium of textiles.

Not surprisingly, mathematics played a central role in the development of modernist textile design. From Moser's virtuoso tessellations to Delaunay's geometric repetition to Verneuil and Ottolenghi's *ad infinitum* mirror images, textiles naturally accommodate sequential formulae. Surface printed textiles, by their very nature, are dependent on logic and repetition – indeed, preliminary drawings for these textiles are often referred to as 'repeats' – and in the 1920s this logic became both the style and content of choice. But by the late 1920s and 1930s, many designers were more concerned with producing textiles according to the natural vertical-horizontal construction of woven fabric and the natural hues of fibres, an impulse that would lead to the development of Constructivism. Still others embraced more traditional approaches to picture-making by relying on recognisable imagery to communicate ideas.

The Modernist Pictorial Textile in Europe

Pictorial textiles from the 1920s tell stories of the era through narratives and readable symbols designed in most part to reflect the roaring excitement of the age. Anything was possible to represent, from Martinis and cigarettes to phosphorescent sea urchins, as textiles developed into illustrated storybooks of an era marked by discoveries in the fields of science, engineering and art. Raoul Dufy's work from this period perhaps best captures the times; he produced thousands of idyllic designs for Bianchini-Férier in a range of subjects, from genre scenes of leisure activities such as tennis or horseracing, to mythological scenes, abstract florals, jungle animals and aquatic fantasies, which were purchased by a primarily exclusive clientele, including Poiret.[56] Dufy's popular textile *Le Cortège d'Orphée* (The Procession of Orpheus) from 1921 was later manufactured by Bianchini-Férier in six colourways and presented in an elaborate fabric swatch book from 1927 (fig.69). This textile is an example of the unification of the arts in that it was inspired to varying degrees not only by Greek art and mythology but also by literature and, in turn, by opera. Formally, the narrative bands, or registers, are not unlike those Dufy would have seen on Greek vase paintings, yet his design was also inspired by poetry, namely a series of 30 poems Guillaume Apollinaire wrote in 1911, titled *Le Bestiaire (ou Cortège d'Orphée)* (The Bestiary, or The Procession of Orpheus), for which Dufy created a series of woodcuts. Apollinaire's inspiration for the poems came from opera, most likely a performance he had seen of Jacques Offenbach's 1858 opera *Orphée aux Enfers* (Orpheus in the Underworld). Since Apollinaire appreciated the integral relationship between art, music and language – the original context of the *Gesamtkunstwerk* – this synchronism may have in turn inspired Francis Poulenc to set six of Apollinaire's poems to song in 1919. Interestingly, Apollinaire had applied the term Orphism in 1912 to what he perceived to be the lyrical and colourful Cubism of Sonia and Robert Delaunay before they chose the alternative term, Simultaneism, in 1913. Dufy, of course, was at the centre of these

developments at the time, and this textile's multi-layered references may represent an homage both to Apollinaire, who was among the many artists who died during the 1918 influenza epidemic, and to the Delaunays. By 1927, the subtlety of the original textile was enlivened in its reproduction in the swatch book by a dazzling colour palette due to technological advancements in colour and fibre, all of which reflected new developments in modern fabric design and production.

Stylised floral patterns, an increasing supply of which originated from pochoir portfolios, were extremely popular during the decade. Designer Eugène Alain Séguy, for example, produced numerous illustrated pattern books during the 1920s, including *Floréal: dessins & coloris nouveaux* (Floral: New Designs and Colours), which represented exotic plants and insects in surprising ways (fig.70). Here one could discover not only abstracted designs but also a range of colours that defied all previous rules regarding colour saturation and combinations. In 1926, E. H. Raskin published *Fantaisies Oceanographiques* (Oceanographic Fantasies), a series of *pochoirs* inspired by underwater plants and organisms. In plate 11 (fig.71), for example, Raskin pits curves against bolts and stripes against solids within an oppositional colour scheme that both delights and confuses the eye.

The Hungarian artist Artur Lakatos (1880–1968), whose career began during the Art Nouveau period, experienced a similar transformation as Verneuil and others had. The delicate Art Nouveau tendrils and whiplashes of his earlier work were replaced in the 1920s by pounding colours, figure/ground ambiguity and lively folk-inspired patterns (fig.72). Lakatos updated traditional folk patterns, typically drawn from embroidered or woven originals, and transformed them with colour and design into an energetic pattern suitable for mass-production.

Marguerite Pangon (1880–1955) also explored new colour and shape relationships for her sumptuous velvet textiles that featured both sea and floral motifs, but she remained committed to the laborious handcrafted process of batik. After studying batik in The Netherlands in 1905, Pangon returned to France to begin a career as a designer and teacher of batik in an effort to establish 'Le Batik Français', or a style of batik that was uniquely French. She distinguished her work from Dutch and Javanese batik by working on velvet (fig.73), and by eliminating wax crackles except when desired for greater texture. Her work was exhibited at the 1925 Paris exposition and published in a beautiful *pochoir* portfolio sponsored by the Minister of Public Instruction. In his discussion of Pangon's art, the writer Yvanhoé Rambosson (1872–1943) found it as stimulating and expressive as any other fine art. 'In all these compositions', he wrote, 'something of the intellectual mixes with the magnificence of matter'.[57]

It was important for critics like Rambosson to defend Pangon's art as legitimate to counter prevailing critical trends that labelled pictorial textile work secondary to painting. The latter critical approach developed from those who saw the similarities between surface-designed and embellished textiles and painting, but could not appreciate the qualities of textiles that distinguished them from painting. Exacerbating the problem, however, were the anonymously designed textiles produced in the 1920s that unabashedly lifted motifs from popular paintings or painting styles such as Cubism. Rambosson emphasised that Pangon was first and foremost an artist who had complete control over the medium she worked with and did not pigeon-hole her as a craftsperson or decorative artist merely because she worked in textiles instead of painting.

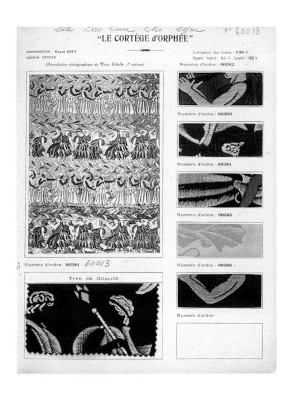

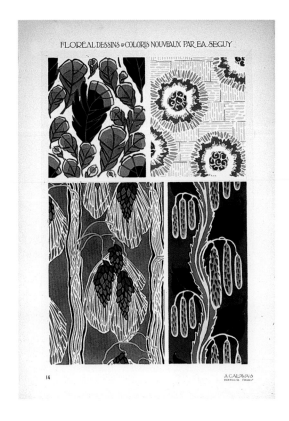

69 (above left)
Raoul Dufy
Le Cortège d'Orphée (The Procession of Orpheus) 1927,
plate 60013, *Tissus modernes: nuances solides c.*1927
fabric samples
33.0 x 27.9 cm (13 x 11 in.)

71(above right)
E.H. Raskin
plate 11 from *Fantaisies oceanographiques*, Paris:
F. Dumas *c.*1926
pochoir print
39.1 x 29 cm (15⅜ x 11⅖ in.)

70 (left)
Eugène Alain Séguy
plate 14 from *Floréal: dessins & coloris nouveaux* (Floral:
New Designs and Colours) 1920s
pochoir print
54.6 x 38.7 cm (21½ x 15¼ in.)

72
Artur Lakatos
folk-inspired bird design for textile
1920–29
gouache on paper
34.2 x 49.5 cm (13½ x 19½ in.)

73
Attributed to **Marguerite Pangon**
panel, Paris 1920s
silk velvet, wax-resist dyed (batik)
88.26 x 190.5 cm (34¾ x 75 in.)

The Pictorial Textile in America

Nevertheless, pictorial textiles were frequently compared to paintings, rather than analysed on their own terms, which ultimately complicated their critical reception throughout the modernist period. This confusion means that artists such as the Americans Marian Buck Stoll (1879–1960) and Marguerite Zorach, who worked in embroidered pictorial textiles, never fit easily into any one particular artistic category – neither fine art nor applied art – thus diffusing their artistic contributions. Stoll's and Zorach's works were admired for their 'fine art' qualities – intuitiveness, expressiveness, expensive-ness – but these qualities were subverted because the textiles were continually compared to paintings, rendering them, in effect, mere simulations. For instance, critics often described Stoll's pictorial embroideries from the 1920s (fig.74) as 'needle pictures', 'paintings in wool', with the 'brushwork of an oil painting'.[58] Yet Stoll worked in embroidery precisely because the inherent qualities of the medium allowed her to explore elements of pictorial design that were not like paintings, such as the stitch texture and direction, the sheen and softness of silk and wool thread and the hand-worked surface. The legitimacy of embroidery as a fine art was continually being called into question.

Zorach seemed unmindful of these questions, however. She worked in embroidery because it was flexible, in literal and practical ways. 'It is work that can be picked up and put down' at will, she wrote, because she was not dependent on capturing a moment in time or making sweeping, expressive gestures.[59] This attitude completely contradicted earlier attempts by embroidery reformers, such as Candace Wheeler, who sought to advance embroidery to a professional level by declaring that it was precisely '*not* a thing to be taken up and laid down

according to moods'.[60] Yet Zorach did not believe she had to defend her position; she was an artist, she worked with embroidery, and she succeeded financially with it. When Zorach's embroidered works were exhibited in 1923, one critic voiced surprise that her work fetched prices as 'high as art, up into the several thousand dollars for a single picture', describing in particular one of her embroidered bed covers as 'a sure cure for insomnia upon waking in the night to study the scenes in a $1,000 bed cover'.[61] Despite this debate over whether or not embroidery was worthy of 'art' prices, another critic commented enthusiastically that Zorach's display of embroidered works constituted 'one of the most exciting exhibitions of the season'.[62] In part because of these mixed messages, artists such as Stoll and Zorach received limited critical attention during their lifetimes and are rarely mentioned in art history surveys. Despite Zorach's unhurried working process, she continued to receive commissions for her embroidered work, including another bed cover in 1925, which she worked on for three years (fig.75). The flexibility of embroidery, a medium Zorach celebrated as having a 'life and form of its own', allowed her to create a picture that is both pictorial – with modelled figures rendered in perspective – and abstract – a textured surface ornamented with shapes and colours. [63] This particular work was also functional, although soon after completion, Zorach reworked it to hang on a wall, thereby altering its character by dispensing with its utilitarian function.

Surface-designed pictorial textiles were to become especially popular in America. The flat surface-designed textile was more versatile than singular, hand-worked embroidered and embellished textiles, and they appealed to conservative American tastes that were not as focused on modernist experiments in textiles as in Europe. Indeed, the United States did not participate in the 1925 Paris exposition because

American art and industry representatives did not believe that American designers were proficient enough in the field of decorative art to compete in an international arena, despite advances in art, architecture and the flourishing silk textile manufacturing industry.[64] Paul Frankl (1866–1934) explained this position in his 1928 book, *New Dimensions: the Decorative Arts Today*:

> The only reason why America was not represented at the exhibition of decorative industrial art held in Paris in 1925 was because we found that we had no decorative art. Not alone was there a sad lack of any achievement that could be exhibited, but we discovered that there was not even a serious movement in this direction and that the general public was quite unconscious of the fact that modern art had been extended into the field of business and industry. On the other hand, we had our skyscrapers, and at that very date (1925), they had been developed to such an extent that, if it had been possible to have sent an entire building abroad, it would have been a more vital contribution in the field of modern art than all the things done in Europe added together.[65]

Although the United States was not represented in the Paris exposition, many American artists and manufacturers immediately recognised the need to engage more fully in the modern style and to focus more attention on textiles that exhibited geometric shapes, bold colour combinations and references to non-Western sources. The 'painterly' embroideries of Stoll and Zorach may have seemed unfashionable and inappropriate to some textile designers and manufacturers, who sought more streamlined and graphic compositions while still working within the pictorial framework. Textile manufacturers with large American markets such as F. Schumacher & Co, Stehli Silks and Mallinson & Co were eager to curtail importation of European textiles in favour of introducing American textile collections that incorporated these new decorative elements, as well as new colours, fabric blends and themes, without alienating their conservative American consumers.[66] Thus, a unique 'conservative modernism' in the realm of pictorial textiles developed in the United States after 1925, which department stores and museums began to market and display.[67] By 1926, both Stehli and Mallinson brought out collections based on American themes, designed by American artists to appeal to the American consumer.[68] The *American* series and the *American National Park* series, respectively, signalled a new focus on both pictorial realism and American nationalism that would continue throughout the next decade.

Stehli's series featured such trademarks of American life as amusement rides, swing music orchestras and skyscrapers, now stylised through the lens of cubistic geometry, and machine-printed in conservative, neutral colours. The series also included innovative designs by the photographer Edward Steichen, who had been involved in fashion and avant-garde activities in Paris from 1906 to 1914 and then worked primarily in the US after World War I. In Paris he organised exhibitions of modern art for Alfred Stieglitz' Gallery 291 and, as one of history's first fashion photographers, created a beautiful spread for the April 1911 edition of *Art et Decoration* featuring softly focused models wearing the latest creations by Paul Poiret.[69] In another first of its kind, Steichen created a series of designs for Stehli produced not from drawings but from photographs. In his 1927 *Moth Balls and Sugar Cubes* (fig.76), for example, one of ten designs he created using commonplace objects, Steichen photographed the balls and cubes from above with a

74
Marian Buck Stoll
Embroidered picture 1926
linen plain weave embroidered with wool
59.7 x 49.5 cm (23½ x 19½ in.)

75
Marguerite Zorach
Panel from bedcover 1925–8
linen and wool, embroidered
232 x 182 cm (91⅓ x 71⅔ in.)

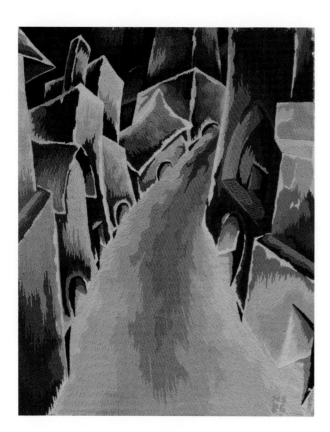

copy camera that captured the silhouettes as well as shadows. His clever solution to textile design would play an important role in both art and industry in the years to follow.

The American Ruth Reeves (1892–1966), who studied with Fernand Léger in Paris during the 1920s, became actively involved in textiles upon her return to New York in 1928. Art and commerce

united when, in 1930, the W. & J. Sloane firm commissioned her to produce a series of 29 screen-printed textiles celebrating American life, of which *Manhattan* (fig.77) is the most well known.[70] Here Reeves contained pictorial representations of the city within angled, crosshatched frames that unify humans, machines and vantage points into a bustling narrative. Reeves' textiles from this series are successful because

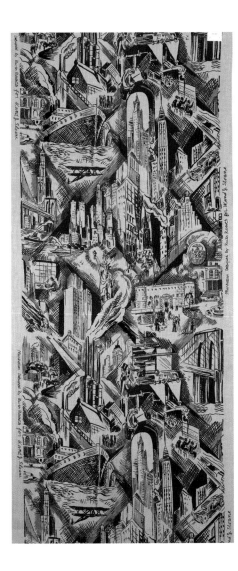

77
Ruth Reeves
Manhattan 1930
printed cotton voile
254 x 94 cm (100 x 37 in.)

76
Edward Steichen
Moth Balls and Sugar Cubes 1927
printed silk crêpe de Chine
20.5 x 19 cm (100 x 37 in.)

she understood the unique properties governing a *length of cloth*. *Manhattan* works well as a vertical and continuous narrative precisely because the image occupies the whole cloth, and the element of repetition actually becomes a significant, rather than restrictive, visual feature.

Work in pictorial textiles, especially as it expressed notions of national identity, continued into the next decade. Textiles became more explicitly representative in order to illustrate political agendas. At the same time, however, many artists abandoned pictorial textiles, which are produced primarily through surface printing and embellishment techniques, in favour of textiles that expressed the constructive properties of cloth itself.

Constructed textiles are generally 'built' through the technique of weaving, unlike surface-designed textiles that are products of printing or other superstructural surface treatments such as embroidery and appliqué. This three-dimensionality made them the ideal medium for working out ideas about Constructivism, an aesthetic philosophy that developed during the early 1920s. Central to Constructivism was the notion of truth to materials, of exploiting rather than disguising the properties inherent to both materials and the processes through which materials are formed. In weaving, Constructivism was expressed in a fairly straightforward shift away from pictorial representations in thread, such as pictorial tapestry, toward rationally produced patterns determined by the horizontal and vertical structures of weaving as well as by the natural hues and textures of fibre. The ideology of Constructivism and its association with neutrality, timelessness and universality, as well as its adaptability to industry, provided a rational alternative to pictorial and embellished textiles. As weavers continued to create unique, one-of-a-kind, handmade works of art, they also began to explore the wider applications of weaving in industry, in architectural work and in pedagogy. The shift from a pictorial to Constructivist focus in weaving meant that preliminary designs, or cartoons, especially those provided by primarily male designers for primarily female weavers, were no longer necessary, in part because a new category of designer-practitioner was emerging: the industrial designer. Like the multi-faceted artist-designer from previous decades, the industrial designer held an ideological position that supported

collaborative and reciprocal dealings between fine and applied art, and had both technical and artistic skills to design objects for mass-production by creating prototypes.

One of the most important sites for such developments in textile design was Germany's Bauhaus, a progressive school of arts and crafts founded by Walter Gropius (1883–1969) in 1919, where a number of key designers worked and innovated until the school closed under Nazi pressure in 1933. Although Germany was renowned for its specialised textile schools, such as those in Krefeld and near large mills and dye works in the east, the Bauhaus was not designed to function purely as a technical school, but rather as a laboratory in which students learned to work with materials to create thoughtfully constructed and aesthetically straightforward utilitarian objects.

The Bauhaus in Weimar: 1919–1925

In his 1919 Bauhaus manifesto, founder Walter Gropius echoed the words of William Morris and Henry Van de Velde: 'Today the arts exist in isolation from which they can be rescued only through the conscious, cooperative effort of all craftsmen… Let us then create a new guild of craftsmen without the class distinctions that raise an arrogant barrier between craftsman and artist!'[1] Indeed, Morris' ideas of social cooperation and the role of crafts in modern life and Van de Velde's pedagogical programmes promoting the finely crafted *Gesamtkunstwerk* formed much of the foundational structure of the Bauhaus. Van de Velde was in fact integrally linked to the formation of the Bauhaus; he moved to Weimar in 1902 to direct the Applied Arts Seminar Institute there, which later became the Grand-Ducal Saxon School of Arts and Crafts in 1907, with the

94 (left)
Ethel Mairet
photograph showing a selection of woven work
by Ethel Mairet 1930s

intention to institutionalise and professionalise handicrafts as a continuation of his reform aesthetics; not surprisingly, textile design and weaving were included among the initial workshops at the school since they played such a significant role in Van de Velde's artistic development.[2] In his role as an architect, he not only designed and built the School of Arts and Crafts, he also renovated the Academy of Fine Arts across the street, the very buildings that the Bauhaus would later occupy from 1919 to 1925. When the outbreak of World War I forced the Belgian Van de Velde to resign his position as director of the School of Arts and Crafts, he recommended Walter Gropius for his replacement; meanwhile Gropius had also been recommended to lead the Academy of Fine Arts because of his architectural background.[3] In 1919, then, when Gropius was officially appointed to direct both schools, he was already prepared for the future and promptly combined the two schools into one, renaming it the Bauhaus. Literally, the term translates to House for Building, a neutral designation that Gropius deliberately chose because it mentions neither art nor craft but implies an environment where one learns to work with materials in order to build a unified *Gesamtkunstwerk*. Josef Albers (1888–1974), who studied at the Bauhaus and was later a professor there, recalled:

> The name evidently implied something other than an academy. Nor was it as intimidating as calling it an institute or a college would have been. And instead of 'workshop', which in fact is what it was, it merely called itself very modestly a 'house', and, typically, not a house of art, or craft, or any mixture of the two, but 'Bauhaus', a 'Haus für Bauen' (house for building), and (again modestly and reticently), for form and design.[4]

Of the various workshops the Bauhaus offered over the years, including glass, bookbinding, metal, furniture, ceramics, typography, wall painting, sculpture, photography and eventually architecture, the weaving workshop was among the most enduring, productive and groundbreaking.[5] Members of the Bauhaus weaving workshop, through their writings, their experiments with fibres, dyes and weaves, and their collaborations with industry, were instrumental in changing the way textiles were conceived of, perceived and practised after 1920.

During the early years, Bauhaus textiles reflected pre-war concerns with both pictorialism and abstract expressionism. As weaving workshop students – most of them women, many with previous textile training – familiarised themselves with the Bauhaus handlooms and the school's apprentice-to-journeyman training philosophy, they produced unique, one-off woven works of art using a variety of fibres in a range of styles. Many of these works, such as a 1920 wall hanging by Margarete Bittkow-Köhler (1890–1964) (fig.78), reflect the early Bauhaus interest in primitivism, inspired by an expanding knowledge of non-Western sources. Bittkow-Köhler's finely woven work is clearly influenced by Pre-Columbian textiles from Peru, which she would have seen in books and museums. The fish and symmetrical cotton plants are nearly verbatim replications of ubiquitous Andean textile motifs, and the blocky crescent-shaped forms in the lower register also share formal affinities with Andean patterns, of which hundreds of examples could be seen at the Berlin Museum für Völkerkunde. For example, a woven Andean textile purchased by the museum in 1907 as part of a large Andean textile acquisition, and illustrated in Max Schmidt's *Kunst und Kultur von Peru* (fig.79), depicts maize plants, sea creatures and bird motifs in horizontal registers resembling the format and style of Bittkow-Köhler's wall hanging.[6] Although Bittkow-Köhler may

78
Margarete Bittkow-Köhler
wall hanging c.1920
linen
258 x 104.2 cm (101½ x 41 in.)

79
page 498 from *Max Schmidt, Kunst und Kultur von Peru*, Berlin: Propyläen Verlag 1929
woven textile with cornstalks, birds and crabs

not have seen this particular example, she would have had opportunities to see others like it at the Berlin museum, or in the extensive collection of illustrated books and journals at the Anna Amalia Library in Weimar, or though travels with her husband, the art historian and supporter of modern art, Dr Wilhelm Köhler, director of the Weimar State Art Museum.

A 1921 chair produced collaboratively by Gunta Stölzl (1892–1983) and Marcel Breuer (1902–1981) (fig.80) also exemplifies early Bauhaus primitivism and expressionism but using different non-Western sources. The chair was probably produced for the first of many Bauhaus building projects, the 1921 Sommerfeld House, for which students and professors from all of the workshops collaborated to achieve a complete *Gesamtkunstwerk*. The deliberately hand-worked surfaces and construction of the chair reveal Breuer and Stölzl's awareness of African sculpture and rugged folk furniture. The chair back, which Stölzl wove directly onto the frame through drilled holes, appears to have been worked in a fairly spontaneous and expressionist manner, an approach the designer would later condemn after the Bauhaus began to embrace Constructivism.[7] 'While at the beginning of our Bauhaus work we started with image precepts – a fabric was, so to speak, a picture made of wool – today we know that a fabric is always an object of use and is predicated equally upon its end use and its origin', she explained in 1926.[8]

These early experiments with pictorial and expressionist concerns in thread had become obsolete even before 1923, when Gropius abandoned the Bauhaus motto 'Art and Craft: A New Unity' and declared a new alliance with industry, a necessary alliance given Germany's impoverished post-war economic conditions.[9] In keeping with the school's new focus on productivity, the weaving workshop was restructured, and students Stölzl and Benita Otte (1892–1976) attended the Krefeld Textile Academy for intensive technical training.[10] By 1923, the Bauhaus weaving workshop was equipped with an in-house dye works, and workshop members began to investigate materials and their properties while simultaneously exploring the relationship of those properties to the inherent horizontal-vertical structure of woven cloth. This Constructivist focus, which was beginning to influence all of the workshops and would lead to a kind of corporate style, is what the Bauhaus is largely remembered for today; members of the weaving workshop were at the vanguard of this new direction. Stölzl's wall hanging from 1922–23 (fig.81) reveals her new understanding of both geometric abstraction and colour relationships achieved through the crossing of different coloured threads.[11] The overall finish of the piece is more precise and controlled than her earlier work, and it is much larger. 'The direction taken by the Bauhaus is becoming more precise', observed Professor Lyonel Feininger (1871–1956) in 1925 with some trepidation; as an Expressionist painter he was concerned that the growing emphasis on utility and streamlined design for industrial application might threaten the traditional practice of art.[12] But while the balance may have shifted toward greater attention to materials and their properties, the focus at the Bauhaus on creative experimentation and producing meaningful forms and ideas never wavered.

The Bauhaus in Dessau and Berlin: 1925–1932

These Constructivist investigations intensified after 1925 when the Bauhaus relocated to a Gropius-designed building in the industrial town of Dessau. The weaving workshop opened the doors to a more expansive dialogue with industry by acquiring multi-

harness dobby and Jacquard looms, as well as other production equipment.[13] Traditional handlooms are built to accommodate one network of vertical warp threads, through which the horizontal weft threads (the pattern-carrying threads) are interwoven. Some looms are equipped with harnesses, activated by foot pedals that allow the weaver to lift up predetermined warp threads in order to achieve greater control of the pattern. Dobby looms have multiple harnesses that control the warp thread, making possible an increasing variety of patterns, and the Jacquard loom uses pre-patterned punch cards to control the warp threads. This new capacity for greater versatility created new financial and pedagogical opportunities; Gropius subsequently formed a limited company, Bauhaus GmbH (Gesellschaft mit beschränkter Haftung, or private limited liability company), that was to sell Bauhaus products and prototypes to firms such as the industrial textile manufacturing firm Polytextil; meanwhile, Stölzl, now in charge of the weaving workshop, designed a three-year training programme to provide weavers with the skills to work in industry or establish independent businesses, which some of them did within the Bauhaus under the Bauhaus umbrella.[14]

Certainly the Bauhaus was not the first association of artists to establish ties to industry. The Deutscher Werkbund (German Work Association) was a direct precursor to the Bauhaus. Formed in Munich in 1907 by a membership of both artists and architects, including Henry Van de Velde, the Werkbund was established precisely to encourage good design for utilitarian products, including textiles, many of which were designed by founding members Peter Behrens and Richard Riemerschmid. Indeed, the Deutscher Werkbund's pre-war successes and conflicts prefigured those that would take place at the Bauhaus, complete with ongoing battles regarding the extent to which one should embrace

either individualism (Van de Velde's viewpoint) or standardisation (founding member Hermann Muthesius' viewpoint) or envision some middle ground where the two could co-exist (which would become the viewpoint for the Bauhaus by Gropius, a 1911 member).[15] The difference, in terms of textiles, is that after the war the Werkbund served primarily as a venue for textile exhibitions, under the expert supervision of Lilly Reich (1885–1947) (the first female board member of the Werkbund in 1920 and later director of the Bauhaus weaving workshop in 1932), while the Bauhaus served as a laboratory in which members worked directly with materials as both designers and producers on industrial equipment to produce art that could also function as prototype.[16] This notion of the woven prototype – that is, an artistically designed, unique work that could also serve as the preliminary diagram and instruction model for mass-production – was one of the Bauhaus weaving workshop's most significant innovations.

Paul Klee was among the Bauhaus professors who provided students with the theoretical skills to understand the interplay between materials and their inherent constructive properties and to approach their work as a process of creative experimentation.[17] By 1927, Klee was teaching sections of his form and colour courses specifically to weaving students; these courses not only instructed students in the artistic possibilities of weaving, but also inspired Klee himself to incorporate these possibilities into his own work. Interestingly, his paintings from the mid-1920s until he left the Bauhaus in 1931 reveal compelling similarities to the processes of weaving, in which the crossing of different coloured or textured threads changes the structural and chromatic density of the network. Klee's watercolour from 1929, *Monument im Fruchtland* (Monument in the Fertile Country) (fig.82), for example, replicates the process of building and crossing colours in registers and blocks

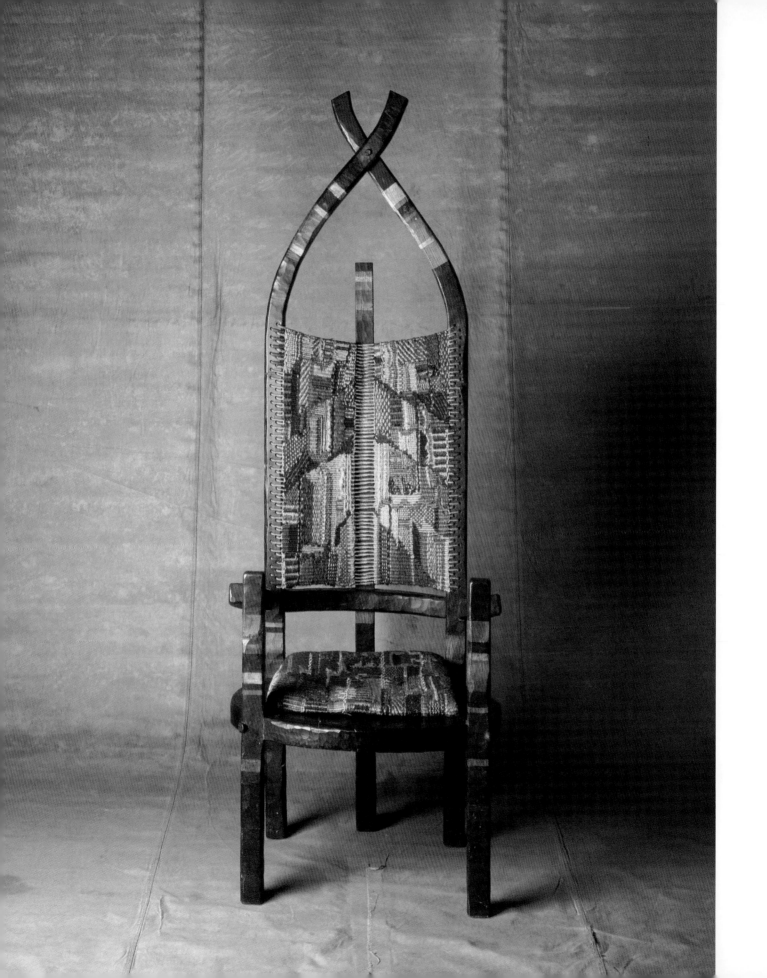

81
Gunta Stölzl
covering/wall hanging 1922–23
tapestry; cotton, wool and linen fibres
256 x 188 cm (100¾ x 74 in.)

82
Paul Klee
Monument im Fruchtland (Monument in the Fertile
Country) 1929
watercolour and pencil on paper on cardboard
45.7 x 30.8 cm (18 x 12⅛ in.)

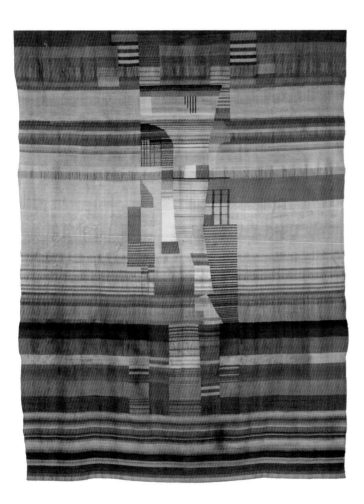

80 (opposite)
Marcel Breuer (chair), **Gunta Stölzl** (textile)
Afrikanischer Stuhl (African Chair) 1921
oak and cherry wood, gold paint with water-soluble colours
in blue and red tones; textile parts from hemp, wool, cotton
and silk, on hemp warp
179.4 x 65 x 67.1 cm (70⅔ x 25⅔ x 26⅖ in.)

in precisely the same way that a weaving is built up from threads, which Stölzl had explored in her 1922–23 wall hanging.[18] He articulated these principles in his work and his teaching, as surviving student notebooks make evident.[19] Student Marguerite Willers (1883–1977) attended Klee's course in 1927; on page 13 of her notebook from his course (fig.83), she has drawn 20 different patterns, all of which are derived from the principles of weaving, indicating how Klee tailored his teaching to emphasise the integral connection between weaving structures and patterns.

Anni Albers (1899–1994), a member of the weaving workshop from 1922 to 1931, exemplified the modern weaver-designer who created both unique, visually complex works of art and prototypes for industry; she was also an accomplished writer who throughout her long career articulated many of the pioneering ideas, techniques and approaches to weaving that she and others developed at the Bauhaus. Albers was responsible for a number of innovations in her woven work, including new weave constructions, such as double-weave, triple-weave and open-weave, and their accompanying structural and chromatic patterning. In 1926 she utilised the triple-weave construction for a large wall hanging (fig.84), one of the first of her thermometer-stripe compositions. A triple-weave textile has three distinct planes, or networks, of thread, each with its own set of warps and wefts. The planes can be interlocked, or sandwiched, by exchanging threads from different planes, which produces an extremely strong cloth with intense colour. The planes can also be woven separately in certain sections, producing pockets, thus a three-dimensional surface is produced with some areas lying flat while others pucker. Albers' wall hanging takes this three-dimensionality into account while optimising the structural and chromatic interplay of interwoven cloth. For this work Albers

83
Marguerite Willers
page 13 from Bauhaus notebook c.1927
graphite on paper
16.51 x 21.59 cm (6½ x 8½ in.)

composed 108 thermometer-stripe rectangles arranged in a precisely controlled sequence of nine units across by twelve units high. The strict horizontal stripe pattern, which alone would have been monotonous, is enlivened and broken up through colour. The dynamic colour combinations – produced from the crossings of just three colours, black, ivory and gold – are not governed by a rigid sequential formula but rather appear to have been achieved through arbitrary methods. The textile, created from both rational and intuitive processes, is at once a

stunning work of art and a prototype of the colours, patterns and densities that Albers was capable of producing on the loom.[20]

Albers would explore this idea of compartmentalising visual information into a grid framework for decades to come, drawing on both her intimate understanding of the weaving process and her increasing knowledge of Andean weavings, which she initially encountered at the ethnographic museum in Berlin.[21] There she would have seen examples of finely constructed Inca tunics whose patterns were formed through sequential formulae and lively, sometimes dazzling, colour combinations. In their colours, shapes and patterns, these tunics contained codified cultural information about the status and rank of the wearer. Albers admired these and other examples of Andean textiles for precisely the same qualities she sought to achieve in her own work: aesthetic beauty, cultural relevance and utilitarian economy and function.

Albers and other Bauhaus weavers experimented not only with weaving processes but also with types of materials that could be woven. They began to create monochromatic and constructive weaves that used both natural fibres, such as cotton, silk, linen and wool, and new synthetic fibres, such as rayon (which they called *kunstseide*, or art silk) and cellophane, that entered the popular market during the 1920s. Although Germany was renowned for its chemical dye works, Bauhaus weavers tended to focus on the natural properties and hues of these fibres. After 1928, when Gropius resigned and architect Hannes Meyer became director, Bauhaus weavers focused increasingly on producing prototype samples rather than fully finished pieces, because the samples were now conceived within the context of their larger function as upholstery, drapery and wall coverings in collaboration with architecture. A woven prototype by Albers from 1928 (fig.85), woven from jute (a cellulose plant fibre) and

cellophane (a cellulose wood pulp fibre) in a broken twill weave (diagonal), could be envisioned as a useful curtain or wall covering because of its lightweight yet dense structure and reflective surface.

Due to the focus on production, Bauhaus textiles became increasingly anonymous, a clear departure from the school's original ideology of individualism, inherited from Van de Velde. Samples for tubular furniture upholstery (fig.86), for example, woven in a twill weave from cotton and wax-covered cotton, remain unattributed other than being woven at the Bauhaus. By 1933, when one of the final advertisements for Bauhaus products appeared in the *Berliner Illustrirte Zeitung* (Berlin Illustrated Newspaper) (fig.87), Bauhaus textiles were conceived and displayed as part of a triad of elements – wallpaper, fabric and furniture – exemplifying the Bauhaus corporate style now associated with 'quality', 'harmony' and 'good taste', rather than individual artistic achievement. Internationally recognised and available to the consumer market to purchase or even imitate, although Bauhaus products were 'protected against inferior imitations' by the Bauhaus label, these Constructivist investigations and innovations had after the dissolution of the school that year become in essence part of the public domain.[22]

The issue of authenticity and of who owns an idea became a topic of debate during the late 1920s and 1930s. For weaver Otti Berger (1898–1944), the years between 1930, when she received her Bauhaus diploma, and 1936, when the Nazis revoked her professional licence for being a foreign non-Aryan (she was Jewish from Yugoslavia), were fraught with frustrations as she sought to patent her weaving prototypes while simultaneously submitting them to large textile manufacturers in London, Zurich and Bergeyk, The Netherlands.[23] The German authorities did not believe that simply combining particular types of threads in particular weave

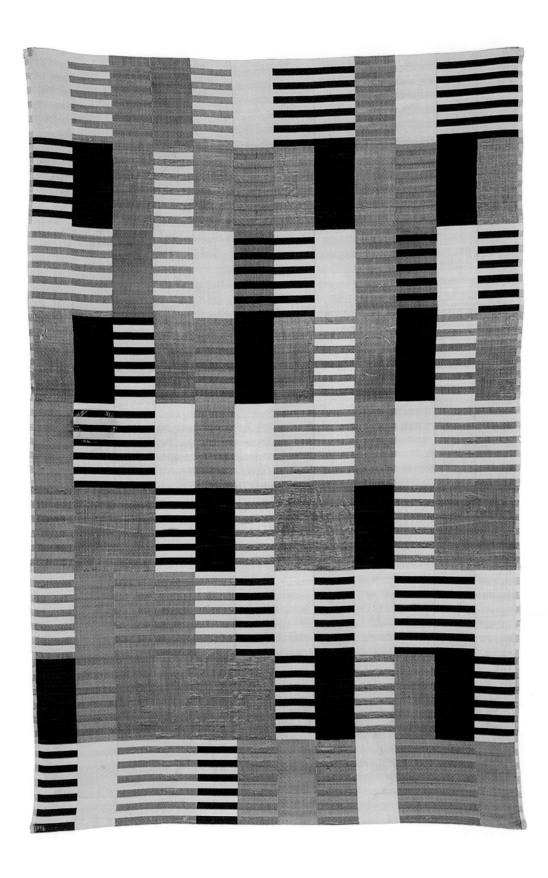

84 (opposite)
Anni Albers
wall hanging 1926
woven silk, three-ply (triple) weave
178.8 x 117.8 cm (70¼ x 46¼ in.)

86 (above)
Bauhaus Weaving Workshop
textile samples for tubular furniture
upholstery after 1927
woven twill weave; cotton and
wax-covered cotton
various sizes

85
Anni Albers
textile sample *c.*1928
woven jute and cellophane,
broken twill weave
15.5 x 11 cm (6⅛ x 4⅓ in.)

87
page 394 from *Berliner Illustrirte Zeitung*, No.11 1933
15.24 x 11.43 cm (6 x 4½ in.)

88
Otti Berger
Christmas card 1937
Typewriting on silk weave
17.3 x 13 cm (6⅞ x 5⅛ in.)

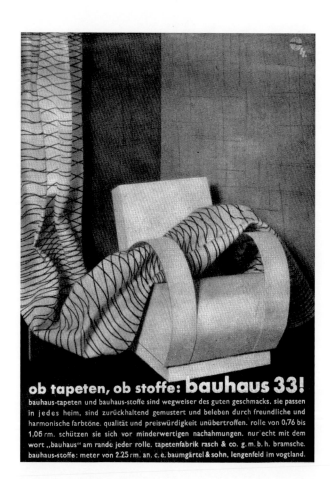

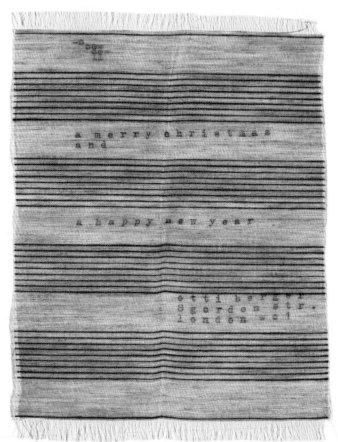

structures constituted an invention worthy of a
patent.[24] Berger eventually received a British patent,
however, paving the way for future industrial designers
to protect their intellectual property. One of her last
weavings was a small Christmas card (fig.88) from
1937 made in London before she returned to
Yugoslavia and ultimate deportation and murder at
Auschwitz.[25] The 'card' is a lustrous, stiff, silk weave
on which she has woven horizontal 'lines' and then

typed a greeting (in the lower-case Bauhaus style)
and a clever signature that personalises what could
have otherwise served as an anonymous sample.[26]

Constructivist Textiles Beyond the Bauhaus

Outside the Bauhaus, designers were not only
conceiving of textiles in new ways but also displaying
them in innovative settings that emphasised the

Ludwig Mies van der Rohe and **Lilly Reich**
photograph of the 'Café Sampt und Seide' ('Velvet and Silk
Café'), for *Die Mode der Dame* (Women's Fashion) *Exhibition*,
Berlin 1927

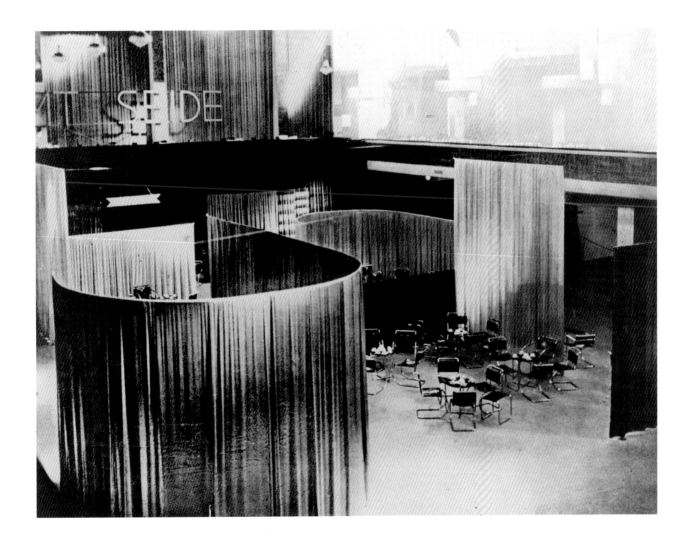

constructive properties of the cloth itself. Lilly Reich's
textile design work both paralleled and enhanced
investigations that were taking place at the Bauhaus.
Through her work in the Deutscher Werkbund, she
was familiar with new textile developments throughout
Germany, especially those in industry. Reich's expertise
lay in her knowledge of textile properties rather than
their means of construction, and through her work in
exhibition design she developed new ways of using
textiles in architectural programmes. Rather than
designing textile structures and patterns, Reich used
textiles to manipulate space. Her most dramatic

design was for the 1927 Café Sampt und Seide (Velvet and Silk Café) for *Die Mode der Dame* (Women's Fashion) Exhibition in Berlin (fig.89), for which she collaborated with architect and partner Ludwig Mies van der Rohe (1886–1969); here, textiles functioned neither as furniture nor fashion but as floating space dividers of contrasting colours and heights.[27] Neither curtains nor walls, these textiles were utilised not for their pictorial potential but as materials to define and determine space, an innovative approach that architects, interior designers and weavers on both sides of the Atlantic would pursue decades later.

Reich and Mies collaborated on a number of large-scale building and exhibition projects, including the German Pavilion and exhibition space at the 1929 International Exposition in Barcelona and the 1931 *Dwelling in Our Time* exhibition in Berlin, which required them to commission textiles from independent sources. One weaver with whom they collaborated was Alen Müller-Hellwig (1901–1993), a licensed weaver in Lübeck who specialised in weaving wall and floor coverings of naturally hued sheep wool, which she created for Reich's room in the *Dwelling in Our Time* exhibition, as well as for Mies' German Pavilion and his 1930 Tugendhat House.[28] She also produced pictorial tapestries, but with abstract rather than purely representational references. The pictorial yet geometric arrangement of her *c.*1930 wall hanging, *Baum* (Tree) (fig.90), recalls early Bauhaus weavings, but the heavy, natural fibre points to a new direction in natural colour and texture based on the inherent properties of the materials. Müller-Hellwig also had expertise in rug design and construction; Reich and Mies admired her work in this area and commissioned her to produce monochromatic sheep wool rugs, first in white, and then in brown, to complement their own innovations in modern architecture and exhibition

design.[29] These interior spaces were united by attention to the interplay of materials – chrome, leather, wool, glass and stone – used without superficial ornamentation that would detract from the sleek *Gesamtkunstwerk*. Müller-Hellwig's rugs, thick with long strands of wool – representing some of the first shag carpets of the modernist period – provided an element of texture and of sound absorption to the interior spaces.[30]

In creating her shag carpets, Müller-Hellwig allowed the yarn itself to become part of the visual pattern and texture of the carpet by adding the element of looped yarns to the weaving process. Rug construction differs in some cases from basic weaving techniques. For example, tufted and hooked carpets involve needle-hooking yarn through a woven base fabric such as canvas. This technique is more like cross-stitch, or even embroidery. Woven carpets, on the other hand, can be produced by the basic flat weave tapestry technique called kelim, or slit-weave if there are openings in the woven web between colour changes. In the case of pile weaves, the technique involves both basic weaving and hooking or knotting techniques. Pile weaves are produced by inserting (looping and knotting) yarns while the network is being woven, so that the ends of the inserted yarns extend out from the surface. These yarns can then be looped back or cut in short (dense) piles or high (shag) lengths, thereby increasing the possibilities for creating texture and pattern through the constructive process.

A number of artists, theorists and architects beyond the Bauhaus championed this notion of exploiting pure or natural ornamentation during the

90 (right)
Alen Müller-Hellwig
Baum (Tree) c.1930
woven wool, jute fringe
158 x 130 cm (62⅕ x 51⅕ in.)

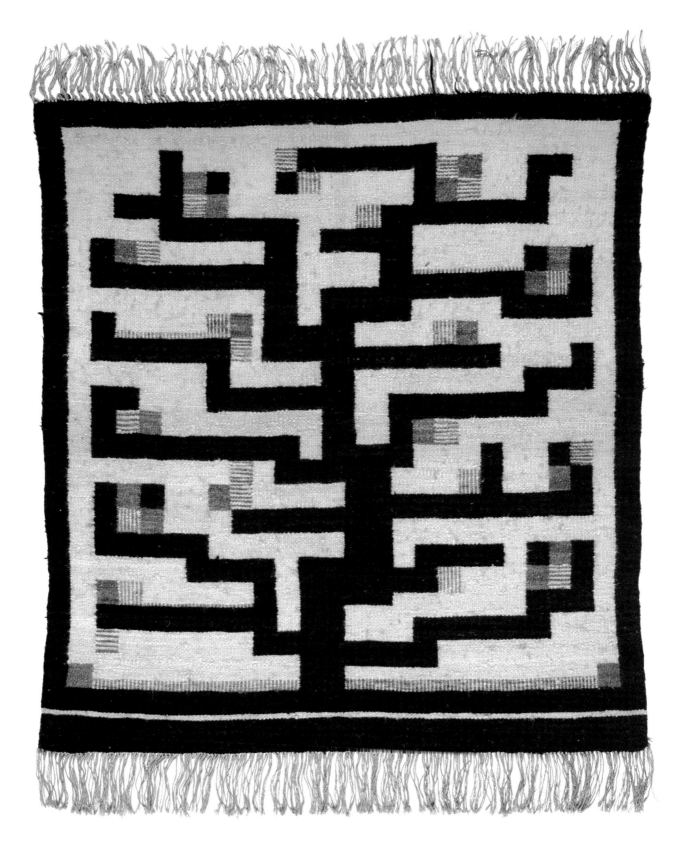

1920s and 1930s, most notably Frank Lloyd Wright and Le Corbusier (1887–1965). Wright promoted the idea of 'organic' decoration as the key principle guiding architectural and interior design, advising designers 'to use no ornament that did not come out of the nature of materials'.[31] Le Corbusier promoted the concept of 'mechanical selection', a machine-based parallel to natural selection, as a guiding principle that ultimately forces out decorative excess and disguise in favour of forms created through 'the application of constructive and modular means' to achieve universal order and clarity.[32] Both architects also theorised that this sensible approach to design was well suited to machine production. For example, Wright was at this time creating his 'textile block' homes from mass-produced concrete blocks stamped with geometric patterns, which produced a highly ornamental effect without the addition of super-structural or applied decorative elements. Indeed, both Wright and Le Corbusier argued that pure design is achieved not by applying ornament to materials but by exploiting what is integral to the materials themselves and their intended purpose. 'Modern decorative art is not decorated', Le Corbusier declared in his pioneering 1925 book, *L'Art décorative d'aujourd'hui* (The Decorative Arts of Today).[33] Ornament, therefore, was perceived as redundant and superficial, much as Adolf Loos had suggested back in 1908 in *Ornament and Crime*. Interestingly, both Wright and Le Corbusier later loosened their strict philosophy to allow for more fusion of utility and art through their design work in both textiles and architecture.

For those working in woven textiles and carpets as designers, not necessarily weavers, the question was how to create designs that conformed to the structural support of the woven web and could be applied without appearing as mere superficial pattern ornamentation or as imitations of paintings. The solution for designer Marion Dorn (1896–1964) was

to eliminate design *per se* in favour of creating visual forms through sculpting processes. She created the pattern for her monochromatic c.1934 rug (fig.91) by utilising two different techniques: flat weaving and looped pile, resulting in a design that appears to be carved.[34] Other textile designers who understood the constructive process of weaving were Paul Rodier and Hélène Henry, both of whom designed furnishing and fashioning fabric with attention to weave construction. They invented complex weaving structures using both hand and mechanical looms to create textured and multi-tonal woven patterns for which the direction of threads and the angle of the light determined the pattern through sheens and shadows rather than surface decoration.[35]

One designer from the period who successfully combined the forms of geometric abstraction with the material properties of fibre and cloth was Irish born, France-based designer Eileen Gray (1879–1976). In Paris in the 1920s she admired the flat geometry of De Stijl and the geometric structure of Cubist collages, and agreed with Le Corbusier's ideas for creating designs based on mathematical proportions and sequences. These sources played a part in her carpet designs, which she sold at her Parisian gallery/boutique Jean Désert (a fictional name that implied a male owner) from 1922 to 1930 and which were woven nearby by a team of weavers directed by Evelyn Wyld.[36] In the spirit of Constructivism, Gray's textiles were designed according to the nature of the chosen material. She experimented with a variety of fibres, such as felt (packed wool fibre); she also utilised different carpet shapes, from square to circular, and explored numerous textile techniques, such as looped pile and shag, in an attempt to create new carpet formats and textures that would complement her modernist furniture and architectural programmes. Some of her carpets were, like Müller-Hellwig's, monochromatic and shaggy; others, such

as the felt mats, were flat and perforated, intended to absorb sound and serve as neutral cushions (fig.92). In fact, these stitched and perforated mats remain groundbreaking contributions to the history of constructive design by challenging conventional approaches to colour, pattern and materials.

Gray also designed visual patterns for her carpets, not through pictorial means but through the technique of collage, which she utilised as cartoons for rugs and wall hangings. These designs represent a dramatic shift in content from traditional pictorial woven work, such as those produced for centuries by renowned weavers at the weaving workshops in Europe, despite being produced under the same general conditions: that of a weaver following the cartoon or recipe made by someone else. Gray and other innovative carpet designers such as Bart van der Leck and Ivan Da Silva Bruhns did not actually weave their carpets and wall hangings, as did weavers at the Bauhaus and other important weavers such as Müller-Hellwig and the Swedish weaver Märta Måås-Fjetterström. Nevertheless, they succeeded in expanding the aesthetic potential of textiles by uniting geometric design with the textured surface of carpets.[37] These modernist wall and floor coverings replaced their pictorial ancestors and fused completely to the geometric *Gesamtkunstwerk* of the 1920s and 1930s décor.

As the heyday of Art Deco decoration was winding down, the Constructivist impulse took over as the prevailing modernist design ideology in England and America, especially as it applied to architecture and interior design. The Constructivist impulse in architecture was institutionalised and referred to as the International Style in 1932 by Alfred Barr, Philip Johnson and Henry Russell Hitchcock of the Museum of Modern Art for an exhibition of the same name. Indeed, the international discourse involving the principles of Constructivism –

maintaining truth to materials, focusing on construction, avoiding superficial ornamentation – grew exponentially during the late 1920s and into the 1930s due in large part to increased educational resources, theoretical publications, museum exhibitions and opportunities for independent designers to collaborate with architects. In addition, the closing of the Bauhaus and the subsequent emigration from the Continent by many of the stars of modernist design contributed to the spread and rise of international Constructivism in Great Britain and America.

In England, poet and art critic Herbert Read (1893–1968) became a vocal proponent for the Constructivist ideology, encouraging the unification of art and industry through a new approach to aesthetic design, which he put forth in his 1934 book *Art and Industry*. Like Morris and others before him, Read believed that the machine prevented artistic contact with and control over the product; yet, unlike his *fin de siècle* predecessor, he believed that designers could successfully unite art and industry by paying careful attention to the principles of construction and, by doing so, could compensate for the loss of direct contact.[38] Even a product such as machine-made lace, for example, 'a peculiarly individualistic art', Read explained, 'can be adapted to the machine and still retain its aesthetic appeal' if the designer follows the laws inherent to the materials and technique.[39] Read singled out as exemplars of this approach two machine-made lace pieces by Professor Otto Lange (1879–1944) (fig.93), who taught at the Staatliche Kunstschule für Textilindustrie (State Art School for the Textile Industry) in Plauen, Germany. Lange's use of geometric abstraction and repetition corresponded appropriately to the mechanistic regularity of machine production and created what Read described as an 'all-over' pattern that is aesthetically pleasing.[40] Read's early use of the term 'all-over', which is now used to describe the fully painted

surfaces of post-World War II Abstract Expressionist canvases, was particularly appropriate within the context of Constructivist textiles, for their designs were not organised around a central pictorial format but were naturally complete and inclusive – 'all-over', in other words, from end to end.

Read also singled out the Edinburgh Weavers for their intelligent and modern use of materials. Founded in 1928 by James Morton as an experimental branch of his firm Morton Sundour Fabrics Ltd and directed by his son Alistair Morton by the early 1930s, Edinburgh Weavers was equipped with an in-house weaving workshop and facilities for screen-printing lengths of fabric. In 1937, Edinburgh Weavers produced a line of textiles titled Constructivist Fabrics that were, paradoxically, printed rather than woven, but designed by artists and sculptors such as Ben Nicholson, Barbara Hepworth, Winifred Dacre and others who considered themselves Constructivists. It was in the realm of woven textiles, however, that Read commended Edinburgh Weavers, because their cloth was a product of direct understanding of the materials and the technique of weaving.[41] Read explained,

> Fabric structure is essentially numerical-arithmetical combinations and permutations of a given number of weft threads within a fixed and invariable warp. Good textile design is not afraid to reveal its geometrical foundations.[42]

Ethel Mairet (1872–1952) was a British weaver who worked in the Constructivist mode by exploring the properties of fibres and dyes – both natural and synthetic – in a variety of weave constructions that emphasised the textures and hues of the fibre, as seen in a photograph of her work from the 1930s (fig.94, p.112). In 1922, she established a weaving workshop called Gospels, which was staffed by

91
Marion Dorn
rug, Wilton Royal Carpet Factory Ltd (manufacturer)
*c.*1934
hand-knotted wool
200 cm x 122 cm (78¾ x 48 in.)

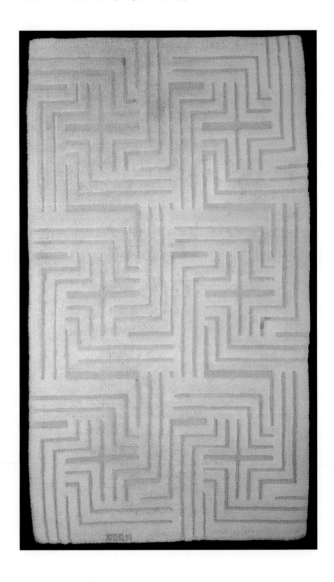

Eileen Gray
felt mat, designed *c.*1928
wool felt
223.52 x 135 cm (88 x 53⅛ in.)

apprentices, some of whom went on to have successful careers in weaving, such as Marianne Straub. Mairet, well known by the 1930s, travelled frequently in Europe in order to learn more about current trends in weaving by some of the leading innovators in the field such as Elsa Gullberg from Sweden, and Gunta Stölzl and Margaret Leischner who had worked at the Bauhaus.[43] Mairet applied what she learned to her woven work for industry and also to her writing, primarily through her second book, *Hand-Weaving Today* (1939) (Mairet's first book, *A Book on Vegetable Dyes*, was published in 1916). In contrast to many weavers and theorists, Mairet did not conceive of weaving as an independent art but one dependent on its utilitarian function, a philosophy that embraced the idea of collaboration. 'Hand-weaving has been in danger of developing on the wrong lines', she wrote,

93
Otto Lange
lace, illustrated in Herbert Read, *Art and Industry* (1934),
1947, page 130
12.7 x 8.89 cm (5 x 3½ in.)

It has set itself on a pedestal as 'art', instead of
recognizing its immense and interesting
responsibilities to present needs and to the
machine…It is dependent on architecture and
clothing; it must work in close collaboration with
both. It cannot ever be an art by itself.[44]

Mairet's words expose the constant tension involving
the value and role of modernist textiles in modern
life, as materials and their construction began to be
perceived as more important than individual
expression. However, this attitude was neither
universally embraced nor consistently adhered to.
Indeed, by the late 1930s, many artists had begun
to explore new artistic possibilities by creating woven
works that referenced personal visions and the
outside world and, in some cases, returning to the
practice of designing for pictorial tapestries.

The Constructivist Impulse in America

America lagged behind Europe in the number of
schools dedicated to investigating modernist woven
textiles until the early 1930s, when a number of
progressive institutions devoted to merging crafts and
industrial design – many of which were modelled
after the Bauhaus – opened in various locations
around the country. Among the most notable were
Cranbrook Academy of Art (1932), Black Mountain
College (1933) and the New Bauhaus (later named
the Chicago Institute of Design) (1937), with
weaving programmes directed by European émigrés
Loja Saarinen, Anni Albers and Marli Ehrmann,
respectively. These European émigrés, along with
many others who worked independently across the
country, spread the canon of Constructivism and
sensible design while embracing new financial and
artistic opportunities in America.

Eliel Saarinen, already internationally recognised
as a modernist architect and designer for whom the
Gesamtkunstwerk was a central principle, emigrated
with his wife Loja from Finland in the 1920s and
began working as an architect, planner and eventually
president of Cranbrook. His artistic ideas were
inspired by what he understood from the work of
Frank Lloyd Wright and members of the Bauhaus,
with the applied arts playing a significant role in his
vision of Cranbrook style from the beginning.[45]
Similarly, once in the United States, Loja Saarinen's
career as a weaver flourished; in 1928 she
established a weaving workshop, Studio Loja
Saarinen, for which she employed a number of
skilled weavers, including Maja Andersson Wirde and
Marianne Strengell, to produce wall hangings and
carpets, primarily for the school, but also for
commercial use, such as those commissioned by
Frank Lloyd Wright.[46] Saarinen textiles from the late
1920s and early 1930s are distinguished by

95
Eliel Saarinen and **Loja Saarinen**
photograph of Saarinen living-room, Saarinen House,
Cranbrook 1928–30

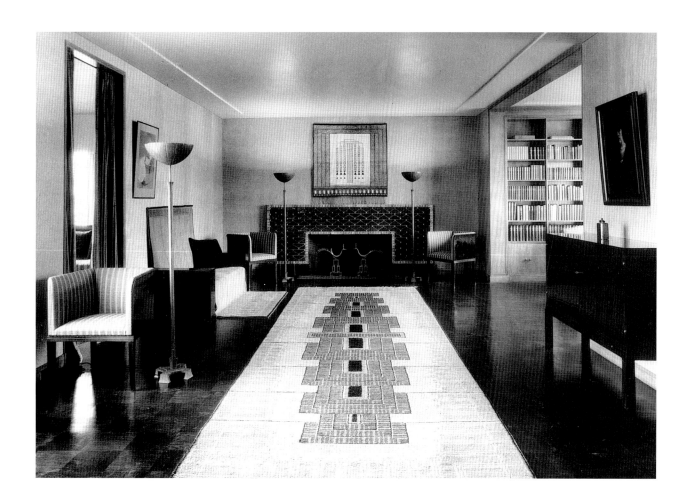

geometrically abstract and symmetrical patterns that recall Eliel's *ryijy* rug from 1904 (fig.25, p.51). The Saarinen living-room, for example, seen in a photograph from 1928–30 (fig.95), exemplifies a total work of art, unified by woven pieces, designed and produced by Studio Loja Saarinen, which are dominated by a spare pattern of blocks, dots and stripes that not only correspond to the architectural

motifs but also shaped the space through texture, size and capacity to filter light.[47] More pictorial than later Bauhaus works, but not excessively decorative, these textiles embody a unique conflation of Scandinavian and folk-inspired textiles, Constructivist use of materials and harmonious pattern design. Later, weavers in the studio began to introduce more referential and descriptive forms, such as human

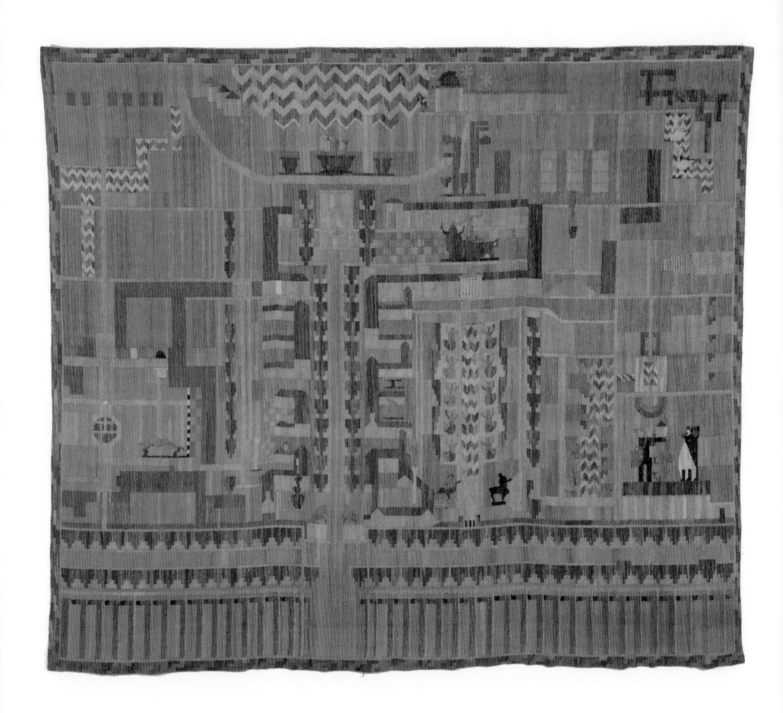

96
Eliel Saarinen (designer), **Studio Loja Saarinen** (weaver)
Cranbrook Map Tapestry 1935
linen warp; linen silk and wool weft; plain weave with discontinuous wefts
262.9 x 313.7 cm (103½ x 123½ in.)

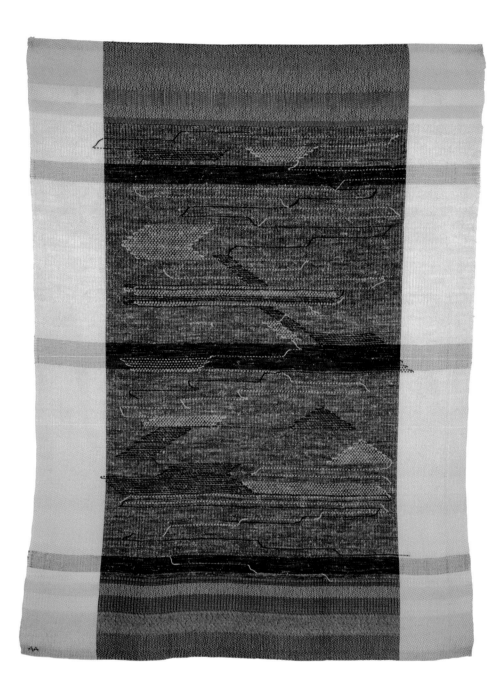

97
Anni Albers
Monte Albán 1936–37
woven silk, linen, wool
146 x 112 cm (370⅞ x 284½ in.)

figures, animals and buildings, while continuing to lock these forms into the geometric structure of the weaving medium. For example, a 1935 tapestry designed by Eliel and woven by Studio Loja Saarinen (fig.96) signals the workshop's move away from the spare designs of a few years earlier toward a more narrative focus. The weaving is in fact a bird's-eye map of Cranbrook that depicts identifiable landmarks on the campus, including trees, people, buildings, even a sculpture of *Europa and the Bull* by Carl Milles.[48] The symmetrical organisation and natural hues of earlier textiles have been replaced by colour shapes that describe and represent water, rooflines and plants, shifting the textile's function from utilitarian construction to pictorial representation.

At Black Mountain College, Anni Albers' work was undergoing a similar transformation as she developed her strict Bauhaus vocabulary into a more poetic and pictorial one, due in large part to changes she was experiencing in her own life as a European coming into contact with ancient American, Native American and American vernacular art traditions. A major shift occurred in Albers' art and writing in the mid-1930s after she and her husband, Josef, made the first of many trips to ancient Mesoamerican sites, including Monte Albán and Teotihuacán. Her weaving, which had become primarily utilitarian at the Bauhaus, became more pictorially referential and individualised. She began to assign titles and her signature to her now one-of-a-kind wall hangings, such as *Monte Albán*, 1936–7 (fig.97), which refers to the ancient Oaxacan site, and she began to use a new technique, the supplementary-weft brocade, or 'floating' weft, which allowed her to float, knot and draw thread across the surface of the cloth.[49] She also continued to exploit the natural properties of the materials and to incorporate patterns that were inherent to particular weaving structures. In *Monte Albán*, Albers limited her colour palette to the characteristic hues of the natural silk, linen and wool fibres while maintaining a strict geometric regularity corresponding to the under and over weave construction, but she added a pictorial dimension in the form of surface lines that refer to the pyramids, plazas and platforms of the ancient site. Working with materials had now become both a practical and spiritual experience for Albers, and she would continue exploring this merging of Constructivist and pictorial elements for the next three decades. In her 1937 essay, 'Work with Materials', she explained,

> If we want to get from materials the sense of directness, the adventure of being close to the stuff the world is made of, we have to go back to the material itself, to its original state, and from there partake in its states of change. We use materials to satisfy our practical needs and our spiritual ones as well.[50]

William Morris would have approved of this philosophy but, like others of her generation, Albers was not opposed to the machine, in part because it saved time and reduced 'the boredom of repetition'.[51]

Albers was probably familiar with the woven work of her contemporaries Dorothy Liebes (1899–1972) and Maria Kipp (1900–1988), who were working on the other side of the country in California, because their career paths and aesthetic ideologies were very similar. All three weavers used handlooms to create utilitarian cloth, although none were opposed to designing prototypes for industry, and all worked on large-scale architectural programmes that brought them financial and artistic recognition. Furthermore, all three weavers explored unconventional materials, such as cellophane, wood splits, metallic yarns and other synthetic and natural materials, in a broad range of weave structures and textures to create new types of woven textiles for modern needs.[52]

Interestingly, both Albers and Liebes followed similar paths toward making unique works of art in thread that went beyond utility, often with only a title to clue the viewer into the descriptive meaning. Liebes did not title her cotton, silk and rayon wall hanging from 1936 (fig.98), but some of her similar works from the time have titles such as *Tree of Life* and *Autumn Fields of Kansas*, indicating that she, like Albers, envisioned her work functioning on a number of levels. As Liebes explained, 'the artist-designer of today is less shackled by tradition than ever and more free to translate his inner experiences and inspiration into concrete form'.[53] Through weaving, these artists used essentially abstract and Constructivist designs but gave them titles that imbued the textiles with narrative content.

Maria Kipp used her practical and artistic skills to transform and enliven the interior spaces of modernist buildings through weaving. Kipp attended the School of Applied Arts in Munich from 1918 to 1920, where Gunta Stölzl and Alen Müller-Hellwig had studied, before attending the more technical Staatliche Hohere Fachschule Für Textilindustrie (State Academy for the Textile Industry) in Münchberg, where she earned a degree in textile engineering.[54] In 1924, Kipp and her husband moved to the booming city of Los Angeles, where she quickly established a successful hand-weaving business through commissions from International Style architects including Richard Neutra and Rudolph Schindler.[55] Kipp produced primarily hand-woven drapery fabric using innovative leno (open-weave) and loop weaves, and synthetic and natural fibres, in carefully coordinated chromatic palettes. Kipp's drapery fabric from c.1940 (fig.99) was woven using linen, Lurex (metallic yarn) and rayon, with two lush, pumpkin-coloured chenille stripes down each side. The combination of textures and tones, and the interweaving of horizontal and vertical bands, creates a sense of three-dimensional depth while retaining a rich surface interest.

By this time Kipp was almost certainly familiar with theoretical positions and practical applications, especially those by Mies and Reich, which advocated the use of fabric to completely cover walls as a method of enlivening and extending space. Furniture designer and theorist Paul Frankl, in his 1928 book *New Dimensions: The Decorative Arts of Today in Words and Pictures*, stated a similar conviction: 'A room completely hung with fabric makes for slight formality but, surprising as it may seem, it creates an effect of space and distance'.[56] Under these conditions, fabric itself becomes the decorative element, replacing wall art, easel painting and murals as the primary element of visual interest.

These groundbreaking advances in Constructivist textiles, including those that re-introduced pictorial references while still maintaining a Constructivist impulse, expanded the scope of modernist textile creation, production and pedagogy by introducing such innovations as the textile prototype, the monochromatic textile and the textile to shape the architectural environment. Interestingly, however, many artists working in textiles during this period up to the 1940s deliberately chose not to embrace the non-objective language of Constructivism but to explore textiles that expressed more obvious pictorial and, in some cases, even propagandistic concerns. By the end of the 1930s, the capacity of textiles to function on a multitude of ideological and artistic levels had reached such a state of maturity through innovation that it was now possible for textile work to touch on an expanded range of approaches – abstract, pictorial, political, Constructivist, machine-made, handmade – while still engaging in the discourses of modern life.

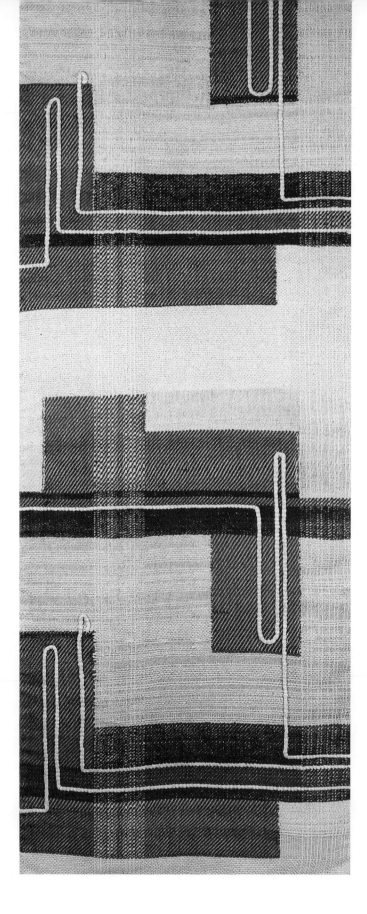

98
Dorothy Liebes
wall hanging 1936
cotton, silk, rayon; hand-woven
tapestry, with floating weft
264.2 x 81.3 cm (104 x 32 in.)

99
Maria Kipp
textile length for drapery c.1940
linen, chenille, Lurex, rayon
289.56 x 132.08 cm (114½ x 52 in.)

Chapter Five:
Nationalism, Surrealism and Pictorialism in the 1930s

using the linoleum block-print technique.[4] This technique, similar to traditional wood block-printing, is a laborious but straightforward printing process whereby a line drawing is carved into a linoleum block; the block is then rolled with textile ink and pressed onto cloth – in this case canvas, linen and other inexpensive fabrics – to create a singular image or, if sequentially repeated, a printed length of cloth. A block-print is thus composed of both negative and positive space, depending on whether the figure or the ground is carved away. This figure/ground relationship is characteristic of the block-print technique and was carefully controlled and exploited by some of the more experienced designers of the MHP, especially Barbara Warren (later Weisman). Her cotton wall hanging, occasionally referred to as *Fertility* (fig.101), represents a *tour de force* block-printing effort on the part of Warren and her team, who created and manipulated five separate blocks (two for the outer border, one each for the inner border, central image and the upper and lower registers) representing the themes of corn and fertility. Three healthy women pose amid a crop of ripe corn surrounded by a border of corn and stalk motifs. This expression of both agricultural abundance and female sensuality, and by implication fertility, would certainly have struck a chord with the people of the heartland in the midst of the depression. Though it is a print and could have been reproduced, it is likely to be a unique piece, as it is lined and equipped with loops for hanging. Most MHP textile designers created less complex images of American icons: fir trees, tepees, deer, eagles, school houses and farm animals were all popular, as well as storybook characters such as the Pied Piper, which probably graced the windows of a nursery school.

Modernist Impulses and the American Identity

Such textiles seem connected neither to Constructivist attention to materials nor to investigations of geometric abstraction that were being produced at the same time by artists such as Maria Kipp and Sonia Delaunay. Yet, as the work of Anni Albers, Dorothy Liebes and Loja Saarinen in the 1930s makes clear, the power of representing and referencing the natural world often became more important than adhering to a strict formalist discourse. The era itself seemed to demand a new attention toward documentation and reflection.

America's fascination with pictorial and narrative themes remained strong during the 1930s. Many artists and writers were reluctant to embrace artistic styles and structures perceived as incomprehensible and cold, preferring to align themselves with humble folk and sublime landscape traditions. In the realm of painting, for example, the rather paradoxical idea of locating and celebrating America's 'home-grown' artistic ancestry was embraced by artists, critics and government sponsors alike who were looking for specifically non-European models to advance as distinctly American, despite the fact that the entire American population, other than indigenous Indians, was the product of importation and immigration. Ironically, this development occurred at the same time that US officials were tightening immigration and tariff laws. It was during this period that the legacies of home-grown masters Winslow Homer, Thomas Eakins (who studied in Europe) and Albert Pinkham Ryder were established. This American 'triad' inspired a new generation of regionalists including Thomas Hart Benton and Grant Wood, whose work, such as Wood's *American Gothic* of 1930, was more palatable and comprehensible to the vast American public than contemporary abstract work by, say, Kandinsky or Picasso.

art from Mexico and Central and South America, including 16 Andean textiles, with paintings and sculptures by modern artists such as Diego Rivera, Max Weber and William Zorach.[1] In the latter book Cahill explained,

> Modern art, like everything else in modern culture, has a complex heritage. Among the diverse sources upon which it has drawn is the art of the ancient civilizations of America.[2]

Cahill's curatorial and scholarly innovations, which continued into the next decade, provided both the visual and pedagogical foundation for a new understanding of American and modern art. Cahill did not claim that the art of Pre-Columbian and Native American societies formed part of America's cultural ancestry, though other critics were making that assertion in their effort to establish an artistic tradition separate from Europe. Although it grew out of an imperialist impulse, the desire to claim a connection between indigenous and modern cultures did serve to elevate national awareness of diverse art traditions elsewhere in the Western hemisphere.

Textiles factored into FAP developments in a variety of ways: through large-scale block-printing projects such as the Milwaukee Handicrafts Project; through documentation projects such as the Index of American Design; and through education programmes across the country designed to revive regional textile traditions, from Indian blankets to Appalachian coverlets. These projects were linked by their shared goal of uniting art and utility and of encouraging awareness of the nation's cultural identity.

In 1935, the Milwaukee Handicrafts Project, under the direction of Elsa Ulbricht (1885–1980), was established to provide women, including African-American women, and later men, the opportunity to earn a living by producing hand-crafted objects such

101
Barbara Warren
Fertility wall hanging produced for the WPA Milwaukee Handcrafts Project 1935–42
linoleum print on cotton
128 x 81.9 cm (50⅜ x 32 ½ in.)

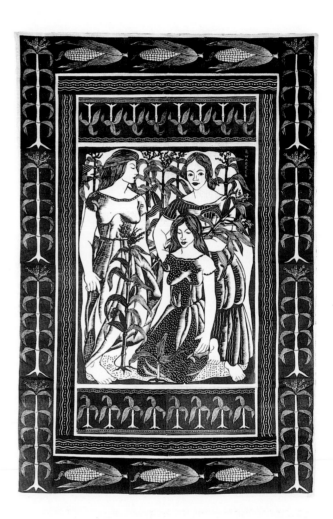

as furniture, rugs, toys and books and especially block-printed wall hangings and furnishing fabric for use in federally funded schools and hospitals and for sale to the public.[3] The block-printing unit alone employed over 5000 skilled and unskilled designers, carvers and printers who, during its eight-year existence, produced a remarkable variety of images

100
bandana
transfer lithography on cotton
56.5 x 55.9 cm (22¼ x 22 in.)

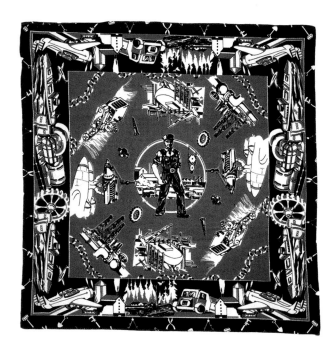

Lee, Dorothea Lange and Walker Evans, remain remarkable today as records of American life during the depression years. Textiles also reflected the era. A bandana from the period (fig.100) was most likely created to celebrate the hope and progress that the WPA brought to Americans. The overall-clad worker in the centre symbolises the power and success of honest work. Surrounding him is a revolving circle of screws, gears and bolts, which in turn is bordered by examples of machinery and technology in the form of turbines, tractors, cranes, pumps, boats and planes, all of which are unified in a field of red, white and blue on sturdy cotton cloth. This textile, representative of most WPA endeavours, embodied the New Deal mission to fulfil both ideological and utilitarian goals.

The Federal Art Project (FAP), directed by writer and museum curator Holger Cahill (1887–1960), was the cultural branch of the WPA. The FAP supported an extensive range of artistic endeavours by employing artists, writers, educators, curators and historians to express and document the modern American experience while preserving and reviving America's cultural past. Artistic works in all media, from murals to posters, from theatre to literature, were created by thousands of artists through FAP funding. Cahill was instrumental in not only promoting America's artistic past but also in linking that past with the modernist present. Some of the innovative exhibits that he organised for the newly established Museum of Modern Art in New York (founded in 1929) before becoming head of the FAP include the 1932 exhibition *American Folk Art: The Art of the Common Man in America 1750–1900*, a survey of the American crafts tradition found in folk, or non-professional, art that Cahill advanced as a vibrant, vital and uniquely American artistic expression, and the 1933 exhibition *American Sources of Modern Art*, for which he juxtaposed Pre-Columbian

emerging national identity by literally recording their observations of specific events and turning points.

The largest of Roosevelt's federally funded New Deal programmes was the Works Progress Administration (WPA), established in 1935 (later called the Work Projects Administration), which promised work and security to those in need, and supported building, training and cultural projects at both the national and regional levels. Some of the nation's most beautiful roads and national parks were created or refurbished under the auspices of the WPA. The documentary photographic portfolios supported by the Farm Security Administration, a branch of the WPA, which included work by Russell

Three divergent trends in modernist textiles emerged during the 1930s that differed from ongoing trends in Constructivism and surface-designed textiles: one concerned with promoting nationalist and domestic agendas, another with further elaborating the international visual language of modernism through Surrealism, and the third with re-invigorating the pictorial tapestry tradition. The scope of creative expression in textiles during the 1930s was thus extensive and highly varied, with subject matter ranging from depictions of Uncle Sam on one end of the spectrum to free-floating amoebae on the other. Modernist textiles of the 1930s could express both political agendas and personal visions. As totalitarianism gained momentum in Europe, and the depression hit hard in America, artists and designers, many now funded by state sources, responded to these events by developing new styles that reflected the era. These political, social and aesthetic developments, integrally related and occurring simultaneously during the 1930s, inspired a variety of artistic responses. Textiles were at the forefront of many of these developments; because of their inherent versatility, artists could use them to perform a variety of functions quickly, publicly and creatively.

The changing social, political and economic conditions in the years preceding the second catastrophic World War impacted the content and form of the visual arts in all media. A new desire on the part of artists and governments to depict the realities as well as the myths of their individual national identities led to the emergence of such new artistic movements as Regionalism, Social Realism

115 (left)
Elsa Schiaparelli (designer)
Une Main à Baiser (A Hand to Kiss) (detail) dress fabric
1936
printed silk crêpe
46.36 x 47.63 cm (18¼ x 18¾ in.)

and Folk Revivalism. At the same time, other artists, architects and theorists continued to work with the streamlined formalism of international Constructivism and to investigate new technological developments. Still others pursued Surrealism as a means of exploring a visual language generated by psychoanalytic theories, dream imagery and automatism. Some of these concerns were manifested in mass-produced, machine-printed textiles; others were expressed through handmade compositions utilising techniques such as quilting, appliqué, needlepoint and tapestry.

The American Identity

In America, the goal to establish a cultural identity and patrimony was both political and artistic. While the state sought to consolidate collective resources and ideologies in the face of economic and political isolation, artists worked to recover and promote America's colonial and indigenous artistic traditions in an effort to define a true American art. Federal work relief programmes initiated by Franklin D. Roosevelt from 1933 to 1942 in response to the depression, in addition to other non-profit and individually sponsored programmes, were essential in helping artists realise these ambitions. Whether publicly or privately supported, these programmes shared the common goal of improving economic and cultural conditions in the United States by helping isolated and impoverished groups – from the Native American and Hispanic societies of New Mexico to pockets of farmers in the Appalachian Mountains – by preserving craft traditions as well as organising educational and marketing programmes that would help these communities support themselves. Many individual artists responded to the changing American social climate and contributed to the

102
Walter Dorwin Teague
Buttresses of the Transportation Building, Century of
Progress Exposition, Chicago 1933
printed silk
36.8 x 46.7 cm (14½ x 18⅞ in.)

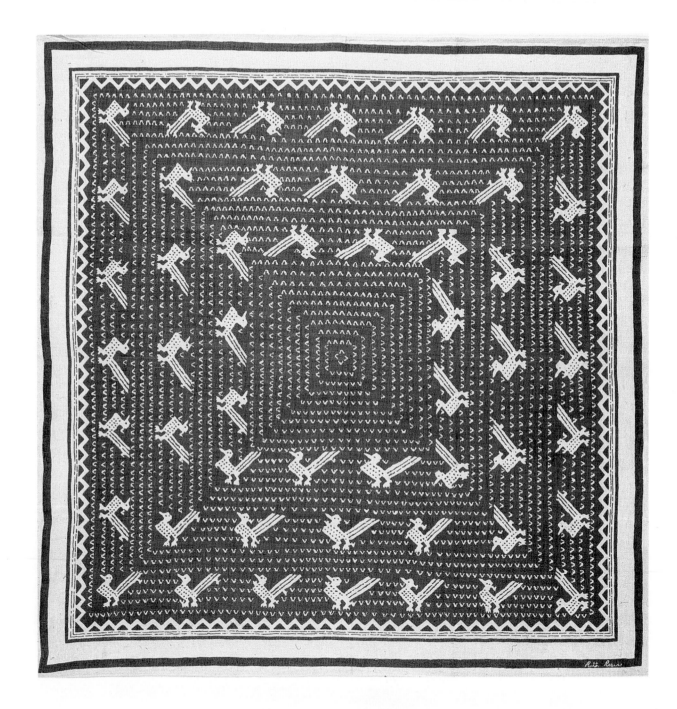

103
Ruth Reeves
tablecloth c.1935
screen-printed linen
89 x 90 cm (35 x 35⅞ in.)

104 (right)
Fannie B. Shaw
The Fannie B. Shaw Prosperity Quilt, Prosperity is Just
Around the Corner 1930–32
cotton; appliqué, embroidery, quilting
218.44 x 182.88 cm (86 x 72 in.)

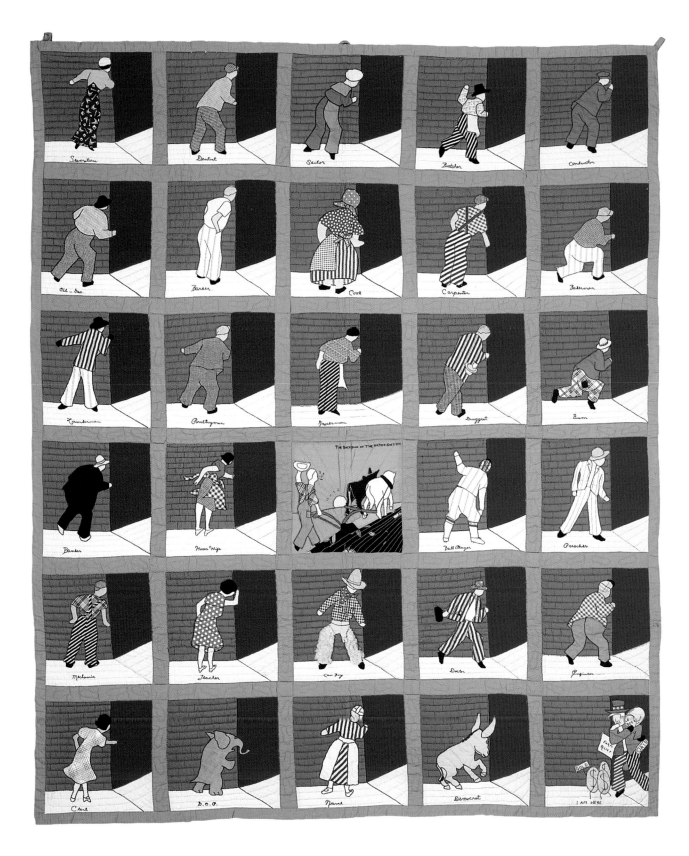

A different group of American artists, many of whom studied art in Europe or at the progressive Art Students League in New York, struck a balance between representation and abstraction with a new hybrid style that combined abstract pictorial figuration with regionalist subjects. For a series of textiles that industrial designer Walter Dorwin Teague (1883–1960) designed for Marshall Fields department store to celebrate the architectural and technological achievements at the 1933 *Century of Progress Exposition* in Chicago, Teague adapted the modernist use of fragmentation and simultaneity to what would become a distinctly American icon: the famous steel buttresses gracing the Transportation Building (fig.102). Teague cleverly softened the scale and coldness of the massive structures through monochromatic background colours and through regular repeats that dissolved the buildings into decorative and rhythmic patterns suitable for fashioning into a summer dress.

Ruth Reeves also utilised modernist visual forms for regional subjects. After she returned to the United States from Europe in 1928, she embarked on a number of textile projects, including her 1930 screen-printed textile series on Americana for W. & J. Sloane company, which included her well-known *Manhattan* textile (fig.77, p.110), and her carpet and wall fabric designs for the new Radio City Music Hall in 1932. For these textile projects Reeves combined representational imagery – skyscrapers, cars, trains and family scenes – with fragmented planes and collage-like silhouettes to create vibrant and engaging images of modern American life. By the mid-1930s, she was exploring additional sources of artistic expression that deepened her connection to Americana, first by travelling to Guatemala in 1934 with funding from the Carnegie Foundation, then by initiating the Index of American Design in 1935, a project funded by the FAP.[5]

Reeves spent four months touring Guatemala, during which time she travelled to ancient Maya sites, recorded her observations in sketchbooks, collected textiles and resided in tourist hotels such as the Mayan Inn, near the ancient site of Tikal, for which she eventually created the interior furnishing textiles.[6] By this time, many ancient Mesoamerican sites in Guatemala and Mexico, such as Tikal, Uxmal, Monte Albán and Teotihaucan, had become tourist destinations for other artists too, including Josef and Anni Albers and members of the Surrealist circle who, although fleeing Europe under unfavourable circumstances, were able to enjoy the vibrant international art community in Mexico and learn about regional artistic traditions, especially the rich textile traditions. Anni Albers, for example, who toured Mexico in 1935 with Josef, most likely wove on a backstrap loom for the first time when she visited Santo Tomas, a small village near Tikal and the Mayan Inn; later, she required her students at Black Mountain College to weave on these low-tech looms, for which one end of the warp is attached to a stable support, such as a tree, while the other end is strapped around the waist to create the proper tension for the weaver to interweave the weft threads.[7] Reeves, too, returned from Guatemala with new ideas for textile designs, such as a series based on her interpretation of Guatemalan colours, weaves, motifs and textile techniques.[8] Her green and white screen-print (fig.103) of stylised birds and scratch marks demonstrates how she used her knowledge of and appreciation for the patterns and colours of Mexican textiles without directly copying them. Years later, after travelling to Peru, she wrote of her modernist approach to ancient textile sources: 'If [my] contemporary fabric has artistic authority and appropriateness for today's living, it is because, regardless of its original inspiration, it is firmly rooted within the framework of twentieth century design and ways of life'.[9]

American Regionalism and Revivalism

Reeves also sought out examples of colonial and American Indian textiles to analyse and from which to draw inspiration but found it difficult to locate visual reproductions and documentary information about these applied arts traditions. She and librarian Romona Javitz subsequently conceived a plan in 1935 to create a repository of American design, the Index of America Design, which was supported and encouraged by FAP director Cahill.[10] Between 1935 and 1942, a nationwide group of artists meticulously recorded and rendered in watercolours thousands of objects, including examples of embroidery, quilts, coverlets, lace, samplers, blankets and hooked rugs.[11] The Index of American Design represented a concerted national effort to locate the 'sources' of American cultural identity, and this effort, in which textiles played a significant role, continues to inform scholars and artists today through documentation of over 18,000 objects under the auspices of the National Gallery of Art in Washington, DC.

One of the ways that artists recovered and promoted the American past was by working in vernacular American art forms, such as quilting, weaving and embroidery. Quilting, for example, was practised nationwide and developed from a broad range of traditions and societies from African-American, to Amish, to Appalachian. Most quilts are created through multi-media techniques that unite appliqué (stitching pieces of cut cloth together on their edges), embroidery (surface stitching) and quilting (stitching together layers of fabric from front to back to form a unified layer), and range in style from highly complex piecework, to random or 'crazy' piecework, to framed pictorial narratives.[12] The technique of making pictorial quilts, traditionally utilised to narrate current events, was adopted by a varied group of artists in the 1930s to express auto-biographical histories and to tell stories of the time in linked compartmentalised squares of information.

Fannie B. Shaw chose a combination of these quilting techniques and styles to simultaneously make a picture and tell a story of the times. Her 'Prosperity' quilt (fig.104), from 1930–32, was meant to express the anxiety that gripped most Americans after the stock market crash of 1929. 'My inspiration came from Herbert Hoover', she later stated. 'Every time you picked up the paper or heard the radio he would talk about good times around the corner. He would make it sound so good. I wondered if I could make a picture of what he said and what he meant. I went to bed one night and couldn't get it off my mind'.[13] Shaw's picture is composed of 30 separate squares surrounded by frames (called sashes) quilted with tiny footprints, in which Shaw depicted a variety of individual types – cook, house-wife, mechanic, nurse – each looking around a corner, waiting for luck to come their way. Uncle Sam, symbolising government subsidies, is depicted in the lower right corner holding 'legal beer' and following three little gold coins walking on legs. Meanwhile, a farmer, 'the backbone of the nation', as Shaw literally stitched onto the fabric, labours industrially at his plough. By making her picture in fabric and using the quilt technique, Shaw could combine text and image, flatness and depth, and reality and fantasy in a repetitive format that other techniques could not replicate. This quilt is indeed a telling picture of the times, created on the backdrop of a utilitarian item that, if things got worse, could have substituted as a warm bedcover. Indeed, American textiles from the 1930s are characterised by this dual artistic and utilitarian functionality.

The quilting tradition was particularly strong in the American South. This tradition, as seen in Harriett Powers' story quilts from the nineteenth century (fig.20, p.44), was characterised by an

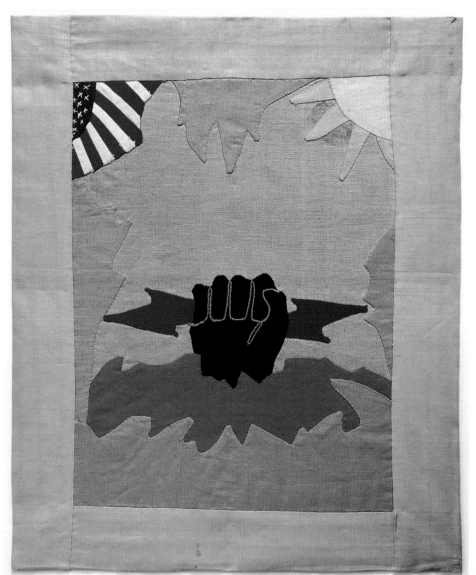

105
Ruth Clement Bond
(designer),
Rose Phillips Thomas (maker)
Tennessee Valley Authority
Appliqué Quilt Design of a
Black Fist 1934
cotton and yarn; pieced, sewn,
and stitched
32.7 x 27.3 cm (12⅞ x 10¾ in.)

106 (right)
rug, 'Proud to be an American', Kirtland, New Mexico
c.1920–40
wool tapestry weave
178.4 x 137.8 cm (70 x 54 in.)

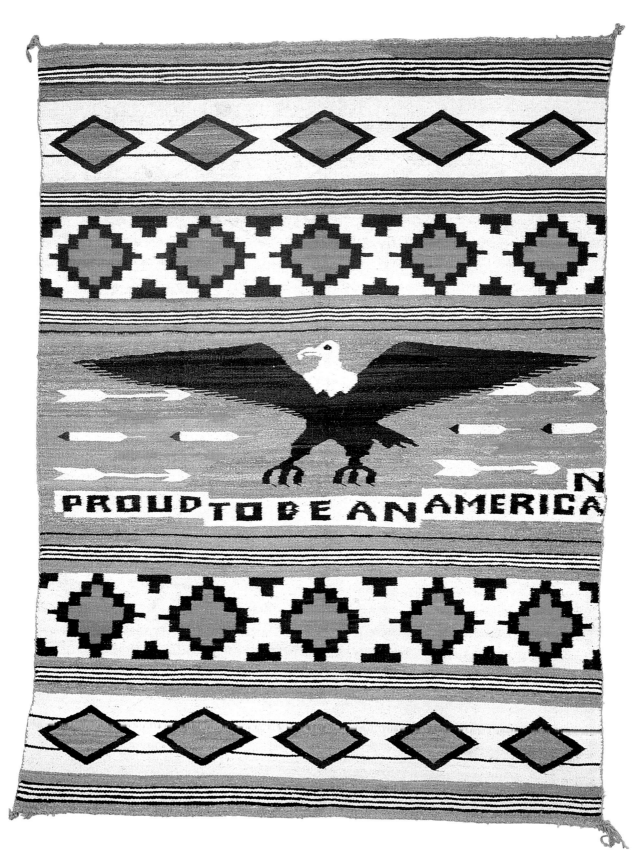

emphasis on narrative and pictorial stories through a technique similar to Fannie Shaw's that united quilting and appliqué but in less formally structured compartments. In Tennessee during the 1930s, Ruth Clement Bond (1904–2005) found her artistic voice through the pictorial quilt vernacular of her African-American heritage in order to share stories addressing her American identity and experiences.[14] She enlisted trained quilter Rose Phillips Thomas to help her elaborate on this tradition and to create small quilted wall hangings inspired by themes of hope and industrial progress. The process was collaborative: Bond designed and cut pieces of cloth, and Thomas stitched them together to create graphically dynamic visual statements. Bond, like many others living in depression-era Tennessee, was elated that the government, through the auspices of the Tennessee Valley Authority (TVA), had brought electric power to the rural communities around the Tennessee River. One of their quilts from 1934, for example, depicts the silhouettes of a man and a crane in an obvious reference to the many TVA dams under construction at the time. That the crane is impossibly perched on a spiky earthen outcropping and is depicted in a smaller scale than the man does not detract from the overall message of progress through labour. Through such industrial progress, Bond envisioned improved conditions for herself and other African-Americans. Indeed, her very first quilt, the 1934 'Black Power' quilt (fig.105), was made to celebrate this progress and power. Bond emphasised the centrally focused black fist holding a thunderbolt – a dual symbol of both black power and electric power – graced by the sun and an American flag in the upper corners. As Bond stated later,

> Our first quilt we called 'Black Power.' That was a pun, of course, TVA being about power. The first quilt showed a bolt of lightning signifying power, held in the hand of a black worker. I gave the quilters the material cutouts and selected the colors. I never learned to quilt, but I made and cut the patterns and made the designs for them. Some people say this was the origin of the term 'black power'. The only thing I was trying to say was that things were opening up for the blacks in the South. The first student interns in the Authority came from many of the black colleges like Fisk and Tennessee State.[15]

These quilts are fascinating in that they reveal a continuity of vernacular textile traditions and techniques transformed though new attention to contemporary events.

In the 1930s, American Indian societies and their rich weaving traditions were also in a state of transformation. Indian societies living in reservations had been generally isolated except for contact with tourists, traders or representatives of oil and mineral companies who leased Indian land. Woven blankets from Southwest Indian societies of this time period are particularly interesting because they exemplify both authenticity and use of traditional materials, uninfluenced by the rest of the culture, and reveal evidence of cultural crossover through use of synthetic dyes, commercial yarns and American icons.[16] These blankets, originally used primarily as mantles but later as rugs, were traditionally woven from naturally hued and dyed cotton and sheep wool on upright looms woven in an upward progression from bottom to top in horizontal registers. Complex information in the form of abstract patterns, symbols and colours was woven into the blankets, which could be understood by those familiar with their meanings. But as brightly hued synthetic dyes became more available, and increased tourism made trade more lucrative, the blankets began to reflect a hybrid cultural blending. For example, a blanket from

107
Russell Lee
Spanish-American woman weaving rag rug at WPA project
(Works Progress Administration), Costilla, New Mexico
1939

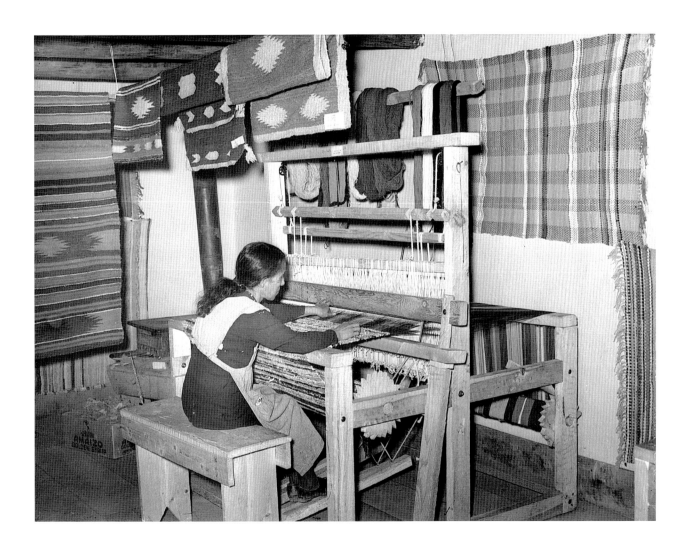

108
Pendleton Woollen Mills
blanket, Green Center Point pattern *c.*1920s–30s
wool
approximately 203 x 162.6 cm (80 x 64 in.)

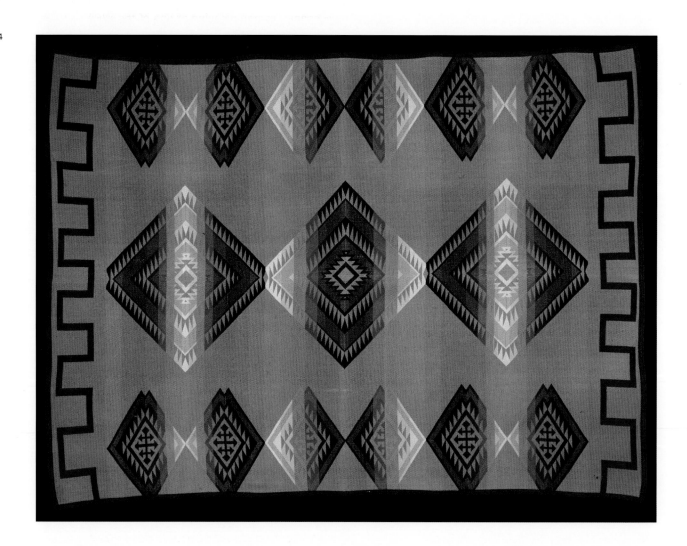

Ashcroft Rug Traders on the Navajo Reservation in
Kirtland, New Mexico (fig.106), was woven in the
1920s or 1930s by a Navajo weaver who noticed
and wanted to capitalise on the tourist market,
perhaps in collaboration with the trader.[17] The blanket
wool was woven in the traditional technique, but the
content, a hybrid mix of bright orange arrows,
stepped diamonds and a flying central eagle, along
with the bold textural phrase, 'Proud to be an
American' (from which the 'n' of American has been
woven into the next register up, because of a space
planning error or misspelling), is clearly meant to

nation through state-controlled industrialisation and agricultural modernisation translated well to the pictorialist mode. A textile by V. Maslov, titled *New Life in the Countryside* (fig.110), celebrates a bountiful harvest made possible through the efforts of collective farming; tractors and wheat harvesting machines, manoeuvred by unified teams of workers, are framed by gigantic wreaths of fruit and flowers to form a cleverly choreographed pattern.[34] Interestingly, the message of progress through industrious labour is not that far removed from the American red-white-and-blue bandana produced around the same time, for both present positive images of progress brought about through significant government restructuring. Other examples of Soviet textiles from this period show gears intermingled with emblematic hammers and sickles to symbolise the unity of state agriculture and industry; still others simulate folk embroidery to pay homage to the rural and peasant classes, the new proletariat workers. These pictorial references were clearly intended as alternatives to the starkly geometric designs Popova and Stepanova created under Lenin's regime, designs now perceived as élitist and incomprehensible. Popova and Stepanova had attempted to re-envision the very function and image of textiles and clothing for a new society by inventing a new, abstract visual language, while designers of pictorial textiles from the Stalinist period manipulated popular imagery in an almost cinematic way to create a picture of reality that could be collectively understood.[35]

In fascist Italy, as well as in Nazi Germany, textiles were used to appeal to the greatest common denominator through the repetition of symbols and references to the common people, a strategy that harks back to Wagner's notion of the *Gesamtkunstwerk*. A scarf from the late 1930s (fig.111) functions as a blatant political poster, an overdetermined effort to get the fascist point across

through a combination of folk motifs, political emblems and repeated text. The fascist regime encouraged women to wear regional costumes, which included wearing scarves with embroidered or simulated embroidered floral motifs, to show national pride in the country's fine regional handcrafts traditions; Mussolini in fact created a national regulatory body in 1932 for the specific purpose of controlling women's dress.[36] While the floral motifs on the corners of this scarf imitate traditional embroidery, and the grain symbolises bountiful harvests, these motifs – and by implication regional identities associated with them, as well as women's roles – were kept in check by the deliberate insertion and repetition of the fascist emblem, the *fasces*. Mussolini had appropriated this symbol in 1926 from a traditional Roman emblem – a bundle of birch surrounding an axe, tied with a ribbon – to symbolise authority and power.[37] Just in case the message was too subtle, the designer filled the centre of the scarf with the word 'DUCE' repeated 20 times. The text here functions like a fascist chant; from every vantage point one perceives the collective shouting of Mussolini's commonly used title, 'LEADER'. The wearer of this scarf could be confident that she was proclaiming her affiliation loud and clear.

In the United States during the late 1930s, graphic art and design was successfully utilised to make political statements by growing student political movements, such as the American Student Union and the American Youth Congress. These active organisations supported racial integration, academic freedom, school financial aid and other social causes.[38] The Union Arts Service, a printing production house associated with the student protest movement, produced screen-printed textiles and graphics to function as consciousness raising posters. The 'Rebel Arts' division of Union Arts produced a series in 1939 that featured bold, single-colour prints

111
Italy, silk scarf late 1930s
73 x 73 cm (28¾ x 28¾ in.)

112
'Rebel Arts' division of Union Arts Service, New York *Stop
Lynching Shame of America* 1939
ink on cotton
90.8 x 57.8 cm (35¾ x 22¾ in.)

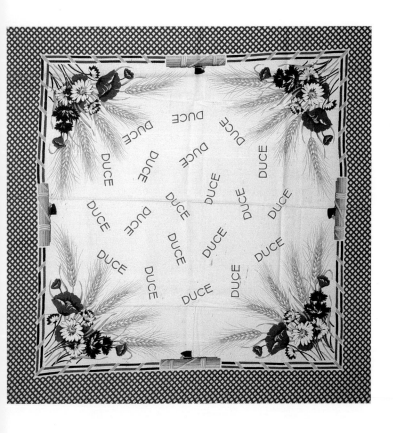

addition, these pictorial textiles often included
political emblems, texts to songs and pledges, and a
repetitive structure that amplified the message
exponentially. These visual strategies made it more
likely that viewers would respond to the image as
something 'real' and believable.

Some of the best-known political textiles are the
Soviet printed cottons that were produced during
Stalin's regime, particularly those from the late

1920s and 1930s that served as allegories to
illustrate the promises of Josef Stalin's first and
second Five-Year Plans (1928–33, 1933–37).
Pictorial and representational in form, these textiles,
produced at the same state-owned factories that
briefly manufactured Popova's and Stepanova's non-
objective and geometric innovations of 1923–24,
were designed with the collective conscious in
mind.[33] Stalin's promise to create a self-supporting

V. Maslov
New Life in the Countryside, cotton textile 1926
printed cotton
62.5 x 59.5 cm (24$\frac{7}{5}$ x 23$\frac{7}{5}$ in.)

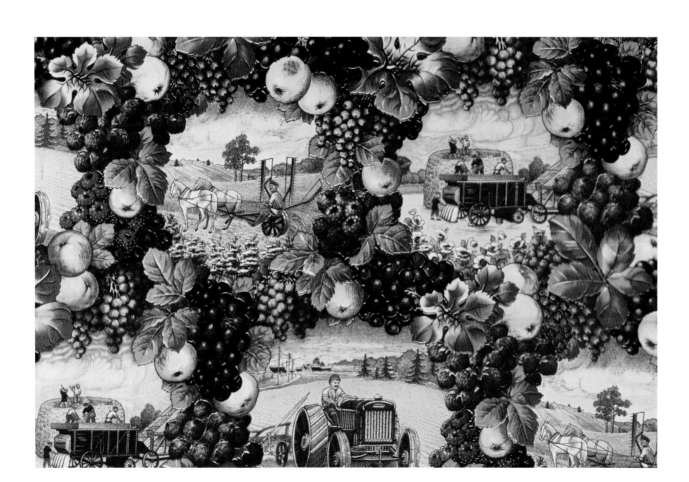

flexible and versatile nature of textiles allowed them to function on a variety of levels during the 1930s for governments and organisations seeking opportunities to spread their ideological messages.[31] Textiles, especially those from fascist Italy, the Soviet Union and the United States, help to illuminate a significant modernist development involving the use of art and design for propagandistic purposes.[32]

Most textiles that were designed to communicate political agendas utilised traditional narrative and representational imagery – which required the reintroduction of folk motifs, figurative pictorialism and political symbols – to clarify the message and ensure that it was received by a majority of individuals. To create images that were easily readable and understood, designers often used the photographic print process, using an actual photograph on which to base the screen- or roller-printed images. In

weaving produced at Berry College in Georgia in the 1930s reveals the 'Whig Rose' pattern (fig.109), 'the favorite old pattern', as Atwater described it, an optically charged double-weave pattern that was clearly not for the novice. Even though the dynamic patterns are modern in appearance to today's eyes, they were not conceived as particularly experimental or avant-garde in nature. As Atwater explained in her recipe,

> The regular treadling and the rose-fashion modification of a simple little star-figure threading is shown with draft No. 30, Diagram 18. In this figure the star is on the 1–2 and 2–3 sheds, and when woven regularly the first block is treadle 1, seven shots – as on paper; as woven on the loom more or fewer according to the material used – treadle 2, six shots; treadle 1, two shots; treadle 2, six shots; treadle 1, seven shots...[26]

In short, the process of overshot weaving preserved links to the American past and celebrated the tactile and meditative qualities of woven thread rather than fostering investigations of the modernist present, which was precisely what Anni Albers was promoting nearby at Black Mountain College at the same time. It is not surprising, therefore, that in the early 1940s Atwater and Albers engaged in a battle of ideologies, published in the pages of the journal *The Weaver*.[27] Albers had suggested that contemporary weavers should approach their work with a spirit of experimentation and an eye to its application for industry. She advanced the notion of creating at the loom rather than following patterns, and of engaging in creative work with materials for artistic means. She wrote,

> Unfortunately today handweaving has degenerated in face of technically superior methods of production. Instead of freely developing new forms, recipes are often used, traditional formulas, which once proved successful. Freshness of invention, of intelligent and imaginative forming has been lost. If handweaving is to regain actual influence on contemporary life, approved repetition has to be replaced with the adventure of new exploring.[28]

Atwater found the idea of free-play at the loom and of separating the woven object from its utilitarian function incongruous, writing:

> A good deal of what Mrs. Albers says about developing individuality is vague to me... 'New exploring' is exciting, and is highly desirable if the explorer happens to be equipped with the technical knowledge and ability to take him somewhere, but the 'new exploring' of one not so equipped is no more than a clumsy fumbling, unlikely to produce anything of value. But there are tremendous values in 'approved repetition'.[29]

This debate points to the very heart of the art/craft dichotomy, without reaching a satisfying resolution, for both weavers extolled the creative aspects of weaving while acknowledging the element of anonymity that comes from following a pattern or designing for industry.

The Political Agenda

Textiles have historically played important roles within the political arena, serving as banners, flags and scrolls, and providing the raw material for uniforms, armbands and patches, for example.[30] On a less obvious level, as in the case of the WPA agenda, textiles have also functioned to identify and consolidate a real or perceived national identity. The

precise colour and shape uniformity, the background colour is not uniform, which gives the appearance that the 'weaver' has run out of a spool of yarn and replaced it with another spool from a slightly different dye lot. In addition, the upper and lower meander patterns are not of uniform size, again giving the impression that the blanket was produced by hand, not machine. This preference for retaining a hand-made quality was certainly an important concern during the 1930s, especially in rural America, where the wheels of change were frequently met with fears of displacement. At the same time, the preference for the handmade object ran counter to parallel use of machine streamlining, particularly apparent in urban architecture and industrial design, that had developed during the 1920s and was supported in the 1930s by progressive American museums such as the Museum of Modern Art.

In other parts of the United States, the handmade object continued to represent important ideological concerns. New Deal and settlement school programmes in the Southern and Appalachian regions, for example, encouraged and inspired revivals of Southern vernacular hand-weaving traditions because weaving, along with other vernacular crafts, proved an ideal medium for representing traditional values – industriousness, honest work, women's work – that were worthy of reviving. Settlement schools, often religiously funded and governed institutions designed to provide practical and moral education to rurally isolated populations, had developed in the South during Reconstruction but gained influence during the depression years, when weaving programmes became important features at schools such as Berea and Berry Colleges, at crafts revival organisations such as Penland School of Handicrafts and The Southern Highland Craft Guild, and at cooperatives such as The Weavers of Rabun, established by Mary Hambidge in the mountains of North Georgia in

1935.[22] Interestingly, while this Southern handicraft tradition was being revived, industrial textile manufacturing in the same region was on the rise. These opposing developments took place mostly in the southern region of the Appalachians, where textile and carpet mill jobs provided steady wages to a new class of rural working poor, many of whom had by that time forgotten the traditional weaving skills of their ancestors. With machine-made, mail-order textiles readily available, hand-weaving had become obsolete.[23] Thus it became important to WPA administrators and social reformers to revive this disappearing art, as well as to restore a sense of the traditional lifestyle and gender roles from which it had developed. Not surprisingly, women were responsible for the laborious tasks associated with weaving: carding the wool (combing the fibre), spinning the yarn (twisting fibre into thread on a spindle or wheel), dying the yarn (fermenting natural plants in dye vats), warping the loom (stringing the vertical threads) and weaving the cloth, usually a coverlet in a double-weave pattern referred to as 'overshot'. Most of these tasks required instructions, or 'recipes', that were handed down from generation to generation.

Weaving, in this context, especially as it applied to women and girls, represented honest work and industrious labour; it was a useful occupation and required careful adherence to pattern directions. The recipes for overshot patterns – with names such as 'Lover's Knot', 'Cross of Tennessee' and 'Christian Ring' – were faithfully recorded over time on graph paper, many of which were diagrammed and annotated in Mary Meigs Atwater's 1928 book, *The Shuttle-Craft Book of American Hand-Weaving*.[24] By following the recipes for overshot patterns, one guaranteed that there would be no random, expressive or haphazard approaches to the overall composition, and thus the tradition would continue.[25] A detail of a

109
Berry College Weavers
'Whig Rose' pattern sample (detail)
wool, double-weave
15.24 x 20.32 cm (6 x 8 in.)

handicrafts programmes were created to preserve the Navajo weaving tradition and encourage other types of weaving projects that would contribute to self-supporting cottage industries.[18] A 1939 photograph by FSA photographer Russell Lee (fig.107) shows a Hispanic woman weaving at one of the WPA handicraft projects in Costilla, New Mexico. What is interesting here is that she is weaving on a traditional European loom, not the regional upright loom, and that she is weaving with rags, not sheep wool, in this case thin strips of rag remnants that have been rolled into a spool of rag yarn, a common material during the supply-starved depression.[19] Displayed around her are examples of both traditional and Navajo diamond-patterned blankets and the more contemporary and European plaid designs of the time. The picture tells a story of transformation and cultural blending that proved to be a recurring theme of the era.

155

While the WPA was helping restore and transform Indian hand-weaving traditions, the Pendleton Woollen Mills in Oregon was producing a line of machine-woven blankets using designs and symbols derived from Native American Indian sources, especially the Navajo, but with completely different results. These modern double-weaves were warmer, more lightweight, and more colourful and colourfast than their native cousins.[20] They were soft, plush and reversible, with different colour combinations on each side, exemplified by a Pendleton blanket from the 1920–30s (fig.108) that was designed with a dazzling red and green colour scheme and a symmetrical pattern that revolves around a centrally focused green centre point. Ironically, these Pendleton blankets, prized by many Indians, sold better than hand-woven originals as trade and ritual blankets for the Southwestern and Western American Indian market.[21] Interestingly, despite the fact that Pendleton dye and weave technology could guarantee

appeal to the modern taste for national icons and slogans combined with nostalgic reminders of the past.

Similar examples of cross-cultural artistic encounters abounded throughout the Southwest, some of which were generated by government programmes. In New Mexico, for example, WPA

with slogans such as 'Down with Fascism', 'Abolish Child Labor', and 'Workers Unite for a Workers World'.[39] In a dynamically graphic red and white textile (fig.112), one powerful fist, raised high in front of a factory building, holds a sign with the words 'Stop Lynching Shame of America'. The message is clear; without racial tolerance, the labour force will not be united or productive, despite white fears of job loss through integration. The designers of these posters utilised a modernist formal vocabulary of angles, silhouettes, text and collage-like shapes to imbue the images with contemporary visual references, but the messages were clearly intended as didactic tools to advance political agendas in the face of domestic and international turmoil.

Alternative Impulses

While textiles sometimes became tools in the development and promotion of national identities, they were also used to explore various manifestations of Surrealism, which by the 1930s had developed into a broad international movement fuelled by the exodus of Surrealist artists from Europe and by exhibitions of Surrealist art, such as the large 1936 *Fantastic Art, Dada, Surrealism* exhibition at the Museum of Modern Art. In general, Surrealism is characterised by two related approaches, that of dream illusionism, typified by the photographic, sharply 'realistic' but fantastically dreamlike imagery of artists such as Salvador Dalí, and that of biomorphism, typified by works of art that appear to be the products of chance and automatism, such as those created by Jean Arp and Joan Miró. The French Surrealist Jean Lurçat worked in the former style, while the American Eve Peri (1903–1963) worked in the latter.

Eve Peri preferred textiles to painting because she could manipulate the mutable, organic textures and materials of textiles freely in their raw and natural state. 'Cloth is very dictating', Peri stated. 'It makes you find one simple concept and then explore it until you have enough'.[40] For her 'fabstracts', as she called them, such as a work from the late 1930s (fig.113), she assembled through collage, appliqué and embroidery a seemingly random juxtaposition of materials and shapes which, upon completion, would produce new associations, from which she would sometimes title her works, such as *Head with Flowers*, 1939 and *Journey to the Moon*, 1945.[41] The practice of free association, facilitated through biomorphic visual forms, had been developed earlier in the century by Freud and Rorschach and was practised enthusiastically by many Surrealists in the 1920s and 1930s. By employing techniques used by psychoanalysts, such as free association, stream of consciousness writing and automatic drawing, Surrealists could explore aspects of the irrational and subconscious mind. Peri was unique in her use of textiles to investigate these characteristics of Surrealism. She was briefly married to the Colombian artist Rafael Alfonso Umaña Mendez (1908–1994), known as Umaña, who studied pictorial tapestry weaving in Spain; together they formed a textile and design operation in the 1930s called Peri-Umaña, producing woven work using both Colombian and European techniques, but today Peri is acknowledged for her 'fabstracts' and her contributions to the art of the Surrealist collage.[42]

By the 1930s the visual style of Surrealism – both dream illusionism and biomorphism – entered the popular consumer market through manufactured textiles. A gouache textile design from Harrell Studios (fig.114) in New York reveals the degree to which designers, many of whom are unknown today, worked with the new visual vocabulary of biomorphism in direct opposition to the commemorative, emblematic

162

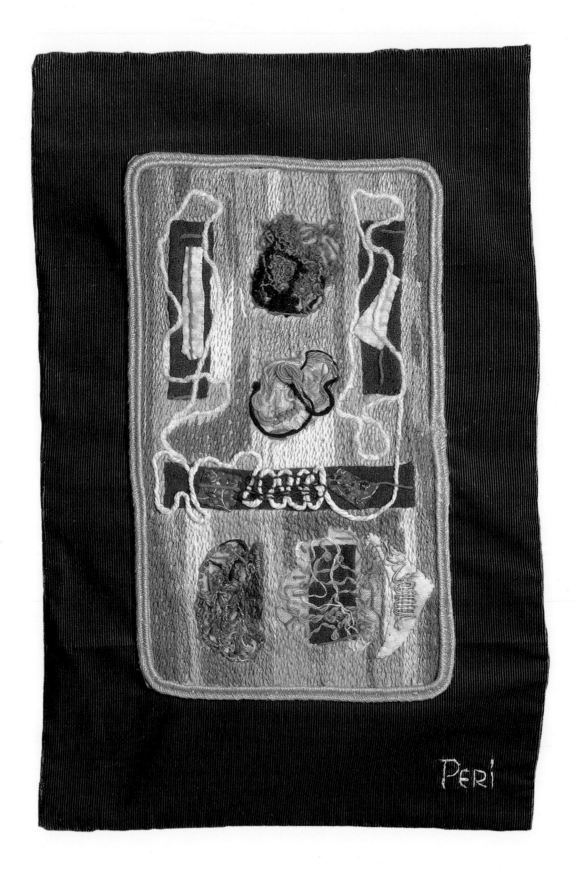

pp 193–200 for examples of early twentieth-century textiles derived from non-Western sources.

7 See James Clifford, *The Predicament of Culture: Twentieth-Century Ethnography, Literature, and Art*, Cambridge, Massachusetts: Harvard University Press, 1988.

8 See Wolfsonian Museum file 1994.9.22 for a list of Werkstätte books that had been hidden during World War II; from the James May collection.

9 See Angela Völker, *Textiles of the Wiener Werkstätte 1910–1932*, London: Thames & Hudson, 1994 (1990), appendix, for a list of Werkstätte textile titles, dates and designers from 1910 to 1932.

10 Völker, ibid, p.206; Karen Davies, *At Home in Manhattan: Modern Decorative Arts, 1925 to the Depression*, New Haven: Yale University Press, 1983, p.10.

11 Völker, ibid, pp 116–20.

12 Völker, ibid, p.49.

13 This textile was copied in watercolour and discussed by Elizabeth Cratsley for her Smith College Master's Thesis, 'An Analysis of Certain Modernist Textile Designs', 1929, pp 44–5.

14 Jay Hambidge, *Dynamic Symmetry: The Greek Vase*, New Haven: Yale University Press, 1920, p.17; Virginia Gardner Troy, 'The Great Weaver of Eternity: Dynamic Symmetry and Utopian Ideology in the Art and Writing of Mary Hambidge', *Surface Design Journal*, vol.23, no.4, Summer, 1999. See Susan Hay, 'Paris to Providence: French Couture and the Tirocchi Shop' in, *From Paris to Providence: Fashion, Art, and the Tirocchi Dressmakers' Shop, 1915–1947*, op.cit., pp 149–50 for a discussion of designer Madeleine Vionnet's adaptation of Dynamic Symmetry for modern clothing.

15 Jane Ellen Starns, 'Mary Crovatt Hambidge: Art and Nature' in, *Southern Arts and Crafts 1890–1940*, Charlotte: Mint Museum of Art, 1996, p.54; Philis Alvic, *Weavers of the Southern Highlands*, Kentucky: University of Kentucky Press, 2003, p.104.

16 Duncan's painted murals were exhibited at the 1925 Paris exposition; although American, he was classified as French because the Americans did not participate in the exposition.

17 Virginia Gardner Troy, *Anni Albers and Ancient American Textiles: From Bauhaus to Black Mountain*, London: Ashgate, 2002, pp 25–30.

18 I am grateful to Jacqueline Jacqué, curator at the Musée de l'Impression sur Etoffes, Mulhouse, for providing me with swatch book examples and information.

19 See Petra Dupuits, *Sonia Delaunay: Metz est Venu*, Amsterdam: Stedelijk Museum, 1992; and Sherry Buckberrough, 'Delaunay Design: Aesthetics, Immigration, and the New Woman', *Art Journal*, vol.54, no.1, Spring, 1995, for further discussion of the multi-purpose function of Delaunay's textiles.

20 Sonia Delaunay, *Tapis et Tissus*, Paris: Moreau, 1929, p.1.

21 Buckberrough, op.cit., p.53.

22 Luc Benoist, 'Les Tissus de Sonia Delaunay' in, *Art et Decoration*, November 1926, p.144.

23 Sonia Delaunay, *Sonia Delaunay: A Retrospective*, foreword by Robert T. Buck; essays by Sherry A. Buckberrough; chronology by Susan Krane, Buffalo, New York: Albright-Knox Art Gallery, 1980, p.219, from 1927 lecture 'The Influence of Painting on Fashion Design'. See Radu Stern, *Against Fashion: Clothing as Art, 1850–1930*, Cambridge: MIT Press, 2004 (1992), p.68, for discussion of the tissu-patron kits.

24 Sonia Delaunay, *Tapis et Tissus*, op.cit., p.1.

25 See Iulia Konstantinova [Julia Tulovsky], 'Avant-Garde Textile Designs of the 1920s. Russia and the West' [in Russian], PhD Dissertation, Moscow State University, 2005, for a discussion of this interaction.

26 Christina Lodder, *Russian Constructivism*, New Haven: Yale University Press, 1990 (1983), p.146.

27 Lodder, ibid, pp 148–9; Stern, op.cit., p.56.

28 Natalia Adaskina and Dmitri Sarabianov, *Popova*, New York: Abrams, 1990, translation by Marian Schwartz, pp 366–7, from Popova's 1921 manuscript, 'On Drawings'.

29 Adaskina, ibid, from Popova's 1921 manuscript.

30 Osip Brik, 'From Picture to Calico-Print', *LEF*, no.6, Moscow, 1924, pp 30–34 in, Charles Harrison and Paul Wood (eds), *Art in Theory 1900–1990*, Oxford: Blackwell, 1998 (1992), translation by R. Sherwood, pp 324–8.

31 A. Lebedeff, 'L'Impression Sur Tissus dans l'Industrie Textile Russe' in, *L'Art Décoratif et Industriel de l'U.R.S.S.*, exhibition catalogue for *1925 Paris Expositon Décoratifs*, Moscow: Mockba, 1925, p.57; Adaskina, op.cit., p.301.

32 Simultané advertisement, illustrated in Tag Gronberg, 'Sonia Delaunay's Simultaneous Fashions and the Modern Woman' in, Whitney Chadwick and Tirza True Latimer (eds), *The Modern Woman Revisited: Paris Between the Wars*, New Jersey: Rutgers Press, 2003, p.114.

33 Gronberg, ibid, pp 114–15.

34 Yvonne Deslandres, *Poiret: Paul Poiret 1879–1944*, New York: Rizzoli, 1987, p.69; Hay, 'Paris', op.cit., p.145.

35 See Dupuits, op.cit., pp 11–27; Petra Timmer, *Metz & Co.: De Creatieve Jaren*, Rotterdam: Uitgeverij 010, 1995, pp 29, 63, 64; 61–191.

36 Timmer, ibid, pp 151–5; Dupuits, ibid, pp 11, 19, 23, 27.

37 See Susan Day, *Art Deco and Modernist Carpets*, California: Chronicle Books, 2002, pp 163–8, for examples of De Stijl carpets.

38 I am grateful to Mr Matteo de Leeuw-de Monti, grandson of Josef de Leeuw, for providing me with information about Huszár's and van der Leck's textiles for Metz & Co. See also Titus Eliëns, 'Nieuwe Kunst: Dutch Decorative Arts from 1880–1910' in, Titus Eliëns, Marjan Groot and Frans Leidelmeijer (eds), *Dutch Decorative Arts 1880–1940*, New York: Battledore, 1997 p.227; Timmer, op.cit., pp 57, 61, 75, 88, 96.

39 See Nancy Troy, *The De Stijl Environment*, Cambridge: MIT Press, 1983, pp 34–44 for a discussion of Huszár's approach to interior design.

40 Most of the artist-designed fabrics for Metz & Co were not mass-produced. Matteo de Monti, personal communication, November 2005.

41 Timmer, op.cit., pp 77–96, 100–115; see also Toos van Kooten, *Bart van der Leck*, Otterlo: Kröller-Müller Museum, 1994, for an overview of van der Leck's career.

42 See Nancy Troy, *De Stijl*, op.cit., pp 31–4 for a discussion of van der Leck's approach to interior design.

43 This carpet was reissued in 1989.

44 Timmer, op.cit., p.115.

45 Elizabeth Ann Coleman, 'Myrbor and other mysteries: questions of art, authorship and émigrés', *Costume*, no.34, 2000, p.102.

46 Coleman, ibid, p.100; Day, op.cit., p.195; 'The Cuttoli Tapestry', *Réalités*, no.107, October 1959, p.64.

47 *Réalités*, ibid.

48 Coleman, op.cit., p.102.

49 Day, op.cit., pp 131–6, 195.

50 Maurice Pillard Verneuil and Alphonse Mucha, *Combinations ornamentales se multipliant à l'infini à l'aide du miroir*, Paris: Librairie centrale des beaux-arts, 1901, p.2.

51 James Trilling, *Ornament: A Modern*

41 Rozsika Parker, *The Subversive Stitch: Embroidery and the Making of the Feminine*, London: The Women's Press, 1984, p.192.

42 Brigitte Leal, *La Donation Sonia et Charles Delaunay*, Paris: Centre Pompidou, 2003, p.100 from Guy Habasque, 'Catalogue de l'oeuvre de Robert Delaunay' in, Pierre Francastel (ed.), *Du Cubisme a l'Art Abstrait*, Paris: S.E.V.P.E.N., 1957, p.201.

43 Leal, ibid, p.104 from Michel Hoog, *Robert et Sonia Delaunay, Inventaire des Collections Publiques Francaises 15, Paris, Musee National D'art Moderne*, Paris: Editions des Musees Nationaux Paris, 1967.

44 Sonia Delaunay, *Sonia Delaunay: A Retrospective*, foreword by Robert T. Buck; essays by Sherry A. Buckberrough; chronology by Susan Krane, Buffalo, New York: Albright-Knox Art Gallery, 1980, p.219 from *Sonia Delaunay, Nous Irons Jusqu'au Soleil*, Paris: Robert Laffont, 1978, p.96.

45 V. Troy, op.cit., pp 29–30.

46 Arthur Cohen, *Sonia Delaunay*, New York: Abrams, 1975, p.64.

47 Sherry Buckberrough, 'Delaunay Design: Aesthetics, Immigration, and the New Woman', *Art Journal*, vol.54, no.1, Spring, 1995, p.53.

48 Parker, op.cit., pp 193–4; Charlotte Douglas, 'Suprematist Embroidered Ornament', *Art Journal*, vol.54, Spring, 1995, pp 42–5.

49 Douglas, ibid, p.42.

50 Jean (Hans) Arp, 'Dada was not a Farce', 1949 in, Robert Motherwell (ed.), *The Dada Painters and Poets: An Anthology*, Boston: G.K. Hall, 1981 (1951), p.294. Rozsika Parker is credited for noting the subversive possibilities of textiles; in *The Subversive Stitch*, op.cit., pp 191–2, she suggests Arp used embroidery because it was outside the culture of high art. See Renee Riese Hubert, 'Sophie Taeuber and Hans Arp: a community of two', *Art Journal*, vol.52, Winter, 1993, pp 25–32 for a discussion of their collaborations.

51 Sandor Kuthy, *Sophie Taeuber – Hans Arp: Künstlerpaare – Künstlerfreunde*, Kunstmuseum Bern, 1988, p.19; Carolyn Lanchner, Sophie Taeuber-Arp, New York: Museum of Modern Art, 1981, pp 9–10.

52 Willy Rotzler and Maureen Oberli-Turner, 'Sophie Taeuber-Arp and the Interrelation of the Arts', *The Journal of Decorative and Propaganda Arts*, vol.19, 1993, p.86.

53 Man Ray, *Self Portrait*, MA: Little, Brown, & Co, 1963, p.33.

54 ibid, p.88; I am grateful to Francis Naumann for providing information about this work, March 2004.

55 Parker, op.cit., p.192.

56 ibid, p.194; Maud Lavin, *Cut with the Kitchen Knife: The Weimar Photomontages of Hannah Höch*, New Haven: Yale University Press, 1993, p.59; Maria Makela, 'By Design: the Early Work of Hannah Höch in Context' in, Peter Boswell, Maria Makela and Carolyn Lanchner, *The Photomontages of Hannah Höch*, Minneapolis: Walker Art Center, 1996, p.62.

57 See Makela, ibid, for further discussion of Höch's reviews and short stories in *Stickerei* pp 57–8.

58 Fabio Benzi, 'Essential Biography' in, Fabio Benzi (ed.), *Balla: The Biagiotti Cigna Collection. Paintings, Futurist Fashion, Applied Arts*, Milan: Leonardo Arte, 1996, pp.159–60.

59 Benzi, ibid, 159–60; Enrico Crispolti, 'Balla Beyond Painting: the "Futurist Reconstruction" of Fashion' in, Fabio Benzi (ed.), *Balla: The Biagiotti Cigna Collection. Paintings, Futurist Fashion, Applied Arts*, ibid, p.14; Emily Braun, 'Futurist Fashion: Three Manifestoes', *Art Journal*, vol.54, no.1, Spring, 1995, pp 34–41.

60 See Radu Stern, *Against Fashion: Clothing as Art, 1850–1930*, Cambridge: MIT Press, 2004 (1992), p.65 for a discussion of Delaunay's impact on the Futurists. See Whitney Chadwick, 'Living Simultaneously: Sonia and Robert Delaunay' in, Whitney Chadwick and Isabelle De Courtivron (eds), *Significant Others: Creativity & Intimate Partnership*, London: Thames & Hudson, 1996, p.44 for another reference to this exchange.

61 Crispolti, op.cit., pp 17–19; Braun, op.cit., pp 34–41; Stern, ibid, 29–42.

62 See Fabio Benzi, 'Balla and Photography: The Modern Gaze' in, Fabio Benzi (ed.), *Balla: The Biagiotti Cigna Collection. Paintings, Futurist Fashion, Applied Arts*, op.cit., pp 29–43 for discussion of Balla's shift within the context of photography.

63 Crispolti, op.cit., p.20; Braun, op.cit., p.36.

64 Crispolti, ibid, p.20; Braun, ibid, p.39.

65 Franca Zoccoli, 'The Shape of Speed' in, Mariella Bentivoglio and Franca Zoccoli, *The Women Artists of Italian Futurism*, New York: Midmarch Arts Press, 1997, pp 144–5.

66 Gabriella Belli, *Depero Futurista: Rome-Paris-New York 1915–1932 and More*, Milan: Skira Editore, 1999, p.19; Franca Zoccoli, 'The Applied Arts and Photography' in, *Women Artists of Italian Futurism*, ibid, p.140.

67 ibid, p.32, n.5.

68 Ashley Callahan, *Enchanting Modern: Ilonka Karasz (1896–1981)*, Georgia Museum of Art, 2003, pp 23–6, 36.

69 Nicola Shilliam, 'Emerging Identity: American Textile Artists in the Early Twentieth Century' in, Marianne Carlano and Nicola Shilliam, *Early Modern Textiles*, Boston: Museum of Fine Arts Boston, 1993, pp 34–7; Abby Lillethun, 'Javanesque Effects: Appropriation of Batik and its Transformations in Modern Textiles' in, *Appropriation, Acculturation, Transformation*, Proceedings of the Textile Society of America Symposium, 2004, pp 34–43.

70 Shilliam, ibid, p.36.

71 Hazel Clark, 'The Textile Art of Marguerite Zorach', *Woman's Art Journal*, Spring/Summer, 1995, p.19, from Zorach's 1945 recollection.

72 ibid, p.22.

73 Callahan, op.cit., p.40; Lauren Whitley, 'Morris De Camp Crawford and American Textile Design 1916–1921', MA Thesis, S.U.N.Y. Fashion Institute of Technology, 1994.

Chapter Three

1 Tim Benton, Charlotte Benton and Ghislaine Wood, *Art Deco*, London: Bulfinch, 2003, pp 13–27.

2 ibid.

3 Madelyn Shaw, 'H. R. Mallinson & Co.: American silk from a Marketing Magician', paper presented at the Eighth Biennial Textile Society of America Conference, Northampton, MA, 2003, p.2. See Alain-René Hardy, *Art Deco Textiles: The French Designers*, London: Thames & Hudson, 2003, pp 8–10 for further discussion of developments in manufacturing.

4 Charlotte Samuels, *Art Deco Textiles*, London: V & A Publications, 2003, p.8.

5 Maria Makela, 'Wearing Wood: WWI and the Development of *Kunstseide* in Germany', College Art Association Paper, Seattle, 2004.

6 See William Rubin (ed.), *'Primitivism' in 20th Century Art*, New York: Museum of Modern Art, 1984. Volume I: Christian Feest, 'From North America'; Philippe Peltier, 'From Oceania'; Jean-Louis Paudrat, 'From Africa'. See Susan Hay, 'Modernist in Fabric: Art and the Tirocchi Textiles' in, *From Paris to Providence: Fashion, Art, and the Tirocchi Dressmakers' Shop, 1915–1947*, op.cit.,

Werkstätte 1910–1932, London: Thames & Hudson, 1994 (1990), p.22 for katagami reference. A nearly identical Moser pattern was reproduced in *Ver Sacrum*, vol.4, p.5, 1899, titled *Lachszug* (Salmon School).

4 Alois Riegl, *Altorientalische Teppiche*, Leipzig: Weigel, 1891.

5 Völker, op.cit., pp 15–20.

6 Brandstätter, op.cit., p.11; the New York branch opened in 1922. The Werkstätte Jubilee book published in 1929 lists some of the retailers inside the dust jacket.

7 Backhausen also produced textiles designed by Hoffmann before 1910 and continued to produce machine woven fabrics by Werkstätte designers such as Dagobert Peche. There was also a weaving workshop, but few samples are preserved; see Völker, op.cit., pp 9–10, 145.

8 Völker, op.cit., pp 111, 121.

9 Völker, op.cit., pp 58, 221.

10 Rebecca Houze, 'From Wiener Kunst im Hause to the Wiener Werkstätte: Marketing Domesticity with Fashionable Interior Design', *Design Issues 18*, no.1, p.3, Winter, 2002; noted by Paul Poiret in *King of Fashion: The Autobiography of Paul Poiret*, translated by Stephen Haden Guest, Philadelphia: Lippincott & Co, 1931, p.161; Radu Stern, *Against Fashion: Clothing as Art,1850–1930*, Cambridge: MIT Press, 2004 (1992), pp 24–6.

11 Angela Völker, 'Patterns and Colors: Peche's Designs for Textiles and Wallpapers' in, Peter Noever (ed.), *Dagobert Peche and the Wiener Werkstätte*, New Haven: Yale University Press, 2002, p.86.

12 ibid, p.86; Völker, *Textiles*, op.cit., p.58.

13 Adolf Loos, 'Ornament and Crime' (1908) in, Isabelle Frank (ed.), *The Theory of Decorative Art: An Anthology of European & American Writings, 1750–1940*, with translations by David Britt, New Haven: Yale University Press, 2000, p.289.

14 See Nancy Troy, *Couture Culture: A Study in Modern Art and Fashion*, Boston: MIT Press, 2002, for a discussion of Paul Poiret's adaptation of this strategy.

15 Völker, *Textiles*, op.cit., p.47.

16 Poiret, King, op.cit., p.161; N. Troy, *Couture*, op.cit., p.46; Susan Hay, 'Modernist in Fabric: Art and the Tirocchi Textiles' in, *From Paris to Providence: Fashion, Art, and the Tirocchi Dressmakers' Shop, 1915–1947*, Providence: Rhode Island School of Design, 2001, p.176.

17 Palmer White, *Poiret*, New York: Clarkson Potter, Inc, 1973, p.119; N. Troy, *Couture*, op.cit., Introduction, pp 2–17; Susan Hay, 'Paris to Providence: French Couture and the Tirocchi Shop' in, *From Paris to Providence: Fashion, Art, and the Tirocchi Dressmakers' Shop, 1915–1947*, Providence: Rhode Island School of Design, 2001, pp 134–5.

18 Hilary Spurling, 'Material World: Matisse, His Art and His Textiles' in, Matisse, *His Art and His Textiles: The Fabric of Dreams*, London: Royal Academy of Arts, 2004.

19 See Yvonne Deslandres, *Poiret: Paul Poiret 1879–1944*, New York: Rizzoli, 1987, p.262 for studio visit; White, op.cit., p.127 states that 'some of the materials for Poiret's gowns were taken for Matisse designs, but they were all by the Martines'. See Picard Audap, *La Création en Liberté: Univers de Paul et Denise Poiret 1905–1928*, auction catalogue, 10 and 11 May 2005, Paris: Picard Audap, 2005, for images of Martine textiles of the same period.

20 For Poiret's art collection see Hotel Drouot auction catalogue, *Tableux Modernes*, featuring works belonging to Poiret, 18 November 1925; see *Renaissance*, vol.5, no.19, September 1917, p.2962, for letter; see White, op.cit., p.137, Hay, 'Paris', op.cit., p.145, and Nancy Troy, *Couture*, op.cit., pp 277–80 for discussion of lawsuit; see Rémi Labrusse, 'Matisse's second visit to London and his collaboration with the "Ballets Russes"', *The Burlington Magazine*, vol.139, no.1134, September 1997, p.589 for Ballets Russes commission.

21 See Spurling, op.cit., p.17 for Matisse's textile collection; White, op.cit., p.86 for Poiret's imported textiles; White, op.cit., p.66 and Roger Benjamin, *Orientalist Aesthetics: Art, Colonialism, and French North Africa 1880–1930*, Berkeley: University of California Press, 2003, p.213 for Poiret's trip to Morocco.

22 Hay, 'Modernism', op.cit., p.176.

23 Lesley Jackson, *Twentieth-Century Pattern Design: Textile & Wallpaper Pioneers*, New York: Princeton Architectural Press, 2002, p.48; Hay, 'Modernism', op.cit., p.178.

24 Cited in Hay, 'Modernism', op.cit., p.177.

25 Jill Lloyd, *German Expressionism: Primitivism and Modernity*, New Haven: Yale University Press, 1991, p.5; Peg Weiss, 'Kandinsky and the "Jugendstil" Arts and Crafts Movement', *The Burlington Magazine*, vol.117, no.866, 1975, p.271; Peter Lasko, 'The Student Years of the Brücke and their Teachers', *Art History*, vol.20, no.1, March 1997, p.71.

26 Lasko, ibid, p.73.

27 Alois Riegl, *Problems of Style, Foundations for a History of Ornament*, translation of *Stilfrragen: Grundlegungen zu einer Geschichte der Ornamentik* (1893) by Evelyn Kain, Introduction by David Castriota, New Jersey: Princeton University Press, 1992, pp 3–13.

28 Wilhelm Worringer, *Abstraction and Empathy (Abstraktion und Einfühlung)*, Munich: Piper-Verlag, 1908, English edition, translated by Michael Bullock, London: Routledge, 1953, pp 16–17, 42; see Virginia Gardner Troy, *Anni Albers and Ancient American Textiles: From Bauhaus to Black Mountain*, London: Ashgate, 2002, pp 9–12 for a discussion of Riegl and Worringer within the context of textiles.

29 Wilhelm Worringer, 'The Historical Development of Modern Art', (Entwicklungs-geschichtliches zur modernsten Kunst), *Der Sturm*, vol.2, no.75, August 1911, translated by Rose-Carol Washton Long in, Timothy Benson and Éva Forgács (eds), *Between Worlds: A Sourcebook of Central European Avant-Gardes, 1910–1930*, Cambridge: MIT Press, 2002, pp 52–4.

30 Lloyd, op.cit., p.44.

31 ibid, pp 9–10, 44.

32 Gerhard Wietek, *Schmidt-Rottluff: Plastik und Kunsthandwerk*, Werkverzeichnis, Munich: Hirmer Verlag, 2001, pp 407–26.

33 Eberhard Kornfeld, *Textilarbeiten Nach Entwürfen von E. L. Kirchner der Davoser Jahre*, Bern: Verlag Galerie Kornfeld, 1999, p.24.

34 Henri Matisse, 'Notes of a Painter' in, Charles Harrison and Paul Wood, *Art in Theory 1900–1990: An Anthology of Changing Ideas*, Oxford: Blackwell, 1998 (1992), pp 72–8. (Originally published as *Notes d'un peintre* in *La Grande Revue*, Paris, 1908, p.73.)

35 Isabelle Anscombe, *Omega and After: Bloomsbury and the Decorative Arts*, London: Thames & Hudson, 1981, pp 32, 166, n.18, from an undated (1915?) Omega catalogue preface by Roger Fry.

36 ibid, p.32.

37 ibid, p.29.

38 ibid, p.28; Whitney Chadwick, *Women, Art, and Society*, London: Thames & Hudson, 1997 (1990), p.260.

39 Anscombe, ibid, p.31 from an undated statement.

40 Richard Shone, *The Art of Bloomsbury: Roger Fry, Vanessa Bell and Duncan Grant*, New Jersey: Princeton University Press, 1999, p.145.

58 See Parry, ibid, p.142 regarding the school; see Blackburn, 'To be poor', op.cit., for a discussion of sweating.

59 Wendy Kaplan (ed.), 'The Art that is Life:' The Arts and Crafts Movement in America 1875–1920, Boston: Museum of Fine Arts Boston, 1998 (1987), p.55.

60 Jan Marsh, 'May Morris: Ubiquitous, Invisible Arts and Crafts-Woman' in, Bridget Elliott and Janice Helland (eds), Women Artists and the Decorative Arts 1880–1935: The Gender of Ornament, London: Ashgate, 2003, p.41; Anscombe, Women's Touch, op.cit., pp 22–7.

61 Poem by William Morris, 1891, from Poems by the Way, 'The Flowering Orchard':
Silk Embroidery.
Lo silken my garden,
and silken my sky,
And silken my apple-boughs
hanging on high;
All wrought by the Worm
in the peasant carle's cot
On the Mulberry leafage
when summer was hot!
See also Marianne Carlano, 'May Morris in Context' in, Marianne Carlano and Nicola Shilliam, Early Modern Textiles: From Arts and Crafts to Art Deco, Boston: Museum of Fine Arts Boston, 1993, p.21. For further discussion of Morris' use of text and plants see Jan Marsh, op.cit., pp 39–41.

62 Lewis Day and Mary Buckle, Art in Needlework: A Book About Embroidery, London: Batsford, 1900, preface, pp 238, 241.

63 Gabriel Weisberg, Stile Floreale: The Cult of Nature in Italian Design, Miami: The Wolfsonian Foundation, 1988, p.17.

64 Anscombe, Women's Touch, op.cit., pp 54–8.

65 Weisberg, Stile Floreale, op.cit., p.27; Parry, 'The New Textiles', op.cit., p.191.

66 Jude Burkhauser, 'The Glasgow Style' in, Jude Burkhauser (ed.), Glasgow Girls, Edinburgh: Canongate Books Ltd, 2001, pp 81–105; Anscombe, Women's Touch, op.cit., p.51.

67 My thanks to Peter Trowles, Curator, Mackintosh Collection, Glasgow School of Art, for providing this information from his files.

68 Burkhauser, 'Glasgow', op.cit., p.81; Parry, 'The New Textiles', op.cit., p.181.

69 See Weisberg, The Origins of L'Art Nouveau: The Bing Empire, op.cit., pp 73–82, for information relating to Bing's contribution to the dissemination of Japanese art in America in the 1880s and 1890s.

70 Erik Mattie, World's Fairs, New York: Princeton Architectural Press, 1998, p.97.

71 See Amelia Peck and Carol Irish, Candace Wheeler: the art and enterprise of American design, 1875–1900, Metropolitan Museum of Art, Yale University Press, 2001.

72 See Kaplan, Art that is Life, op.cit., p.63 for a discussion of Wheeler's use of the company name.

73 Candace, Wheeler, The Development of Embroidery in America, New York: Harper & Brothers, 1921, p.119.

74 ibid, pp 142–3.

75 Peck and Irish, Candace Wheeler, op.cit., pp 81, 219–21.

76 ibid, p.221 from Wheeler's book, Yesterdays in a Busy Life, 1918, p.246.

77 Diane Ayres, American Arts and Crafts Textiles, New York: Abrams, 2002, p.44; Kaplan, Art that is Life, op.cit., pp 304–6, 319–320.

78 Nancy Green and Jessie Poesch, Arthur Wesley Dow and the American Arts and Crafts, New York: Abrams, 2000, pp 58, 116, p.124.n.16; Ayres, American Arts, op.cit., p.62.

79 Christa Mayer Thurman, 'Textiles: As Documented by The Craftsman' in, Janet Kardon (ed.), The Ideal Home 1900–1920: The History of Twentieth Century American Craft, New York: Abrams, 1993, pp 100–110.

80 Ayres, American Arts, op.cit., p.102.

81 Thurman, 'Textiles: As Documented', op.cit., pp 103–4.

82 Gustav Stickley, 'The Use and Abuse of Machinery, and its Relation to the Arts and Crafts', The Craftsman, vol.11, issue 2, November 1906.

83 For images of early Wright carpets see David Hanks, The Decorative Designs of Frank Lloyd Wright, New York: Dutton, 1979, pp 109, 126–7.

84 Janet Berlo and Patricia Cox Crews, Wild by Design: Two Hundred Years of Innovation and Artistry in American Quilts, Seattle: University of Washington Press, 2003, pp 20–21.

85 Regenia Perry, Harriet Powers's Bible Quilts, New York: Rizzoli, 1994, p.6.

86 Perry, ibid, p.4. Maude Wahlman in, Signs and Symbols: African Images in African American Quilts, Georgia: Tinwood Books, 2001, pp 73–4, suggests they are baptismal robes and that Powers may have been a conjure-woman or elder member of a Masonic lodge.

87 Dorothee Bieske, 'Die Webschule in Scherrebek' in, Scherrebek: Wandbehänge des Jugendstils, Heide: Boyens Buchverlag,

2002, pp 10–23; Laurie Stein, 'German Design and National Identity 1890–1914' in, Wendy Kaplan (ed.), Designing Modernity: the arts of reform and persuasion, 1885–1945, London: Thames & Hudson, 1995, p.66.

88 Bieske, ibid, p.78.

89 ibid, p.120.

90 Wendy Kaplan, 'Traditions Transformed: Romantic Nationalism in Design, 1890–1920' in, Wendy Kaplan (ed.), Designing Modernity: the arts of reform and persuasion, 1885–1945, op.cit., p.27.

91 Kaplan, 'Traditions', ibid, pp 27–8.

92 See Elisabet Stavenow-Hidemark, 'Scandinavia: "Beauty for All"' in, Wendy Kaplan (ed.), The Arts and Crafts Movement in Europe and America: Design for the Modern World, London: Thames & Hudson, 2005, p.196, for a discussion of a different open-work tapestry by Hansen.

93 Dekorative Kunst, vol.4, no.1, 1901, p.32.

94 Kaplan, 'Traditions', op.cit., p.30.

95 Christa Mayert Thurman, 'Textiles' in, Design in America: The Cranbrook Vision 1925–1950, New York: Abrams, 1983, pp 175–6 notes a Saarinen nephew who recalled seeing a loom and Loja making batiks at their home, Hvitträsk.

96 Gregory Wittkopp, 'Saarinen House: A Marriage of Weaving and Architecture', Fiberarts, vol.21, November 1994, p.39; Kaplan, 'Traditions', op.cit., p.30.

97 Kaplan, 'Traditions', op.cit., pp 30–32.

98 Sandra Alfoldy, 'Laura Nagy: Magyar Muse' in, Bridget Elliott and Janice Helland (eds), Women Artists and the Decorative Arts 1880–1935: The Gender of Ornament, London: Ashgate, 2003, pp 140–42; Cecillia Öri-Nagy, 'The History of Textile Art in Gödöllö' in, Women at the Gödöllö Artists' Colony, London: Hungarian Cultural Centre, 2004, pp 11–17.

99 Katalin Glellér, The Art Colony of Gödöllö (1901–1920), Gödöllö Municipal Museum, 2001, p.28.

Chapter Two

1 Christian Brandstätter, Wiener Werkstätte, Design in Vienna 1903–1932, New York: Abrams, 2003, translated from the German 'Design der Wiener Werkstätte 1903–1932' by David H. Wilson, Colophon, pp 7–8.

2 ibid, p.9.

3 Angela Völker, Textiles of the Wiener

NOTES

Translations by the author unless otherwise noted.

Introduction

1 As Morris put it, 'Art is man's expression of joy in his labor'. William Morris, 'Art Under Plutocracy', lecture delivered to the Russell Club, Oxford, 1883 in, Charles Harrison and Paul Wood (eds), *Art in Theory 1815–1900*, London: Blackwell, 1998, p.759.
2 ibid.
3 Dorothy Liebes, *Contemporary Decorative Arts*, San Francisco: *Golden Gate International Exposition*, 1939, p.92.
4 See Pat Kirkham and Lynne Walker, 'Women Designers in the USA 1900–2000: Diversity and Difference' in, *Women Designers in the USA 1900–2000: Diversity and Difference*, New York: Bard Graduate Center, 2000, pp 49–83, for a concise summary of historical and contemporary issues on the subject of women and design, including education, collaboration and critical reception, which draws from the pioneering work of Judy Chicago, Lucy Lippard, Patricia Mainardi, Linda Nochlin and Rozsika Parker, among others. See also Bridget Elliott and Janice Helland, *Women Artists and the Decorative Arts 1880–1935: The Gender of Ornament*, London: Ashgate, 2002, Introduction, pp 1–14, for a summary that also draws from these scholars and others, such as Anthea Callen and Isabelle Frank, while noting that the decorative arts 'presented women with certain opportunities that were not available elsewhere', p.5. See also Whitney Chadwick, *Women, Art, and Society*, London: Thames & Hudson, 1997 (1990), and Isabelle Anscombe, *A Woman's Touch: Women in Design from 1860 to the Present Day*, Penguin, 1984, on the topic of women's work and handicrafts.
5 See Rozsika Parker, *The Subversive Stitch: Embroidery and the Making of the Feminine*, London: The Women's Press, 1984, for a discussion of this issue within the context of embroidery.
6 Linda Nochlin and Sutherland Harris noted in their 1976 book, *Women Artists: 1550–1950*, New York: Knopf, that 'advanced women artists involved in the decorative arts in the early twentieth century were contributing to the most revolutionary directions – both social and aesthetic – of their time', p.61; cited in Parker, ibid, p.190.

Chapter One

1 Richard Wagner, 'The Art-Work of the Future' (1849) in, Charles Harrison and Paul Wood (eds) with Jason Gaiger, *Art in Theory, 1815–1900: An Anthology of Changing Ideas*, Massachusetts: Blackwell, 1998, p.471.
2 ibid, pp 471–8.
3 ibid, p.472.
4 William Morris, 'The Revival of Handicraft', in *Fortnightly Review*, November 1988 in, Isabelle Frank (ed.), *The Theory of Decorative Art: An Anthology of European & American Writings, 1750–1940*, with translations by David Britt, New Haven: Yale University Press, 2000, p.176.
5 ibid, pp 170–75.
6 See Gillian Naylor, 'Domesticity and Design Reform: the European Context' in, Michael Snodin and Elisabet Stavenow-Hidemark (eds), *Carl and Karin Larsson: Creators of the Swedish Style*, London: Victoria & Albert Museum, 1997, pp 74–87, for a discussion of this development.
7 Rozsika Parker, *The Subversive Stitch: Embroidery and the Making of the Feminine*, London: The Women's Press, 1984, Chapter One.
8 Henry Van de Velde, *Récit de Ma Vie*, Volume I, edited by Anne van Loo, Brussels: Flammarion, 1992, p.192; Amy Ogata, *Art Nouveau and the Social Vision of Modern Living: Belgian Artists in a European Context*, Cambridge: Cambridge University Press, 2001, pp 29–31.
9 Erika Billeter, *Europäische Textilien*, Zürich: Kunstgewerbemuseum Zürich, Buchdruckerei AG, 1963, p.10.
10 Van de Velde, *Récit de Ma Vie*, Volume I, op.cit., p.191; Sigrid Barten, *Um 1900: Verborgene Schätze aus der Sammlung des Museums Bellerive Zürich*, exh.cat., Zürich: Museum Bellerive, 1999, p.34.
11 Lesley Jackson, *Twentieth-Century Pattern Design: Textile & Wallpaper Pioneers*, New York: Princeton Architectural Press, 2002, p.28.
12 Barten, *Um 1900*, op.cit., p.34.
13 Van de Velde, *Récit de Ma Vie*, Volume I, op.cit., translation by V. Troy and Aziza Ali, pp 191–2.
14 ibid, p.193.
15 Van de Velde, 'Observations Toward a Synthesis of Art' in, Isabelle Frank, *The Theory of Decorative Art: An Anthology of*

European and American Writings 1750–1940, New Haven: Yale University Press, 2000, p.196.

16 ibid, p.200.

17 Marianne Carlano, 'Wild and Waxy: Dutch Art Nouveau Artistic Dress', *Art Journal*, vol.54, no.1, Spring, 1995, p.31; Ogata, op.cit., p.107; Radu Stern, *Against Fashion: Clothing as Art, 1850–1930*, Cambridge: MIT Press, 2004 (1992), pp 11–22.

18 *Dekorative Kunst*, vol.4, no.1, p.45.

19 Ogata, op.cit., p.107; Parry, Linda, 'The New Textiles' in, Paul Greenhalgh (ed.), *Art Nouveau 1890–1914*, New York: Abrams, 2000, p.183; Stern, op.cit., p.13.

20 See Sheila Blackburn, '"To be poor and to be honest…is the hardest struggle of all": Sweated Needlewomen and Campaigns for Protective Legislation, 1840–1914' in, Beth Harris (ed.), *Famine and Fashion: Needlewomen in the Nineteenth Century*, London: Ashgate, 2005, pp 243–57, for a discussion of 'sweating' in both its domestic and factory contexts.

21 I am grateful to Anna Jackson at the Victoria & Albert Museum for her help locating the kimono. For discussions of Bing's contact with Japanese art see Gabriel Weisberg's books, *Art Nouveau Bing: Paris Style 1900*, New York: Abrams, 1986; and Gabriel Weisberg, Edwin Becker and Évelyn Possémé (eds), *The Origins of L'Art Nouveau: The Bing Empire*, Amsterdam: Van Gogh Museum, 2004; and Nancy Troy, *Modernism and the Decorative Arts in France: Art Nouveau to Le Corbusier*, New Haven, Yale University Press, 1991, 'Chapter One: Art Nouveau in Paris'.

22 Gloria Groom (ed.), *Beyond the Easel: Decorative Painting by Bonnard, Vuillard, Denis, and Roussel, 1890–1930*, Chicago: Art Institute of Chicago, 2001, pp 50–52; Nicholas Watkins, 'The Genesis of a Decorative Aesthetic' in, Groom, ibid, p.6.

23 Maurice Denis, 'Definition of Neo-Traditionism' (1890/1913), translation by Peter Collier in, Charles Harrison and Paul Wood (eds), *Art in Theory 1815–1900: An Anthology of Changing Ideas*, Oxford: Blackwell, 1998, p.863.

24 Groom, op.cit., pp 51–3; 91–3; Watkins, op.cit., p.21.

25 Groom, op.cit., pp 48, 51, 131.

26 Ágnes Prékopa, 'József Rippl-Rónai's Decorative Art' in, *József Rippl-Rónai's Collected Works*, Budapest: Hungarian National Gallery, 1998, p.112.

27 See note 4, Introduction, for references on this subject.

28 For a discussion of the conflation between fine art and the department store during this period see Nancy Troy, op.cit., p.27.

29 Weisberg, *Art Nouveau Bing: Paris Style 1900*, op.cit., pp 10–43.

30 ibid, p.40; Nancy Troy, op.cit., pp 43–7.

31 See Weisberg, *The Origins of L'Art Nouveau: The Bing Empire*, op.cit., pp 9–31 for a summary of Bing's business practices.

32 See Wendy Kaplan (ed.), *'The Art that is Life:' The Arts and Crafts Movement*, Boston: Museum of Fine Arts Boston, 1998 (1987), pp 174–5, for discussion of the Society of Blue and White Needlework; see Rens Heringa and Harmen Veldhuisen, *Fabric of Enchantment – Batik from the North Coast of Java*, LA: Los Angeles County Museum of Art, 1996, p.17, for discussion of Javanese batik and synthetic dyes after 1890.

33 Weisberg, *Art Nouveau Bing: Paris Style 1900*, op.cit., pp 29–30; and Niggl Reto, 'Hermann Obrist: Spitzenwirbelspirale' in, Hans Ottomeyer and Margot Brandlhuber (eds), *Wege in die Moderne: Jugendstil in München 1896 bis 1914*, München: Klinkhardt & Biermann, 1997, p.25.

34 Hans Wichmann, *Von Morris bis Memphis: Textilien der Neuen Sammlung Ende 19. bis ende 20. Jahrhundert*, with essays by Stephan Eusemann, Basel: Birkhäuser Verlag, 1990, p.46.

35 Niggl, op.cit., pp 25, 30.

36 Parry, 'The New Textiles', op.cit., p.181; Wichmann, op.cit., p.46.

37 Peg Weiss, *Kandinsky in Munich: the Formative Jugendstil Years*, New Jersey: Princeton University Press, 1985 (1979), p.33.

38 Mary Logan, 'Hermann Obrist's Embroidered Decorations', *The Studio*, vol.9, 1896, p.100.

39 John Maciuika, *Before the Bauhaus: Architecture, Politics, and the German State 1890–1920*, Cambridge: Cambridge University Press, 2005, p.31; Weiss, *Kandinsky in Munich*, op.cit., pp 28–30.

40 Maciuika, op.cit., p.31, notes Kirchner's (1903–1904) and Klee's tenure, and notes that, due to eye problems, Obrist left the school in 1904. Taeuber studied at the school between 1910 and 1914, interrupted in 1912 by study at the School of Arts and Crafts in Hamburg. Sandor Kuthy, *Sophie Taeuber – Hans Arp: Künstlerpaare – Künstlerfreunde*, Bern: Kunstmuseum Bern, 1988, p.19.

41 See Maciuika, op.cit., p.60 for a discussion of Obrist's pedagogy in relation to Van de Velde's.

42 Peg Weiss, 'Kandinsky and the "Jugendstil" Arts and Crafts Movement', *The Burlington Magazine*, vol.117, no.866, 1975, p.272.

43 *Dekorative Kunst*, vol.12, no.7, 1904, p.232.

44 See Maciuika, op.cit., p.4, for a discussion of early German schools of applied art; see pp 35–45 for a discussion of the Darmstadt colony.

45 Weiss, 'Kandinsky and the "Jugendstil"', op.cit., p.270.

46 ibid, pp 270–72; Vivian Endicott Barnett, *Vasily Kandinsky: A Colorful Life: The Collection of the Lenbachhaus*, Munich, New York: Abrams, 1996, p.96.

47 Weiss, *Kandinsky in Munich*, op.cit., pp 33, 125, 211n.59.

48 Gabriele Bader-Griessmeyer, *Münchner Jugendstil-Textilien: Stickereien un Wirkereien von un nach Hermann Obrist, August Endell, Wassily Kandinsky und Margarete von Brauchitsch*, München: Tuduv Verlag, 1985, pp 58–9.

49 Weiss, 'Kandinsky and the "Jugendstil"', op.cit., p.271; Barnett, op.cit., p.126.

50 Barnett, op.cit., p.587; Weiss, *Kandinsky in Munich*, op.cit., p.135.

51 Cited in Kenneth Lindsay and Peter Vergo, *Kandinsky: Complete Writings on Art, Volume One (1901–1921)*, Boston: G.K. Hall, 1982, p.197.

52 Titus Eliëns, 'Nieuwe Kunst: Dutch Decorative Arts from 1880–1910' in, Titus Eliëns, Marjan Groot and Frans Leidelmeijer (eds), *Dutch Decorative Arts 1880–1940*, New York: Battledore, 1997, p.27.

53 Toorop and his colleague Johan Thorn Prikker were associated with Henry Van de Velde as early as 1885 through their joint membership in the Belgian Société des Vingt, in Eliëns, ibid, pp 42–4.

54 Gillian Naylor, *The Arts and Crafts Movement*, London: Trefoil Publications, 1990 (1971), p.123.

55 Linda Parry, *Textiles of the Arts and Crafts Movement*, London: Thames & Hudson, 1997 (1988), pp 25–9; Naylor, *Arts and Crafts*, op.cit., pp 104–5.

56 Parry, *Textiles of the Arts and Crafts*, op.cit., p.180; Jackson, *Twentieth Century*, op.cit., p.13.

57 See Parker, op.cit., pp 183–4 for a discussion of gender roles at the Royal School as well as outside commissions and male designers.

were never fully resolved, in part because of the interactive nature of theoretical debate itself, for which innovation leads to critique, which spurs further innovation.56

Modernist textiles allowed artists to blaze new creative paths that deviated from traditional channels, leading them to discover new venues, economic opportunities and collaborative opportunities for their work, from showroom, to gallery, to exposition, to architectural project. Artists working in textiles exploited the inherent versatility and flexibility of the medium in order to interconnect with parallel artistic endeavours, such as fashion, theatre and even politics, ushering in a period energised by experimentation and leading to the rewriting and reinvisioning of the rules and categories that constitute art history.

Textiles were at the forefront of Constructivist discourses that encouraged exploration of new visual forms to match the inherent structure and properties of the textile materials. They were conceived both for their structural qualities and their end use. These important Constructivist investigations in textiles led to the development of the prototype and to new notions of the role of the artist within the context of industrial design and engineering. Unique to this period was the model of the handmade textile, often made with technologically advanced materials, which mediated contact between art and industry and pointed to new ways that textiles could instigate transformations in other areas, such as space planning and architectural design. Indeed, today's highly engineered super textiles are a result of these early experiments in constructive and industrial design.

The transformative and explorative aspects of modernist textiles make them tangible documents of an era in transition. In some cases they exemplified the best art of the period, inspiring pioneering theoretical advancements and leading to innovations in other media. Far from being merely derivative reflections of prevailing styles and artistic movements, these modernist textiles were authentic artistic expressions resulting from considerable intellectual and technical enquiry. Other examples of textile work from the period pinpointed significant changes taking place in industry, commerce and society within the context of modern art and life. Perhaps no artistic medium best embodies the dynamism of the age than textiles.

nature of textiles by advancing them as fulfilling the functional and aesthetic needs of their time and place. It is worth recalling Liebes' observation, 'By their fabrics ye shall know them' since for this exhibition she identified nearly all of the main exemplars of modernist textiles created during the previous two decades, displaying them both as singular objects and within fully furnished rooms.[55] By doing so, she contributed to the dialogue begun decades before that advanced textiles as primary elements in the formation of the total work of art.

Conclusion

The story of the modernist textile – as it developed from the Art Nouveau and Arts and Crafts movements through the experimental 1910s, the decorative 1920s and the Constructivist, nationalist and revivalist 1930s – is indeed rich and complex. By studying modernist textiles, we get a new perspective on this influential period in art history, a deeper understanding of its major aesthetic movements, theoretical conflicts and technical developments. Seen from this vantage point, the history of modern art and industry becomes more expansive, more complicated and ultimately more fascinating.

Textiles were essential to *fin de siècle* efforts to unify arts and crafts within both domestic and public spheres; they provided artists with the opportunity to make meaningful artistic statements while taking part in the highly valued process of handcrafting. They were used in art education reform to address and instigate developments in abstract design and the role of applied arts in everyday life. In an era marked by tensions between high and minor arts, artists frequently used textiles to initiate artistic investigations that were decidedly disconnected from the process and context of painting. Indeed, textiles were ideal

alternatives to painting and came to embody progressive ideas about the unified environment within the context of the *Gesamtkunstwerk*. Photographs of early twentieth-century interiors and expositions published in the many decorative arts journals from the period are unanimous in their attention to textiles, and much theorising focused on the role of textiles in modern life.

The modernist textile was chameleon-like in the way it was used to appropriate visual forms and techniques from other worlds. Artists not only examined non-Western textiles for inspiration – Japanese embroidery, Javanese batik, Moroccan rugs, Andean weavings – but also transformed these textile traditions into expressions and visual forms relevant to their modern era. Textiles were also used to draw connections across time periods and cultural divides. Through their imagery, technique and function, textiles can carry cultural information on a variety of levels that other media cannot; thus modernist textiles can be understood as encapsulated social documents of the era.

Despite the historic association between textiles and women's work, which occasionally ignited criticism of modernist textiles as examples of decorative excess and of minor artistic accomplishment, modernist textiles also provided both women and men with an entrée into realms where they could earn artistic recognition and financial independence. Furthermore, the fluid and ambiguous nature of textiles during the first decades of the twentieth century actually allowed and encouraged many of those working with them to cross and even subvert gender and artistic hierarchies. While the art/craft, fine/applied, major/minor and male/female dichotomies that continually encircled theoretical discussion of modernist textiles largely dissipated by the 1940s, due to the significant degree of innovation and achievement in the field, these opposing forces

determined by the knotted stitches, gives scale to the rooms, a measuring rod', Le Corbusier wrote, and through their 'color and geometry, create a proportional average between materials, surfaces of the walls, and pieces of furniture'.[50] Similarly, Le Corbusier's early easel paintings of universal objects such as bottles and guitars were intended to provide an element of clarity to a room's overall visual organisation through standardisation of subject matter, as well as to function much like murals by becoming part of the architectural whole. Through woven reproductions of his painted work in pictorial tapestry he was able to envision his art functioning as large-scale murals in a non-painterly, textured, moveable and utilitarian medium, thereby expanding the artistic potential of the original conception. He later referred to woven tapestries as 'nomadic murals', commissioning many of them for his post-war architectural programmes because they 'are eminently mural works, but one can take them down and roll them under one's arm when he wants to move them to a different location or a different home'.[51] His 1936 tapestry for Marie Cuttoli, titled *Marie Cuttoli* (fig.117), depicts an abstract, reclining nude female behind a knotted cord tied to a grey boat, a theme of boats, nudes and rope that he had recently explored in his paintings. For what was to be his first tapestry design, Cuttoli had asked him to add a double border to the original as a visual frame, which is commonly used in tapestry to avoid dependence on bulky wood frames, in which he included a pine cone and shell, objects that, along with the nude and boat, inspired poetic reaction, as Le Corbusier referred to them.[52] This large tapestry, the size of a wall, fulfils Le Corbusier's requirement for an art that serves an architectural as well as a poetic function while maintaining the integrity of the materials from which it is made.

In 1936, many of Cuttoli's tapestries, which were woven between 1933 and 1936 from originals produced in the 1930s, were exhibited in London, Brussels and Stockholm before travelling to venues in America, where they were received with favourable attention. The travelling exhibitions included work by Braque, Dufy, Miró, Léger, Lurçat, Matisse, Picasso and Rouault. In the preface of the catalogue for New York's Bignou Gallery exhibition, the former Premier of France, Edouard Herriot, noted that these 'audacious experiments' were in fact responsible for reinvigorating the classic tradition in French tapestry and would soon be the 'classics of tomorrow'.[53] The exhibition then travelled to Chicago and finally, in 1939, with additional works from Cuttoli's collection bringing the total to over 20 tapestries, to the *Golden Gate Exposition* in San Francisco under the supervision of Dorothy Liebes, who directed the Decorative Arts Division.

Liebes, by then a respected weaver, was also an articulate writer with a broad knowledge of textile theory, history and contemporary trends. For the San Francisco exposition, she assembled a remarkable international cross-section of over 200 modernist textiles from the 1920s and 1930s, including textiles by Anni Albers, Marion Dorn, Raoul Dufy, Ethel Mairet, Ruth Reeves, Loja Saarinen, the Milwaukee Handicraft Project and Marguerite Zorach. In her catalogue essay, Liebes clearly demonstrated a grasp of the issues that modern textile designers, weavers and manufacturers were addressing at the time regarding new materials and new contexts for the role of textiles in modern life. The modernist textile, as Liebes explained, was both a 'dependent expression' in terms of its relationship to architecture and a 'bona fide textile expression' in terms of its role as an inherently unique art medium with a distinct set of aesthetic conditions.[54] For these reasons, Liebes was able to largely resolve the paradoxical

117
Le Corbusier
Marie Cuttoli 1936
tapestry, wool and silk
147 x 175 cm (58 x 69 in.)

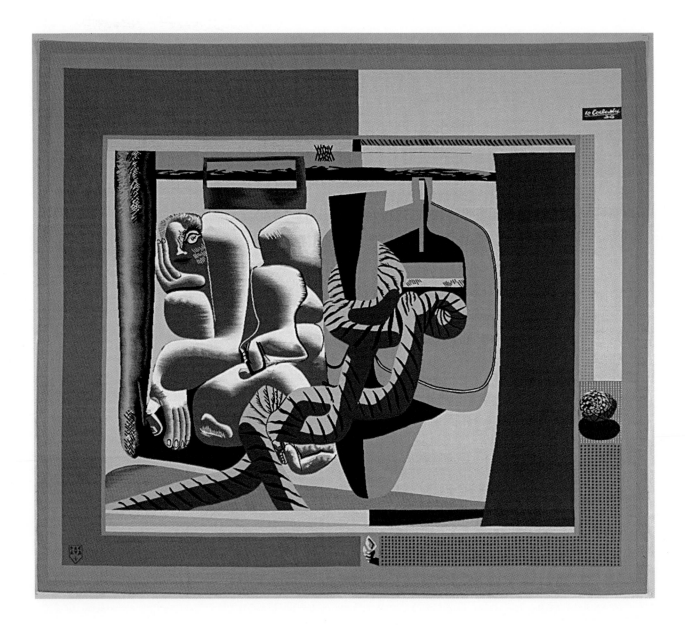

116
Jean Lurçat
needlepoint screen 1928
wool, linen, cotton (detail), three panels,
each: 195.5 x 73.6 cm (77 x 29 in.)

– the original work of art has been removed from its original context and transformed by other hands into something different. This transformation does not necessarily deprive tapestry of artistic merit, however. Indeed, in many cases, the tapestry has a more commanding presence than the original.

In the early 1930s, Marie Cuttoli decided to shift her Maison Myrbor textile production operations from North Africa back to France so that she could focus entirely on commissioning artist-designed tapestries from the renowned tapestry workshops in France. Cuttoli and her husband, Paul, had by that time assembled a significant collection of modern art by notable artists such as Pablo Picasso, Georges Braque, Fernand Léger, Georges Rouault, Raoul Dufy, Henri Matisse and Jean Lurçat. Cuttoli's idea was to translate many of these works into tapestries, as well as commission new ones by a wider range of artists that included Le Corbusier, Paul Klee, Sonia Delaunay and Jean Arp, to be used as cartoons for tapestries. Cuttoli, serving as an *editeur*, a publisher of sorts, was well aware of the rich French tapestry tradition whereby skilled weavers produced masterfully accurate woven reproductions from original paintings. The process had been perfected at the state weaving works in Aubusson, Beauvais and at the Gobelins workshop in Paris, which Louis XIV established in the seventeenth century. These historic tapestries were coveted for their scenes of aristocratic leisure, their enormous scale, and their expert technical artistry that demonstrated the weaver's skilled understanding of complex colour crossing and ability to finely pack the silk and wool yarns – with scores of stitches to the square centimetre – into seamlessly woven pictures. Cuttoli enlisted these great weaving houses, as well as affiliated private workshops, such as Atelier Pinton in Aubusson, to revive the tapestry tradition but now with modern paintings, watercolours and collages as their

models.[47] These collaborations led Cuttoli, her artists, weavers and collectors to envision modern tapestry in completely new ways in light of the changing relationship between art and architectural space.

The lengthy process of producing pictorial tapestry begins with a preliminary work of art – commonly called a cartoon but more precisely called a maquette – that is subsequently enlarged to a full-size cartoon. The cartoon is then adhered to the back side of the vertical warp threads so that the weaver can follow the pattern as faithfully as possible while interlacing the colour- and pattern-carrying weft threads. While this procedure may seem mechanical and rote, the actual process requires tremendous skill, and the results are not simply reproductions but in fact transformations, in which the size, texture, hue and perceptual field of the original has become something else entirely. It is not surprising that modernists concerned with theories of design and decorative arts, especially regarding the role of art in relation to other arts, the modern *Gesamtkunstwerk* in other words, collaborated with Cuttoli on this ambitious project. Indeed, Le Corbusier provided her with at least two designs for tapestries during the 1930s.[48]

Le Corbusier viewed textiles as occupying a middle ground between standardised object and work of artistic and poetic interest, preferring a hand-woven Moroccan carpet for the floor of his model house, *L'Esprit Nouveau*, at the 1925 Paris exposition, to a luxury silk carpet, such as those from Asia, for example, or even to a machine-manufactured one. His choice was based upon the fact that the Moroccan carpet possessed literal warmth, bright colours, geometric patterns and nubby surface texture while still being perceived as a common and inexpensive object, qualities that contributed to the overall integrity of Le Corbusier's total work of art.[49] These textiles also provided a sense of proportion and geometry to the room. 'Their geometric design,

and political textiles that were being produced at the same time.

This textile design might be one of the earliest examples of a graphic composition for mass production that unites striated umbrella forms, dot and line elements, and biomorphic and architectural shapes in an all-over pattern. These features would ultimately dominate the modernist vocabulary of the 1940s and 1950s by textile designers such as Ray Eames and Lucienne Day.

The textile work by fashion designer Elsa Schiaparelli (1890–1973) (fig.115, p.140) clearly illustrates the intersection between the esoteric, illusionistic vocabulary of Surrealism and the international consumer marketplace. Titled *Une Main à Baiser* (A Hand to Kiss), the textile depicts a field of free-floating, disembodied arms whose elegantly poised hands sprout bouquets of flowers. This truly surreal image, drawn from the violent impulses that motivated much Surrealist work from the 1920s, has now been transformed into a fabric suitable for framing, tailoring or upholstering, manufactured by the American firm Drucker-Wolf for distribution to the conservatively modern American market.

Jean Lurçat first began experimenting with textiles after World War I, borrowing his medium – needlepoint – from his mother, who was an avid practitioner; indeed she executed his first two needlepoint works, which he referred to as canvas 'tapestries', in 1917 and 1919.[43] Lurçat had been looking for a means of expression other than painting that would allow him to explore the fundamentals of colour and shape. He chose needlepoint on canvas, because, as he later wrote,

It forces the designer to think in a primitive way with values and juxtaposition. What excellent limitations! One comes through it trained, experienced; purged of the idiosyncrasies of easel painting.[44]

By the late 1920s, Lurçat was collaborating with Marie Cuttoli on textile commissions for her Maison Myrbor boutique and was well on his way to devoting the rest of his long artistic career to textile design; indeed, he essentially abandoned painting in favour of textiles in 1939.[45] Lurçat's finely worked needlepoint screen from 1928 (fig.116), perhaps executed in Algeria under Cuttoli's supervision, depicts a surrealistic underwater scene in bright woollen yarns that absorb rather than reflect light and are soft to the touch. A floating mermaid, whose arms metamorphose into fish and whose spinal column spouts leaves, dominates the centre panel. The two side panels depict similar scenes of metamorphoses, as organic, cell-like shapes, filled with fantastic animals, birds and human limbs, float amid a field of tangled vines. The content is at once recognisable yet beyond the scope of one's normal waking reality. The image seems generated by memories of a dream state, but the scale and laborious process puts Lurçat's work on a more monumental, less intimate level than Surrealist paintings – precisely the distinction Lurçat wanted to achieve. Lurçat believed that textiles were superior to painting because their inherent qualities – monumental, architectural, intensely hued and naturally warm and textural – could not be achieved in painting.[46]

The Pictorial Tapestry

Largely because of Lurçat and Cuttoli's work, the story of the modernist textile took an interesting twist at the end of the 1930s with the re-emergence of the pictorial tapestry. This might at first glance seem like a step backward on the path so many artists and theorists had taken in their efforts to advance the autonomous properties of textiles as a bona fide art. After all, pictorial tapestries are by nature reproductions

114
Harrell Studios
design for textile *c*.1930–39
gouache and graphite on paper
54.6 x 67 cm (21½ x 26⅜ in.)

113 (left)
Eve Peri
wall hanging *c*.1938–41
linen, corduroy, wool and yarn; sewn, stitched and pieced
68.6 x 54 cm (27 x 21¼ in.)

Perspective, Seattle: University of Washington Press, 2003, pp 28, 87.

52 See Fabio Benzi (ed.), *Balla: The Biagiotti Cigna Collection. Paintings, Futurist Fashion, Applied Arts*, Milan: Leonardo Arte, 1996, p.160; and Exposition internationale des arts décoratifs et industriels modernes, *L'Italie à l'Exposition internationale des arts décoratifs et industriels modernes*, Catalogue illustré, édité par les soins du Commissariat général de l'Italie, Paris, 1925, p.50 for photographs of the installation.

53 Gabriella Belli, *Depero Futurista: Rome-Paris-New York 1915–1932 and More*, Milan: Skira Editore, 1999, pp 21–7.

54 Wolfsonian Museum files, 'First Text' essay by Gianni Franzone, 1993.

55 Exposition internationale, Italie, op.cit., p.37.

56 Alain-René Hardy, *Art Deco Textiles: The French Designers*, London: Thames & Hudson, 2003, p.46.

57 Yvanhoé Rambosson, *Les Batiks de Madame Pangon*, Paris: Charles Moreau, 1925, p.3.

58 William Storey, 'New Techniques and Designs in Needlework', *New York Times*, 9 January 1938, p.SM14; 'Uber Bild-Stickerei' in, *Stickerei- und Spitzen*, October 1925, pp 6–7; Jane Cobb, 'Needle Pictures', *New York Times*, 15 September 1940, p.113.

59 Cited in Nicola Shilliam, 'Emerging Identity: American Textile Artists in the Early Twentieth Century' in, Marianne Carlano and Nicola Shilliam, *Early Modern Textiles*, Boston: Museum of Fine Arts Boston, 1993, p.33, from *American Magazine of Art*, December 1935.

60 Candace Wheeler, *The Development of Embroidery in America*, New York: Harper & Brothers, 1921, p.119.

61 'Zorach Tapestries Depict New York', *New York Times*, 11 February 1923, p.E4.

62 Cited in Hazel Clark, 'The Textile Art of Marguerite Zorach', *Woman's Art Journal*, Spring/Summer, 1995, p.22.

63 Cited in Shilliam, op.cit., p.31 from *Art in America*, vol.44, Fall, 1956, p.48.

64 Samuels, op.cit., p.8. *Davison's Textile Blue Book*, the annual directory of textile industry companies published by Davison Publishing, New York, lists hundreds of silk manufacturers in the Northeastern United States already by 1917. See also Madelyn Shaw, 'H. R. Mallinson & Co.: American silk from a Marketing Magician' paper presented at the Eighth Biennial Textile Society of America Conference, Northampton, MA, 2003, pp 3–5.

65 Paul Frankl, *New Dimensions: The Decorative Arts of Today in Words and Pictures*, New York: Payson and Clarke, 1928, p.61.

66 See Richard Slavin, 'F. Schumacher and Company and the Art Moderne Style', *The Magazine Antiques*, April 1989, pp 964–73; Madelyn Shaw, 'H. R. Mallinson & Co.', op.cit., pp 3–5.

67 Roger Gilman, 'The International Exhibition of Metalwork and Textiles', *Parnassus*, vol.2, no.8, December 1930, p.46.

68 Slavin, op.cit., pp 964–73; Shaw, 'Mallinson', op.cit. p.5; Madelyn Shaw, 'American Fashion: The Tirocchi sisters in Context' in, *From Paris to Providence: Fashion, Art, and the Tirocchi Dressmakers' Shop, 1915–1947*, op.cit., p.110; Elizabeth Cratsley, 'An Analysis of Certain Modernist Textile Designs', Master's Thesis, Smith College, 1929, p.41.

69 Mark Haworth-Booth, 'Photography: the New Vision' in, Tim Benton, Charlotte Benton and Ghislaine Wood, *Art Deco*, London: Bulfinch, 2003, p.285.

70 See Whitney Blausen, 'Textiles Designed by Ruth Reeves', Master's Thesis, Fashion Institute of Technology, 1992, and 'Ruth Reeves: A Pioneer in American Design', *Surface Design Journal*, Winter, 1995, pp 5–6, 36, for information about Ruth Reeves and W. J. Sloane.

Chapter Four

1 Walter Gropius, 'Manifesto of the Staatliche Bauhaus in Weimar' in, Isabelle Frank (ed.), *The Theory of Decorative Art: An Anthology of European & American Writings, 1750–1940*, with translations by David Britt, New Haven: Yale University Press, 2000, p.83.

2 See Magdalena Droste, *Bauhaus: 1919–1933*, Berlin: Bauhaus-Archiv, 1990, pp 12–13 for introduction to the Bauhaus; see John Maciuika, *Before the Bauhaus: Architecture, Politics, and the German State 1890–1920*, Cambridge: Cambridge University Press, 2005, for a discussion of art and architecture before the Bauhaus.

3 Van de Velde also recommended Hermann Obrist; Droste, ibid, p.16.

4 Cited in Jeannine Fiedler and Peter Feierabend (eds), *Bauhaus*, Cologne: Könemann, 2000, p.176. The full name of the school was Staatliches Bauhaus in Weimar (State Bauhaus in Weimar).

5 For information dealing with the Weimar Bauhaus Weaving Workshop, see Walter Scheidig, *Crafts of the Weimar Bauhaus*, New York: Reinhold, 1967; Hans Wingler, *The Bauhaus*, Cambridge: MIT Press, 1986 (1969); Sigrid Weltge, *Bauhaus Textiles*, London: Thames & Hudson, 1993; Magdalena Droste (ed.), *Das Bauhaus Webt*, Bauhaus-Archiv Berlin, Dessau, Weimar, Berlin: GH Verlag, 1998; Anja Baumhoff, *The Gendered World of the Bauhaus: The Politics of Power at the Weimar Republic's Premier Art Institute, 1919–1932*, Frankfurt: Peter Lang Pub Inc, 2001; Virginia Gardner Troy, *Anni Albers and Ancient American Textiles: From Bauhaus to Black Mountain*, London: Ashgate, 2002.

6 V. Troy, *Anni Albers*, ibid, pp 26–30, 48–50; Max Schmidt, *Kunst und Kultur von Peru*, Berlin: Propyläen-Verlag, 1929, p.498.

7 Magdalena Droste, *Gunta Stölzl*, Berlin: Bauhaus-Archiv, 1987, p.41; Weltge, op.cit., p.7; V. Troy, *Albers*, op.cit., pp 64–6.

8 Wingler, op.cit., p.116.

9 Droste, *Bauhaus*, op.cit., p.58.

10 Droste, *Bauhaus*, op.cit., p.73 notes that in 1922 they studied dyes, and in 1924 they studied weaving technology at Krefeld.

11 Clark V. Poling, *Bauhaus Color*, Atlanta: High Museum of Art, 1975, p.37.

12 Jeannine Fiedler et al., *Bauhaus*, op.cit., p.274; Droste, *Bauhaus*, op.cit., p.60.

13 Weltge, op.cit., pp 90, 104; Anja Baumhoff, 'The Weaving Workshop' in, Jeannine Fiedler et al., *Bauhaus*, op.cit., pp 471–2.

14 Droste, *Bauhaus*, op.cit., p.151.

15 Laurie Stein, 'German Design and National Identity 1890–1914' in, Wendy Kaplan (ed.), *Designing Modernity: the arts of reform and persuasion, 1885–1945*, London: Thames & Hudson, 1995, pp 70–73. Matilda McQuaid, *Lilly Reich: Designer and Architect*, New York: Museum of Modern Art, 1996, p.13.

16 For a discussion of Reich's leadership at the Werkbund see Matilda McQuaid, ibid, pp 13–14.

17 See Poling, op.cit., for information regarding Klee's pedagogy using colour; Droste, *Bauhaus*, op.cit., pp 62–5 and 144–5 for an account of Klee's Bauhaus teaching; see Weltge, op.cit., pp 60, 109, and Jenny Anger, 'Klee's Unterricht in der Webereiwerkstatt des Bauhaus' in, Droste, *Bauhaus Webt*, op.cit., pp 33–41 for discussion of Klee's role in the Weaving Workshop; see V. Troy, *Albers*, op.cit., pp 80–9, for Klee's teaching and Weaving Workshop student notebooks.



18 See Poling, op.cit., p.24 for a discussion of Klee's colour scales.

19 V. Troy, *Albers*, op.cit., p.82.

20 V. Troy, *Albers*, op.cit., pp 75–7.

21 Anni Albers and Nicholas Fox Weber, video interview, 1984, in the Josef and Anni Albers Foundation, Bethany, CT.

22 T'ai Smith, 'Redressing the Gender of Industry: In and Around Bauhaus Textile Production', presentation at the College Art Association conference, Seattle, 2004, p.9.

23 Smith, ibid, p.1; Droste, *Bauhaus Webt*, op.cit., p.299; Weltge, op.cit., pp 122, 201.

24 Smith, ibid.

25 Weltge, op.cit., p.124.

26 Under Lilly Reich's brief direction during the last months of the Bauhaus, members of the textile workshop, which had begun to produce designs for surface printed textiles, explored the use of type as pattern; see Weltge, p.144.

27 McQuaid, op.cit., p.25; Weltge, op.cit., p.119.

28 Weltge, op.cit., pp 99, 160; Eva Brües, *Zwei Generationen: Bildgewebe von Gabriele Grosse: Bildgewebe von Alen Müller-Hellwig*, Mönchengladbach: Städtisches Museum Schloss Rheydt, 1981, p.3.

29 Brües, ibid.

30 Baumhoff, 'Weaving', op.cit., p.477 credits Reich and Mies with coming up with the idea of the monochromatic shag rug; Susan Day, *Art Deco and Modernist Carpets*, California: Chronicle Books, 2002, credits Marie Cuttoli and Eileen Gray as experimenting with the monochromatic rug earlier, in the 1920s and 1929, respectively, pp 131, 138.

31 Frank Lloyd Wright, *Modern Architecture*, New Jersey: Princeton University Press, 1931, p.74.

32 Le Corbusier (Charles Edouard Jeanneret) and Amédée Ozenfant, 'Purism', from *L'Esprit Nouveau*, vol.4, 1920 in, Charles Harrison and Paul Wood (eds), *Art in Theory 1900–1990*, Oxford: Blackwell, 1998 (1992), pp 239–40.

33 Le Corbusier, *The Decorative Arts of Today*, translated by James Dunnell, Cambridge: MIT Press, 1987, p.84.

34 Christine Boydell, *The Architect of Floors: Modernism, Art, and Marion Dorn Designs*, London: Schoeser, 1996, pp 68–70; Isabelle Anscombe, *A Woman's Touch: Women in Design from 1860 to the Present Day*, New York: Penguin, 1985, pp 172–6.

35 Alain-René Hardy, *Art Deco Textiles: The French Designers*, London: Thames & Hudson, 2003, pp 246, 250.

36 Wyld directed until 1927, then the looms were moved to the basement of Désert; Philippe Garner, *Eileen Gray: Designer and Architect*, Berlin: Taschen, 1993, pp 24–9; Day, op.cit., pp 136–8, 190. For a discussion of how Gray differed from Le Corbusier, see Bridget Elliott, 'Housing the Work: women artists, modernism and the maison d'artiste: Eileen Gray, Romaine Brooks and Gluck' in, *Women Artists and the Decorative Arts 1880–1935: The Gender of Ornament*, London: Ashgate, 2002, pp 183, 191, n.5.

37 Day, op.cit., pp 136–41.

38 Herbert Read, *Art and Industry*, London: Shenval Press, 1947 (1934), pp 125–6.

39 ibid, p.129.

40 ibid, pp 154–60.

41 ibid, pp 122–30; Valerie Mendes, 'Carpets and Furnishing Textiles' in, *Thirties – British art and design before the War*, British Arts Council, 1979, pp 88–9.

42 Read, op.cit., p.125.

43 Margot Coatts, *A Weaver's Life: Ethel Mairet 1872–1952*, Bath: Crafts Study Centre, 1983, pp 89–92; Mary Schoesser, 'Marianne Straub' in, Margot Coatts (ed.), *Pioneers of Modern Craft*, Manchester: Manchester University Press, distributed exclusively in the USA by St Martin's Press, 1997, pp 83–94.

44 Cited in Anscombe, op.cit., p.153, from *Hand-Weaving Today*.

45 Christa Mayer Thurman, 'Textiles' in, *Design in America: The Cranbrook Vision 1925–1950*, New York: Abrams, 1983, pp 174–6.

46 Thurman, ibid, pp 175, 189; Gregory Wittkopp, 'Saarinen House: A Marriage of Weaving and Architecture', *Fiberarts*, vol.21, November 1994, p.36.

47 Thurman, ibid, p.187; Wittkopp, ibid, pp 35–50.

48 I am grateful to Roberta Gilboe of the Cranbrook Museum for sharing information about this work.

49 V. Troy, *Albers*, op.cit., pp 115–21.

50 Anni Albers, 'Work With Material', 1937 in, Brenda Danilowitz (ed.), *Anni Albers: Selected Writings on Design*, Hanover: Wesleyan University Press, 2000, p.7.

51 ibid.

52 Dorothy Liebes, *Contemporary Decorative Arts*, San Francisco: *Golden Gate International Exposition*, 1939, p.92. Liebes notes these additional materials, 'lacquered plastics, treated leathers, artificial horsehair, non-tarnishable metals, and glass threads'.

53 ibid, p.93.

54 Marlyn Musicant, 'Maria Kipp: Autobiography of a Hand Weaver', *Studies in the Decorative Arts*, vol.VIII, no.1, Fall–Winter, 2000–2001, pp 95–7.

55 ibid, p.101. Mary Schoeser and Whitney Blausen, '"Wellpaying Self Support": Women Textile Designers' in, Pat Kirkham and Lynne Walker (eds), *Women Designers in the USA 1900–2000: Diversity and Difference*, New York: Bard Graduate Center, 2000, pp150–51.

56 Paul Frankl, *New Dimensions: The Decorative Arts of Today in Words and Pictures*, New York: Payson and Clarke, 1928, p.30.

Chapter Five

1 Holger Cahill, *American Sources of Modern Art*, New York: Museum of Modern Art, 1933, pp 3–28, *American folk art; the art of the common man in America, 1750–1900*, New York: Museum of Modern Art, 1932; Cahill also edited in 1934 with museum director Alfred Barr, Jr, *Art in America in Modern Times*, New York, Reynal & Hitchcock.

2 Cahill, *American Sources*, ibid, p.5.

3 Kathryn Elizabeth Maier, 'A New Deal for Local Crafts: Textiles from the Milwaukee Handicrafts Project', Master's Thesis, University of Wisconsin-Milwaukee, May 1994, p.4; Mary Kellogg Rice, 'Designing for the Unskilled: A WPA Project in Milwaukee', *Surface Design Journal*, Summer, 1998, pp 8–11; Mary Kellogg Rice and Elsa Ulbricht, 'Block Printed Draperies', *Design*, February 1944, vol.45, no.6, p.22.

4 Maier, ibid, p.9.

5 Whitney Blausen, 'Textiles Designed by Ruth Reeves', Master's Thesis, Fashion Institute of Technology, 1992, Chapter Five; Whitney Blausen, 'Ruth Reeves: A Pioneer in American Design', *Surface Design Journal*, Winter, 1995, pp 5–6, 36.

6 Blausen, 'Textiles', ibid, p.70.

7 Virginia Gardner Troy, *Anni Albers and Ancient American Textiles: From Bauhaus to Black Mountain*, London: Ashgate, 2002, p.115.

8 Blausen, 'Textiles', op.cit., p.70; Sarah Burns, 'Fabricating the Modern: Women in Design' in, Marian Wardle (ed.), *American Women Modernists: The Legacy of Robert Henri, 1910–1945*, Utah: Brigham Young University, 2005, pp 32–8.

9 Ruth Reeves, 'Pre-Columbian Fabrics of Peru', *Magazine of Art*, vol.42, no.3, March 1949, p.107.

10 Virginia Tuttle Clayton, 'The Index of American Design: Picturing a National Identity', *Antiques*, December 2002, pp 76–7.

11 Clayton, ibid, p.82, n.2.

12 Janet Berlo and Patricia Cox Crews, *Wild by Design: Two Hundred Years of Innovation and Artistry in American Quilts*, Seattle: University of Washington Press, 2003, pp 15–21.

13 I am grateful to Kevin Tucker of the Dallas Museum of Art for providing information about this quilt; Jacqueline Atkins, 'Tradition and Transformation: Women Quilt Designers' in, Pat Kirkham (ed.), *Women Designers in the USA 1900–2000: Diversity and Difference*, New York: Bard Graduate Center, 2000, p.173.

14 Atkins, ibid, pp 173–4; April Kingsley, 'Ruth Clement Bond and the TVA Quilts' in, Janet Kardon (ed.), *Revivals! Diverse Traditions 1920–1945*, New York: Abrams, 1994, pp 119–21.

15 The Associates of the American Foreign Service Worldwide Spouse Oral History Collection, interview with Ruth Clement Bond; Kingsley, ibid, p.120.

16 Janet Berlo and Ruth Phillips, *Native North American Art*, Oxford: Oxford University Press, 1998, pp 63–8.

17 Wolfsonian Museum file xx1989.384; Berlo, ibid, p.65.

18 William Wroth, 'The Hispanic Craft Revival in New Mexico' in, Janet Kardon (ed.), *Revivals! Diverse Traditions 1920–1945*, op.cit., p.86.

19 I am grateful to Hilary Cooper-Kenny at Crazy as a Loom Weaving Studio for information about rag weaving.

20 Dale Chihuly, *Chihuly's Pendleton's*, Seattle: Portland Press, 2000, pp 1–3.

21 ibid.

22 Jane Kessler, 'From Mission to Market: Craft in the Southern Appalachians' in, Janet Kardon (ed.), *Revivals! Diverse Traditions 1920–1945*, op.cit., pp 122–4; Wendy Kaplan, 'Women Designers and the Arts and Crafts Movement' in, *Women Designers in the USA 1900–2000: Diversity and Difference*, op.cit., p.95; Virginia Gardner Troy, *The Weaving Room: A History of Weaving at Berry College*, exh.cat., Mt Berry: Berry College, Martha Berry Museum; and Athens: Georgia Museum of Art, 2002, p.12.

23 Kathleen Curtis Wilson, *Textile Art from Southern Appalachia: the quiet work of women*, Johnson City, TN: Overmountain Press, 2001, p.x.

24 Mary Meigs Atwater, *The Shuttle-Craft Book of American Hand-Weaving*, New York: Macmillan, 1951 (1928) , pp 123–4.

25 V. Troy, *Weaving Room*, op.cit., pp 3–9.

26 Atwater, op.cit., p.144.

27 Sigrid Weltge, *Bauhaus Textiles*, London: Thames & Hudson, 1993, pp 167–8; Anni Albers, 'Handweaving Today – Textile Work at Black Mountain College', *The Weaver*, vol.6, no.1, 1941, pp 1–4; Mary Atwater, 'It's Pretty – But is it Art?', *The Weaver*, vol.6, no.3, 1941, pp 13–14, 26.

28 Anni Albers, ibid, p.3.

29 Atwater, 'Pretty', op.cit., p.13.

30 See Rozsika Parker, *The Subversive Stitch: Embroidery and the Making of the Feminine*, London: The Women's Press, 1984, pp 191, 197–201 for examples and discussion of embroidered Suffrage movement banners in Britain.

31 See Jacqueline Atkins, 'Wearing Propaganda: Textiles on the Home Front in Japan, Great Britain, and America during the Greater East Asian War, 1931–45', *Textile*, vol.2, no.1, March 2004, pp 24–45, for a discussion of wartime propaganda textiles.

32 See Jonathan Woodham, *Twentieth Century Design*, Oxford: Oxford University Press, 1997, Chapter Four, 'Design and National Identity', pp 87–109 for a discussion of propagandistic design.

33 Tatiana Strizbenova, 'The Soviet Garment Industry in the 1930s', *The Journal of Decorative and Propaganda Arts*, vol.5, Summer, 1987, p.162.

34 Lidya Zaletova et al., *Revolutionary Costume: Soviet Clothing and Textiles of the 1920s*, New York: Rizzoli, 1989, p.130; Woodham, op.cit., p.91.

35 See Benjamin H. D. Buchloh, 'From Faktura to Factography', *October*, 30, Fall, 1984, pp 83–118, for a discussion of this development within the context of photography.

36 Eugenia Paulicelli, 'Fashion, the Politics of Style and National Identity in Pre-Fascist and Fascist Italy', *Gender & History*, vol.14, no.3, November 2002, pp 541–2.

37 See Dennis Doordan, 'In the Shadow of the Fasces: Political Design in Fascist Italy', *Design Issues*, vol.13, no.1, Spring, 1997, pp 39–52, for examples of the fasces in Fascist design.

38 Robert Cohen, *When the Old Left was Young: Student Radicals and America's First Mass Student Movement, 1929–1941*, New York: Oxford University Press, 1993, pp xiii–xx.

39 These examples are among other Union Arts textiles at the Wolfsonian Museum.

40 Cited in Michael Rosenfeld Gallery, *Fiber and Form: The Woman's Legacy*, New York: Michael Rosenfeld Gallery, 1996, p.10.

41 Janet Koplos, 'Eve Peri at Michael Rosefeld', *Art in America*, vol.85, no.1, January 1997, p.101.

42 See Elisabeth Aschehoug, 'New Textures Made in Fabrics', *The New York Sun*, 5 February 1938, for information about Peri-Umaña.

43 Jean Lurçat, *Rétropective: Peinture, Tapisseries*, Saint-Denis: Musée de Saint-Denis, 1966, pp 14–15; Gérard Denizeau, *Jean Lurçat*, Lausanne: Acatos, 1998, p.xxxiv.

44 Jean Lurçat, *Designing Tapestry*, London: Rockliff, 1950, p.19.

45 Galerie Beyeler Bâle, *Collection Marie Cuttoli, Henri Laugier, Paris*, Bâle: Editions Beyeler, 1970, p.55; Denizeau, op.cit., p.xx.

46 Jean Lurçat, *Designing Tapestry*, op.cit., Chapter One.

47 Martin Battersby, *The Decorative Thirties*, New York: Walker and Company, 1971, p.106; Day, op.cit., p.105; Denizeau, op.cit., p.xx.

48 His tapestry, 'Arcachonier', from the collection of Marie Cuttoli, which refers to the town of Arcachon on the Atlantic coast of France where Le Corbusier vacationed in 1928, was lent to the *San Francisco Golden Gate Exposition* in 1939, Dorothy Liebes, *Contemporary Decorative Arts*, San Francisco: *Golden Gate International Exposition*, 1939, p.94; his tapestry 'Marie Cuttoli' was woven in 1936, and is now in the collection of the Fondation Le Corbusier.

49 Brooke Pickering, 'Moroccan Carpets and Twentieth Century Design', paper presented at the International Conference on Oriental Carpets, Marrakesh, 2001, p.2; published in Cloudband Magazine online (www.cloud band.com), 27 September 2001, p.2.

50 Klaus Minges, 'Die Rezeption der Berberteppiche in Europa' in, *Berber Teppiche und Keramik aus Morokko*, Zürich: Museum Bellerive, 1996, p.20, from Le Corbusier, *L'Almanach de l'Architecture Moderne*, Paris: B. Crès & Cie, 1926, pp 170–1.

51 Le Corbusier letter to Oscar Niemeyer, 23 February 1959 in, Martine Mathias, *Le Corbusier Oeuvre Tissé*, Paris: Philippe Sers, 1987, p.14. Romy Golan, 'L'Eternel Decoratif: French Art in the 1950s' in, *Yale French Studies*, no.98, 2000, p.115, notes

that Le Corbusier first used the term 'Muralnomad' in the catalogue for an exhibition at Galerie Denise René, *Douze tapisseries inédites executées dans les Ateliers Tabard à Aubusson*, in 1952.

52 Fondation Le Corbusier Bulletin, *Informations*, 26 October 2004, p.11; Mathias, ibid, p.12.

53 Bignou Gallery, *Modern French Tapestries*, New York: Bignou Gallery, 1936, p.1.

54 Dorothy Liebes, *Contemporary Decorative Arts*, San Francisco: *Golden Gate International Exposition*, 1939, pp 92–3. Mary Schoeser and Whitney Blausen, '"Wellpaying Self Support": Women Textile Designers' in, Pat Kirkham and Lynne Walker (eds), *Women Designers in the USA 1900–2000: Diversity and Difference*, New York: Bard Graduate Center, 2000, p.153.

55 Liebes, ibid, p.92.

56 For example, the term 'fibre art' that emerged later in the century, referring to advanced sculptural work with textile related materials, served to reinforce the uncertain and marginal status of textiles by qualifying them as something other than pure art. See Elissa Auther, 'Classification and Its Consequences: The Case of "Fiber Art"', *American Art*, vol.16, no.3, Autumn, 2002, pp 2–9.

BIBLIOGRAPHY

Adaskina, Natalia and Sarabianov, Dmitri, *Popova*, translation by Marian Schwartz, New York: Abrams, 1990.

Albers, Anni, 'Work With Material' (1937) in, Danilowitz, Brenda (ed.), *Anni Albers: Selected Writings on Design*, Hanover: Wesleyan University Press, 2000, pp 6–7.

Albers, Anni, 'Handweaving Today – Textile Work at Black Mountain College', *The Weaver*, vol.6, no.1, 1941, pp 1–4.

Alfoldy, Sandra, 'Laura Nagy: Magyar Muse' in, Elliott, Bridget and Helland, Janice (eds), *Women Artists and the Decorative Arts 1880–1935: The Gender of Ornament*, London: Ashgate, 2003, pp 138–49.

Alvic, Philis, *Weavers of the Southern Highlands*, Kentucky: University of Kentucky Press, 2003.

Anscombe, Isabelle, *Omega and After: Bloomsbury and the Decorative Arts*, London: Thames & Hudson, 1981.

Anscombe, Isabelle, *A Woman's Touch: Women in Design from 1860 to the Present Day*, New York: Penguin, 1985.

Arp, Jean (Hans), 'Dada was not a Farce' (1949) in, Motherwell, Robert (ed.), *The Dada Painters and Poets: An Anthology*, Boston: G.K. Hall, 1981 (1951), pp 291–5.

Atkins, Jacqueline, 'Tradition and Transformation: Women Quilt Designers' in, Kirkham, Pat (ed.), *Women Designers in the USA 1900–2000: Diversity and Difference*, New York: Bard Graduate Center, 2000, pp167–83.

Atkins, Jacqueline, 'Wearing Propaganda: Textiles on the Home Front in Japan, Great Britain, and America during the Greater East Asian War, 1931–45', *Textile*, vol.2, no.1, March 2004, pp 24–45.

Atwater, Mary Meigs, *The Shuttle-Craft Book of American Hand-Weaving*, New York: Macmillan, 1951 (1928).

Atwater, Mary 'It's Pretty – But is it Art?', *The Weaver*, vol.6, no.3, 1941, pp 13–14, 26.

Auther, Elissa, 'Classification and Its Consequences: The Case of "Fiber Art"', *American Art*, vol.16, no.3, Autumn, 2002, pp 2–9.

Ayres, Diane, *American Arts and Crafts Textiles*, New York: Abrams, 2002.

Bader-Griessmeyer, Gabriele, *Münchner Jugendstil-Textilien: Stickereien un Wirkereien von un nach Hermann Obrist, August Endell, Wassily Kandinsky und Margarete von Brauchitsch*, München: Tuduv Verlag, 1985.

Barnett, Vivian Endicott, *Vasily Kandinsky: A Colorful Life: The Collection of the Lenbachhaus, Munich*, New York: Abrams, 1996.

Baron, Stanley, *Sonia Delaunay: The Life of an Artist*, New York: Abrams, 1995.

Barten, Sigrid, *Um 1900. Verborgene Schätze aus der Sammlung des Museums Bellerive Zürich*, exh.cat., Zürich: Museum Bellerive, 1999.

Battersby, Martin, *The Decorative Thirties*, New York: Walker and Company, 1971.

Baumhoff, Anja, *The Gendered World of the Bauhaus: The Politics of Power at the Weimar Republic's Premier Art Institute*, 1919–1932, Frankfurt: Peter Lang Pub Inc, 2001.

Baumhoff, Anja, 'The Weaving Workshop' in, Fiedler, Jeannine et al. (eds), Bauhaus, Cologne: Konemann, 2000, pp 466–79.

Belli, Gabriella, *Depero Futurista: Rome-Paris-New York 1915–1932 and More*, Milan: Skira Editore, 1999.

Benjamin, Roger, *Orientalist Aesthetics: Art, Colonialism, and French North Africa 1880–1930*, Berkeley: University of California Press, 2003.

Benoist, Luc, 'Les Tissus de Sonia Delaunay' in, *Art et Decoration*, November 1926, pp 141–4.

Bentivoglio, Mariella and Zoccoli, Franca, *The Women Artists of Italian Futurism*, New York: Midmarch Arts Press, 1997.

Benton, Tim, Benton, Charlotte and Wood, Ghislaine, *Art Deco*, London: Bulfinch, 2003.

Benzi, Fabio (ed.), *Balla: The Biagiotti Cigna Collection. Paintings, Futurist Fashion, Applied Arts*, Milan: Leonardo Arte, 1996, including his chapter, 'Balla and Photography: The Modern Gaze', pp 29–48.

Berlo, Janet and Phillips, Ruth, *Native North American Art*, Oxford: Oxford University Press, 1998.

Berlo, Janet and Crews, Patricia, *Wild by Design: Two Hundred Years of Innovation and Artistry in American Quilts*, Seattle: University of Washington Press, 2003.

Bieske, Dorothee, *Scherrebek: Wandbehänge des Jugendstils*, Heide: Boyens Buchverlag, 2002.

Bignou Gallery, *Modern French Tapestries*, New York: Bignou Gallery, 1936.

Billeter, Erika, *Europäische Textilien*, Zürich: Kunstgewerbemuseum Zürich, Buchdruckerei AG, 1963.

Blackburn, Sheila, '"To be poor and to be honest…is the hardest struggle of all": Sweated Needlewomen and Campaigns for Protective Legislation, 1840–1914' in, Harris, Beth (ed.), *Famine and Fashion: Needlewomen in the Nineteenth Century*, London: Ashgate, 2005, pp 243–57.

Blausen, Whitney, 'Textiles Designed by Ruth Reeves', Master's Thesis, Fashion Institute of Technology, New York, 1992.

Blausen, Whitney, 'Ruth Reeves: A Pioneer in American Design', *Surface Design Journal*, Winter, 1995, pp 5–6, 36.

Boydell, Christine, *The Architect of Floors: Modernism, Art, and Marion Dorn Designs*, London: Schoeser, 1996.

Brandstätter, Christian, *Wiener Werkstätte, Design in Vienna 1903–1932*, New York: Abrams, 2003, translated from the German 'Design der Wiener Werkstätte 1903–1932', by David H. Wilson, Colophon.

Brandt, Frederick, *Late 19th and Early 20th Century Decorative Arts*, Virginia: Virginia Museum of Fine Arts, 1985.

Braun, Emily, 'Futurist Fashion: Three Manifestoes', *Art Journal*, vol.54, no.1, Spring, 1995, pp 34–41.

Brik, Osip, 'From Picture to Calico-Print', *LEF*, Moscow, no.6, 1924, pp 30–34 in, Harrison, Charles and Wood, Paul (eds), *Art in Theory 1900–1990*, Oxford, Blackwell, 1998 (1992), translated by R. Sherwood.

Brües, Eva, *Zwei Generationen: Bildgewebe von Gabriele Grosse: Bildgewebe von Alen Müller-Hellwig*, Mönchengladbach: Städtisches Museum Schloss Rheydt, 1981.

Buckberrough, Sherry, 'Delaunay Design: Aesthetics, Immigration, and the New Woman', *Art Journal*, vol.54, no.1, Spring, 1995, pp 51–5.

Burkhauser, Jude (ed.), *Glasgow Girls*, Edinburgh: Canongate Books Ltd, 2001.

Burns, Sarah, 'Fabricating the Modern: Women in Design' in, Wardle, Marian (ed.), *American Women Modernists: The Legacy of Robert Henri, 1910–1945*, Utah: Brigham Young University, 2005, pp 30–56.

Cahill, Holger, *American Folk Art: the Art of the Common Man in America 1750–1900*, New York: Museum of Modern Art, 1932.

Cahill, Holger, *American Sources of Modern Art*, New York: Museum of Modern Art, 1933.

Callahan, Ashley, *Enchanting Modern: Ilonka Karasz (1896–1981)*, Georgia Museum of Art, 2003.

Carlano, Marianne, 'May Morris in Context' in, Carlano, Marianne and Shilliam, Nicola, *Early Modern Textiles: From Arts and Crafts to Art Deco*, Boston: Museum of Fine Arts Boston, 1993, pp 11–25.

Carlano, Marianne, 'Wild and Waxy: Dutch Art Nouveau Artistic Dress', *Art Journal*, vol.54, no.1, Spring, 1995, pp 30–33.

Chadwick, Whitney, 'Living Simultaneously: Sonia and Robert Delaunay' in, Chadwick, Whitney and De Courtivron, Isabelle (eds), *Significant Others: Creativity & Intimate Partnership*, London: Thames & Hudson, 1996, pp 31–50.

Chadwick, Whitney, *Women, Art, and Society*, London: Thames & Hudson, 1997 (1990).

Chihuly, Dale, *Chihuly's Pendleton's*, Seattle: Portland Press, 2000.

Clark, Hazel, 'The Textile Art of Marguerite Zorach', *Woman's Art Journal*, Spring/Summer, 1995, pp 18–25.

Clayton, Virginia Tuttle, 'The Index of American Design: Picturing a National Identity', *Antiques*, December 2002, pp 74–83.

Coatts, Margot, *A Weaver's Life: Ethel Mairet 1872–1952*, Bath: Crafts Study Centre, 1983.

Cohen, Arthur, *Sonia Delaunay*, New York: Abrams, 1975.

Cohen, Robert, *When the Old Left was Young: Student Radicals and America's First Mass Student Movement, 1929–1941*, New York: Oxford University Press, 1993.

Coleman, Elizabeth Ann, 'Myrbor and other mysteries: questions of art, authorship and émigrés', *Costume*, no.34, 2000, pp 100–103.

Cratsley, Elizabeth, 'An Analysis of Certain Modernist Textile Designs', Master's Thesis, Smith College, Massachusetts, 1929.

Crispolti, Enrico, 'Balla Beyond Painting: the "Futurist Reconstruction" of Fashion in, Benzi, Fabio (ed.), *Balla: The Biagiotti Cigna Collection. Paintings, Futurist Fashion, Applied Arts*, Milan: Leonardo Arte, 1996, pp 17–28.

Danzker, Jo-Anne Birnie and Brandlhuber, Margot, *Schönheit der Formen: Textilien Des Munchner Jugendstils*, Munich: Museum Villa Stuck, 2004.

Davies, Karen, *At Home in Manhattan: Modern Decorative Arts, 1925 to the Depression*, New Haven: Yale University Press, 1983.

Day, Lewis F. and Buckle, Mary, *Art in Needlework: A Book About Embroidery*, London: Batsford, 1900.

Day, Susan, *Art Deco and Modernist Carpets*, California: Chronicle Books, 2002.

Delaunay, Sonia, *Tapis et Tissus*, Paris: Moreau, 1929.

Delaunay, Sonia, *Sonia Delaunay: A Retrospective*, foreword by Robert T. Buck; essays by Sherry A. Buckberrough; chronology by Susan Krane, Buffalo, New York: Albright-Knox Art Gallery, 1980.

Denis, Maurice, 'Definition of Neo-Traditionism' (1890), translation by Peter Collier in, Harrison, Charles and Wood, Paul (eds), *Art in Theory 1815–1900: An Anthology of Changing Ideas*, Oxford: Blackwell, 1998, pp 862–9.

Denizeau, Gérard, *Jean Lurçat*, Lausanne: Acatos, 1998.

Deslandres, Yvonne, *Poiret: Paul Poiret 1879–1944*, New York: Rizzoli, 1987.

Doordan, Dennis, 'In the Shadow of the Fasces: Political Design in Fascist Italy', *Design Issues*, vol.13, no.1, Spring, 1997, pp 39–52.

Douglas, Charlotte, 'Suprematist Embroidered Ornament', *Art Journal*, vol.54, Spring, 1995, pp 42–5.

Douglas, Charlotte, 'Six (and a Few More) Russian Women of the Avant-Garde Together' in, Bowlt, John and Drutt, Matthew (eds), *Amazons of the Avant-Garde*, New York: Guggenheim Foundation, 2000, pp 39–58.

Droste, Magdalena, *Gunta Stölzl*, Berlin: Bauhaus-Archiv, 1987.

Droste, Magdalena, *Bauhaus: 1919–1933*, Berlin: Bauhaus-Archiv, 1990.

Droste, Magdalena (ed.), *Das Bauhaus Webt*, Bauhaus-Archiv Berlin, Dessau, Weimar, Berlin: G H Verlag, 1998.

Drouot, Hotel, auction catalogue of *Tableux Modernes* and works belonging to Poiret, 18 November 1925.

Dumas, Ann, Flam, Jack and Labrusse, Remi (eds), *Matisse, His Art and His Textiles: The Fabric of Dreams*, London: Royal Academy of Arts, 2004.

Dupuits, Petra, *Sonia Delaunay: Metz est Venu*, Amsterdam: Stedelijk Museum, 1992.

Eidelberg, Martin (ed.), *Designed for Delight: Alternative Aspects of Twentieth-Century Decorative Arts*, Montreal: Montreal Museum of Decorative Arts, 1997.

Eliëns, Titus, Groot, Marjan and Leidelmeijer, Frans (eds), *Dutch Decorative Arts 1880–1940*, New York: Battledore, 1997.

Elliott, Bridget, 'Housing the work: women artists, modernism and the *maison d'artiste*: Eileen Gray, Romaine Brooks and Gluck' in, Elliott, Bridget and Helland, Janice, *Women Artists and the Decorative Arts 1880–1935: The Gender of Ornament,* London: Ashgate, 2002, pp 176–91.

Elliott, Bridget and Helland, Janice, *Women Artists and the Decorative Arts 1880–1935: The Gender of Ornament*, London: Ashgate, 2002.

Exposition internationale des arts décoratifs et industriels modernes, *L'Italie à l'Exposition internationale des arts décoratifs et industriels modernes*, catalogue illustré, édité par les soins du Commissariat général de l'Italie, Paris, 1925.

Fanelli, Giovanni and Rosalia, *Il tessuto moderno: disegno, moda, architettura 1890–1940*, Firenze: Vallecchi, 1976.

Fiedler, Jeannine and Feierabend, Peter (eds), *Bauhaus*, Cologne: Könemann, 2000.

Frankl, Paul, *New Dimensions: The Decorative Arts of Today in Words and Pictures*, New York: Payson and Clarke, 1928.

Galerie Beyeler Bâle, *Collection Marie Cuttoli, Henri Laugier*, Paris, Bâle: Editions Beyeler, 1970.

Garner, Philippe, *Eileen Gray: Designer and Architect*, Berlin: Taschen, 1993.

Gilman, Roger, 'The International Exhibition of Metalwork and Textiles', *Parnassus*, vol.2, no.8, December 1930, pp 45–6.

Glellér, Katalin, *The Art Colony of Gödöllö (1901–1920)*, Gödöllö Municipal Museum, 2001.

Green, Nancy E. and Poesch, Jessie, *Arthur Wesley Dow and the American Arts and Crafts*, New York: Abrams, 2000.

Gronberg, Tag, 'Sonia Delaunay's Simultaneous Fashions and the Modern Woman' in, Chadwick, Whitney and Latimer, Tirza True (eds), *The Modern Woman Revisited: Paris Between the Wars*, New Jersey: Rutgers Press, 2003, pp 109–23.

Groom, Gloria, *Beyond the Easel: Decorative Painting by Bonnard, Vuillard, Denis, and Roussel, 1890–1930*, Chicago: Art Institute of Chicago, 2001.

Groot, Marrjan and de Roode, Ingeborg, *Amsterdamse School Textiel 1915–1930*, Tilburg: Uitgeverij Thoth Bussum, 1999.

Gropius, Walter, 'Manifesto of the Staatliche Bauhaus in Weimar' in, Frank, Isabelle (ed.), *The Theory of Decorative Art: An Anthology of European & American Writings, 1750–1940*, with translations by David Britt, New Haven: Yale University Press, 2000, p.83.

Hambidge, Jay, *Dynamic Symmetry: The Greek Vase*, New Haven: Yale University Press, 1920.

Hanks, David, *The Decorative Designs of Frank Lloyd Wright*, New York: Dutton, 1979.

D'Harcourt, Raoul, *Les Tissus Indiens du Vieux Perou*, Paris: Morancé, 1924.

Hardy, Alain-René, *Art Deco Textiles: The French Designers*, London: Thames & Hudson, 2003.

Haworth-Booth, Mark, 'Photography: the New Vision' in, Benton, Tim, Benton, Charlotte and Wood, Ghislaine, *Art Deco*, London: Bulfinch, 2003, pp 284–95.

Hay, Susan, Shaw, Madelyn et al. (eds), *From Paris to Providence: Fashion, Art, and the Tirocchi Dressmakers' Shop, 1915–1947*, Providence: Rhode Island School of Design, 2001.

Heringa, Rens and Veldhuisen, Harmen, *Fabric of Enchantment – Batik from the North Coast of Java*, Los Angeles: Los Angeles County Museum of Art, 1996.

Houze, Rebecca, 'From Wiener Kunst im Hause to the Wiener Werkstätte: Marketing Domesticity with Fashionable Interior Design', *Design Issues* 18, no.1, Winter, 2002, pp 3–23.

Hubert, Renee Riese, 'Sophie Taeuber and Hans Arp: a community of two', *Art Journal*, vol.52, Winter, 1993, pp 25–32.

Jackson, Lesley, *Twentieth-Century Pattern Design: Textile & Wallpaper Pioneers*, New York: Princeton Architectural Press, 2002.

Kaplan, Wendy, 'Traditions Transformed: Romantic Nationalism in Design, 1890–1920' in, Kaplan, Wendy (ed.), *Designing Modernity: the arts of reform and persuasion, 1885–1945*, London: Thames & Hudson, 1995, pp 19–47.

Kaplan, Wendy, 'Women Designers and the Arts and Crafts Movement' in, Kirkham, Pat (ed.), *Women Designers in the USA 1900–2000: Diversity and Difference*, New York: Bard Graduate Center, 2000, pp 85–99.

Kaplan, Wendy (ed.), *The Arts and Crafts Movement in Europe and America: Design for the Modern World*, London: Thames & Hudson, 2005.

Kessler, Jane, 'From Mission to Market: Craft in the Southern Appalachians' in, Kardon, Janet (ed.), *Revivals! Diverse Traditions 1920–1945*, New York: Abrams, 1994, pp 122–33.

Kingsley, April, 'Ruth Clement Bond and the TVA Quilts' in, Kardon, Janet (ed.), *Revivals! Diverse Traditions 1920–1945*, New York: Abrams, 1994, pp 119–21.

Kirkham, Pat and Walker, Lynne 'Women Designers in the USA 1900–2000: Diversity and Difference' in, Kirkham, Pat (ed.), *Women Designers in the USA 1900–2000: Diversity and Difference*, New York: Bard Graduate Center, 2000, pp 49–83.

Konstantinova, Iulia [Julia Tulovsky], 'Avant-Garde Textile Designs of the 1920s. Russia and the West' [in Russian], PhD Dissertation, Moscow State University, 2005.

Kooten, Toos van, *Bart van der Leck*, Otterlo: Kröller-Müller Museum, 1994.

Koplos, Janet, 'Eve Peri at Michael Rosenfeld', *Art in America*, vol.85, no.1, January 1997, p.101.

Kornfeld, Eberhard, *Textilarbeiten Nach Entwürfen von E.L. Kirchner der Davoser Jahre*, Bern: Verlag Galerie Kornfeld, 1999.

Kuthy, Sandor, *Sophie Taeuber – Hans Arp: Künstlerpaare – Künstlerfreunde*, Bern: Kunstmuseum Bern, 1988.

Labrusse, Rémi, 'Matisse's second visit to London and his collaboration with the "Ballets Russses"', *The Burlington Magazine*, vol.139, no.1134, September 1997, pp 588–99.

Lanchner, Carolyn, *Sophie Taeuber-Arp*, New York: Museum of Modern Art, 1981.

Lasko, Peter, 'The Student Years of the Brücke and their Teachers', *Art History*, vol.20, no.1, March 1997, pp 61–99.

Lavin, Maud, *Cut with the Kitchen Knife: The Weimar Photomontages of Hannah Höch*, New Haven: Yale University Press, 1993.

Leal, Brigitte, *La Donation Sonia et Charles Delaunay*, Paris: Centre Pompidou, 2003.

Lebedeff, A., 'L'Impression Sur Tissus dans l'Industrie Textile Russe' in, *L'Art Décoratif et Industriel de l'U.R.S.S.*, exh.cat., *1925 Paris Expositon Décoratifs*, Moscow: Mockba, 1925, pp 53–7.

Le Corbusier (Charles Edouard Jeanneret) and Ozenfant, Amédée, 'Purism', from *L'Esprit Nouveau*, vol.4, 1920 in, Harrison, Charles and Wood, Paul (eds), *Art in Theory 1900–1990*, Oxford: Blackwell, 1998 (1992), pp 237–40.

Le Corbusier, *The Decorative Arts of Today*, translated by James Dunnell, Cambridge: MIT Press, 1987.

Liebes, Dorothy, *Contemporary Decorative Arts*, San Francisco: *Golden Gate International Exposition*, 1939.

Lillethun, Abby, 'Javanesque Effects: Appropriation of Batik and its Transformations in Modern Textiles', *Appropriation, Acculturation, Transformation*, Proceedings of the Textile Society of America Symposium, 2004, pp 34–43.

184

Lindsay, Kenneth and Vergo, Peter, *Kandinsky: Complete Writings on Art, Volume One (1901–1921)*, Boston: G.K.Hall, 1982.

Lloyd, Jill, *German Expressionism: Primitivism and Modernity*, New Haven: Yale University Press, 1991.

Lodder, Christina, *Russian Constructivism*, New Haven: Yale University Press, 1990 (1983).

Logan, Mary, 'Hermann Obrist's Embroidered Decorations', *The Studio*, vol.9, 1896, pp 98–105.

Loos, Adolf, 'Ornament and Crime' (1908) in, Frank, Isabelle (ed.), *The Theory of Decorative Art: An Anthology of European & American Writings, 1750–1940*, with translations by David Britt, New Haven: Yale University Press, 2000, pp 288–94.

Lurçat, Jean, *Designing Tapestry*, London: Rockliff, 1950.

Lurçat, Jean, *Rétropective: Peinture, Tapisseries*, Saint-Denis: Musée de Saint-Denis, 1966.

Lynton, Norbert, *Ben Nicholson*, London: Phaidon Press, 1993.

Maciuika, John, *Before the Bauhaus: Architecture, Politics, and the German State 1890–1920*, Cambridge: Cambridge University Press, 2005.

Maier, Kathryn Elizabeth, 'A New Deal for Local Crafts: Textiles from the Milwaukee Handicrafts Project', Master's Thesis, University of Wisconsin-Milwaukee, May 1994.

Mainardi, Patricia, 'Quilts: the Great American Art', *The Feminist Art Journal*, vol.2, no.1, Winter, 1973, pp 18–23.

Makela, Maria, 'By Design: the Early Work of Hannah Höch in Context' in, Boswell, Peter, Makela, Maria and Lanchner, Carolyn, *The Photomontages of Hannah Höch*, Minneapolis: Walker Art Center, 1996, pp 49–80.

Makela, Maria, 'Wearing Wood: WWI and the Development of *Kunstseide* in Germany', College Art Association Paper, Seattle, 2004.

Marsh, Jan, 'May Morris: Ubiquitous Invisible Arts and Crafts-Woman' in, Elliott, Bridget and Helland, Janice (eds), *Women Artists and the Decorative Arts 1880–1935: The Gender of Ornament*, London: Ashgate, 2003, pp 35–52.

Mathias, Martine, *Le Corbusier Œuvre Tissé*, Paris: Philippe Sers, 1987.

Matisse, Henri, 'Notes of a Painter' in, Harrison, Charles and Wood, Paul, *Art in Theory 1900–1990: An Anthology of Changing Ideas*, Oxford: Blackwell, 1998 (1992), pp 72–8, (originally published as *Notes d'un peintre* in *La Grande Revue*, Paris, 1908).

Mattie, Erik, *World's Fairs*, New York: Princeton Architectural Press, 1998.

McQuaid, Matilda, *Lilly Reich: Designer and Architect*, New York: Museum of Modern Art, 1996.

Mead, Charles W., *Peruvian art; a help for students of design*, New York: American Museum of Natural History, Guide Leaflet, no.46, 1929 (1917).

Mendes, Valerie, 'Carpets and Furnishing Textiles' in, Opie, Jennifer and Hollis, Marianne (eds), *Thirties – British art and design before the War*, British Arts Council, 1979, pp 87–92.

Michael Rosenfeld Gallery, *Fiber and Form: The Woman's Legacy*, New York: Michael Rosenfeld Gallery, 1996.

Minges, Klaus, 'Die Rezeption der Berberteppiche in Europa' in, Minges, Klaus, *Berber Teppiche und Keramik aus Morokko*, Zürich: Museum Bellerive, 1996, pp 18–24.

Morris, William, 'Art Under Plutocracy', lecture delivered to the Russell Club, Oxford, 1883 in, Harrison, Charles and Wood, Paul (eds) with Jason Gaiger, *Art in Theory, 1815–1900: An Anthology of Changing Ideas*, Massachusetts: Blackwell, 1998, pp 558–63.

Morris, William, 'The Revival of Handicraft', *Fortnightly Review*, November 1988 in, Frank, Isabelle (ed.), *The Theory of Decorative Art: An Anthology of European & American Writings, 1750–1940*, with translations by David Britt, New Haven: Yale University Press, 2000, 169–76.

Musicant, Marlyn, 'Maria Kipp: Autobiography of a Hand Weaver', *Studies in the Decorative Arts*, vol.VIII, no.1, Fall–Winter, 2000–2001, pp 92–107.

Naumann, Francis, 'Man Ray and America: The New York and Ridgefield Years: 1907–1921' (Volumes I and II), PhD Dissertation, Graduate Center, City University of New York, 1988.

Naylor, Gillian, *The Arts and Crafts Movement*, London: Trefoil Publications, 1990 (1971)

Naylor, Gillian, 'Domesticity and Design Reform: the European Context' in, Snodin, Michael and Stavenow-Hidemark, Elisabet (eds), *Carl and Karin Larsson: Creators of the Swedish Style*, London: Victoria & Albert Museum, 1997, pp 74–87.

Ogata, Amy, *Art Nouveau and the Social Vision of Modern Living: Belgian Artists in a European Context*, Cambridge: Cambridge University Press, 2001.

Öri-Nagy, Cecilia, 'The History of Textile Art in Gödöllö' in, Keserü, Katalin and Németh, Zsófia (eds), *Women at the Gödöllö Artists' Colony*, London: Hungarian Cultural Centre, 2004, pp 11–17.

Ottomeyer, Hans and Brandlhuber, Margot (eds), *Wege in die Moderne: Jugendstil in München 1896 bis 1914*, München: Klinkhardt & Biermann, 1997.

Parker, Rozsika, *The Subversive Stitch: Embroidery and the Making of the Feminine*, London: The Women's Press, 1984.

Parry, Linda, *Textiles of the Arts and Crafts Movement*, London: Thames & Hudson, 1997 (1988).

Parry, Linda, 'The New Textiles' in, Greenhalgh, Paul (ed.), *Art Nouveau 1890–1914*, New York: Abrams, 2000, pp 178–91.

Paulicelli, Eugenia, 'Fashion, the Politics of Style and National Identity in Pre-Fascist and Fascist Italy', *Gender & History*, vol.14, no.3, November 2002, pp 537–59.

Peck, Amelia and Irish, Carol, *Candace Wheeler: the art and enterprise of American design, 1875–1900*, Metropolitan Museum of Art and Yale University Press, 2001.

Perry, Regenia A., *Harriet Powers's Bible Quilts*, New York: Rizzoli, 1994.

Picard Audap, *La Création en Liberté: Univers de Paul et Denise Poiret 1905–1928*, auction catalogue, 10 and 11 May 2005, Paris: Picard Audap, 2005.

Pickering, Brooke, 'Moroccan Carpets and Twentieth Century Design', paper presented at the International Conference on Oriental Carpets, Marrakesh, 2001, p. 2; published in Cloudband Magazine online (www.cloudband.com), 27 September 2001.

Poiret, Paul, *King of Fashion: The Autobiography of Paul Poiret*, translated by Stephen Haden Guest, Philadelphia: Lippincott & Co, 1931.

Poling, Clark V., *Bauhaus Color*, Atlanta: High Museum of Art, 1975.

Prékopa, Ágnes, 'József Rippl-Rónai's Decorative Art' in, Ilidko Nagy, József (ed.), *József Rippl-Rónai's Collected Works*, Budapest: Hungarian National Gallery, 1998, pp 111–12.

Rambosson, Yvanhoé, *Les Batiks de Madame Pangon*, Paris: Charles Moreau, 1925.

Raskin, E. H., *Fantaisies oceanographiques: en 25 planches en couleurs, proposant 58 fantaisies*, Paris: F. Dumas, c.1926.

Ray, Man, *Self Portrait*, MA: Little, Brown, & Co, 1963.

Read, Herbert, *Art and Industry*, London: Shenval Press, 1947 (1934).

Réalités, 'The Cuttoli Tapestry', *Réalités*, no.107, October 1959, pp 64–71.

Reeves, Ruth, 'Pre-Columbian Fabrics of Peru', *Magazine of Art*, vol.42, no.3, March 1949, pp 103–7.

Reiss, Winold, *You Can Design*, New York: McGraw-Hill, 1939.

Rice, Mary Kellogg, 'Designing for the Unskilled: A WPA Project in Milwaukee', *Surface Design Journal*, Summer, 1998, pp 8–11.

Riegl, Alois, *Altorientalische Teppiche*, Leipzig: Weigel, 1891.

Riegl, Alois, *Problems of Style, Foundations for a History of Ornament*, translation of *Stilfrragen: Grundlegungen zu einer Geschichte der Ornamentik* (1893) by Evelyn Kain, introduction by David Castriota, New Jersey: Princeton University Press, 1992.

Rodchenko, Alexander and Stepanova, Varvara, 'Constructivist Art' (1921) in, Hertz, Richard and Klein, Norman (eds), *Twentieth Century Art Theory*, New Jersey: Prentice Hall, 1990, pp 22–4.

Rotzler, Willy and Oberli-Turner, Maureen, 'Sophie Taeuber-Arp and the Interrelation of the Arts', *The Journal of Decorative and Propaganda Arts*, vol.19, 1993, pp 84–97.

Rubin, William (ed.), *'Primitivism' in 20th Century Art*, New York: Museum of Modern Art, 1984. Volume I: Christian Feest, 'From North America'; Philippe Peltier, 'From Oceania'; Jean-Louis Paudrat, 'From Africa'.

Samuels, Charlotte, *Art Deco Textiles*, London: V & A Publications, 2003.

Schmidt, Max, *Kunst und Kultur von Peru*, Berlin: Propyläen-Verlag, 1929.

Schoeser, Mary and Rufey, Celia, *English and American Textiles from 1790 to the Present*, London, Thames & Hudson, 1989.

Schoeser, Mary, 'Textiles, Surface, Structure, and Serial Production' in, Kardon, Janet (ed.), *Craft in the Machine Age 1920–1945*, New York: Abrams, 1995, pp 110–21.

Schoeser, Mary, 'Marianne Straub' in, Coatts, Margot (ed.), *Pioneers of Modern Craft*, Manchester: Manchester University Press; distributed exclusively in the USA by St Martin's Press, 1997, pp 83–94.

Schoeser, Mary and Blausen, Whitney, '"Wellpaying Self Support": Women Textile Designers' in, Kirkham, Pat and Walker, Lynne (eds), *Women Designers in the USA 1900–2000: Diversity and Difference*, New York: Bard Graduate Center, 2000, pp 145–65.

Seguy, E. A., *Floréal: dessins & coloris nouveaux*, Paris: A. Calavas, 1920s.

Shaw, Madelyn, 'H. R. Mallinson & Co.: American silk from a Marketing Magician', paper presented at the eighth Biennial Textile Society of America Conference, Northampton, MA, 2003.

Shilliam, Nicola, 'Emerging Identity: American Textile Artists in the Early Twentieth Century' in, Carlano, Marianne and Shilliam, Nicola, *Early Modern Textiles*, Boston: Museum of Fine Arts Boston, 1993, pp 28–44.

Shone, Richard, *The Art of Bloomsbury: Roger Fry, Vanessa Bell and Duncan Grant*, New Jersey: Princeton University Press, 1999.

Slavin, Richard, 'F. Schumacher and Company and the Art Moderne Style', *The Magazine Antiques*, April 1989, pp 964–73.

Smith, T'ai, 'Redressing the Gender of Industry: In and Around Bauhaus Textile Production', presentation at the College Art Association Conference, Seattle, 2004.

Starnes, Jane Ellen, 'Mary Crovatt Hambidge: Art and Nature' in, Anderson, Bill (ed.), *Southern Arts and Crafts 1890–1940*, Charlotte: Mint Museum of Art, 1996, pp 52–60.

Stein, Laurie, 'German Design and National Identity 1890–1914' in, Kaplan, Wendy (ed.), *Designing Modernity: the arts of reform and persuasion, 1885–1945*, London: Thames & Hudson, 1995, pp 49–77.

Stern, Radu, *Against Fashion: Clothing as Art, 1850–1930*, Cambridge: MIT Press, 2004 (1992).

Stickley, Gustav, 'The Use and Abuse of Machinery, and its Relation to the Arts and Crafts', *The Craftsman*, vol.11, issue 2, November 1906.

Strizbenova, Tatiana, 'The Soviet Garment Industry in the 1930s', *The Journal of Decorative and Propaganda Arts*, vol.5, Summer, 1987, pp 160–75.

Thurman, Christa Mayer, 'Textiles' in, Clark, Robert and Belloli, Andrea (eds), *Design in America: The Cranbrook Vision 1925–1950*, New York: Abrams, 1983, pp 173–211.

Thurman, Christa Mayer, 'Textiles: As Documented by The Craftsman' in, Kardon, Janet (ed.), *The Ideal Home 1900–1920: The History of Twentieth Century American Craft*, New York: Abrams 1993, pp 100–110.

Timmer, Petra, *Metz & Co.: De Creatieve Jaren*, Rotterdam: Uitgeverij 010, 1995.

Trilling, James, *Ornament: A Modern Perspective*, Seattle: University of Washington Press, 2003.

Troy, Nancy, *The De Stijl Environment*, Cambridge: MIT Press, 1983.

Troy, Nancy, *Modernism and the Decorative Arts in France: Art Nouveau to Le Corbusier*, New Haven: Yale University Press, 1991.

Troy, Nancy, *Couture Culture: A Study in Modern Art and Fashion*, Cambridge: MIT Press, 2002.

Troy, Virginia Gardner, 'The Great Weaver of Eternity: Dynamic Symmetry and Utopian Ideology in the Art and Writing of Mary Hambidge', *Surface Design Journal*, vol.23, no.4, Summer, 1999, pp 8–13.

Troy, Virginia Gardner, *Anni Albers and Ancient American Textiles: From Bauhaus to Black Mountain*, London: Ashgate, 2002.

Troy, Virginia Gardner, *The Weaving Room: A History of Weaving at Berry College*, exh.cat., Mt Berry: Berry College, Martha Berry Museum; and Athens: Georgia Museum of Art, 2002.

Velde, Henry Van de, *Récit de Ma Vie, Volume I*, van Loo, Anne (ed.), Brussels: Flammarion, 1992.

Velde, Henry Van de, 'Observations Toward a Synthesis of Art' in, Frank, Isabelle, *The Theory of Decorative Art: An Anthology of European and American Writings 1750–1940*, New Haven: Yale University Press, 2000, pp 194–200.

Verneuil, Maurice Pillard, *Etude de la plante: son application aux industries d'art: pochoir, papier peint, etoffes, céramique, marqueterie, tapis, ferronnerie, reliure, dentelles, broderies, vitrail, mosaïque, bijouterie, bronze, orfévrerie*, Paris: Librairie centrale des beaux-arts, c.1900.

Verneuil, Maurice Pillard and Mucha, Alphonse, *Combinations ornamentales se multipliant à l'infini à l'aide du miroir*, Paris: Librairie centrale des beaux-arts, 1901.

Verneuil, Maurice Pillard, *Kaleidoscope: ornements abstraits: quatre-vingt-sept motifs en vingt planches* / composés par Ad. et M.P.-Verneuil; pochoirs de J.Saudé, Paris: Albert Lévy, c.1925.

Völker, Angela, *Textiles of the Wiener Werkstätte 1910–1932*, London: Thames & Hudson, 1994 (1990),

Völker, Angela, *Patterns and Colors: Peche's Designs for Textiles and Wallpapers* in, Noever, Peter (ed.), *Dagobert Peche and the Wiener Werkstätte*, New Haven: Yale University Press, 2002, pp 127–35.

Wagner, Richard, 'The Art-Work of the Future' (1849) in, Harrison, Charles and Wood, Paul (eds) with Jason Gaiger, *Art in Theory, 1815–1900: An Anthology of Changing Ideas*, Mass.: Blackwell, 1998, pp 471–8.

Wahlman, Maude Southwell, *Signs and Symbols: African Images in African American Quilts*, Georgia: Tinwood Books, 2001.

Watkins, Nicholas, 'The Genesis of a Decorative Aesthetic' in, Groom, Gloria (ed.), *Beyond the Easel: Decorative Painting by Bonnard, Vuillard, Denis, and Roussel, 1890–1930*, Chicago: Art Institute of Chicago, 2001, pp 1–27.

Weisberg, Gabriel P., *Art Nouveau Bing: Paris Style 1900*, New York: Abrams, 1986.

Weisberg, Gabriel P., *Stile Floreale: The Cult of Nature in Italian Design*, Miami: The Wolfsonian Foundation, 1988.

Weisberg, Gabriel P., Becker, Edwin and Possémé, Évelyn (eds), *The Origins of L'Art Nouveau: The Bing Empire*, Amsterdam: Van Gogh Museum, 2004.

Weiss, Peg, 'Kandinsky and the "Jugendstil" Arts and Crafts Movement', *The Burlington Magazine*, vol.117, no.866, 1975, pp 270–77, 279.

Weiss, Peg, *Kandinsky in Munich: the Formative Jugendstil Years*, New Jersey: Princeton University Press, 1979 (1985).

Weltge, Sigrid, *Bauhaus Textiles*, London: Thames & Hudson, 1993.

Wheeler, Candace, *The Development of Embroidery in America*, New York: Harper & Brothers, 1921.

White, Palmer, *Poiret*, New York: Clarkson Potter Inc, 1973.

Whitley, Lauren, 'Morris De Camp Crawford and American Textile Design 1916–1921', MA Thesis, S.U.N.Y. Fashion Institute of Technology, 1994.

Wichmann, Hans, *Von Morris bis Memphis: Textilien der Neuen Sammlung Ende 19. bis ende 20. Jahrhundert*, with essays by Stephan Eusemann, Basel: Birkhäuser Verlag, 1990.

Wietek, Gerhard, *Schmidt-Rottluff: Plastik und Kunsthandwerk, Werkverzeichnis*, Munich: Hirmer Verlag, 2001.

Wilson, Kathleen Curtis, *Textile Art from Southern Appalachia: the quiet work of women*, Johnson City, TN: Overmountain Press, 2001.

Wilson, Richard Guy, *The Machine Age in America 1918–1941*, New York: Abrams, 1987.

Wingler, Hans, *The Bauhaus*, Cambridge: MIT Press, 1986 (1969).

Wittkopp, Gregory, 'Saarinen House: A Marriage of Weaving and Architecture', *Fiberarts*, vol.21, November 1994, pp 35–50.

Woodham, Jonathan, *Twentieth Century Design*, Oxford: Oxford University Press, 1997.

Worringer, Wilhelm, *Abstraction and Empathy (Abstraktion und Einfühlung)*, Munich: Piper-Verlag, 1908, English edition, translated by Michael Bullock, London: Routledge, 1953.

Worringer, Wilhelm, 'The Historical Development of Modern Art' (Entwicklungsgeschichtliches zur modernsten Kunst), *Der Sturm*, vol.2, no.75, August 1911, translated by Rose-Carol Washton Long in, Benson, Timothy O. and Forgács, Éva (eds), *Between Worlds: A Sourcebook of Central European Avant-Gardes, 1910–1930*, Cambridge: MIT Press, 2002, pp 52–4.

Wright, Frank Lloyd, *Modern Architecture*, New Jersey: Princeton University Press, 1931.

Wright, Frank Lloyd, 'The Art and Craft of the Machine' (1901) in, Frank, Isabelle (ed.), *The Theory of Decorative Art: An Anthology of European & American Writings, 1750–1940*, with translations by David Britt, New Haven: Yale University Press, 2000, pp 201–12.

Wroth, William, 'The Hispanic Craft Revival in New Mexico' in, Kardon, Janet (ed.), *Revivals! Diverse Traditions 1920–1945*, New York: Abrams, 1994, pp 84–93.

Zaletova, Lidya et al., *Revolutionary Costume: Soviet Clothing and Textiles of the 1920s*, New York: Rizzoli, 1989.

INDEX

(du) = dates unknown